C000049146

Photography from the Turin Shroud to the Turing Machine

for Romi Mikulinsky

Photography from the Turin Shroud to the Turing Machine

Yanai Toister

intellect

Bristol, UK / Chicago, USA

First published in the UK in 2020 by
Intellect, The Mill, Parnall Road, Fishponds, Bristol, BS16 3JG, UK

First published in the USA in 2020 by
Intellect, The University of Chicago Press, 1427 E. 60th Street,
Chicago, IL 60637, USA

Copyright © 2020 Intellect Ltd

All rights reserved. No part of this publication may be reproduced,
stored in a retrieval system, or transmitted, in any form or by
any means, electronic, mechanical, photocopying, recording, or
otherwise, without written permission.

A catalogue record for this book is available from the British Library.
Cover designer: Alex Szumlas
Copy editor: MPS Technologies
Production manager: Jessica Lovett
Typesetting: Contentra Technologies

Cover image: Gottfried Jäger, Lochblendenstruktur 3.8.14 C 2.5.1, 1967.
Multiple Camera obscura work. Colour coupler print (Agfacolor) 50 x 50 cm.
Archive of the artist. Copyright 2019: Artist and VG Bild-Kunst Bonn, Germany.

Print ISBN: 978-1-78938-156-6
ePDF ISBN: 978-1-78938-157-3
ePub ISBN: 978-1-78938-158-0

Printed and bound by Severn, Gloucester

To find out about all our publications, please visit
www.intellectbooks.com.
There, you can subscribe to our e-newsletter,
browse or download our current catalogue,
and buy any titles that are in print.

This is a peer-reviewed publication.

This book was published with the support of:

 The Shpilman Institute of Photography

 The Israel Science Foundation.

Contents

Form is henceforth divorced from matter. In fact, matter as a visible object is of no great use any longer, except as the mould on which form is shaped. Give us a few negatives of a thing worth seeing, taken from different points of view, and that is all we want of it. Pull it down or burn it up, if you please [...]. Matter in large masses must always be fixed and dear; form is cheap and transportable. We have got the fruit of creation now, and need not trouble ourselves with the core.

Oliver Wendell Holmes[1]

Photos are 'objects' because they have a palpable support (paper or such like). Images on screens are not 'objects' in the following sense: they demand apparatus in order to be distributed. But photos are not 'objects' in the traditional sense of the term. The information that they carry is not contained in its volume but rests upon its surface and may be transferred from one support to another. Photos (just like printed texts) form a bridge between the culture of 'objects' and the culture of 'pure information'. However, photos are closer to the culture of informatics than to printed texts, because the information that they carry was elaborated according to the programme within the apparatus. Hence, photos are the last phenomenon of the culture of 'objects' and the first of the culture of 'pure information'. And their distribution illustrates such a revolutionary transition.

Vilém Flusser[2]

Introduction

One of the most compelling stories of modernity is that of photography. From a mere fantasy shared by a handful of people less than two centuries ago, it has become a ubiquitous form of representation and communication, embedded into every aspect of modern life. This story has since taken a dramatic twist: photography's materiality has become redundant and its symbolic apparitions have been made fluid, endlessly animated across the cultural field.[3] Consequently, photography today is, quite literally, both nowhere and everywhere, difficult to define and nearly impossible to contain. Therefore, somewhat paradoxically, even though numerous technologies now seem to facilitate potentially infinite possibilities of post-industrial making, sharing and archiving of photographic images, many commentators fear that the story of photography is nearing its end. Talk about the end of photography, and what will follow it, or is already upon us, is nowadays almost commonplace.[4]

Meanwhile, in just a single generation, the advent of digital computation has wrought seismic changes in how we communicate, learn and think.[5] It has reconfigured most, if not all, of our forms of experience and mediation of the world. Human culture, it has even been suggested, is no longer dependent on our physical being because it can emerge independently from silicon without recourse to the hydrocarbons we are still made of. Yet while these reveries are now omnipresent, fuelling much of the anxiety in our collective psyche, the operation, design and *creative* potential of information technology and computing are understood by relatively few. This might explain why there remains a reluctance to understand emerging artistic practices as deeply tied to previous technologies. This is especially disturbing when some of such practices rely on and perpetuate previous forms of aesthetic mediation. By ignoring this, we miss the opportunity to understand how earlier information machines like photography have always presented radical new potentials for extending creativity, and how computation continues to do so in similar ways.

The premise of this book is that the two aforementioned stories are not incommensurable. The former is the latter's historical precedent, not only its prologue. The latter story does not serve as the former's epilogue. In fact, we often discover that two seemingly unconnected stories are simply episodes within a single, unfolding story.

1

In other times, it may even turn out that they were nothing but conflicting narratives of the same story. If this is indeed the case with photography and computation, we need to weave these two threads together more consistently than the literature has done hitherto. Therefore, one task undertaken in this book is to retell the tale of photography so that its short history foretells its current state. Another is to do so theoretically and with means that do not prioritize any of the two dramatic ends but rather presents both as speculative propositions for one narrative.

To do so this book was conceived with two key metaphors: the Turin Shroud and the universal Turing machine. Both, I contend, are powerful vehicles for tracing the history and theory of photography. Nevertheless, I am interested in these metaphors only as conceptual models, as sets of propositions for philosophizing photography. Thus, neither will be scrutinized historically and both will mostly remain in the background, as befits their ephemerality.[6] Simultaneously, I will foreground a wide range of theoretical toolkits in support of this innovative approach: 'As a technology, photography is a primitive form of information technology. As an artistic strategy, it is an early form of algorithmic art'.

This book is also motivated by the postulation that the story of photography, as it is most often narrativized in critical or academic contexts, is remarkably monolithic. It revolves, with rare exceptions, around one of three approaches: the first based on art theory and aesthetics, the second on linguistic or semiotic investigation and the third on phenomenological inquiry. For art and aesthetics the pertinent question is photography's potential for artefactuality. For the linguistic investigation, or semiotic approach, photography is a dynamic signage system that must always be 'decoded' in order to be 'read'. Finally, phenomenology regards photography as a cluster of objects and events, all to some extent theoretical as well as actual, which should be observed, perceived and cognitivized. No matter which of the three approaches is adopted, however, most writing on photography is comprised of assumptions, definitions and dichotomies that are largely consistent. While the theory of photography played a central role in defining various phases of modernity, and has been pivotal in transitioning between them from classical to late to postmodernity, its salient feature is the narrowness of its repertoire. In sum, according to this foundational discourse, from Talbot to Bazin to Barthes, to name but a few eminent writers, every photograph can be understood as a Turin Shroud on paper.

The Turin Shroud is one of the most heavily studied and most contentious artefacts in history. It is notoriously controversial because of two trivial questions: the age of its cloth and, more importantly, the way in which the image of a man, who appears to have suffered physical trauma in a manner consistent with crucifixion, has come to appear on it. Many have argued that the image is acheiropoietic – created without hands and coming into existence miraculously. It has been suggested that the image depicts Jesus and that it has been created either by his

blood or by neutron radiation during the moment of his resurrection. Others have proposed contradictory theories based on disciplines ranging from chemistry to biology and from medical forensics to optical image analysis. According to these theories, the image has been created either by a form of ancient painting, by an obscure method of chemical pigmentation, or even by a medieval form of photography. Common to all scientific theories is the agreement that the image has been doctored in one way or another.

Advocates of the acheiropoietic view counter, however, that empirical analysis or logical methods are simply insufficient for the level of understanding required for perceiving the miracle of the shroud. In many ways they are right. Whether the laws of physics prove or refute this religious myth is of marginal importance. The shroud may or may not have been in contact with the body of Jesus Christ. The image may or may not have been created independently of human agency. Nevertheless, it *does* resemble many other manmade depictions of how Jesus looked or how he died.

Thus, the outcome of the debate about the shroud's authenticity remains largely irrelevant to both religious belief and science. We may refute the claim that the shroud or the image fixed on it date back to the first century, and therefore must be forms of subsequent fakery, but we must nevertheless concede that the shroud *is* an immensely important symbolic object. As such, it is more important to art and communication than it is to other fields of inquiry.

Somewhat surprisingly, the Turin Shroud metaphor has been mentioned only occasionally with reference to photography,[7] far too rarely considering how often photography, much like the shroud, is used as a site for discussion about the relation between depiction and representation. This discussion leaves photography torn between the supposed polarities of expression and authenticity, but also bound to both and confined between truth-to-appearance and truth-to-world. This has been reiterated in most theoretical accounts of photography, even those that seem to be distinguishable. Much like the religious paradigms of the shroud, these may not be fully scientific definitions but they are immensely important and useful to many authors. Writing about photography thus all too often reads like a discussion of the Turin Shroud. In other words, this writing revolves around 'an ontological privilege' with which photography has been born, separating it from other breeds of pictures. Arguably, although the names, definitions and descriptions for this privilege often change, many still cling to it. It may be explained and understood via a special mode of access, namely the artefact known as the photograph. This shall be the focus of Chapter 1.

Considered generically, photographs are commonly viewed as instances of privileged if not miraculous transference. That magic lies in how objects in the world re-present themselves in photographs, or in the precise kind of presence they afford objects. Either way, it is continually alleged that it is not abstractions, concepts, or

calculations that inhabit photographs but precisely the objects that appear in them. By virtue of the power of these appearances, beliefs may be enshrined, doctrines disseminated, and doubts dissipated. Crucially, in a photograph, objects do not appear by the power of a living god but rather by virtue of another power: the benevolence of nature and its 'hand' made of light.

Thus, the photographic camera has traditionally been equated to the eye. As such, the camera has often been understood as an extension of our perceptual and cognitive apparatus. This conditioning of visual perception makes human vision and pictorial representations co-extensive, setting up a supposed uniformity between looking at a photograph and looking at the world. However, as forms of perceptual magic transform, so do the material conditions of living generally, along with technologies and modes of representation. In time, these changes have led us to think in particular ways that are appropriate to them. This holds true for cave paintings, holy texts, theatre performances and other forms of human expression, but perhaps above all for photographs.

In other words, the construal wherein the only equivalence actuated in photography is the eye-camera is lacking, because it is contingent on an all-too-specific premise of 'nature'. At best, it can be taken to convey the idea that the camera replicates the basic physiological structure of the biological eye, namely a photosensitive surface encased by a darkened chamber with an opening formed of a lens, and that both systems articulate the same electromagnetic material. But as photography has changed, and photographs are no longer produced exclusively by cameras, we can appreciate how much can be gained from another construal. Because the construction of an image always involves extremely complicated processes, from either a physiological or a cultural point of view, the mutual relations forged between these two types of optical instruments can compound this complexity in various ways. If our vision has forever been 'camerafied' then, I propose, this is because photography is an apparatus and practice for generating visual representations, thereby heralding new kinds of human-machine reciprocities. As it affects minds more than eyes, it not only challenges definitions of vision but also problematizes beliefs and dogmas pertaining to perception, cognition and creativity. This shall be the focus of Chapter 2.

Being a migratory system, photography has come to be used by many disciplines. Note, for example, how quickly it was incorporated into newspaper journalism, not to mention fairground entertainments or the timeworn culture of the erotic, to cite just a small, provocative array of first uses. Today it is being integrated into numerous multimedia systems – in a plethora of specialties, disciplines and sub-disciplines and across fields as various as law enforcement, medicine and astronomy. Within many of these domains, the exponentially growing powers of computer programming are yoked into technologies such as machine vision, augmented reality and virtual reality where they conjure up veritable spaces of

experience and sensation. Therein, photograph-like images no longer make or even care to make a claim for a causal connection to anything in the world. The new image (also called digital, algorithmic or 'softwared',[8] see Chapter 4) is located in a cybernetic sphere removed from human habitation, occupied by objects that have never basked in any kind of light or that have never occupied space and time as these have been popularly understood since the European enlightenment. Quasi-photographic images, as I call them, are rarely 'a type of icon or visual likeness, which bears an indexical relationship to its object'[9] as photographs have so often been described.

The photographic image, which Roland Barthes famously described as 'a message without a code',[10] is now better served if comprehended as nothing but code. In fact, without code the contemporary photograph is nothing at all. If anything, it is a cluster of voltage differences that can just as easily be outputted as a text or audio file, or a long and inscrutable string of digits. Thus, the traditional photo-theoretical model of object-image consistency must give way to an alternative, perhaps almost semiotic, model of object-code-image interdependency. Put differently, photography could be defined in terms of multiple systems of classification and abstraction, multiple symbolic processes of transformation, and their interchangeability with other processes and syntactic systems.

It is often overlooked that not only the photographic image but also the camera, film (or sensor) and algorithm are cultural objects. This means that their design and construction contain much information and many implicit affordances. All these need to be made explicit and then interrogated so that we can understand the structures of belief and the patterns of cognition that photography, considered as a general apparatus, tends to generate, even as individual images themselves often appear, distractingly, not to be principally concerned with such large, philosophical issues. Important insights may thus be gained from dissociating thinking *about photography* from thinking *through photographs*. Photography's cultural value has for too long been measured almost exclusively in terms of its products. Instead, it now ought to be redefined by studying the relationships between its components: the electromagnetic, optical, mechanical and photochemical, and now the exclusively digital elements and procedures that combine as a prototypical process for the production of prototypical artefacts. So how should we apprehend these extensive systems that empower photography?

This book argues that photography has never been a 'natural' process but rather a radicalization of a cultural process of abstraction that has for 40,000 years defined human communication. As such, it is the culmination of a process leading to the gradual abolition of all natural dimensions. Friedrich A. Kittler defined this process as the $n-1$ dimensional signifier.[11] Crucial for this alternative definition is the understanding that the $n-1$ dimensional signifier does not only reduce dimensions. More

importantly, it *conceals*, *disguises* and *distorts* the signified, that is, the *n* dimensional. Photography catapulted humanity into a 'zero-dimensionality', which Vilém Flusser dubbed 'the universe of technical images'.[12] Kittler similarly referred to 'the world of the symbolic' or 'the world of the machine',[13] which he believed came to exist with the 'super-medium' of the computer. In this book, I draw on both Flusser's and Kittler's terminologies to contend that photography and the computer are complementary. When theorized *as* computation, photography is the most elegant explanation for *how* so many human modes of visual expression have been abstracted and *why* these modes are nowadays being replaced by electronic code. Appropriately, the alternative construal advanced in this book stems from Flusser's unique 'programmatic cosmology'. This also facilitates two secondary objectives of this book: to bridge between two different and largely unconnected lineages of photography scholarship practised in the English-speaking world and Continental Europe, and do so using toolkits from both photography theory and media studies.

In Flusser's taxonomy, traditional human consciousness comprises two competing, albeit very similar 'world images'. These are dubbed, the 'finalistic' and 'causal'. The former view is the reflection of religious traditions and mystical, foundational experiences. The latter arises from the natural sciences, according to which every event is the effect of specific causes, which are in turn causes of specific effects. One may therefore conclude that, in the absence of another, third, perspective, it is possible to live simultaneously with both finalistic and causal realities. Furthermore, both views have an identical linear structure, which could be summarized as 'purpose-aim' and 'cause-effect'. Traditional photography theory, I argue, is comprised of both and consequently necessitates that photographs should always be demonstrative or consequential. Contrariwise, Flusser argues that photography is prototypical of the programmatic world image and is free of this dichotomy. In it, finalistic and causal linearity are but two dimensions, two modes of an ever-expanding, all-inclusive program. This program both absorbs preceding world images and transforms them. Here, the universe and everything in it are explained as a situation in which 'particular and inherent virtualities – part of the universe since its origin – have realized themselves by chance, whilst other virtualities – that will be realized by chance in the future – remain, as yet unrealized'.[14] This shall be the focus of Chapter 3.

What characterizes programs is the fact that they are systems in which chance becomes necessity. They are 'games' in which every virtuality, even the least probable ones, will sooner or later be realized, so long as the game is played for a sufficiently long time, regardless of who the 'player' is. While this view puts all ideologies within parentheses, it is especially relevant for the theory and philosophy of photography. In that specific context, chance has never described as a relevant factor within the technical process. Thus, the calculation of chance events has until recently

rarely been seen as fundamental to the structure of the medium. The universal Turing machine metaphor, which is contrasted to the Turin Shroud metaphor, thus emerges as a potent means for enhancing our understandings of photography's intricate workings. Such a construal does not contradict the dominant perspective, that of the Turin Shroud, or attempt to nullify it. It simply integrates it into a richer conceptual framework, which has the force to become the new paradigm for theorizing photography.

A Turing machine is a hypothetical device conceived by British mathematician Alan Turing to help understand the limits of mechanical computation.[15] As such, it models a machine that mechanically operates on a roll of paper imprinted with symbols that the machine can read and sometimes write onto. The roll shifts just a bit to the left, a bit to the right or not at all. Notably, the manner in which the machine reads determines what is subsequently written. It depends on the sign or its absence: whether Turing machines leave the mark standing or delete it, or conversely, whether they leave the empty space standing or replace it with the sign. The operation of the machine is always fully determined by a finite set of elementary instructions that are set down in advance, or, in other words, an algorithm.

The Turing machine has never been intended as a practical computing technology and as such, remained a fully hypothetical device. Nevertheless, various models of the machine have been described in Turing's papers and in the exchanges that followed. More importantly, Turing machines can be harnessed together for complex computations, the output of one becoming the input of another, and so on. Thus, Turing postulated the possibility of a universal machine, now mostly known as a universal Turing machine, which could emulate the behaviour of *any* given Turing machine. Given any table of instructions that defined a Turing machine, it could therefore carry out those very instructions. Crucially, such a universal machine would thus become programmable.

Here, as before with the Turin Shroud, I am deliberately using a metaphor that is as versatile as it is abstract. This time, however, with regard to the history and theory of photography, there is not even the odd reference or note anchoring this connection to precedent. To date, the universal Turing machine has never been applied as a conceptual framework for examining photography's past or present. According to such an alternative account, photography may be defined not merely in terms of capturing devices, imprinting processes or depiction traditions. These are, we might say, but a few of its protocols and they do not exclusively define its entirety. There is an abundance of other possibilities that are discernible and others that have simply not yet been realized. Attuned to this historical yet ever-developing complexity, this book concludes in Chapter 5 by articulating select photographic explorations as akin to early forms of algorithmic art. This is also the place to clarify that, while art and art history are but one context for photography, this book is often a book

about photography *in* art and *as* art, particularly when it engages with questions of objecthood, artefactuality and artisthood.[16]

To think of photography as an algorithmic art form is to argue that it potentially creates, and in fact must create, *classes* of artworks, and never just individual ones. It is a form wherein creative agents, be they photographers or programmers, never work in the realm of realities. Rather they always work in the realm of undecidable propositions, possibilities and potentialities. Therefore, a work of art in photography is by default, just like in any form of algorithmic art, a single instantiation of an infinite multitude of possible works.

Algorithms are finite descriptions of infinitely dynamic processes. However, these descriptions have a unique standing: they are both operational *and* executable. Algorithms are, we could say, text and machine rolled into one – a machine born of text and a text that can grow into a machine.[17] But the same has always been true of photography as well, as Peter Henry Emerson declared in 1892: 'If you think photography to be an art, you must decide who is the artist in the case of an automatic machine – the penny, the person who drops the penny in the slot, or the automatic machine [...]'.[18] This book makes the argument that photography *is* the realm of automatic machines but that its artists are never required to drop a penny in the slot because they can, and in fact must, design the machine. In photography, as in later forms of algorithmic art, ideas and their instantiations are always code, and this code, both historically and contemporarily, is incorporated into its own execution. It is artistic concept in its strictest form of description – a programmatic master form for all arts in the age of post-industrial production: technical, electronic, digital, interactive and networked. In concluding this introduction, we must keep in mind that one of the most intelligent definitions for photography, qua medium, was 'the engine of visualization'.[19] However, because the medium of photography has clearly become *media*, we now require additional definitions. The definition proposed in this book is 'the program of visualization' or more simply 'A Visualization Turing Machine'.

NOTES

1. Oliver Wendell Holmes, 'The Stereoscope and the Stereograph', *The Atlantic Monthly* (June 1859).

2. Vilém Flusser, 'The Distribution of Photographs', in *Something Other Than Photography: Photo & Media*, ed. Claudia Giannetti (Oldenburg: Edith-Russ-Haus for Media Art, 2013), 134.

3. Daniel Palmer, 'Light, Camera, Algorithm: Digital Photography's Algorithmic Conditions', in *Digital Light*, ed. Sean Cubitt, Daniel Palmer and Nathaniel Tkacz (London: Open Humanities Press, 2015), 144.

4. I should note that this discourse isn't without nuance and has shifted in the past two decades from 'after photography' to 'post-photography' and recently to 'post-post-photography'.

5. Jon McCormack and d'Inverno Mark, eds., *Computers and Creativity* (Heidelberg: Springer, 2012), vii.

6. The Turin Shroud is a real object but, for all intents and purposes, it is almost inaccessible, having been put on public display only 18 times since the fourteenth century. The Turing Machine is not an object or a 'real' machine but rather 'an abstract machine', a hypothetical construct described in Alan Turing's papers.

7. André Bazin, *What Is Cinema?*, trans. Hugh Gray (Berkeley: University of California Press, 2005), 14; Patrick Maynard, 'The Secular Icon: Photography and the Functions of Images', *The Journal of Aesthetics and Art Criticism* 42, no. 2 (1983): 155; Cynthia Freeland, 'Photographs and Icons', in *Photography and Philosophy: Essays on the Pencil of Nature*, ed. Scott Walden (Malden: Blackwell Publishing, 2008), 58.

8. Respectively: Daniel Rubinstein, 'The Digital Image', *Mafte'akh; Lexical Review of Political Thought* 6, no. 1 (2014); Eivind Røssaak, 'Algorithmic Culture: Beyond the Photo/Film-Divide', in *Between Stillness and Motion: Film, Photography, Algorithms*, ed. Eivind Røssaak (Amsterdam: Amsterdam University Press, 2011); Ingrid Hoelzl and Rémi Marie, *Softimage: Towards a New Theory of the Digital Image* (Bristol, UK: Intellect, 2015).

9. Rosalind Krauss, *The Originality of the Avant-Garde and Other Modernist Myths* (Cambridge, MA: The MIT Press, 1985), 203.

10. Roland Barthes, 'The Photographic Message', in *Image, Text, Music*, ed. Stephen Heath (New York: Hill and Wang, 1977), 17.

11. Friedrich A. Kittler, *Optical Media: Berlin Lectures 1999*, trans. Anthony Enns (Cambridge, UK: Polity Press, 2010), 227.

12. Vilém Flusser, *Into the Universe of Technical Images*, trans. Nancy Ann Roth (Minneapolis: University of Minnesota Press, 2011).

13. Friedrich A. Kittler, 'The World of the Symbolic – A World of the Machine', in *Literature, Media, Information Systems*, ed. John Johnston (London: Routledge, 2012).

14. Vilém Flusser, 'Our Programme', *Philosophy of Photography* 2, no. 2 (2011): 206.

15. Alan M. Turing, 'On Computable Numbers, with an Application to the *Entscheidungsproblem*', *Proceedings of the London Mathematical Society* 42, no. 2 (1936).

16. These three terms designate the condition of being an object, an artefact and an artist, respectively. The first two terms are relatively common in art discourses. The third term is coined by van Winkel. Camiel van Winkel, *The Myth of Artisthood* (Amsterdam: Mondriaan Fund, 2013).

17. Frieder Nake, 'Paragraphs on Computer Art, Past and Present' (paper presented at the 'Ideas Before Their Time: Connecting Past and Present in Computer Art' conference, London, 2010).

18. Original publication: Peter Henry Emerson, 'Photography Not Art', *The Photographic Quarterly* (January 1892). Excerpts reprinted in: Nancy Newhall, *P.H. Emerson: The Fight for Photography as a Fine Art* (New York: Aperture, 1975), 98.

19. Patrick Maynard, *The Engine of Visualization: Thinking through Photography* (Ithaca: Cornell University Press, 1997).

1. The Nature of Photography

But an immediate fact about the medium of the photograph (still or in motion) is that it is not painting. (An immediate fact about the history of photography is that this was not at first obvious.)

Stanley Cavell[1]

At the core of classic accounts of photography, there is always the same seed of belief. Photography is inherently different from its predecessors in art, as revealed in a close reading of its early scholarship. It is arguably unique in that it has some privileged connection to nature. A convenient point of departure is to accept this historical proposition tentatively, but without endorsing it. I am then compelled to ask: What constitutes nature in photography and where might it be located? What is the nature of photography? Can it have a 'nature' that is not contingent on agents, institutions and power relations? In the broadest context, examining these questions is one objective of this chapter. It starts from photography's 'classic' foundations, but at no point does it accept them fully.

After establishing provisional definitions of nature and photography reflecting how these two phenomena became intertwined in mid-nineteenth century discourses, this chapter will provide a strategic overview of various reiterations of orthodoxies publicized in the late nineteenth century and throughout the twentieth. I conduct this inquiry from a topographic perspective, examining the history of the terrain now known as 'the theory of photography'. In interrogating the foundational presumptions here, I first trace the shifts in focus that this field has undergone – from a fixation on photography as inseparable from nature to more promising propositions that photography is a new type of machine.

I will argue that the theory of photography can be traced back to pronouncements by proto-photographers.[2] Even so, it rarely provides answers to questions raised in the nineteenth century, nor does it adequately address any crucial question asked today. Earlier on, the theory of photography tended to echo art-historical debates, often being, in one form or another, mere exercises attempting to distinguish photography and film from painting. It later incorporated discourses from fields as diverse as semiotics, psychoanalysis,

feminism and Marxism.[3] At the same time, it became absorbed into those very battlegrounds and thereby lost much of its individual thrust. And so, the theory of photography is characterized by a dearth of writing, the relative segregation of compelling texts and disappointingly ephemeral conceptual threads. This is especially surprising given the prominence photography continues to hold in art, culture and mass media. Of the rare few texts within this field that are genuinely about photography, some strike the reader as being severely counterintuitive whereas others are overly simplistic.

This chapter will conclude with philosophical ideas that will refine the core questions of photography. Here, photography's special qualities are seen to derive from the fact that it is fundamentally a contraption, a mechanism or an automaton. Importantly, within these parameters photography is thought to ensure that what is seen in a picture is always causally determined by variables that are beyond the photographer's control. Throughout this chapter, I am informed by the conviction that the most promising modes of inquiry for a fruitful theory of photography tend to emerge from philosophy. This point will be gradually driven home throughout this book. One such mode, emerging from discourses in aesthetics, epistemology and the philosophy of mind is now known as the philosophy of photography. This maverick strand, which appeared towards the end of the twentieth century, will be interrogated and developed towards the end of this chapter, as well as in Chapter 2. It will be interfaced with media and new media philosophies in Chapters 3, 4 and 5.

From Nature to Machine

Louis-Jacques-Mandé Daguerre is a leading contender for the title of 'inventor of photography'. His carefully considered wordings reveal not only an inventor and entrepreneur but also a man aware of the influence of foundational statements. In September 1839 he describes the Daguerreotype process as follows: 'It consists in the spontaneous reproduction of the images of nature received in the camera obscura, not with their own colours, but with very fine gradation of tones'.[4] Another contender, Englishman William Henry Fox Talbot, is responsible for another carefully considered and equally puzzling description: '[...] The Process by Which Natural Objects may be Made to Delineate Themselves without the Aid of the Artist's Pencil'.[5]

Clearly, while the technologies these inventors bequeathed us have changed a great deal, the terminologies they used have proven much more resilient. Photography is still discussed as 'spontaneous reproduction'. We may not need to refer to 'nature reflected' or to how 'Natural Objects May Be Made to delineate themselves' simply because we have alternative ways to describe a quality of passivity.

11

Such pronouncements ultimately present photography as a means, or at least as a way to devise means by which nature can be made to represent itself and do so mechanically or automatically.

In fact, with respect to a photograph he had made, Talbot commented: 'I made in this way a great number of representations of my house in the country [...] And this building I believe is the first that was ever yet known to have drawn its own picture'.[6] This photograph was subsequently included in *The Pencil of Nature* (Figure 1). Was Talbot's house really the first to picture itself? Probably not; it may have been another house, in an earlier image accredited to Frenchman Nicéphore Niépce. This historical controversy notwithstanding, rather than the content of Talbot's argument, it is its *form* that I am interested in – his intriguing vocabulary and choice of metaphors. In other words, not the question which building was first but rather, first at *what*?

Could a building actually 'have drawn its own picture'? And what prompted Talbot to claim that his pictures were representations? Why would he desire it to be so? Furthermore, what part in the making of those representations was he claim-

FIGURE 1: William Henry Fox Talbot, *Lacock Abbey in Wiltshire* (Plate XV in The Pencil of Nature), 1844.

ing for himself? Were they made by him or in conjunction with someone or some-thing else? Can representations be made in the same sense that pictures are made or only in a metaphorical sense? The class of pictures in question is now called the photograph. According to Talbot's initial account, the labour involved in drawing pictures of natural objects is distinct from the effort required for making photo-graphic representations of those very same objects. Portrayed as such, it is evident why Talbot's process, and others deriving from it, will commonly be understood as bearing only limited similarity to the traditional processes of painting. Daguerre's process differed to the extent that it allowed for only one such 'representation' to be made. Nevertheless, similar reservations were expressed about the Daguerreotype. These statements have been reiterated throughout the history of photography. As demonstrated below, they were rarely placed under scrutiny. With so many debat-able concerns arising from these statements, the terminology within the history of photography is also the starting point for a theory of photography.

As the quotations above may have implied, the underlying question of 'first at what?' ultimately concerned the possible status of the photographic object as an artefact. Traditional art history dichotomies attach immense importance to *what* makes an artefact look the way it does. Usually a picture would be the result of a laborious process of physical and mental craftsmanship. Could artefacts come into being in another way? Talbot, for one, seems to have believed they can:

> You make the powers of nature work for you, and no wonder that your work is well and quickly done [...]. There is something in this rapidity and perfection of execution, which is very wonderful. But after all, what is nature, but one great field of wonders past our comprehension? Those, indeed, which are of everyday occurrence, do not habitually strike us, on account of their familiarity, but they are not the less on that account essential portions of the same wonderful whole.[7]

From the outset then, the pictures that this new-born medium generated were understood in ways reminiscent of the Turin Shroud – an essential portion of a 'wondrous whole', whose powers are beyond comprehension. Notwithstanding, this book is not so much interested in wonders but rather in the structure of *belief* in wonders. Talbot believed that photography was a confirmation of nature, and so I now ask: What does the term 'nature' afford photography? In exploring that question, I bear in mind that the currently separated disciplines of science, art and literature were often embodied at that time in a single person and sometimes even in a single text. This was especially true of many of the early writers on photography. Talbot, for one, was not only an artist but also an amateur poet well versed in both philology and linguistics. He was also a politician, a chemist and a minor authority in mathematics, a point of some symbolic importance that will be clarified below.

13

While nature played a leading role in other early descriptions of photography, no one was quite sure how to discuss the way in which it was made manifest. Were photographic pictures so striking for their origin in nature or for their outward aspect that so often resembled the appearance of nature? Niépce, for example, wrote of works that were 'a faithful image of nature' as well as of 'the copying of views from nature'.[8] Daguerre was similarly ambiguous and referred to both 'a nature *received* in the camera obscura' and 'a nature *reflected* by means of the camera obscura'.[9] These descriptions raise the possibility that nature might be understood as either a passive or an active entity. Does nature demand fidelity to be received and is it always copied when it is being reflected? Put differently, is it produced by photographs or is it actually the producer of photography? The former interpretation would suggest that even in photography, nature retains the same set of ideas that artists, at least since the Renaissance, have always sought to affirm. Photography, according to this interpretation, is only different to the degree that it offers finer renderings of the same values. The latter interpretation, however, 'nature as producer',[10] is much more radical and necessitates a different set of ideas altogether that will unfold in the following chapters. Either way, it would not be far-fetched to speculate that the reason for at least some creative formulations was simply to avoid the awkward implications arising from these questions.[11]

Niépce ascribed to photographs the capacity to be faithful to nature. Is nature, then, being painted by photography or is it induced to paint itself? Is it drawn or does it draw? Is the natural world being produced or reproduced in photographs, or is it the producer of photography and therefore of all photographs? Daguerre, on the other hand, probably ascribed more potency to the apparatus. He spoke of delivering to buyers 'the effects of nature', of a 'perfect image of nature' and of 'the imprint of nature'.[12] What this seems to suggest is that somehow nature is all of the above: 'In conclusion, the daguerreotype is not merely an instrument which serves to draw nature; on the contrary it is a chemical and physical process which gives her the power to reproduce herself'.[13] Talbot is equally confusing when he speaks of photography as a way of letting 'nature substitute her own inimitable pencil' and 'photogenic drawing or nature painted by herself' as well as 'the possibility of fixing upon paper the image formed by the Camera Obscura, or rather, I should say, causing it to fix itself'.[14]

However photography was described in those early days, the nouns and verbs associated with it offered stimulating ideas. Niépce, for example, made various attempts to decline nouns and conjugate verbs from Greek in an effort to name his new invention. These included words like *physautographie* (painting by nature itself), *physautotype* (copy by nature itself) and *phusalethotype* (true copy from nature).[15] But what did the suffix 'type' mean? Why did

he insist on it? Derived from *tupos*, it means 'moulded' or 'patterned', as in 'archetype' and 'prototype'. Could Niépce have suspected that photography would harbour more potential if developed to become a machine enabling numerous and thus competing instantiations of any single 'nature'? Niépce died in 1833, a few years before the formal announcement of photography that Daguerre, his former partner, immodestly named *Daguerreotype*. Talbot, similarly, chose *Talbotype* but also used *calotype*, from the Greek word *kalos* (beautiful), as in calligraphy.

Whether, at the time of its emergence, photography was perceived as a descendant of familiar artistic processes, albeit ones that yielded surprising results, or was understood to be a radically new process, remains an open question.[16] Be the answer as it may, upon reading the aforementioned texts it is evident that photography's first theorists acknowledged the role of nature in those crucial years. But what did this role entail and to what extent did its acknowledgement support ideas of duplication and bifurcation as creative strategies? The answer to this latter question depends on our conceptions of 'mould' and 'pattern'.

Nature as Light, Image and Object

To articulate the unique interdependency of photography and nature I will now highlight three possible 'identities' for nature in the nineteenth century. The first and most obvious is nature's purported identity as light or, in its most common articulation, the sun. This is emphasized in the term *heliograph* (from Greek, literally 'sun drawing') eventually chosen by Niépce for his invention, as well as in the subsequent terms 'sun picture', 'photogenic drawing', 'photogram' and of course 'photograph', all applied to Talbot's negative-positive process. In a similar vein, Oliver Wendell Holmes the elder, an American poet, essayist and the inventor of the American stereoscope, wrote that 'The honest sunshine is nature's sternest painter, yet the best'.[17] Only a few years later, author and critic Lady Elizabeth Eastlake wrote that in a photograph, 'light is made to portray in a celerity'. The object of her essay was to decide, 'how far the sun may be considered an artist',[18] rather than an art medium. This point is also reiterated in Talbot's own words:

> they assist the artist in his work; they do not work for him. They do not dispense with his time; nor with his skill; nor less his attention. All they do is guide his eyes and correct his judgment; but the actual performance of the drawing must be his own [...]. The present invention differs totally in this respect (which may be explained in a single sentence), viz. that, by means of this contrivance, it is

not the artist who makes the picture, but the picture which makes itself. All
that the artist does is to dispose the apparatus before the object whose image
he requires [...] The agent of this operation is solar light.[19]

A second proposed identity for nature, as an optical image, may be first distin-
guished in an earlier text by Talbot who, while honeymooning in Lake Como
in 1833, wrote: 'the idea occurred to me – how charming it would be if it were
possible to cause these natural images (of the camera) to imprint themselves
durably, and remain fixed upon the paper'.[20] A few years later, in 1839, he
wondered whether by means of a solar microscope one might 'cause that image
to impress itself upon the paper, and thus let nature substitute her own inimitable
pencil, for the imperfect, tedious tools of the draftsman'.[21] After all, the image
in the camera obscura has been a result of artifice in Europe for at least three
centuries, and had long before been observed to occur spontaneously.[22] Thus
the early pioneers of photography could have understandably been engaging in
devising means for fixing images already available, as opposed to developing
new media for forming them. Therefore, when *Athenaeum* reported Talbot's
invention that same year, it was remarked that: 'The most fleeting of things – a
shadow, is fixed and made permanent'.[23] A similar concept was expressed in an
early news article about Daguerre's demonstration; he was said to have 'found
a way to fix the images which paint themselves within a camera obscura'.[24]
Therefore, the ensuing optical and photochemical inventions could be viewed
as mere refinements of a process already in existence. That is, until they reached
a stage of singular importance with the appearance of Eadweard Muybridge's
pictures, about which I will soon elaborate. Here, again, the photographer may
be understood as requisite to the picture but the picture is still assumed to be
made by nature.

A third possible personification of nature, namely as the agent that makes
the picture, may be found in the object photographed itself. The possibility
for such interpretation arises first and foremost from Talbot's above-quoted
words: 'And this building is the first that was ever yet known to have drawn
its own picture'. Put differently, because Talbot saw photography as a 'natu-
ral' process he could also argue that it was the 'Natural Objects' that were
responsible for 'drawing' and not 'the artist's pencil'. The ambiguity of this
situation was captured in the title of Talbot's formal paper submitted to the
Royal Society, when arguing precedence over Daguerre's claim to the inven-
tion of photography: 'The Process by Which Natural Objects May be Made to
Delineate Themselves without the Aid of the Artist's Pencil'.[25] This perplexity
is remarkably resonant in writings on photography and film all the way to the
end of the twentieth century.

Many texts from the earlier days of photography demonstrate an unusual elasticity of language – with metaphors that remain pivotal in the theory of photography. In them, we find a picture of photography that is both active and passive, that draws nature while simultaneously allowing nature to draw itself. Portrayed as such, a photograph was believed to reflect its object while also constituting it. Furthermore, because this belief was so successful in blurring several phenomenological distinctions, perhaps unintentionally so, it also gave rise to a startling new idea: that nature *itself* could be understood as not only a latent image but also an imaging machine in waiting.

Naturalism and Mechanism

Peter Henry Emerson was a physician who turned to photography intent on promoting it as an independent art form. Emerson's aesthetic theory, which was based on scientific principles of optics and perception, was a protest and at times direct attack on contemporaries in England such as Henry Peach Robinson, whom he criticized for denying the connection between art and science.[26] He dismissed their work as being 'the quintessence of literary fallacies and art anachronisms'.[27] To that end Emerson, who held the opinion that the photographic process was capable of perfection, rejected the manual retouching of photographic prints, which he referred to as 'the process by which a good, bad or indifferent photograph is turned into a bad drawing or painting'.[28]

Emerson's theory of 'Naturalistic Photography', held that photographs were first and foremost pictures.[29] As such they could serve one of two intimately linked but somewhat opposed cognitive purposes: the delivering of information and the satisfying of aesthetic interest. The interrelationship between these two purposes, or rather the possibility thereof, was to haunt photography in various ways for most of the twentieth century.

Emerson believed that the aim of the artistic photographer was 'naturalistic' representation – the imitation of the effects of nature on the eye. This, supposedly, was no different from the traditional aim of the artist in other media throughout history. Emerson's naturalistic representation of a scene meant that it was, as much as possible, identical with the visual impression an observer would obtain had he stood at the actual spot from which the photograph was taken. Emerson pursued this argument in a series of lectures, articles and books, which culminated in an 1889 textbook titled *Naturalistic Photography for Students of the Art*.[30] The book was devoted to a discussion of the characteristics of human vision and the application of this knowledge to the selection and use of a lens so that its 'drawing power' would render a scene with 'natural' perspective and with the correct

amount of detail, appropriately distributed throughout the various planes of the scene. Emerson's naturalistic program was never universally accepted as a whole – his advocacy of printing processes was widely accepted but his theory of focusing remained controversial.[31]

Surprisingly, it was none other than Emerson himself who in 1890 brought his program of naturalism to an abrupt end with the publication of a pamphlet titled *The Death of Naturalistic Photography*. Here Emerson boldly retracted his former view that photography could in principle achieve artistic status, now arguing that photographs could never be works of art on the grounds that the photographer's interpretation of subject matter was at the very least inhibited by lacking sufficient control over relevant variables. This spectacular retraction culminated in his 1892 declaration that 'the photographer does not make his picture – A MACHINE DOES IT ALL FOR HIM (sic)'. In the rest of this published argument, Emerson imagined someone confronting the photographer and summarizing the case against him. This argument, would be reiterated in the theory of photography:

> You selected the view: that was art. You arranged it well, focused it well:
> that was art [...]. Then you started a machine, and that machine drew the
> picture for you; you merely fixed its work by chemicals, which is [...] not
> art. You selected some ready-made paper, and the sun printed your picture
> [...]. That is photography, with an iota of art in the selection of the paper. We
> find you have not proved [...] you are an artist, for you can execute nothing.
> You cannot even draw a cube fairly [...]. If you think photography to be an
> art, you must decide who is the artist in the case of an automatic machine
> – the penny, the person who drops the penny in the slot, or the automatic
> machine [...].[32]

As charming as this quote is, its conceptualization of the machine is rather simplistic. A machine is set in motion not only because a penny is dropped in a slot. A picture is made not only because a machine is set in motion but because the machine has been predesigned. In other words, such a conflict between human and machine is not only superficial but somewhat artificial. Its sole purpose is to serve that which is not machine, or, in this case, to consecrate the human penchant for discrepancy that we commonly call creativity. This view is still common. Other fundamental components and demarcations introduced into Emerson's theory of Naturalism have also been conventionalized – most notably the uncompromising belief in *causal* variables as the exclusive formative effect in photography. Put differently – in photography, unlike other art forms: 'under the same physical conditions the same results will always follow'.[33]

The Rise of Photographic Mechanisms

To understand the primacy of physical conditions let us briefly examine one technical variable that has proven to be of pivotal importance to the practice and theory of photography: exposure length. Before Eadweard Muybridge's famous photographs depicting animal and human movement, this variable was rarely considered important. Up until then, exposure times were relatively long: Niépce's heliographs required exposures of approximately eight hours while Daguerre's first processes required 15 to 30 minutes. By the early 1840s, it shrunk to a minute or two. Across the channel, Talbot's first 'photogenic drawings' required 30 to 60 minutes, though with his subsequent invention of the calotype process, this was quickly reduced to a few. The advent of glass plate photography in the late 1840s and early 1850s accelerated exposures by a comparable factor and brought exposure times down to a few seconds. Exposure times of fractions of a second only became available in the 1870s, introduced by Leland Stanford's engineers who designed sophisticated mechanical shutters for Muybridge that were faster than all their predecessors.[34]

Equipped with that technology, Muybridge succeeded in 'freezing' photographs of the galloping of Stanford's mare, *Sally Gardner*, at the Palo Alto racetrack. Only this way could it be demonstrated that certain phases of its gallop did indeed include moments when all four hooves were off the ground. Thus, when a newspaper reported Muybridge's static photographs it declared: 'the grand discovery of an eye which could catch, and a plate which would register the most evanescent of movements'.[35] Grand as the discovery may have been, it received a cool response from artists, other photographers and the public. The photographs, it was claimed, were 'unnatural' and even 'unrealistic'.[36] This response did not stem from doubts about the reliability of Muybridge's accomplishment but from a justified feeling that the accomplishment challenged not only prevailing standards of portrayal but also notions about human perception. For even if one believes that horses indeed gallop as in Muybridge's photographs, one has no way of corroborating or refuting this belief, other than through viewing more photographs of the same type.

Importantly, the discovery pertained to much more than horses' hooves, but to the human eye. This organ, so it transpired, was completely oblivious to numerous phenomena made accessible exclusively through the camera and the 'optical unconscious' it made conscious, as Walter Benjamin argued.[37] Thus, if there are natural phenomena to which the eye was indifferent and even blind, then the option of belief in vision was shaken once again. From then on the saying would be: *seeing is not believing*.

To what can the revelation of these domains of visibility be attributed? Certainly not to the laws of nature known since the seventeenth century, but only to the mechanics

of photography. Thus shutter speed became an essential feature that the viewer could not ignore. Moreover, in such circumstances, even earlier photographs in which no movement was represented were attributed less to the bounties of vision and more to the camera in which the shutter was installed. This may explain how and why photographs would gradually be perceived less as a wonder of nature and more as a product of mechanical action. It turned out that the device, a mere machine, was the sole source of the photograph's authority. By the turn of the century, therefore, it became apparent that it was not Leon Battista Alberti's perspective construction, the optics of Robert Hooke and Isaac Newton or the chemistry of John Herschel that constituted the great discovery that allowed photography to open new domains of visibility. It was the mechanics of Leland Stanford's anonymous engineers. This would eventually evolve into a modern rivalry for photographic authorship that pit humans against their own technology.

From Mechanism to Automatism

> In sum, the views and trends that marked the beginning of photography have not changed much in the course of its evolution. (To be sure, its techniques and contents have, but that is besides the point here.)
>
> Siegfried Kracauer[38]

Various twentieth-century writers on film have found that in order to develop critical methods for film analysis they must first devote their attention to the photographic image as a benchmark against which more traditional pictorial media can be measured. Erwin Panofsky, André Bazin and Stanley Cavell, among others, offer ontological definitions that are at times elegant, but too monolithic in approach. Nevertheless, they form an important backbone for contemporary discourses within the theory of photography. Other important contributions include the writings of Rudolf Arnheim and Siegfried Kracauer. These offer theoretical accounts that yield better insights. I will scrutinize these to demonstrate how the classic theoretical position regarding photography, stated in the most general terms, is that a photograph always contains certain necessary connections to a real life original. Those connections do not and simply cannot exist in traditional arts like painting or sculpture. But what are they? And what, if anything, do they guarantee? How important are they for our understanding of photographs?

Most people, if asked, would no doubt say that whereas a painter can paint whatever he or she wants, the photographer must depict an object, a situation or state of affairs that is already 'there'. Whereas a painter 'creates', the photographer

'finds', 'selects' or 'organizes' before he or she 'captures' his or her pictures. Unfortunately, not only Peter Henry Emerson but also many other photographers agree with this view.[39,40]

According to this view, photographers use a machine to set up situations that rely on the natural laws of refraction and chemical or electrical change to produce pictures. Photographs are thus the practical realization of the general artistic ideals of objectivity and detachment. It follows therefore that photographs are not only different from other kinds of pictorial representation but that they may not be representations at all. Having laid out these fundamental, historical precepts of photography, I will examine and extend these contentions throughout the book.

The Things Themselves

First published in 1936, Panofsky's essay 'Style and Medium in the Motion Pictures' argues that the circumstances of the invention of film as an art form are unprecedented. Descending from photography, film, he asserts, arose *not* due to an artistic urge but rather as a result of the discovery and consequent improvement of a new technique.[41,42] Only when the technique had been sufficiently perfected did the new art form appear. According to this narrative, film is a new medium and as a consequence it possesses virtues, strengths and also weaknesses that are unique to it.

According to Panofsky's account, the processes of earlier representational arts always conform, to a greater or lesser degree, to idealistic conceptions of the world:

> The painter works on a blank wall or canvas which he organizes, into a likeness of things and persons according to his idea [...] The same is true for the sculptor with his shapeless mass of clay or his untooled block of stone or wood; of the writer with his sheet of paper or his dictaphone; and even of the stage designer with his empty and sorely limited section of space.[43]

Furthermore, Panofsky adds that the painter 'does not work with the things and persons themselves' and that processes of earlier representational arts 'start from an idea to be projected into shapeless matter and not with the objects that constitute the physical world'.[44] Upon reading these descriptions it should immediately become clear that Panofsky's conception of art is fairly conservative, even by the standard of the early to mid-twentieth century – a blank canvas will need to be 'organized' and a block of wood is 'a shapeless mass' so long as it is 'untooled'.[45] Clearly, this is not the only way to make a sculpture, as Marcel Duchamp, Kurt Schwitters and many others went on to demonstrate.

Moreover, 'the movies', argues Panofsky, 'organize material things and persons, not a neutral medium, into a composition that receives its style [...] not so much by an interpretation of the artist's mind as by the actual manipulation of physical objects and recording machinery [...]'[46] This 'recording machinery' is, undoubtedly, the same machinery as in Emerson's late manifesto. Unsurprising as this view may be, one implicit suggestion concealed here is important: 'projection' of one form of matter onto another can, in and of itself, constitute a style. This is clearly a break from previous aesthetic traditions wherein 'style' is understood to emerge only when ideas are projected onto matter. Note, however, that here too, style, whatever it may be, does not guarantee artistic interpretation, which is still understood to be lacking, a point that other critics will repeat. Nevertheless, whether or not the photographer is seen to be an artist, whether or not photography and film are seen as art forms, is of lesser importance right now. More important is that according to Panofsky's account, humans play little to no part in the process by which movies and only movies 'do justice' to a materialistic interpretation of the universe.[47] Panofsky's conclusion is that 'The medium of the movies is the physical reality as such'.[48] To paraphrase, matter projected as image can also be understood as reality. Of course, Panofsky thinks of reality plain and simple, not virtual or augmented reality as one might nowadays suspect. This nonetheless proves how, for decades, photography and film have been harbingers of types of thinking that exceed the confines of art, for better or worse.

A point of interest here is Panofsky's choice of words: movies apparently organize material *independently of the artist's mind*. The same holds true for photography of course. This analysis differs significantly from what earlier conceptualizations would have led us to expect. Earlier on, in the nineteenth century, photographs were praised for their ability to deceive and astonish the viewer who was unaware of them not being hand-marked surfaces. Further, photography was supposed to free the artist from the laborious work of the draftsman. Put differently, photography was to free the artist from the artist's hand. Panofsky's interpretation is different: 'machinery' now frees the artist's mind and not only his hand. But how does the camera supplement the mind? Does it also expand it?

In an attempt to construct a theory of cinematic realism, French film critic André Bazin published in 1945 a text titled 'The Ontology of the Photographic Image'. For Bazin, the transition from Baroque to photography, and subsequently to film, marked the perfecting of a physical process. As such, he viewed photography as radically different from other forms of representation, much like the way Panofsky saw film. The difference, however, was not predicated on *what* was made but rather on *how* it was made: 'The solution is not to be found in the result achieved but in the way of achieving it'. The result was, of course, the satisfying of a human need – a psychological appetite for illusion.

22

But what exactly is this special way of 'achieving resemblance'? Is it, according to these last accounts, a *machine*? Deriving as it may from *nature*, this machine may be understood to inherit nature's capacity to shape-shift and confuse. Photography then stands in stark contrast to painting: 'No matter how skillful the painter, his work is always in fee to an inescapable subjectivity. The fact that a human hand intervened cast a shadow of doubt over the image'.[49] This is obviously not the case with photographs, Bazin infers. Painting at times, perhaps always, benefits from the subjectivity of a human presence, the human hand. Photography, on the contrary, is supposed to derive its advantage of technical perfection from the *absence* of such a presence. For Bazin, the difference between paintings and photographs thus lies not in the result achieved by photography but in the *psychological* fact embedded within that achievement: the conception that 'an illusion' can be generated by a form of 'mechanical reproduction in the making of which man plays no part'.[50] But does mechanical reproduction necessarily prevent man from playing a part? In later chapters, I shall argue that mind-independence and human agency are not mutually exclusive.

Notably, the conflict between style and likeness is a relatively modern phenomenon, one of which there is little trace before the advent of photography. Therefore, in Bazin's account, which conforms to many common art-historical narratives, modern painting could, with the invention of the photographic plate, abandon the 'resemblance complex'[51] that had for so long occupied Western art. Much like the Turin Shroud, it matters very little whether we accept the hypothesis that man plays no part in the making of photographic illusion. Nonetheless, there is no way but to acknowledge that theory has largely adopted this idea and that, since the mid-nineteenth century, resemblance *is* part and parcel of the history of photography.

For Bazin, the technical character of the medium can be seen to necessitate a kind of objectivity. His phrasing in the original French text contains a play on the word *Objectif* (lens): 'For the first time, between the originating object and its reproduction there intervenes only the instrumentality of a nonliving agent. For the first time an image of the world, is formed *automatically*, without the creative intervention of man'.[52] The photographer's personality, he notes, enters into the process only in his selection of lens and object. In this respect Bazin's account conforms completely to the tone expressed in Emerson's statements. In photography, both conclude, the final result may on occasion reflect something of the photographer's personality, but this does not play the same role as in painting.

What about authorship then? If man plays no part in photography and there is no creative intervention, who then is to be credited as the creator of a photograph? Who is its author? Is there one? Are 'the things themselves', to paraphrase

Panofsky,[53] credited for the photograph? This issue is not resolved in Bazin's account, which alternates between use of words like mechanical and automatic and then abruptly nature again: 'Photography affects us like a phenomenon in nature, like a flower or a snowflake whose vegetable or earthly origins are an inseparable part of their beauty'.[54]

In passing, I argue that authorship *is* possible in photography but it is different and found elsewhere than in the arts. It is to be attributed to larger-scale operations within the medium and not always to everyone who engages with it. Perhaps not to 'man' but rather to 'men'. Not to the photographer but to others, whom I shall later call 'programmers'. As always, much like nature and machine, 'man' and 'human' are also to be seen as suspect terms, especially when it comes to operations claiming originality, value or pertinence to art.

It further emerges that photography's unprecedented production process, whether described as natural, mechanical or automatic, has first and foremost affected the psychology of viewing images. To that extent, all that Bazin's 'way achieved' does is to confer upon photographs an aura of credibility that simply does not exist in other types of images: 'In spite of any objections our critical spirit may offer, we are forced to accept as real the existence of the object reproduced, actually re-presented, set before us, that is to say, in time and space'.[55] And it is because of these objections of the critical spirit that Bazin acknowledges that his previously quoted description of transference from nature to reproduction, from reality to representation, is *unnatural*: 'A very faithful drawing may actually tell us more about the model but despite the promptings of our critical intelligence it will never have the *irrational* power of the photograph to bear away our faith'.[56] To that end Bazin includes, although only in a footnote, a rare reference to the Turin Shroud, which, in his view, contains features of both a relic and a photograph.

The photograph of an object thus satisfies a human need for something much more than just approximation. Presented as an extreme case of objectivity, resemblance or verisimilitude, it can thus become a magical transfer, just like the shroud. Bazin takes this idea one step further:

> The photographic image is the object itself, the object freed from the conditions of time and space that govern it. No matter how fuzzy, distorted, or discolored, no matter how lacking, in documentary value the image may be, it shares, by virtue of the very process of its becoming, the being of the model of which it is the reproduction; it is the model.[57]

Taken literally, of course, this hypothesis is ontologically absurd, or such that should leave us 'ontologically restless' as Stanley Cavell puts it.[58] After all, Bazin himself has acknowledged that photographs promote irrationality. Nevertheless, critical writing

on photography frequently emerges from exactly this ground. An object and its photograph can be treated as synonymous. Therefore most theories of photography still promote the psychologically necessary idea that, in one way or another, photography *is* an essentially mechanical process that reproduces what it records.

Whereas this view, as rendered by Bazin, is fairly clear in how it defines various qualifying characteristics that make a medium an art, concern should be raised about Bazin's understanding of concepts of identification. Other writers such as Cavell, Rudolph Arnheim and Siegfried Kracauer offer more moderate interpretations of these definitions. What is important, however, is Bazin's insistence that how we respond to photographs relies heavily on folk conceptions of how they are produced. Put differently, it is not *nature* that gives rise to a *machine*, which in turn changes the way a mind sees. Rather, a construct of the mind, a machine, changes the way nature appears to us.

Echoing Bazin's emphasis on photography as an automatic recording process, American philosopher Cavell also sees photography as 'performing' an unprecedented role in the history of representational art. For him, because photography is 'closer' to the world than painting, photographs are also, in some sense, 'special'. To understand *how* photographs are special Cavell first thinks about the photograph's connection with what it is a photograph of: 'the image is not a likeness; it is not exactly a replica, or a relic, or a shadow, or an apparition either, though all of these natural candidates share a striking feature with photographs – an aura or history of magic surrounding them'.[59]

Cavell's phrasing alludes to a conception of a photograph as necessarily 'of something in the world'. However, and in contrast to Panofsky and Bazin who identify the difference between painting and photography in technology, Cavell portrays it as psychological more than anything else. Recall that Panofsky believed in the newer medium's capacity to work with 'the things themselves' and Bazin claimed that this 'special' way of coming into being resulted in ontological differences between paintings and photographs. Cavell, on the other hand, expresses the difference between photographs and other forms of representation as follows: 'So far as photography satisfied a wish, it satisfied a wish not confined to painters, but the human wish, intensifying since the Reformation, to escape subjectivity and metaphysical isolation [...]'.[60] Therefore photography does much more than merely express a wish to overcome time by creating substitutes for the dead, as Bazin would have it.[61] In Cavell's account, photography satisfies a wish to escape time altogether, to transcend the limits of human finitude, to confirm our presence in the world and free our world from the vagaries of *our* subjectivity.[62]

Much like the Turin Shroud, photographs are supposedly not handmade or even manmade. However, and unlike the shroud, when it comes to photographs the overwhelming consensus is that their making is in some form manufacturing – whether by way of nature, a mechanism or another means. In doing so, argues

Cavell, 'photography overcame subjectivity in a way undreamed of by painting, a way that could not satisfy painting, one that does not so much defeat the act of painting as escape it altogether: by automatism, by removing the human agent from the task of reproduction'.[63]

For our present purposes, it is less important whether or not the proto-photographers ever saw themselves as being in competition with painting. Art history has it that at some point following the emergence of photography, the quest for visual realism diverged. Painting supposedly receded from reality in order to maintain conviction in the relevance of its connection with the world. As Cavell put it, 'A painting *is* a world; a photograph is *of* the world'.[64] Photography, according to this orthodoxy, could maintain reality, not merely as an idea but as presence or lack of presence.[65] Cavell's insights introduce the possibility that an account of photography need not be based on ontological qualities. It may instead stress the importance of perceptual qualities that are, in a sense, peculiarities existing in the nature of human vision and of human language. For example, the logic of what Cavell calls 'sights', as opposed to sounds, is pivotal in his analysis:

> We said that a record reproduces a sound but we cannot say that a photograph reproduces a sight (or a look, or an appearance) [...] A sight is an object [...] objects don't *make* sights, or *have* sights [...] they are too *close* to their sights to give them up for reproducing; in order to reproduce the sights they (as it were) make, you have to reproduce *them* [...].[66]

It is impossible to claim that a photograph is a reproduction of a sight in exactly the same way that an audio recording is a reproduction of sound. A photograph is something different. Perhaps what is missing in our understanding of it is not a word, or a set of terms, but, rather, something out there in nature, in *our* nature. The fact that objects don't make sights, or have sights, alludes to this. Clearly, one might, as Bazin does on occasion, try thinking of a photograph as a visual mould or impression,[67] but this does not solve the problem. Moulds, stamped impressions and imprints all have clear procedures for getting rid of their originals. In photography, contrarily, there are only procedures as to how to *maintain* the original. In fact, concepts of recording and reproduction are simply not the most useful way to think of photography. Perhaps, as Henri Van Lier proposed, our languages still lack appropriate terms with which to discuss photography, arguably because they have all been originally forged to speak about architecture, painting or literature.[68]

To conclude, Cavell argues that we still do not know what the photograph is, and that further, 'we do not know how to place it ontologically'.[69] In my view, we simply do not *want* to know what the photograph is or how to place it ontologically. All we want is to believe in the photograph and in all photographs

alike. Thus I further argue that attempting to utilize language to define photography ontologically is an effort doomed to failure – not because there are too many photographs but rather because there are too many *kinds* of photographs. A more useful application of language with respect to photography must incorporate *epistemological* efforts, attempting to discover what, if anything, is common to the workings of various kinds of *photographies*.[70]

Approaches and Tendencies

To that end, the work of Rudolf Arnheim introduces a germane outlook; Photography has, or can have more than one function. Like his contemporaries, Arnheim's account starts from a familiar position. In terms of their relationship to reality, the difference between painting and photography lies in the distinctive ways that they are made: 'Whereas the painter has a perfectly free hand with color and form in presenting nature',[71] photography contains a fundamental peculiarity: 'the physical objects themselves print their image by means of the optical and chemical action of light'.[72] Moreover, because photography is '*obliged* to record mechanically the light values of physical reality',[73] it has 'an authenticity from which painting is barred by birth'.[74] Further, a picture produced by camera has a characteristic that other pictures do not possess. Because it acquires some of its unique visual properties through the technique of mechanical recording, it ultimately provides the viewer with a specific kind of experience that depends on his *awareness of its mechanical origin*: '(1) the picture is coproduced by nature and man and in some ways looks strikingly like nature, and (2) the picture is *viewed* as something made by nature'.[75]

Arnheim's analysis becomes forceful when he attempts to explain photographic realism not only on the basis of ontological qualities but also on the basis of the qualities viewers *attribute* to photographs: 'Photography, and its offspring, film, are art media so near to nature that the general public looks upon them as superior to such old-fashioned and imperfect imitative techniques as drawing and painting'.[76] In other words, photography and film are the fulfilment of the age-old striving for verisimilitude only insofar as they are near to nature and that is why we *look* on them as superior. But one's concept of nearness is usually subjective and so there may be ways to look at photography differently. Additionally, what happens when a given photograph does not 'look' to be 'near to nature' at all? What happens when painting does? Earlier on I quoted Bazin to allude to this very same question: photography's procedures are psychological as much as they are natural, mechanical or automatic.

Arnheim poses the question of perceiving in real life, in contrast to perceiving by way of a photograph. For him, 'in real life every experience or chain of

experiences is enacted for every observer in an *uninterrupted* spatial and temporal sequence',[77] while photographs and film always demonstrate a slicing of the space-time continuum. Arnheim takes this point to argue that there is more than just one kind of photograph:

> Since our field of vision is full of solid objects, but our eye (like the camera) sees this field from only one station (*sic*) point at any given moment, and since the eye can perceive the rays of light that are reflected from the object only by project-ing them onto a plane surface – the retina – the reproduction of even a perfectly simple object is not a mechanical process but can be set about well or badly.[78]

Of course, our eyes are *not* stationary; they are in constant movement that is often involuntary. Nevertheless, this passage is notable for several reasons: first, because it equates the eye and camera; second, because it does so in the unexpected direc-tion ('eye like the camera' rather than 'camera like the eye'); and third, because it unties vision, perception and reproduction. For if, in the case of humans, the eye is understood as mechanical but reproduction is *not* mechanical, why not apply the same understanding to the camera? Even if the camera itself is understood as being merely mechanical, this does not mean that camera reproductions must be mechanical as well. Given the right circumstances, we could justifiably expect that, even in an age of mechanical reproduction, certain mechanical reproductions would not be *fully* mechanical.[79]

Like others, Arnheim implies that the emergence of photography signifies a watershed moment for art.[80] However, according to his version the evolution of art has never been about one goal but two: two kinds of functions or 'approaches', as he calls them. The first is, of course, the ability to accurately mimic reality, which he calls 'documentary' or 'representational'. The second is the ability to express human experience, emotion or values, which he calls 'aesthetic'. This differenti-ation may seem on a par with Emerson's divisions: 'Any artistic medium tempts the artist to do violence to nature; and although it is fitting for the artist to submit to the conditions of his medium, it is on the other hand essential that he should not let himself be led into being unfaithful to nature'.[81] However, if we invoke Emerson's 'naturalism' then in Arnheim's account, naturalism simply depends on choosing the most characteristic aspect of the object or the right approach to follow. That is a matter of intention like anything else: 'in artistic photography and film, those aspects that best show the characteristics of a particular object are not by any means always chosen; others are often selected deliberately for the sake of achieving specific effects'.[82] So, if Emerson's naturalism required that the right *amount* of detail be depicted, Arnheim, in contrast, requires an amount of the right *kind* of detail: 'we ask whether the picture is characteristic of what it purports to

show. A photograph may be authentic but untrue, or true though inauthentic'.[83] These points ultimately lead Arnheim to conclude that photography is perfect in the documentary function (offering the highest degree of realism) but weaker in in its aesthetic function. When viewing photography, he concludes, 'We are on vacation from artifice'.[84]

Note that while Arnheim himself described his *Film as Art* as an attempt to refute early accusations, such as those made by Baudelaire,[85] that photography was nothing but a mechanical copy of nature,[86] his own descriptions of photography in the early text and of photography's 'fundamental peculiarity' in a later text[87] were remarkably similar to the very same accusations he set out to refute. More significantly, they were also similar to other nineteenth-century arguments, such as Talbot's. Arnheim's statement that 'the physical objects themselves print their image by means of the optical and chemical action of light'[88] still echoed the build-ing that has 'drawn its own picture'.

To recap, photography can always manifest presence of authentic physical real-ity, that very same reality whose irrational, incompletely defined facets challenge the image-maker's desire for visually articulate form: 'This unshaped quality of the optical raw material exerts its influence not only when the viewer recognizes the objects that have been projected on the sensitive coating of the film but is actually more manifest in highly abstract photographs in which objects have been reduced to pure shapes'.[89] These words clearly demonstrate that, in spite of Arnheim's own statements, his views are mostly an embodiment of nineteenth-century thought. This is also the case for many other twentieth-century writers. If the nineteenth century, as a whole, can be seen, at least within the history of photography, as a continuous attempt to conceive of, and refine, the art of fixing a shadow, then most of the twentieth century remains under that same shadow.

This shadow, previously cast by 'the things themselves', is what Siegfried Kracauer calls 'natural necessity'.[90] Contrasting photography with concepts of memory and history, he eventually concludes that a photograph differs from a traditional artwork on the basis of how each represents history. As noted, from the Renaissance and up to the mid-twentieth century, artworks have been oriented to a concept of nature whose specificity unfolds over centuries. But by encapsulating the *idea* of nature, argues Kracauer, the traditional artwork has in fact been able to distance itself from 'the things themselves' and orient itself towards 'higher purposes'. These, he concludes, are now found in the traditional arts and in the writing of history, but *not* in photography. Kracauer then uses the term 'natural necessity' to describe those components of history that the photographer is obliged to include and that the painter has the option of excluding.

Kracauer continues by asserting that an artistic activity is most eloquent only when it finds *the object appropriate to its technology*. But what is photographic

technology and what is the object appropriate to it? Most accounts of photographic technology set the bounds of their theory between the camera obscura and the advent of the light sensitive digital sensor. This, I argue, is insufficient. For a valid theory or philosophy of photography we must now be able to think about photography as a set of *technologies* for performing *diverse* actions that go beyond reproduction and representation. I shall elaborate on these ideas in the following chapters.

Kracauer's concerns regarding what he considers 'justified' photography are clear. It is photography that *lacks* any artistic or 'formalist' tendencies, as he would later call them. In contrast to Bazin who places crucial emphasis on the connection between the photograph and the photographed object, Kracauer emphasizes the link between the photograph and the time that it was taken.[91] It follows, therefore, that if photography is a function of the flow of time, its substantive meaning will vary to the extent that it belongs to the domain of the present or to some phase of the past: 'photography is bound to time in precisely the same way as fashion. Since the latter has no significance other than as current human garb, it is translucent when modern and abandoned when old'.[92] In the photograph, Kracauer claims, any concrete object becomes a costume. For what remains in a photograph is not what the consciousness perceives but rather those contexts from which consciousness has already departed. These words sound like an extremely inflexible interpretation of photography. They argue, somewhat tautologically, that photography is only one thing because it must be that thing. They differ from Bazin's views in arguing that a photograph is never the object itself because it is always a somewhat adulterated version thereof.

For Kracauer, the totality of all photographs can be understood as the general inventory of a nature that cannot be further reduced.[93] However, here too we are looking at another problematic attempt to extract ontological standing only from *existing* conditions of natural connections and not from *possible* ones. Like others, Kracauer claims that in photography, for the first time in history, the inert presents itself *independently* of human beings. Consequently, the task of photography is to disclose the previously unexamined foundations of nature: 'This warehousing of nature promotes the confrontation of consciousness with nature. Just as consciousness finds itself confronting the unabashedly displayed mechanics of industrial society, it also faces, thanks to photographic technology, the reflection of the reality that has slipped away from it'.[94] This view reads not so much as an analysis of the existing state of affairs but rather as a call to answer the question of what can and should be done with photographs. For consciousness must establish a provisional status for these configurations that have been newly created by photography. Perhaps photographs can be used to arouse curiosity about alternative taxonomies of nature?

With this in mind, Kracauer began his 1960 book, *Theory of Film: The Redemption of Physical Reality* with László Moholy-Nagy's assertion that photography

shows us 'wonders of the external universe'.[95] Kracauer contends that photography takes on two new functions unforeseeable in earlier periods. First, in constantly adding new viewpoints and perspectives, photography has enlarged our vision and adjusted it to modern man's existential situation in the technological age. Second, photography has influenced the trajectory of modern art, particularly by contributing to the rise of abstract art. Thanks to its technological advance, he maintains, photography has been able to leave its mark on painters and sculptors and eventually prompt them to break away from obsolete visual schemata.[96]

Kracauer's second account underscores a conflict that has defined photography throughout its history: the conflict between a tendency towards realism and a tendency to reveal underlying form. The former culminates in recordings of nature. The latter, in artistic creations that are similar to or imitate painting. This can, of course, be seen as the cause of the nineteenth-century rivalries between the so-called 'realist' and 'artist photographers', whose inclinations Kracauer calls 'formative'. Artist photographers avoided the scientific approaches of positivism, which realists relied upon, and instead favoured artistic ideas of beauty and creativity.[97] As in Emerson's case, this was perceived by contemporary realists, or naturalists, as complete disregard for the very properties of the medium. In fact, their attitude verged on defiance. This controversy, however, remained unresolved throughout the twentieth century. This, I suspect, was due to the fact that both the 'realist' and 'formative' tendencies relied upon the same simplistic belief that photographs were always copies of nature. For this reason, and while asserting themselves in a variety of unimaginative ways, both tendencies continue to perpetuate their simplicity today.

Kracauer asserts that achievements in any given medium are most satisfying aesthetically if they build on the specific properties of the medium or if they are appropriate to its technology. We have seen how, traditionally, photography is diametrically opposed to painting when it comes to the degree of elusiveness each medium contains, since it has an unrivalled claim to truth and reality. Therefore, for a photographer's approach to be called 'photographic', asserts Kracauer, it must in every instance apply the realistic tendency. This in turn implies that a beautiful and perhaps significant composition will usually *lack* photographic quality.[98] Thus, for photography to have any special value in relation to other modes of expression, maintains Kracauer, the formalist tendency should never be allowed to overwhelm the realist. For too much formalist intervention may result in a work that cannot be considered photographic. Furthermore, in some borderline cases in which experimental photographers have tried to give equal weight to both the realist and the formative tendencies, the resulting works have ended up in a no-man's-land, somewhere between reproduction and expression. Kracauer refers to these cases as a special genre of graphic arts that is *not* photography

31

proper.[99] Today, as argued in detail in later chapters, all photographs belong precisely to this genre.

In the vein of his 'photographic approach', Kracauer names four notable qualities of the photographic medium. The first is the photograph's affinity to an un-staged reality: 'pictures which strike us as intrinsically photographic seem intended to render nature in the raw, nature as it exists independently of us'. Second, he sees photography as tending to stress the fortuitous: 'Dreams nurtured by the big cities thus materialized as pictorial records of chance meetings, strange overlappings and fabulous coincidences [...] even the most typical portrait must retain an accidental character [...]'. Third is the quality of endlessness: 'its frame marks a provisional limit; its content refers to other contents outside the frame; and its structure denotes something that cannot be encompassed – physical existence'. The fourth and final quality is the medium's affinity for the indeterminate. Here Kracauer refers to a photograph Proust wrote about: 'it simply fails to tell us anything about his behaviour in general or his typical attitudes. It so radically isolates a momentary pose [...] that the function of this pose within the total structure [...] remains everybody's guess'.[100]

I accept at least three of these four qualities as definitions that expand the concepts of art and creativity. In fact, as surprising as this may sound, fortuity, endlessness and indeterminability are all qualities that characterize algorithmic art, of which, I argue below, photography is a precursor. For the time being, Kracauer's definitions will serve as the starting point for a discussion that will conclude with a new understanding of photography. In this understanding, photography will be seen as unique not because of its affinity to 'things themselves', but rather because of its ability to transmit raw information. Definitions for the types of clusters of information that photography transmits can then arise only as the result of the fortuitous, endless or indeterminate forms in which those clusters are received and processed.

From Automatism to Ideal Photography

I mark out a certain spot from which a particular view of a street may be obtained. I then place a frame before that spot. I move the frame so that, from the chosen spot, only certain parts of the street are visible, others are cut off. I do this with all the skill available to me, so that what is seen in the frame is as pleasing as it might be: the buildings within the frame seem to harmonize, the ugly tower that dominates the street is cut off from view, the centre of the composition is the little lane between two classical facades which might otherwise have gone unnoticed, and so on. There I have described an activity which is as circumscribed by aesthetic intentions as anything within the

experience of the normal photographer. But how could it be argued that what I see in the frame is not the street itself but a representation of it? The very suggestion is absurd.

Roger Scruton[101]

So far I have demonstrated how, since the early days of photography, writing on photography has insisted on a chasm separating photographs from pictures of other kinds – arguing in various ways that a photograph is always a photograph of something that actually exists, or at one time existed. This belief is not always stated explicitly but it is still evident and prevails throughout theory. Furthermore, because photographs are believed to differ from other pictures in such a fundamental way, special theoretical considerations are required to account for them. Therefore, even if Roger Scruton's above statement seems intentionally argumentative, it nevertheless does rely on, and articulate, the same belief.

Among the scholarly accounts reviewed so far, the best known is possibly André Bazin's, which has become representative of classic photography theory in general. Bazin's exotic pronouncement that the photographic image is *itself* the object photographed has often been restated. And whilst this claim may be easily criticized if taken at face value, it does nevertheless emerge from a well-established theoretical convention. So, even if it would require the most extreme of circumstances for anyone to confuse a photograph of an object with the object photographed, this, in and of itself, cannot be sufficient ground for rejecting Bazin's account. Therefore I ask: What if there were another way to interpret Bazin's sentiment? Would this render his overall argument more plausible? Would this provide us with a more useful terminology to characterize photography?

To that end, I now turn to Scruton's arguments in 'Photography and Representation'. Setting a record for aesthetic scepticism about photography, it will facilitate the transition from engagement with the theory of photography in this chapter to engagements with the philosophy of photography in Chapters 2 and 3. Before delving into Scruton, an important terminological note is in order. Bazin and others use the word *object* to refer to 'the object photographed'. Scruton, on the other hand, uses the word *subject* to refer to the same. He does use the word *object* but in a variety of other ways – to refer to an intentional object of sight, to a represented object, or to refer to a material art object. For reasons that will soon be made clear, I find that Scruton's terminology confusing. Therefore, and in order to maintain absolute consistency throughout this book, I shall use the word *object* only in Bazin's original sense. The word *subject* will be reserved for occasions related to 'theme' or 'content'. Scruton's term *material object* will not be used and instead I will use the terms *artwork* or *artefact*.

Scruton argues that it is impossible to have aesthetic interest in a photograph *as a photograph* and that, even if we do find photographs used in art, an artwork that is strictly photographic cannot exist. This conclusion, which in other accounts remains muted, rests on the widely held view that something can be an artwork only if it sustains aesthetic interest in its own right.[102] Of course, this particular conception sets a standard that inevitably rules out not only photography but also many other progenies of art created since Duchamp. Be that as it may, in order to fully unpack Scruton's complicated formula we must first understand what, in his account, 'aesthetic interest' really is.

The power of an artwork, asserts Scruton, lies in an ability to function as a *representation*. For an artwork to be a representation it must be the product of a process that is *intentional* and expresses human thought or emotion *on behalf of the artist*. Artefacts made by strictly photographic means are supposedly natural, mechanical or automatic. In other words they are purely *causal* and are *not* expressions of artistic intention. It therefore follows that it is impossible to have an aesthetic interest in an artefact made by strictly photographic means. Such an artefact may very well generate interest but that interest is not aesthetic.

Paintings, according to this argument, enable an aesthetic relationship because they do not necessitate an object to exist in reality. All that is necessary for a painting is the intention to represent an object. In fact, according to this line of thinking, we cannot understand paintings without ascribing intentional states to their makers. Photographs, on the other hand, result from a cause-and-effect relationship with reality – the objects depicted *must* exist in reality; they are therefore not a representation of that reality. Only intentional detachment from reality can render the object's 'presentation' a 'representation'. Thus, whereas painting possesses a quality of intentional relationship with the object, photography does not and is therefore not a real form of art. Moreover, the viewer's awareness of the dominant presence of reality in a photograph actually makes reality the centre of the viewing experience, thus causing the photograph itself to be transparent for the viewer. I shall treat the concept of transparency in detail in Chapter 2. For the time being, the main idea here is that according to Scruton's extreme scepticist account, the aesthetic qualities of a photograph exist in reality. The action of photographing, in and of itself, adds nothing to that reality.

Another important distinction within the Scrutonian argument concerns various kinds of interest in pictures. First, there is the case of 'genuine' aesthetic interest in a picture. Here the interest pertains only to pictorial properties of the picture, such as line, colour or texture, and remains indifferent to the object represented, which is considered wholly irrelevant or simply unknown. For this case, we could say that the picture is of interest as an abstract composition.

Second, there is interest in the way the picture refers to an object. Such interest may only arise when an observer recognizes the object and understands or at least acknowledges the reference. For example, an observer may take interest in a particular gesture of a certain figure in a painting or in a particular way of painting that gesture. Clearly, in this case there is interest in the object as such, but there is also and primarily interest in the object's pictorial representation. More importantly, what is gained by this interest can only be gained by looking at the picture. It cannot be gained by looking at the object. Such interests naturally apply to the use of any medium – the way that it can present its objects or the way the objects can be represented by artists working in the medium. Here the representation is, in and of itself, a source of interest. It is irreplaceable by any 'real-world' object depicted and cannot not be treated as a surrogate for that object, if it exists. The interest here is not in representation for the sake of its object but rather in representation *for its own sake*. We could say that the 'essence' of the picture, to the extent that pictures have essences, is representation. This type of interest forms the core of aesthetic experiences throughout the history of pictorial art in the West. Notably, this case still precludes attempts to reference cultural, semantic or cognitive processes, and not objects. Of course, numerous artworks since the early twentieth century have been doing mainly if not just that.

Finally there is the case of all 'weaker' kinds of interest in a picture – only as a 'surrogate' for the object presented. Here the interest is solely in things depicted: as they may describe characteristics of the object that make it interesting. In this case, the interest in the picture is derivative: it lies in the fact that the picture reveals the characteristics of an object. The picture is treated as a means of accessing the depicted object in it, and is therefore dispensable. According to Scruton, photographs, or in his vocabulary pictures made by purely photographic means obviously fall within this category. Much like the Turin Shroud, their importance lies in, and only in their ability to offer the experience of direct physical or perceptual access. What is important here is that, thus far, Scruton's distinctions revolve not around different types of pictures, as in previous accounts, but around the different types of viewing *experiences*.

In stark contrast stands another distinction Scruton makes – that between instances of actual photography and what he calls 'ideal photography', which is of particular importance to his theory. Contrary to intuition, actual photography differs from ideal photography not in the same ways as, for example, an actual painting differs from an ideal one. An ideal photograph stands in a very unambiguous relation to an object – a photograph is a photograph of something: 'if a photograph is a photograph of a subject, it follows that the subject exists, and if x is a photograph of a man, there is a particular man of whom x is the photograph'.[103] What is also implied here is that the object of which x is a photograph is more or less as it appears in the photograph.

35

To summarize Scruton's somewhat circular argument thus far, it is impossible to take aesthetic interest in an ideal photograph because it is not representational and no artefact can be an artwork unless it arouses aesthetic interest as a representation. Inevitably what follows is that artefacts of the sort Scruton calls an ideal photograph cannot be works of art. On the other hand, non-ideal photographs, of whatever kind, may sometimes be artworks because it is possible to take aesthetic interest in them, because they are representational. They are representational only because they 'pollute' the idea of ideal photography using techniques of painting.[104] Put differently one could say that a photograph, according to Scruton, can only be an artwork if it is not an ideal photograph. Furthermore, not only photographs cannot be representations but also any representation can never be achieved using photography alone. It is only through interference in the causal relation between the photograph and its object that a photograph ceases to be a photograph of that object. This categorical differentiation, I maintain, excludes many, if not all photographs from the definition of photography.

In characterizing the relation between the ideal photograph and its object, Scruton characterizes not an intention but a causal process. So even if there may be intentional acts involved in photography, as many have indeed confirmed, this does not preoccupy him for in his view, these are *not* an essential to the photographic relation. The essential aspect is that the ideal photograph yields an appearance, and that appearance is *not* interesting as the realization of an intention but, rather, *only* as a record of how an actual object looked. Namely, photograph x cannot exist without the pre-existence of the object about which we may say that x is a photograph of. Crucially for this uncompromising account, the pre-existence of the object and the causal chain it necessitates eclipse whatever intentional occurrences take place prior to or subsequent to them. Thus, even if Scruton acknowledges that there may have been other circumstances involved in the creation of a given photograph, these do not contradict the imperative existence of a particular object bearing causal relation to photograph x.

Bearing in mind Scruton's unique terminology, that is his use of the word 'subject', this is a very compelling idea. In many ways, it epitomizes most of the views that we have so far considered. As noted, Scruton's ideal photograph stands in a causal relation to its object and presents it by reproducing its appearance: 'in understanding something as an ideal photograph, we understand it as exemplifying this causal process, a process which originates in the subject "represented" and which has as its end point the production of a copy of an appearance'.[105] By 'a copy of an appearance' Scruton means a photographic artefact such that what is seen in it by a person with normal eyes and normal understanding resembles as nearly as possible what is seen when such a person observes the object itself from a certain angle at a certain point in its history. Scruton then concludes that a person studying an ideal photograph is given a very good idea of how something

looked: 'with an ideal photograph it is neither necessary nor even possible that the photographer's intention should enter as a serious factor in determining how the picture is seen. It is recognized at once for what it is – not as an interpretation of reality but as a presentation of how something looked. In some sense looking at a photograph is a substitute for looking at the thing itself'.[106]

Accordingly, the ideal photograph is also incapable of representing anything that is unreal.[107] Photographs are thus 'fictionally incompetent'.[108] There cannot be photographic fictions because things that do not exist can have no causal traces, that is to say photographs. Moreover, it is only by virtue of its fictional incompetence that a photographic representation may be worthy of close attention in the first place. Photographs are really 'surrogates' for the interest one would have presumably otherwise taken in what they are of, that is to say objects, situations or states-of-affairs. Furthermore, it is only by virtue of the photograph's ability to act as a visual reminder of its object that we are tempted to say that it represents it. Had it not been for this resemblance, asserts Scruton, it would have been impossible to see from the photograph how the object looked, except by means of scientific knowledge that he considers irrelevant to any interest in its visual aspect:

> Contrast here the case of an electron microscope which punches out on a ticker tape a codified indication of a crystal's atomic structure. Is that a representation of the atomic structure? If it is, then why not say that any causal relation which enables us to infer the nature of the cause from the properties of its effect provides us with a representation of the cause in the effect? Such a concept of representation would be uninteresting indeed.[109]

As shown below, such a concept of representation is compelling and in fact stands at the core of all human activities mediated by computer. In Scruton's extreme positivist approach, however, the typical reason for being interested in photographs, assuming what he does about their causality, is that they are true to the facts of their object and they tell us useful things about it.

Scruton's views will be further treated in Chapter 2. Of course, if we accept them we may reluctantly have to concede that causality cannot yield representation. However, is it correct to infer that photographic mechanism or automatism is a purely causal process? The historical and theoretical processes that have resulted in the set of technologies called photography may imply that this is *not* the case. In the following chapters, I will be making several claims that deal with this idea. First, that many circumstances are involved in the creation of every photograph. Second, that some of those are indeed solely causal but others are entirely intentional. Third, many sets of circumstances, be they causal or intentional, remain invisible to most us and so one way to think of them is as predetermined,

perhaps even random variables. Fourth, particularly recently, photography is almost always characterized by those variables. Lastly, and most importantly, photography makes clear that, for art at least, causality and intentionality are not mutually exclusive. This gives rise to a more general question: Are concepts of artistic representation, in the manner that they are understood and implemented in theory, really applicable to photography? From this point onwards, I will argue that more useful concepts may be extracted from theories of information and computation, from algorithmic art and from media philosophy.

The Visual and Mechanical Models

> There is something charming and yet nasty about the belief in the special relation of picture to world. It is charming because it allows us to 'enter' with ease into pictures and allows them to 'extend' into our world. It allows us to think of pictures as 'true to life' [...] In brief, it allows us to feel a proximity to what is depicted and urges us to conclude that in certain important respects looking at a picture is equivalent to looking at what is pictured [...] But this belief in the special relation of picture to world has a pernicious aspect; it holds sway over us and mocks thought with a vengeance.

> Joel Snyder[110]

The above quote encapsulates the understanding to which I have already alluded: photography's privileged connection with the world may not be more than a fanciful metaphor, manifested in a variety of ways throughout the classic theories of photography. But before we delve into alternative theories of photography, let me briefly offer a quick conclusion to the thinking developed in this chapter.

Whatever disagreements may be found within existing theory these are minor when considering the broad areas of agreement. This is most evident in all the assertions quoted thus far. These have, without exception, assumed only one very particular and intimately linked source of authority for the photograph: similarity with objects in the world through causality, be it natural, mechanic or automatic. That is why most critics make the same claim: photographs do not matter to us because of what they are or what they contain, but because they allow access to what is *not* in them – 'the things themselves' or any other ontological stand-in for 'reality'. For some, like Roland Barthes, that moment was always a moment past, but the photograph nevertheless remained loyal to that past and to the 'things' in it.[111]

This authoritative standing of photography is usually promoted by two theoretical models – the visual and the mechanical.[112] The visual model stresses the supposed similarity between the eye and the camera as optical systems. It further

posits that a photograph usually shows us or ought to show us what we would have seen with our human eyes. The mechanical model, on the other hand, stresses that a unique connection necessarily exists between what we see in a photograph and what was, at some point, out there in the world. According to this model, even if some photographs do not show us a scene as we would have perceived it ourselves, the causal connection previously discussed nevertheless guarantees a kind of reliability. Of course, most theories of photography use both models interchangeably or simply conflate elements of each. Arguing against both, Snyder and Allen state:

> The image is a crafted, not a natural, thing. It is created out of natural material (light), and it is crafted in accordance with, or at least not in contravention of, 'natural' laws. This is not surprising. Nor is it surprising that something in the camera's field will be represented in the image; but how it will be represented is neither natural nor necessary.[113]

The visual model is implausible for several reasons. First, because our vision simply does not operate like a camera. As discussed in the following chapters, it may in the future, but for the time being it does not. No processes in photography are consonant to what actually happens in human vision.[114] Nevertheless, even if we put neurology aside for the time being, there are plenty of anatomical reasons to reject the human vision-camera analogy or even the eye-camera analogy. Here are a few: we see through two eyes and not one, our eyes are never stationary – they are always moving, so our vision is more similar to video than to still photography, our field of vision is elliptical and is not formed within a rectangular boundary, our eyes are foveate causing our vision to be sharp only at its centre and not edge to edge and we can never see things in sharp focus across all plains of view, meaning that there is no human equivalent to photography's potential for full depth of field.

With this, I hope, it is made clear why the visual model should be rejected – it simply fails to establish anything other than the suggestion of resemblance itself. This is how Snyder and Allen put it: 'The notion that a photograph shows us "what we would have seen had we been there ourselves" has to be qualified to the point of absurdity'.[115] Meeting all the conditions required by the visual model vitiates the hypothesis itself. Instead of demonstrating that the camera shows us what our eyes could or would have seen, the visual model raises the disconcerting proposition that, if our vision worked like photography, then we would see things the way a camera does.[116] Further, I suspect that the camera-eye consonance is no more helpful for people investigating human vision than it is for investigators of photography. The more the supposed consonance is investigated, the more it becomes clear that we probably do not receive, form or otherwise possess neatly

packaged images with clearly delineated borders. And even if we do 'possess' images in one way or another, there is probably nothing in human physiology that even remotely resembles the process of storing an image in one place where it can then be preserved, quarried, located, retrieved and shared.[117]

As noted earlier, when Eadweard Muybridge succeeded in 'freezing' the rapid motion of horses galloping, his photographs were deemed 'unnatural' and even 'untrue'. Even if some did believe that horses might gallop as Muybridge had photographed them, that proposition could unfortunately be confirmed only by other photographs and *not* by human vision. This is where the mechanical model comes into play. For with the model it can be argued that even when photographs do not show us objects or scenes as we would have seen them, they are nevertheless, because of their unique genesis, accurate records of those objects or scenes as they actually were. The frozen motion always bears a causal relation to motion in physical reality.

What follows is that even for those photographs that show us things we have never seen or are never likely to see, because they fall within the definition of Walter Benjamin's 'optical unconscious',[118] all are still natural, objective and contain 'an authenticity from which painting is barred by birth'.[119] Therefore, it matters not whether the camera expands our normal visual experience. According to the mechanical model, a photograph may or may not be a substitute for vision, an expanded or modified version of it. What matters is that a photograph is the *inevitable* outcome of a causal chain of events: 'No doubt it is this sense of inevitability, this feeling that a photograph is the end result of a series of cause-and-effect operations performed upon "physical reality," that inclines us to impute a special sort of veracity to photographs'.[120]

Put differently, according to the mechanical model, photography is a process essentially different from the genesis of handmade pictures. The painter must employ his mind to generate artistic representation. Consequently he can, by genius or guile or conceit or simple human error, change a given scene, mutilate it or elevate it. A photographer on the other hand uses a pre-existing set of cognitions and apparatuses that have been made available to him to record a given scene with or through pre-programmed mechanical procedures. According to this view, no matter how great the photographer's range of control, no matter how labyrinthine the path from scene to image, one can always find mechanical connections between the two. The photographer, therefore, cannot intervene in the process of representation; rather, it is the world that delivers itself to the photographer in the form of an image. This view, or views similar to it, allows critics as well as photographers to speak of photographs as 'consubstantial with the objects they represent', 'perfect analogons', 'traces', 'records', 'documents' of those objects or simply 'stencils of the real'.

The unique status occupied by photography in Western culture is thus predicated on a contiguous, causal link that unites the photograph with its referent. This link is supposedly formed of light that can then be perceived as almost a 'custodian of truth'. But is this notion really useful? Does it guarantee anything? Snyder argues it does not:

> As a general explanation for resemblance, causal genesis is certainly lacking. Suppose that in a fit of anger I smash a wall with a large hammer. The wall may dent, but there is no reason to conclude that the dent must bear a resemblance to the head of the hammer. This is not to suggest that causal laws are inoperative in this case but simply that such laws do not guarantee even the suggestion of resemblance.[121]

The problem arises not because the rules of causality prove too little, but because they prove too much. Such notions can account for whatever a photograph looks like. For according to these notions, if a photograph is exposed to thirty-two times more light than necessary, the resulting photograph, although it would most probably be blank white, would owe its appearance to laws of nature, mechanism or automatism. Similarly, a corresponding under-exposure would result in a natural, mechanical or automatic pitch black. John Hilliard's *Camera Recording Its Own Condition (7 Apertures, 10 Speeds, 2 Mirrors)* demonstrates this point (Figures 2–3). The work is a gridded display of seventy photographs, ranging from pure white to pure black and corresponding to all possible combinations of aperture size and shutter speed in Hilliard's camera, seen reflected in a mirror. Although not all photographs pass as 'correct' exposures, at least fifteen do, illustrating the point that photographs may be anything but a privileged access mode to 'real-world' objects.

In cases like bullet holes, footprints, or signet rings, to name but a few examples from literature, and even in the case of the Turin Shroud, the apparent explanatory power of impression derives from what appears to be the transfer of formal properties from the impressing object to the receiving medium. Even if impression by means of physical contact does work this way, there is no comparable contact in photography. It is dangerous, if not simply wrong, to extend notions of impression by means of physical contact to photography. In fact, even object-oriented otologists would not contend that objects are 'active' in the photographic process.[122] Rather, it is light or other forms of electromagnetic radiation that are. These affect a radiation-sensitive medium and bring about minute, but highly complex chemical or physical changes in it. Thus, even if 'impression' were the right term to characterize these changes, what causes the impression is never objects. Furthermore, not only films and sensors but in fact any material is affected by electromagnetic radiation. Thus, films and sensors are impressed by light but this is equally true of human skin and blank canvases.

FIGURE 2: John Hilliard, *Camera Recording Its Own Condition (7 Apertures, 10 Speeds, 2 Mirrors)*, 1971. Silver gelatin photos on card, on Perspex, 218 x 183 cm. Collection: Tate Gallery, London.

To conclude this chapter, if both the visual and the mechanical model of photography explain so little, why are they perpetuated? One possible reason could be that they have never been intended as serious accounts of the photographic process. They may have only been rhetorical tropes put forth as

FIGURE 3: John Hilliard, *Camera Recording Its Own Condition (7 Apertures, 10 Speeds, 2 Mirrors)*, 1971. Silver gelatin photos on card, on Perspex, 218 x 183 cm (detail). Collection: Tate Gallery, London.

ways to acknowledge the existence of ideas outside the realm of art. Thus, what is truly significant about a photograph of a building is not really that the building itself has drawn or printed its own image, or that the photograph shows us the building as we ourselves would or could have seen it, or that it establishes something in the way of scientific truth about all buildings. What is perhaps significant is that *this* building is not a product of an artist's mind: it is real. This understanding is more often implied than stated explicitly, but it nevertheless forms the core of all theories of photography, those treated here and others. However the technical and conceptual histories of the camera may be understood, it should be acknowledged that most classic theories of photography are severely flawed. In the following chapters, I will go on to show that photographs are always made and controlled by people but *not* in the same ways as handmade pictures. To the extent that photography matters to us as art,[123] it matters because it is a 'different' kind of art.[124] I will contend that it is different indeed, but not in ways thus far considered.

NOTES

1. Stanley Cavell, *The World Viewed: Reflections on the Ontology of Film*, Enl. ed. (Cambridge, MA: Harvard University Press, 1979), 17.

2. This term was coined by Geoffrey Batchen. Geoffrey Batchen, *Burning with Desire: The Conception of Photography* (Cambridge, MA: The MIT Press, 1999).

3. For example: Pierre Bourdieu, *Photography: A Middle-Brow Art*, trans. Shaun Whiteside (Stanford: Stanford University Press, 1990); Victor Burgin, *Two Essays on Art Photography and Semantics* (London: Robert Self (Publications), 1976); *Thinking Photography* (London: Palgrave Macmillan, 1982); *The End of Art Theory: Criticism and Postmodernity* (Atlantic Highlands, NJ: Humanities Press International, 1986); Allan Sekula, 'The Traffic in Photographs', *Art Journal* 41, no. 1, Photography and the Scholar/Critic (1981); 'The Body and the Archive', *October* 39 (1986); 'Reading an Archive: Photography between Labour and Capital', in *Visual Culture: The Reader*, ed. Jessica Evans and Stuart Hall (London: Sage Publications, 1999); John Tagg, *The Burden of Representation: Essays on Photographies and Histories* (Basingstoke, England: Macmillan Education, 1988).

4. Reprinted in: Alan Trachtenberg, ed., *Classic Essays on Photography* (New Haven: Leete's Island Books, 1980), 11.

5. This is in fact the title of a paper Talbot wrote. It was read to the Royal Society on 31 January 1839 and later published as a 12-page booklet. Original publication: *Some Account of the Art of Photogenic Drawing, or, the Process by Which Natural Objects May Be Made to Delineate Themselves without the Aid of the Artist's Pencil*, London: R. and J.E. Taylor, 1839. Reprinted in: Beaumont Newhall, ed., *Photography: Essays & Images: Illustrated Readings in the History of Photography* (New York: The Museum of Modern Art, 1980), 23–30.

6. Reprinted in: ibid., 28.

7. Quoted in: Gail Buckland, *Fox Talbot and the Invention of Photography* (London: Scholar Press, 1980), 31.

8. Quoted in: Batchen, *Burning with Desire*, 62.

9. Ibid., 62–63. Emphasis mine.

10. This is an intentional play on words on the title of Walter Benjamin's well-known essay 'The Author as Producer'. Reprinted in: Walter Benjamin, *The Work of Art in the Age of Its Technological Reproducibility, and Other Writings on Media*, trans. Edmund Jephcott, Rodney Livingstone and Howard Eiland (Cambridge, MA: Belknap Press of Harvard University Press, 2008), 79–95.

11. To be clear, these questions are cultural questions deriving from the fact that nature itself is nothing but a cultural construct. Ross Gibson, *South of the West: Postcolonialism and the Narrative Construction of Australia* (Bloomington: Indiana University Press, 1992), 75.

12. Quoted in: Helmut Gernsheim and Alison Gernsheim, *L.J.M. Daguerre: The History of the Diorama and the Daguerreotype* (New York: Dover Publications, 1968), 79–81.

13. Quoted in: ibid., 81.

14. Taken from a letter from Talbot to Herschel. Quoted in: Larry J. Schaaf, *Out of Shadows: Herschel, Talbot, & the Invention of Photography* (New Haven: Yale University Press, 1992), 48.

15. Note that here too there is a differentiation between a passive and an active stance. Aaron Scharf, *Pioneers of Photography: An Album of Pictures and Words* (New York: N. Abrahams, 1975), 39; *Art and Photography* (New York: Penguin Books, 1986), 6; Joel Snyder, 'What Happens by Itself in Photography?', in *Pursuits of Reason: Essays in Honor of Stanley Cavell*, ed. Ted Cohen, Paul Geyer and Hilary Putnam (Lubbock: Texas Tech University Press, 1993), 361.

16. See for example: Jonathan Crary, *Techniques of the Observer: On Vision and Modernity in the Nineteenth Century* (Cambridge, MA: The MIT Press, 1992); Peter Galassi, *Before Photography: Painting and the Invention of Photography* (New York: Museum of Modern Art 1981); Sarah Greenough et al., *On the Art of Fixing a Shadow: One Hundred and Fifty Years of Photography* (Washington, DC: National Gallery of Art, 1989).

17. Original publication: 'Doings of the Sunbeam', *The Atlantic Monthly* (July 1863): 1–15. Reprinted in: Newhall, *Photography*, 73.

18. Original publication: 'Photography', *Quarterly Review (London)* 101 (April 1857): 442–68. Reprinted in: ibid., 84, 88.

19. William Henry Fox Talbot, 'Photogenic Drawing', *The Literary Gazette* (2 February 1839): 73.

20. *The Pencil of Nature*, ed. Facsimile (Chicago: KWS Publishers, 2011), 4.

21. Reprinted in: Newhall, *Photography*, 27.

22. Systematic attempts to develop a system of perspective are usually considered to have begun around the fifth century BC in the art of ancient Greece. This was detailed in Aristotle's *Poetics* as *Skenographia*. Euclid's *Optics* introduced a mathematical theory of perspective, but there is debate over the extent to which this coincides with the modern mathematical definition of perspective. Some medieval artists in Europe, as well as in the Islamic world and in China, were aware of the basic principle of varying the relative size of elements according to distance. Nonetheless, for various reasons, this principle was rarely applied in classical art. Around 1413 Filippo Brunelleschi demonstrated the geometrical method of perspective, used today by artists, by painting the outlines of various Florentine buildings onto a mirror. When the building's outline was continued, he noticed that all of the lines converged on the horizon line. Brunelleschi never published the mathematical principles of perspective. Nevertheless, the wide proliferation of accurate perspective paintings in Florence suggests that these principles were quickly made known to others. In 1436 Leon Batistta Alberti published his well-known treatise *De Pitura* (The Picture). There he outlined a proper method of showing distance in painting. Alberti's primary breakthrough was not to show the mathematics in terms of conical projections, as it actually appears to the eye. Instead, he formulated the theory based on planar projections, or how the rays of light, passing from the viewer's eye to the landscape,

would strike the picture plane (the painting). He was then able to calculate the apparent height of a distant object using two similar triangles. The mathematics behind similar triangles is relatively simple, having been formulated by Euclid. In the 1520s Albrecht Durer, working in Nuremberg Germany, discusses in this last book of *Underweysung der Messung* (Four Books on Measurement) an assortment of mechanisms for drawing in perspective from models and provides woodcut illustrations of these methods. These are often reproduced in discussions of perspective.

23. Quoted in: Buckland, *Fox Talbot and the Invention*, 44.

24. Original publication: H. Gaucheraud, *La Gazette de France* (6 January 1839). Reprinted in: Newhall, *Photography*, 17.

25. Ibid., 23–30.

26. Henry Peach Robinson was an English pictorialist photographer who was best known for his use of combination printing, i.e. joining multiple negatives or prints to form a single photographic image. Not coincidently this is the same technique used in Gustave Le Gray's seascapes as well as in Oscar Gustave Reilander's allegorical image from 1857 *The Two Ways of Life*.

27. Quoted in: Beaumont Newhall, *The History of Photography* (New York: The Museum of Modern Art, 1982), 141.

28. Ibid.

29. Emerson's use of the term *Naturalism* is somewhat different from its uses in literature (for example Georg Lucáks' discussion around literary Naturalism). It is also very different from uses within the fields of philosophical investigation called Ontological Naturalism and Methodological Naturalism. Georg Lucáks, 'Narrate or Describe? A Preliminary Discussion of Naturalism and Formalism', in *Writer & Critic and Other Essays*, ed. Arthur D. Kahn (New York: The Universal Library, 1971); Mario De Caro and David Macarthur, eds., *Naturalism in Question* (Cambridge, MA: Harvard University Press, 2004).

30. Peter Henry Emerson, *Naturalistic Photography for Students of the Art & the Death of Naturalistic Photography* (New York: Arno Press, 1973).

31. We might do well to recall that Emerson also warned against the unwanted effects of excess amounts of definition, which he believed were not only 'untrue to the human senses' but also 'artistically false', in spite of being 'scientifically true'. This contention remains pertinent today as photography continues its quest towards finer detail through higher resolution. Ibid.

32. Original publication: Peter Henry Emerson, 'Photography Not Art', *The Photographic Quarterly* (January 1892). Excerpts reprinted in: Nancy Newhall, *P.H. Emerson: The Fight for Photography as a Fine Art* (New York: Aperture, 1975), 98.

33. Ibid., 99.

34. Josef Maria Eder, *History of Photography*, trans. Edward Epstean (New York: Dover Publications, 1978), 501–06.

35. Original publication: 'Depreciation: Effects of Instantaneous Photography', *California Spirit of the Times* (8 May 1880). Reprinted in: Newhall, *Photography*, 142.

36. Rebecca Solnit, *River of Shadows: Eadweard Muybridge and the Technological Wild West* (New York: Penguin Books, 2004), 177–206.

37. This idea has been introduced by Benjamin and developed by Krauss and others. Benjamin, *The Work of Art*; Rosalind Krauss, *The Optical Unconscious* (Cambridge, MA: The MIT Press, 1993).

38. Siegfried Kracauer, *Theory of Film: The Redemption of Physical Reality* (London: Oxford University Press, 1960), 11.

39. This is how Victor Burgin phrased it: 'It seems to be extensively believed by photographers that meanings are to be found in the world much in the same way that rabbits are found on downs, and that all that is required is the talent to spot them and the skill to shoot them'. Of course Burgin's context is somewhat different but his point is nonetheless clear and accurate. Victor Burgin, 'Photographic Practice and Art Theory', in *Thinking Photography*, ed. Victor Burgin (London: Palgrave Macmillan, 1982), 40.

40. I'll note that contemporary theory still has not given up the belief in those connections, even though maintaining it now does require life support. To clarify this point – think of the discourse surrounding the images from Obama and Trump's inauguration ceremonies. Why the controversy if now, in the age of post truth, no one expects or believes in photographic veracity?

41. Erwin Panofsky, 'Style and Medium in the Motion Pictures', in *Film Theory and Criticism: Introductory Readings*, ed. Leo Braudy and Marshal Cohen (London: Oxford University Press, 1974), 151.

42. This is what Peter Galassi referred to as the 'bastard left by science on the doorstep of art'. Galassi, *Before Photography*.

43. Panofsky, 'Style and Medium in the Motion Pictures', 168.

44. Ibid.

45. In fact, this is clearly a conception echoing or embedding the early Greek myth of the sculptor revealing a hidden form from within a block of marble. This myth was later included in Ovid's *Metamorphoses* as the tale of Pygmalion, a sculptor who fell in love with an ivory statue of a woman he had carved.

46. Panofsky, 'Style and Medium in the Motion Pictures', 169.

47. Ibid., 168–69.

48. Ibid., 169.

49. André Bazin, *What Is Cinema?*, trans. Hugh Gray (Berkeley: University of California Press, 2005), 12.

50. Ibid.

51. The age old desire to copy nature. Ibid., 13.

52. Ibid. Emphasis mine.

53. Panofsky, 'Style and Medium in the Motion Pictures', 168.

54. Bazin, *What Is Cinema?*, 13.

55. Ibid., 13–14.

56. Ibid., 14. Emphasis mine.

57. Ibid.

58. 'A Photograph does not present us with "likenesses" of things; it presents us, we want to say, with the things themselves. But wanting to say that may well make us ontologically restless'. Cavell, *The World Viewed*, 17.

59. Ibid., 18.

60. Ibid., 21.

61. Bazin, *What Is Cinema?*, 9–10.

62. Cavell, *The World Viewed*, 21–22.

63. Ibid., 23.

64. Ibid., 24.

65. Interestingly, Cavell, as opposed to other writers, names exclusion and not inclusion as the virtue by which photography maintains reality. He argues that the camera's finitude is in fact its strongest quality. If every photograph is a portion of an indefinitely larger field, then other contiguous portions of that same field could in principle and in practice also be included in the photograph but are removed: 'when a photograph is cropped, the rest of the world is cut out. The implied presence of the rest of the world, and its explicit rejection, are as essential in the experience of a photograph as what it explicitly presents'. So a photograph is 'of the world' because it is always about the implied presence of parts of that world. And when these parts are absent, then they have been rejected – suggesting that they are even more present. Ibid.

66. Ibid., 19–20.

67. Bazin, *What Is Cinema?*, 12.

68. Henri Van Lier, *Philosophy of Photography*, trans. Aarnoud Rommens, Lieven Gevaert Series (Leuven, Belgium: Leuven University Press, 2007), 9.

69. Cavell, *The World Viewed*, 17–18.

70. To the best of my knowledge, it is John Tagg who first suggested this term to indicate the idea that there are multiple types and forms of photography. It is now the title of an important academic journal, one of the rare journals dedicated exclusively to the theory of photography. Tagg, *The Burden of Representation*.

71. Rudolf Arnheim, *Film as Art* (Berkeley: University of California Press, 1957), 155.

72. Rudolf Arnheim, 'On the Nature of Photography', *Critical Inquiry* 1, no. 1 (1974): 155.

73. Arnheim, *Film as Art*, 155. Emphasis added.

74. Arnheim, 'On the Nature of Photography', 154.

75. Ibid., 156.

76. Arnheim, *Film as Art*, 158.

77. Ibid., 20. Emphasis added.

78. Ibid., 10.

79. This is an intentional play on words around the expression 'Mechanical Reproducibility', the usual English translation of the important term Walter Benjamin coined. Benjamin, *The Work of Art*.

80. 'This curious development signifies to some extent the climax of that striving after likeness to nature which has hitherto permeated the whole history of the visual arts...', Arnheim, *Film as Art*, 157.

81. Arnheim, 'On the Nature of Photography', 157.

82. Arnheim, *Film as Art*, 11.

83. Arnheim, 'On the Nature of Photography', 157.

84. Ibid.

85. Charles Baudelaire, *Art in Paris 1845-1862: Salons and Other Exhibitions*, trans. Jonathan Mayne (London: Phaidon Press, 1965).

86. Arnheim, 'On the Nature of Photography', 155.

87. Ibid.

88. Ibid.

89. Ibid., 160.

90. Originally titled 'Die photographie'. This text first appeared in the Frankfurter Zeitung on 28 October 1927. It was later included in *The Mass Ornament: Weimar Essays*, trans. Thomas Y. Levin (Cambridge, MA: Harvard University Press, 1995); Siegfried Kracauer, 'Photography', Critical Inquiry 19, no. 3 (1993): 427.

91. 'the last memory-image outlasts time because it is unforgettable; the photograph, which neither refers to nor encompasses such a memory-image, must be essentially associated with the moment in time at which it came into existence'. Ibid., 428.

92. Ibid., 430.

93. 'the turn to photography is the go-for-broke game of history'. Ibid., 435.

94. Ibid.

95. Kracauer, *Theory of Film*, 8.

96. 'Contemporary photographic records and painterly abstractions have this in common: they are both remote from the images we have been able to form of reality in a technically more primitive age'. Ibid., 9.

97. Ibid., 12–18.

98. Ibid.

99. Ibid., 18.

100. Ibid., 18–20.

101. Roger Scruton, 'Photography and Representation', *Critical Inquiry* 7, no. 3 (1981): 596.

102. This view is related to, if not directly derived from, the classic modernist project of articulating medium-specificity – the idea that there are specific qualities inherent to every medium.

103. Scruton, 'Photography and Representation', 579.

104. Ibid., 578.

105. Ibid., 587.

106. Ibid., 588.

107. 'if a photograph is a photograph of a man, then there is some particular man of whom it is a photograph'. Ibid.

108. Dan Cavedon-Taylor, 'In Defence of Fictional Incompetence', *Ratio* 23, no. 2 (2010).

109. Scruton, 'Photography and Representation', 590.

110. Joel Snyder, 'Picturing Vision', *Critical Inquiry* 6, no. 3 (1980): 502.

111. Roland Barthes, *Camera Lucida*, trans. Richard Howard (New York: Hill and Wang, 1980).

112. Joel Snyder and Neil Walsh Allen, 'Photography, Vision, and Representation', *Critical Inquiry* 2, no. 1 (1975).

113. Ibid., 151.

114. Even in fields like machine vision and computational photography, where processes are very complicated, there is still no comparable process to human vision.

115. Snyder and Allen, 'Photography, Vision, and Representation', 151–52.

116. This is indeed the point made by Harun Farocki when he states: 'at first the camera imitates the human eye but quickly outstrips its model'. I return to this idea in Chapter 4. Harun Farocki, 'War at a Distance', (2003), 11:15 mins.

117. Importantly, this point is valid more for traditional photography than for digital photography. In the latter it can similarly be argued that there is no 'one place' where the image is stored.

118. This idea is introduced in Benjamin's well-known 'Little History of Photography'. It was consequently developed by Rosalind Krauss. Benjamin, *The Work of Art*, 274–98; Krauss, *The Optical Unconscious*.

119. Arnheim, 'On the Nature of Photography', 154.

120. Snyder and Allen, 'Photography, Vision, and Representation', 157.

121. Snyder, 'Picturing Vision', 507.

122. Object-oriented ontology (OOO) is a twenty-first-century school of thought that rejects the privileging of human existence over the existence of nonhuman objects. OOO maintains that objects exist independently of human perception and are not ontologically exhausted by their relations with humans or other objects. Thus, for object-oriented ontologists, all relations, including those between nonhumans, distort their related objects in the same basic manner as human consciousness and exist on an equal footing with one another. If an object-oriented ontologist were to argue with Andre Bazin or Roger Scruton, for example, they would maintain that a hypothetical object x is 'caused' by its photograph as much as it 'causes' it.

123. This is of course an intended pun on the title of Michael Fried's book. Michael Fried, *Why Photography Matters as Art as Never Before* (New Haven: Yale University Press, 2008).

124. And this references the title of a John Szarkowski article. As will soon be made clear, my conception of the difference in question diverges from his quite considerably. John Szarkowski, 'Photography a Different Type of Art', *The New York Times Magazine* 13 April 1975.

2. A Philosophy of Photography

Let us photograph a man [...] Let us take three shots in which we will keep the man the same size in the finished frame while also varying the focal length of the lens and the subject-to-camera distance [...] one shot with a wide-angle-lens, one shot with a normal lens, and one with a telephoto lens. The result will be three shots [...] of the self-same subject. As a matter of empirical fact, however, the patterns of light of these shots will differ grossly enough that the disparities can be detected even by an untrained eye [...] each delivers a different pattern of light, not because of physical changes in the subject but because of changes in the focal length of the lens [...] each is identical 'to a mold' with its subject. However, identity is a transitive relation – if x is identical to y, and y is identical to z, then x is identical to z. Hence, each of the three shots, if identical to the model must also be identical to each other. But the shots will not be identical in terms of the light pattern they deliver.

Noël Carroll[1]

The above passage was written in response to André Bazin's ontology of the photographic image, which was revisited in the previous chapter. Here Carroll articulates, in accessible philosophical language, the crux of the problem with what Snyder and Allen had appropriately titled the mechanical model. As noted, such formulations, rife in the literature on photography, utilize a wide variety of notions to characterize the photographic process[2] and an equally wide variety of terms to characterize the status of photographs.[3] As argued, the problem here is not that these formulations do not confirm anything, but rather that they confirm *too much*. For even when they are applied responsibly they merely demonstrate how *any* shot (no matter how fuzzy and distorted), with *any* type of lens resulting in *any* array of light patterns is still intimately linked to the object.

It would be mistaken to assume, however, that the intuitions informed these formulations have been made redundant by the postmodernist form of

51

photographic criticism. Even in that context, they still hold sway. They can be easily recognized in the many writings that take as their starting point a small cluster of theoretical approaches building up from either Charles Sanders Peirce's notion of indexical signs, Roland Barthes's concepts of denotation and connotation (or his later 'punctum' and 'studium') or Walter Benjamin on social commitment.[4]

These approaches, while important for being deeply related to the politics of the late twentieth century, still recycle familiar intuitions and arguably do not offer new insights on photography per se.[5,6] Such writing still predominantly relies on the same ontological intuitions criticized in the previous chapter. These are aptly summarized by Diarmuid Costello and Dawn M. Wilson: '(1) The photographic process is, in some sense, automatic. (2) The resultant images are, in some sense, realistic. (3) The realism of photographs, in some sense, depends on the automatism of the photographic process'.[7] Put differently, postmodernist photographic criticism recycles the same ontological argument about photography to address different problems altogether. These include society (gender and feminism), political economy (Marxism) and psychology (psychoanalysis).[8]

In order to plot a route out of this predominant but problematic rhetoric I will now advance a different form of enquiry, one that emerges from the philosophy of photography. Positioned at the nexus of aesthetics, epistemology and the philosophy of mind, the philosophy of photography is a relatively new field. It is also sparsely populated, with only a handful of monographs exclusively devoted to it.[9] The total volume of writing is much smaller than that in the thriving philosophy of film, despite film being a younger medium. Of these monographs, I will utilize ideas by Patrick Maynard towards the end of this chapter and will thoroughly develop other ideas by Vilém Flusser in Chapter 3.

The philosophy of photography is far from being a unified discipline. Two largely independent, albeit overlapping, sets of debates structure the field, one broadly ontological, the other epistemological. The ontological debate is represented by Roger Scruton, among others.[10] These are philosophical developments of earlier theoretical treatments of photography. They recognize photography's 'special' character and posit that it is always a *mind-independent* form of picture, generated by a purely causal chain of events. At first assessment, this ontological argument does not seem to preclude the possibility of an epistemological debate. The more photography is said to be a mind-independent or 'objective' process, the more this seems to guarantee an epistemologically unique kind of picture. That is, by virtue of its being 'objective', photography stands out as the sole type of picture that is a 'record' of 'the facts' and not of intentional states.

However, as has been made explicitly clear in the previous chapter, this ontological (or essentialist) argument is often questionable and runs the risk of being 'quite damning' as Noël Carroll put it.[11] Thus, not only does this line of enquiry not deliver satisfactory ontological definitions, it also ends up ridiculing itself for its overarching and unwarranted claims. As philosopher Ted Cohen puts it, 'The alleged special relation of photographs to the world is, allegedly, related to the alleged mechanical or automatic character of photography'.[12] In fact, Carroll proceeds, even were we to succeed in specifying the essence of a given medium, this would lend no support to prescriptive claims that attempt to circumscribe its acceptable uses. At best, such claims lack normative force because in weak formulations they are trivial and in strong formulations they fail to account for, let alone determine, actual cases of success or failure. This is clearly the case in Scruton's conception of an 'ideal photograph'. It is a strong formulation indeed but also one that precludes validation because any such attempt would have to utilize examples that are 'actual photographs', an irrelevant formulation in Scruton's terminology. Nonetheless, since it is 'actual photographs' we are interested in, we must acknowledge that there may not be any particular features that are essential and common to *all* photographs. In fact, given that photography has rarely comprised a single technology, I question whether there could even be such features. Therefore, when we look at the differences between the many things we have historically called photography, we ought to realize that 'photograph' is only a resemblance concept. Photographs form a family group, with many overlapping sets of features, but there is no single set of features common to all the 'things' to which the word photograph pertains.

Writing on photography often starts with examining the material and physical features of photographs as a means of drawing conclusions about the ontological status of photography as a bearer of certain epistemic qualities. Instead, we may do better to first examine the various uses and misuses to which photography is put, the diverse ways in which these are achieved and how these achievements, in turn, recondition their users. This, I argue, is a more effective way to discover which technological or conceptual characteristics are significant, meritorious or definitive of the photographic medium. Down the road, this will reveal that a viable form of essentialism is impossible and that, accordingly, photography is better served if understood as a set of *media*.[13] Hereafter, this chapter will attempt to put the ontological argument to rest. It will then proceed by linking the epistemological debate to the analytic philosophy of photography and present selected arguments from that debate in order to develop an alternative philosophy of photography in Chapter 3.

Photographs as Seeing

In addition to disturbing every definition of art, the emergence of photography in the nineteenth century has also imbued the already muddled term 'seeing' with significant philosophical challenges. Kendall Walton's 'transparency thesis' is an ambitious attempt to use photography to account for this term.[14] In doing so this analytic thesis has set the terms for several intriguing debates about photography, both ontological and epistemological.[15] I will now briefly outline some choice aspects of Walton's thesis before delving into several subsequent debates which contain vocabularies and propositions that will prove relevant in crafting a new narrative of photography. In doing so I shall occasionally be using the term *manugraphy*, which has emerged from post-Walton debates. Coined by Jonathan Friday, it refers to all non-photographic types of pictorial media.[16] I shall be using individual medium names (painting, drawing, engraving etc.) when reference to only one of those media is required.

The starting point of Walton's thesis is traditional as he too, like Scruton and others, assumes that photographs and manugraphs differ in their manners of production, given that photographic depiction is mostly independent of the photographer's intentions.[17] However, in Walton's account the kind of realism characteristic of photography is *not* ordinary and has little to do with the post-Renaissance quest for realism in painting. Photography, he argues, is a form of *perceptual* contact and as such deserves to be called a supremely realistic medium in an *epistemologically unique* way.[18] Photography's type of realism, he contends, should be understood as nothing less than a contribution to the enterprise of seeing.

To trace the starting point for this complicated and controversial argument we might recall Oliver Wendell Holmes' nineteenth-century dubbing of photography as 'a mirror with a memory'.[19] Walton himself prefers to start with Bazin's assertions. The most interesting of these is, for him, the one where Bazin compares the silver screen to a mirror: 'It is false to say that the screen is incapable of putting us "in the presence of" the actor. It does so in the same way as a mirror – one must agree that the mirror relays the presence of the person reflected in it – but one with a delayed reflection, the tin foil of which retains the image [...]'.[20] Walton accepts this assertion and develops it further. His argument starts by stating the obvious: 'Mirrors are aids to vision, allowing us to see things in circumstances in which we would not otherwise be able to; with their help we can see around corners'. He then adds that: 'Telescopes and microscopes (also) extend our visual powers in other ways, enabling us to see things that are too far away or too small to be seen with the naked eye' before arguing that: 'Photography is an aid to vision also, and an especially versatile one'. Walton then arrives at a surprising conclusion: 'With the assistance of the camera, we can see not only around corners and what

is distant or small; we can also see into the past. We see long deceased ancestors when we look at dusty snapshots of them [...] Photographs are *transparent*. We see the world *through* them'.[21]

Thus, photography supplements vision by helping us discover things that we cannot otherwise discover. But Walter Benjamin has already alluded to this point. Notwithstanding, other types of pictures have, in some circumstances, the same potential, as do verbal reports. Do these supplement vision too? Not quite. In Walton's formulation photographs are not merely duplicates or reproductions of objects, or substitutes thereof. Manugraphs and verbal reports can be that too. In his example, when one looks at a photograph of a dead relative this entails that one *literally* sees the relative. Does Walton's argument constitute an extension of the ordinary English sense of the word 'see'? Quite possibly, but he still presents it as a straightforward one. For him our theory is in desperate need of a term that applies to two types of seeing – both one's seeing of loved ones when standing before them (which we would simply call ordinary seeing) and one's 'seeing' of the same in a photograph from the family album (which we could call 'photographic seeing').

I will shortly outline some strong objections to this conception. These will be used to argue that, while there may be theoretical strategies to validate use of the word seeing in this latter sense, applying the former sense of seeing is *not* possible here and such use is altogether misguided. Of course, intuitions on this matter are likely to differ, depending chiefly on the kind of photographic depiction one has in mind to begin with and on the evolving role of photography in our lives. Think for example of the type of portrait photograph known as the passport photograph. Following Walton, an analytic philosopher might hold that this type of photograph is traditionally used to enable the immigration officer to 'see' me and the immigration officer exercises that ability to verify my identity. Here one could even say that this is the only way for him to 'see' me. Looking at my face would not do the trick. If my passport photograph does not match my appearance, it will not be able to pass.[22] The problem implicit in this account becomes clear if we think of Thomas Ruff's oversized 'passport photographs'. In them, one might argue, it is impossible to see a 'person' but rather only generic representations of 'personhood' (Figure 4).

Recognizing that this counter-intuitive idea cannot be accepted uncritically, Walton provides two necessary conditions for any experience to count as 'seeing through'. First, *belief-independent counterfactual dependence*, meaning that one's experience must depend causally and counterfactually on what is seen.[23,24] But this does not suffice. Think for example about a computer equipped with vision abilities. Such a computer can be programmed to recognize various objects but nonetheless would not have beliefs. Therefore, it could print out verbal descriptions of what is in front of it. An artwork that playfully engages with exactly these ideas,

FIGURE 4: Thomas Ruff *Porträt (A. Zeitler) B*, 1998 C-print 225 x 176 cm 88 5/8 x 69 1/4 inches © Thomas Ruff/VG Bild-Kunst, Bonn 2019. Courtesy of Sprüth Magers.

and proves that looking at the descriptions obviously cannot count as seeing is Matt Richardson's 'Descriptive Camera'. In Richardson's system camera images are automatically forwarded to Amazon Mechanical Turkers who are instructed to return a written description of what appears in the image. These descriptions are then outputted by a thermal printer.[25]

Reading such descriptions obviously cannot count as seeing, and so Walton adds that 'seeing' requires the occasioning of the same sort of discriminatory errors as those we are prone to make when seeing the world with the naked eye. He calls this *preservation of real similarity relations*. Walton explains this notion in terms of the errors of discrimination we can make. We can easily confuse a house and a barn in looking at them, and likewise we can easily confuse a photograph (and a picture) of a house with that of a barn. But we are more likely to confuse the word 'house' with 'hearse', than with 'barn'. Photographs preserve the real similarity relations of things, but verbal descriptions scramble them. Hence one does not see an object through its description, even if that description is mechanically generated; but one does see it through its photograph. Here is how another philosopher, Gregory Currie, summarizes Walton's position:

> A mode of access to information about things counts as perceptual if and only if it (i) exhibits natural counter-factual dependence and (ii) preserves real similarity relations. Painting fails to satisfy (i) and mechanically generated descriptions fail to satisfy (ii) so neither is a perceptual mode of access. Photography satisfies both, so it is a perceptual mode of access.[26]

Intriguingly, Walton uses two science-fiction-like thought experiments to tie his definition of seeing to photography. Curiously, both are heavily influenced by neuroscientific studies on the ability called blindsight:

> Suppose that a neurosurgeon disconnects Helen's eyes from her optic nerves and rigs up a device whereby he can stimulate the optic nerves at will. The doctor then stimulates Helen's nerves in ways corresponding to what he sees, with the result that she has 'visual' experiences like ones she would have normally if she were using her own eyes [...] Helen seems to be seeing things, and her visual experiences are caused by the things which she seems to see. But she doesn't really see them; the doctor is seeing for her [...].

> Contrast a patient who receives a double eye transplant or a patient who is fitted with artificial prosthetic eyes. This patient does see. He is not relying in the relevant manner on anyone's beliefs about the things he sees, although his visual experiences do depend on the work of the surgeon and on the donor of the transplanted eyes or the manufacturer of the prosthetic ones.[27,28,29]

Manugraphs, Walton alleges, resemble the case of the doctor. There, our visual experiences are largely determined by the artist's beliefs. Photographs, on the other hand, are like the case of prosthetic eyes. There, our visual experiences are *not* dependent on the artist's beliefs because there is an identifiable causal route from object to image to experience.

Presented in this way, it is evident that despite its deviant analytic structure, Walton's argument is ultimately brought forth in support of traditional sentiments. Walton's belief-independent counterfactual dependence and his preservation of real similarity relations are analytic philosophical nomenclature for what Snyder and Allen called the mechanical and the visual model, respectively. Walton's transparency thesis, in other words, does not diverge from the familiar theoretical course marked early in the history of photography. Previously erected around notions of 'nature', 'machine' or 'automatism', Walton's argument advances the familiar claim that a photograph is in some sense always a manifestation of an object and not only an image of it. In Walton's account this special connection is 'causal' and is supposed to be the one via which it is possible to 'see' the object. In contrast, the connection between an object and a manugraph of it is intentional and does not afford 'seeing'.

Numerous objections have been raised to Walton's thesis. What has provoked the most heated debate is the conclusion that because we see objects through photographs, then photographs are transparent. These critical voices have argued that even if mind-independent counterfactual dependence were to guarantee the retention of rich similarity relations, this would still not suffice to establish that any mode of access to information about an object could count as seeing. And so, it seems, it has been agreed that the overlap between ordinary seeing and 'seeing through photographs' is patchy at best.[30] However, an alternative philosophical trajectory has not yet been suggested. This is what I intend to do next.

Snipped by the Falling Shutter

Some of the philosophical difficulties with Walton's extreme position can be contested from a straightforward, technical standpoint. The locution 'seeing through photographs', I argue, obscures more than it clarifies and neglects crucial differences between various examples of seeing and seeing objects in photographs. In Walton's view, the fact that we can see stars in the night sky, although they may have ceased to exist, implies that we might also be able to 'see' someone in a photograph, even if they died long ago. As long as an object is photographed, we can therefore 'see' it. But, we might ask, what about star photographs? According to Walton's account, if I am now sitting in front of my computer looking at a photograph from Thomas Ruff's well-known series *Sterne* (Figure 5), which is open on my browser, then I am literally seeing the stars in Ruff's photographs.

FIGURE 5: Thomas Ruff *09h 32m/-25°*, 1992 C-print 260 x 188 cm 102 3/8 x 74 inches.
© Thomas Ruff/VG Bild-Kunst, Bonn 2019. Courtesy of Sprüth Magers.

This defies logic. I could have had Thomas Ruff's book open on my lap, as I had many times, and still would *not* be seeing those stars. Not because it is light outside or because I am sitting in a café with a roof above my head. I am not seeing those stars because I do not know whether they still exist or have ceased to long ago. To the extent they do exist I still have no idea *where* they exist in relation to me. In case they have ceased to exist I have no clue *when*. Some of that information may be available from the caption but no matter what I do, I will rarely know these things without looking at the caption and I will *never* know these things from just looking at the photograph. In fact, no photograph of an object in outer space or on earth conveys such information. No photograph can give Walton what he wants. Nonetheless, the star photograph example is very important for demonstrating a few basic ideas about photography.

Walton, as you may recall, relied on only two conditions to claim seeing through photographs: counterfactual dependence and preservation of similarity relations. Nigel Warburton's taxonomy, on the other hand, requires no less than four concurrent features to qualify photography as seeing. I will now elaborate on these conditions in order to prove why we do not see the stars in Ruff's photographs and why we do not see through photographs at all. First, there is the condition of virtual simultaneity. In straightforward cases, what is seen is almost always virtually simultaneous with what is actually happening. The slight delay between the actual point in time when a light array is reflected or emitted from a certain object and the time when that 'same' light array strikes the retina depends solely on the speed of light. However, since this speed is so high, we treat this time delay as practically non-existent. Seeing is therefore the simplest way of acquiring real time knowledge about the world.

The one and only activity we might engage in when these differences do matter is when looking at the stars with a naked eye. In such cases, any star we would be looking at would be seen not as it is now but rather as it was perhaps millions of years ago. This delay is due to the vast distance between us and the star. Should it explode while we are watching it, the explosion would only be visible millions of years later. Further, in the unlikely event that one were to travel to the stars plotting his or her trajectory based only on observations made from Earth, this would result in serious navigational errors. We should note, however, that even though there is no virtual simultaneity here, the fixed speed of light does make for a calculable time delay. Photographs, on the other hand, always involve a delay that is not constant or calculable. It is, for all we know, a stochastic variable. I can view a photograph of a person immediately after it was made or days, months and even many years later. Often I do not know when the photograph was taken. When I do, that knowledge is not derived from the photograph itself. Rather it is conveyed by another form of communication – the caption or, nowadays, metadata.

Second, there is sensitivity to change. Visible changes in the object are matched by changes in what is seen. But photographs do not match changes in objects after the objects have been photographed. I can view a photograph of a person again and again, days, months, even years after it was taken and the person, if still living, will have changed or even died, and yet the photograph remains the same (to be concise: a photographic print may change with time but a photograph may not). The only changes possible are those that stem from changes in the object between two or more hypothetical shots (which, as I will later argue, if taken by the same apparatus, must be taken at separate temporal points). To use the star example again, if one were able to gaze continuously at a star for millions of years, then, eventually, one would see it explode. Even that, however, would still not afford an experience of change in the photographed image itself.

Third, there is temporal congruity. If Leland Stanford's mare took X seconds to run Y meters, it would take me the same number of seconds to see her do so. On the other hand, it is not necessary for me to take X seconds to see Muybridge's photograph of that event. In fact, the time it takes to see Muybridge's photograph or any other has nothing to do with the time represented in the photograph itself. Even if Muybridge had filmed the horse running (which, of course, he couldn't have), there is still no guarantee that the footage would run for those same X seconds. That footage could be played in slow motion, fast motion, in a loop or in reverse.

The fourth condition is knowledge about the causal chain. In order to see an object, we require at least basic knowledge about how our perceptions are linked to the object that caused them. We also want to know which features of our perceptions are to be discarded because they have arisen from deviant causal chains, and so on. For example, if I am now seeing a blurry pattern constantly floating somewhere to the right but always within my field of view then I can assume that there is an oily fingerprint on my eyeglasses and I have a way of verifying or discrediting that assumption. This requirement, like the other three, stems from the evolutionary function of sight as an aid to finding our way around. This may be possible with a camera obscura but not with photography. All uses of photography provide very little knowledge about the causal chain of events from object to image. All uses of photography include not one but many unknown random variables. I shall have more to say about this shortly.

In summary, photographs are incapable of exhibiting the first three of these conditions, and only rarely exhibit the fourth. Therefore we should agree that the use of the verb 'to see' in the context of photography is inappropriate and very confusing. Does this provide us with reason enough to fully dismiss the claim that we can literally see through photographs to the objects that caused them? Yes it does. In Currie's words, 'Walton has failed to establish a case for Transparency [...] what is correct in his argument can be accommodated by the view that

photographs are representational, that seeing a photograph of X is a matter of seeing a representation of X rather than seeing X itself'.[31]

Warburton's four conditions may also have a strong bearing on the causality claim. Considering that seeing functions primarily as a means of acquiring true beliefs about our environment, it is crucial that there be a regular pattern of causal connection between an object and our experience of it. If, due to unknown causal roles played by other agents, or due to the absence of a fixed time gap between the event and its perception, and if the pattern of causal connection is irregular, then we lose the basis for making these judgments about what causes our sensory experience. Photography breaks the causal connections that exist in ordinary seeing. What also follows, despite numerous attempts to prove otherwise, is that the role of causal chains within the photograph itself always remains unknown. In Warburton's words, 'the causal umbilical cord between object and image is snipped by the falling shutter'.[32]

We have defied Walton on his own turf and have proven his theory to be extremely vulnerable. We can now proceed by proposing the idea that photography is not a cohesive technology but rather a set of sometimes overlapping *technologies*. I will then conclude this chapter with an attempt to define the common ground shared by all these technologies. Finally, I will present photography as a unique type of participation-free information processing program.

Photography as Technologies

The question 'What is a photograph?' has been treated time and again throughout the history of writing about photography. The answers, as I have demonstrated, have usually been too similar. Walton's patently inadequate transparency thesis is arguably the culmination of these attempts. Accordingly, could other theories of photography be at similar fault? To me, the inadequacy of Walton's theory for photography has far wider implications. It suggests that the mere attempt to use the photograph as a launching pad for an ontological enquiry of photography has been doomed from day one. In fact, all that is necessary for a successful objection to Walton's theory – as well as many others – is to argue that even if certain photographic technologies can be understood as transparent, this does not mean transparency for photographs as well. And even if some photographs were transparent, this does not mean that photography as a technology is too.

An understanding of the complexity of the connection between photographic products and the technologies that produce them is sorely needed and not only for essentialist reasons. It is needed as a way to distinguish between various photographic technologies and the idea of photography *itself* as a technology, and an evolving one at that. This is increasingly important now that the photograph is only one of photography's potential end products, as I will later show.

In fact, we can easily foresee a future where, in spite of the ever-increasing use of photography, there will be no more photographs, or not necessarily in the form we know them – at least not in the strict sense of permanent markings of light on surfaces.[33] Therefore, a less futile way to answer the question must be sought. That way is *not* to ask ontologically, 'What is a Photograph' or 'What is photography', but rather ask epistemologically, 'What does photography do?' and 'How does photography do what it does?' This is precisely what Patrick Maynard sets out to do.

By giving precedence to process over product, Maynard, much like photography's early pioneers, is able to present photography as an 'alliance of science with art'.[34] In Maynard's philosophy, photography is a technology for doing *various* things, notably the amplifying of several human capacities and powers for a variety of scientific and artistic purposes. By addressing these individually as well as in interaction, it becomes possible to develop a philosophy of photography that does equal justice to its ontological and epistemic qualities.

Arguably, looking into unique qualities of photographic products, if such there are, is always less promising than looking into the character of the processes that form photography. Not only because the typical photographic product changes from period to period but mainly because our definition of what constitutes a photographic product changes even more. Doing that requires us to ask what photographic processes are intended for, what they are processes of and what they enable us to do.

According to Maynard, photography is first and foremost a family of technologies for the production of *images*, not pictures. Maynard understands image, perhaps technically, as a visual display marking; a surface marked for the sake of being looked at and seen; a surface marked for the sake of being recognized as having been produced for the purpose of being seen. Images are the global physical states of such surfaces. So, in applying Maynard's viewpoint to examples from the classical theory of photography, only signet ring impressions would be considered authentic images. According to this view, bullet holes and footprints, which are only by-products of human actions and not their purpose, are not images. Furthermore, images, as opposed to pictures, need not always depict anything. In fact, only some images are actually pictures, and, of those, only some are pictures of anything perceptible. The latter point is important: it signals a refusal to theorize photography primarily in terms of the dictum that 'a photograph is always a photograph of something'. As a result, Maynard's account is not committed to realism, resemblance or even reference, which most accounts on photography still adhere to. Instead, in his technical outlook, the idea of an image as opposed to a picture is paramount.

When propounded as 'a family' of imaging technologies, photography enables us to do a *variety* of things. These have been, until now, chiefly to extend our

powers of *depiction* and *detection*. Further on, I shall develop these concepts. Until then it is crucial to note that by having aesthetic ontological and epistemological considerations that are *not* mutually exclusive, such a theory of photography is less likely to become obsolete after the development of new technologies.

Within the context of the dominant theoretical paradigm, the argument that we have become familiar with thus far is that 'that which hands have touched becomes interpreted; that which is machine made is something else'. Maynard's argument, on the other hand, is different. He claims that non-interpretation, insofar as it exists at all, does *not* amount to 'accuracy'.[35] Maynard therefore names two independent aspects of image authenticity: one related to causality and another to information or content. In his lexicon these are called *causal* characteristics and *image* characteristics. So, despite the fact that both are part and parcel of our feelings about photographic 'authenticity', they are very different. Photographs are pictures or visual descriptions of the objects they are of, but they are also, at least partly, 'visual effects' or 'manifestations' of those same objects. Furthermore, for Maynard, the exaggerated credit that photographs receive for 'realism' is simply due to their effect as manifestations.[36]

In this construal, then, 'mechanisms' or 'causalities' do make a big difference to the issue of photography, but, surprisingly, not for the same reason that theory usually holds. Mechanisms, according to Maynard's account, do *not* avoid interpretation, filtering and distortion.[37] In fact, I shall later argue that mechanisms or apparatuses, by fault or by virtue of their very construction, *cannot* avoid interpretation and distortion. Furthermore, to the extent that 'objectivity' is a sought-after quality, and is taken to be more than just 'broadly and loosely pertaining to an object', we should simply say that photographs are 'objective' because they *seem* 'objective' due to their characteristically rich information content.

We have two dissimilar appetites for images. One is for certain kinds of visual descriptions or evocations. Here we look for accuracy, vividness and verisimilitude. The other is for causal manifestation, which has been *mistaken* for an insatiable appetite for unmediated visual description. This mistake is what makes the description seem authoritative, no matter how fuzzy, distorted, torn or out of focus it is. So, whereas Bazin's view, as Maynard chooses to summarize it, is that 'Mechanism, therefore non-interpretation, therefore authenticity', Maynard's view, as I would like to summarize it, is 'Mechanism, thereby *sense of* manifestation, thereby authenticity'.

Moreover, according to this hypothesis, we all too often treat photographs as manifestations of what they are of, but hardly ever treat handmade pictures this way.[38] Therefore, we might do well to reassemble new groupings of images and image functions. Accordingly, the 'image as manifestation' is a category that, for Maynard, could incorporate much more than we first realized. In terms of cultures

and history it may be a more inclusive class than the partly overlapping class of 'descriptive' or 'depictive' images. This gives us a different context for considering 'photo-family' images. We may then see the 'manifestation' image class as a subclass of something that might be thought to include relics and souvenirs after all.

Nevertheless, even with the 'image as manifestation' category, it is still wrong to assume that manifestation or causation and depiction must always be connected in photography. In fact, we should ask ourselves *why* it is that we feel that causation and depiction must generally be connected and why it is that we so often desire that they be connected. Looking at and thinking seriously about news photographs, for example, reveals that they have as much documentary value as the average drawing. Perhaps that is the source of their pernicious charm. Thus, it is my firm belief that the news photograph, and any photograph for that matter, gains its 'authority of causality' or 'authority of manifestation' exclusively from being highly depictive and not the other way around.

Of course, we must bear in mind that not all pictures are depictions. Many pictures are in fact not pictures of anything. The same goes for photographs. There is no reason to presume that a photograph of an object must also be a depiction of that object. Photographic pictures are just an economical, efficient and therefore the most widespread sort of picture – a picture made by means of photographic processes. There is, however, no reason to suppose that pictures made by photographic processes must depict at all. There are many that do not. Consider New Vision[39] and Generative or Concrete Photography.[40] In these traditions, there is no depiction, and in some cases, quite explicitly so, and that is perhaps why, to this day, they form the exception to the historical canon of photography. Nor should we assume that, if there is depiction in photographs, it is a depiction of what the photographs are of. Think for example about Edward Weston's peppers or note the rich tradition stretching from Alvin Langdon Coburn to James Welling.

If we replace the term manifestation with the term detection, as Maynard finally does, this theory becomes even more effective. Maynard describes the depictive function as 'a prosthetic extension of our innate powers of visual detection by means of light'[41] and states that photography might very well be characterized as the historical site of spectacular interaction between depictive and detective functions.[42] He argues that depiction and detection should be seen as distinctly *separate* categories. In principle neither one entails the other. Pure detection that is detection *without* depiction, is, we could say, the 'sensing' and then 'tracing' of electromagnetic radiation. Be it from within the visible spectrum, what we call light, or from elsewhere in the spectrum. I shall elaborate on some of these later in this book. Detection also includes the 'tracing' and subsequent registration of various 'channel conditions' that are responsible for how the image looks and

that are not themselves depicted or even depictable. These include the type of film stock or colour profile and anything pertaining to the design and construction of the lens, camera and system as a whole.[43] Though these causal conditions can be depicted if they are incorporated in such a way as to prescribe themselves, such as when a movie camera is panned at a slow enough shutter speed to depict its own movement, they need not be and usually are not.

By contrast, pure depiction, that is, depiction *without* detection, includes all those photographs and, as mentioned earlier, traditions of photography that deliberately depict object X by photographing object Y. In such traditions, what is being depicted cannot really be detected, certainly not in the constellation that it is being depicted. Spirit photographs of the late nineteenth century are a fine example.[44] In fact, even within the mainstream histories of photography there are numerous instances where depiction is celebrated for being alien, perhaps impossible within the circumstances it was achieved. Think of Oscar Gustave Rejlander and Jeff Wall.[45]

Nevertheless, although depiction and detection are in principle distinct, in practice they generally interact. Most photographs are both a means of detecting various features of a given scene and a way of depicting that very same scene. When they coincide, depiction and detection generally complement one another. As already noted, adopting Maynard's viewpoint, we could argue that it is more common that depiction will aid detection but the opposite may also be possible. For example, in various kinds of medical scanning and imaging – where our only concern is to detect information about the condition of human tissue – we are nevertheless also afforded depiction as a means of facilitating detection. In this case we could say, à la Walton, that photographic imaging technologies allow us to indirectly 'see' inside a body by looking at a computer screen, while we imagine indirect seeing to be direct seeing of what the screen shows. In this way, the depictive function of photo-technologies amplifies our powers of imaginative visualization, while their detective function amplifies our capacity to acquire knowledge perceptually.

To conclude, the significant merit of Maynard's terminology is that it disentangles the workings of photographic technologies in ways that do not commit us to an all-or-nothing contract with photography. Thus, we are at liberty to decide for ourselves whether, and to what degree, to accept or reject the classic Turin Shroud construal, which in this chapter is represented mainly by Walton's transparency thesis.

Maynard, I should note, does *not* completely reject this classic construal and offers a modified version of it in the following confluence of ideas: 'to photograph something is to produce something which is both a photochemical trace made by it and a depiction of it [...] Photographs of things are above all kinds of pictures, portrayals, or

depictions of them'.[46] Historically, photographic technologies have typically, but not always, produced depictions of the same objects that they have also detected. Nevertheless, and no matter how one chooses to read the above quote, with computationally enhanced imaging even Maynard's modified construal becomes problematic. Not because the 'trace' is no longer 'photochemical' but mainly because, as I have earlier argued, there are fewer and fewer instantiations of photographic depiction that is performed by purely detective functions. Put differently, theoretical notions about photography are also contingent on the empirical history of its uses, as well as on our resultant divergent beliefs. Thus, were those to change this could render Maynard's construal of photography open to revision. If this is correct, as photography relocates to computational habitats, a new and expanded philosophy of photography is in order.

Transmission

By now I hope to have conveyed the impression that photographs are rarely 'closer to the world' than other breeds of pictures are. Photographs, it has been established, no matter how they come into existence, do not put us in physical contact with 'the things themselves'. It has also emerged that no serpentine narrative can convince an attentive photo-theory reader that photographs are a form of seeing and not a form of sensorial contact. But Walton's theory still offers one notion that has gone largely unexplored: the implicit suggestion that photographs put us in *perceptual* contact with the world.

To determine if and by what means this is possible I will now utilize a 'non-doxastic' objection to Walton's transparency thesis, to question the types of information that photographs convey, the forms they convey them in and the experience these make possible. This will serve as an introduction and transition to another philosophy of photography, one that merits epistemological and not ontological structures. 'Why are photographs epistemically special in a way that other sorts of depictive representations are not?' ask Jonathan Cohen and Aaron Meskin.[47] 'Why, for example, do photographs but not paintings carry evidentiary weight?'[48] Most theories account for this curiosity by stressing the special relation that photographs bear to the objects they are of. It is therefore generally understood that photographs but not manugraphs support counterfactuals about the appearance of whatever it is they depict. According to orthodoxy, this is why photographs are widely regarded as more reliable sources of evidence about their depicta.

Doxastic objections to Walton make *egocentric information* a necessary condition of seeing – knowledge about relative spatio-temporal locations. In action, such information allows me to determine the distance of objects *from me,* and

their direction *relative to me*. Perhaps an object is within reach (for example my eyeglasses that I have just taken off); maybe it is reachable by a short walk (e.g. the next-door neighbour's house); or maybe I can see the object and can identify that it is not within my reach (a bird on the top of the neighbour's tree). Cohen and Meskin argue that this sets an unattainable criterion for seeing because a person could conceivably see an object without knowing exactly where it is situated. Examples might include seeing through fog or navigating a mirror maze.[49]

Instead, Cohen and Meskin's non-doxastic objection to Walton does not confuse the conditions required for seeing with those required for *knowing* that one sees. This allows for beliefs about the location of what one sees to be undermined, without the exercise undermining seeing. To allow this, Cohen and Meskin introduce an *informational* conception of visual experience as a non-doxastic process.[50] This is a conception of seeing that does carry egocentric spatial information. I shall shortly return to egocentrism, but before I do, it is important to clarify the term 'information-carrying' and its implications. 'Information-carrying' is used here to indicate a link between independent variables that can be described as appropriate, objective, probabilistic and counterfactual-supporting. To illustrate this point let us momentarily think about display patterns. Suppose, as in Cohen and Meskin's example, that I am feeling feverish and take a thermometer reading. My thermometer carries information about my body temperature only if there is an objective, probabilistic correlation between the two. That is, if the thermometer is now showing a reading of 37 degrees Celsius then an objective, probabilistic correlation would require that my body temperature also be 37 degrees right now. Moreover, for this correlation to count as information carrying, it must support counterfactuals: if, contrary to fact, my body's temperature were different, the thermometer would differ accordingly. That is, the probability of my temperature being 38.5 degrees Celsius when the thermometer reading is 38.5 Celsius is much higher than the probability of my temperature being only 37 degrees Celsius when the thermometer reading is 38.5 Celsius, assuming the thermometer is in order, functioning properly and free from outside interferences.

It is crucial for Cohen and Meskin's argument that such objective, probabilistic correlations hold *independently* of anyone's beliefs about the matter. By way of analogy, whether photographs carry egocentric information is not a matter of what we are justified in believing about their depicta, having inferred that belief from their natural, mechanical, causal or otherwise special genesis. It is only a matter of the objective, probabilistic relations they bear to those depicta. In other words, what is at question here is the probability that a photograph would carry, and in turn convey, relevant types of information. In this straightforward account, we do not see through photographs simply because there is no objective, probabilistic, counterfactual-supporting relation between what is depicted in them and

its depiction. Of course, there is always the slight possibility of a de facto correlation if one desired, Magritte style, to superimpose a photograph over the window through which it was taken. In all other conceivable cases, if a person were to move from one location to another holding a photograph in their hand, their egocentric relation to what the photograph depicted would change *without* its depiction changing accordingly. Seeing the photograph therefore does not constitute seeing what it depicts: it fails to support the relevant counterfactuals. To reiterate, what distinguishes Cohen and Meskin's objection to Walton from other objections is that objective, probabilistic relations, or lack thereof, exist independently of beliefs about whether such information is or can be carried.[51]

If photographs are not transparent, as we have demonstrated, are they nonetheless unique? What, if anything, characterizes them and how? In Cohen and Meskin's terms, photographs are epistemically privileged in the manner that they carry and transmit *various* types of information *independently of one another*. Most often photographs carry and transmit visual information about the visually accessible properties of objects – for example the relative colour and shape properties of one object in relation to another object. This is what Cohen and Meskin call *v-information*.[52] However, they argue persuasively that photographs transmit v-information independently of transmitting egocentric spatial information, or, in their taxonomy, *e-information*. In fact, photographs fail to transmit e-information altogether.

We may thus conclude that the source of photographs' epistemic advantage is in the fact that they carry information about the visual properties of their representational objects but *not* about their egocentric location. Being what Cohen and Meskin call 'spatially agnostic informants',[53] photographs convey information about visual properties even when egocentric information is unavailable. Ordinary vision, on the other hand, as well as other visual prostheses at the start of Walton's slippery slope (spectacles, binoculars and telescopes for example), can only carry visual information by virtue of carrying egocentric information. In other words, I can see a bird on a tree only when I can see the location of the bird on the tree and the location of the tree in relation to me. Photographs are thus 'undemanding' sources of visual information – they provide it even when egocentric information is unattainable. As such they may best be described as providers of unique epistemic experience or, more accurately, as unique epistemic containers.[54]

Perception

Disturbingly, some of the above insights can equally be applied to manugraphs. A Cézannesque painting of a basket of apples, for example, also carries and transmits

v-information without e-information about the basket. I thus arrive at the second phenomenon that occurs exclusively around photographs: their ability to make their viewers *spatially absent*. To explain this I will now refer to images in general, before returning specifically to photographs. Lambert Wiesing argues that images allow for a type of perception that bears potential to *suspend* one's immersion in their physical existence. Images, it is easy to argue, are non-immersive (and this will remain the case so long as augmented reality is not a part of our daily routines). If images were immersive, then the perception of an object in an image could not be distinguished from the perception of an object in the world. This is, quite simply, why seeing through photographs is still impossible. Further, it is precisely because images are non-immersive that Wiesing is able to suggest that they afford immersion-free perception. He calls this 'Perception without Participation'.[55] In phenomenological terms, I might paraphrase this as 'being in the world without the tedious requirement of presence in the world'.

This position has several merits. When one is removed from real-world events in a way that is unthinkable in the real world then one is also isolated and safe. Real-world events sometimes have nasty ways of turning spectators into active participants, not only those theatregoers sitting in the front row of experimental theatre performances but everyone else too. Think for example of occasions when spectators at aerial aerobatics shows involuntarily became participants when an aircraft crashed. In real life there is no such thing as 'an innocent viewer'. Recall how many war photographers have been killed while trying to get a shot. And how many viewers of war photographs have ever been killed? Or think of Werner Herzog's *Grizzly Man*.[56] In real life every viewer is at least potentially also a participant. No position can ever remove one from the reach of causality. Some images double as objects too (and more on that shortly). But so long as an object x that is viewed is *not* an image-object of object x, the viewer remains an integral part of the same physical world as the object and is, at least potentially, always in harm's way.

The viewer of an image, on the other hand, is always out of harm's way. He exists in a chaos free zone and is protected by the categorical gap between the world and its image. In fact, only by viewing an image can I be, if only partly, removed from causality into an absolute position of security and complete distance, unburdened by the dictates of physicality. But this sense of safety is not available to me alone; it is available to anyone. Therefore any person viewing an image is, in some sense, a viewer that in the real world cannot exist. We could thus argue that images are as useful and necessary as they are because they permit, and in fact require, a homogenizing of subjective experience and a complete de-individualization of their viewers. When I see an image I may only see it in a way that is hardly different, almost identical, to that of other persons seeing the same image. This is *never* the case when seeing an object or state-of-events in the real world. I and only I can occupy

the volume of space from which I am viewing the object at the time I am viewing it. Two people can never see the same object the same way because they cannot occupy the *exact* same location at *exactly* the same time. This is not the case with images.

Moreover, nowhere is this more extreme than with photographs. The reason is that photographs, contrary to all other image types, are always *un*tethered to their physical supports, independent of their 'photograph carriers',[57] the print or surface they are on and made of. Photographs have traditionally been different in the sense that their physical supports have always been exchangeable, cheap and possibly redundant in comparison to the physical support required for all other image types. Thus I argue that photographs do not even afford that small measure of individual localization that a canvas affords. In other words, with photographs there is no and cannot be an individual point of view from which the image can be viewed. Several people can see exactly the same photograph that I am viewing and they can see it exactly as I am seeing it and at exactly the same time. And even though these people occupy different and often unconnected volumes of space they still do not see it from different points of view. They cannot. A photograph always has one point of view and one only. You can change your position in front of a photograph as much as you want but you can never find an individual point of view. This holds true regardless of whether the photograph is mounted, framed, presented as-is (simply printed on photo-paper) or, nowadays, projected.[58]

A photograph only ever assigns its viewers one vantage point that is the same for everyone. It does not offer an individual point of view. Notwithstanding this individual point of view, my seeing it here and now does not prevent others from seeing it exactly as I do. The creation of a photograph enables perceptual contact with aspects in the world, which is the same for me and for all other viewers. This is not the case when seeing objects in the world and it is arguably not the case when seeing other types of pictures. Photographs eliminate the physicality of their viewers. They are thus spatially agnostic informants for spatially absent informees.

Mutually Inclusive

Curiously, the advent of so-called 'digital' photography has given new life to the intuition that photographs differ from other pictures in terms of their connection to the world. Previously, in order to draw a clear distinction between photographs and other pictures, this traditional argument relied on the 'fact' that photographs were unmediated by human agency. Nowadays a similar intuition is at play. This is clear from the undiminished concern about image-ductility and the resulting attempts to characterize digital photography as a distinct new medium.[59] For, of course, if the digital sensor and computer afford such malleability then it follows that the good old film and darkroom did not. In every respect this is simply a new

spin on everyday conceptions of photography that have always plagued theory. As I have argued repeatedly in the last two chapters, these conceptions are altogether misguided. The photographic apparatus, however defined, is extremely complex. Notions of photographic artefactuality have similarly always been ductile. I shall elaborate on this point in Chapter 4.

Nevertheless, this old-new intuition presents interesting challenges and opportunities to anyone attempting to philosophize photography *today*. The debates about the malleability of digital photographic images, as opposed to the 'veracity' of so-called analogue ones, can be turned around to highlight the ways in which the theory of photography has always been underpinned by what is mostly folk-psychological beliefs. Furthermore, in thinking about photography today, we must bear in mind that neither the distinct epistemic status of photographs nor the significance of photography in general may be explained by relying on fine points of physics or chemistry. Such an endeavour cannot do justice to photography because it ultimately only historicizes and theorizes it in relation to parochial histories of art.

The first two chapters of this book have concentrated on two formative problematics within the philosophy of photography: whether it is justified to position causality in contradiction to intentionality or agency when it comes to photography's modes of operation and whether it is possible to claim that photographs are 'transparent', and consequently purport to be 'seeing-through'. As I have demonstrated, the second debate emerges from the first and the first stems from earlier exchanges in the theory of photography. Thus far, and despite several commentators having pointed out the intentional aspects of photography, the belief that something still differentiates photographs from manugraphs is retained. Both sides of the photographic causality-intentionality debate continue to be adamant and a successful synthetic account of photography's workings still eludes us.[60]

However, does the fact that a photograph, considered causally, is always 'of' and only of 'a thing' entail that it cannot also be something else too, something else entirely? Perhaps we should not expect to find a coherent account of photography to emerge as long as we remain captive in the belief that photography is indebted to nature or that it even has a nature. Therefore, and in keeping with Costello and Wilson, it is my view that causation and intentionality, automatism and agency, privileged (photographic) realism, and privileged (painterly) fictional competence are *not* necessarily mutually exclusive.[61] Even to the extent that they are in opposition, understanding them as zero-sum alternatives is neither coherent not constructive as it sets up a tension between the aesthetic and epistemic significance of photographs that is nothing but perverse. Furthermore, I believe that paying more attention to various other uses of photography – be those popular, commercial or scientific – should enable a new philosophy of photography to emerge and would endow it with wider insights.

Some of the key challenges towards a new philosophy of photography can therefore be defined as follows: providing a satisfactory account of how exactly metaphors of nature, mechanicality or automatism, widely taken as useful in reference to photography, should be used with, and integrated into, concepts of information and computation; understanding, within this premise, mind-independence and intentionality in photography and clarifying that the relation between them is manifest in much more than just the actions or gestures of the photographer; and explaining the 'realism' of photographic images not in relation to traditional artistic realism, that is to say pictorial-depictive realism, but rather in relation to algorithmic processes and other cognitive and computational forms of signification.

NOTES

1. Noël Carroll, *Philosophical Problems of Classical Film Theory* (Princeton: Princeton University Press, 1988), 133–34. Carroll uses the term 'subject' in the same sense as does Scruton. This should be seen in contrast to the sense used by André Bazin and Kendall Walton ('the object photographed'). In spite of this divergence and in order to avoid confusion I am using the word 'object' in these contexts. Please see Chapter 1 'From Automatism to Ideal Photography' for further explanation.

2. For example: natural, mechanical, automatic, unmediated, agent-less, causal, mind-independent.

3. For example: authentic, faithful, objective, truthful, accurate.

4. For example in: Victor Burgin, ed. *Thinking Photography* (London: Palgrave Macmillan, 1982).

5. Notably, Burgin himself alludes to exactly the same point: It is essential to realise that a theory does not find its object 'sitting waiting for it' in the world; theories constitute their own objects in the process of their evolution. 'Water' is not the same theoretical object in chemistry as it is in hydraulics – an observation which in no way denies that chemists and engineers alike drink, and shower in, the same substance. By much the same token, 'photography' is not the same object in photography theory as it is when it appears in a general theory of the social formation. Each theory will have its own theoretical object. Ibid., 9.

6. As with much of the critical work of the time, part of Burgin's solution was to position his alternative critical framework within Marxist cultural theory, itself then strongly focused on a reimagining of the production of meaning, at a whole-of-society level. But while *Thinking Photography* deservedly became, and remains, a classic in its field, neither it, nor the many subsequent works that it inspired and informed – nor, indeed, Marxist cultural theory itself – seem to have fully dislodged the tendencies and traditions in criticism that Burgin rightly sought to tackle. The task, more than 30 years

later, is at best incomplete. Greg Battye, *Photography, Narrative, Time: Imaging Our Forensic Imagination*. (Bristol: Intellect, 2014 xi)

7. Diarmuid Costello and Dawn M. Phillips, 'Automatism, Causality and Realism: Foundational Problems in the Philosophy of Photography', *Philosophy Compass* 4, no. 1 (2009): 2.

8. 'The legacy of photography's theorization in the 1980s is thus a split: while the countless ontological and indexical discussions have seemingly overplayed deliberation of photography's essence, it may be said in equal measure that the subject of these Marxist writings was never truly photography at all'. Douglas R. Nickel, 'History of Photography: The State of Research', *The Art Bulletin* 83, no. 3 (2001): 554–55.

9. Norton Batkin, *Photography and Philosophy*, ed. Robert Nozick, Harvard Dissertations in Philosophy (New York: Garland Publishing, 1990); Vilém Flusser, *Towards a Philosophy of Photography* (London: Reaktion, 2000); François Laruelle, *The Concept of Non-Photography*, trans. Robin Mackay, Bilingual ed. (New York: Urbanomic/Sequence Press, 2011); Patrick Maynard, *The Engine of Visualization: Thinking through Photography* (Ithaca: Cornell University Press, 1997); Henri Van Lier, *Philosophy of Photography*, trans. Aarnoud Rommens, Lieven Gevaert Series (Leuven, Belgium: Leuven University Press, 2007).

10. Dan Cavedon-Taylor, 'In Defence of Fictional Incompetence', *Ratio* 23, no. 2 (2010); Robert Hopkins, 'Factive Pictorial Experience: What's Special About Photographs', Noûs 46, no. 4 (2012).

11. Carroll, *Philosophical Problems of Classical Film Theory*, 134.

12. Ted Cohen, 'What's Special About Photography?', *Monist* 71 (1988): 298.

13. Medium-specific approaches dominate because they suit the purposes of those who aim to show that, by virtue of being an independent medium, photography constitutes a distinct art form. They equally serve the purposes of sceptics who, for identical reasons, deny that photography is an art. Curiously, this way of thinking is also visible in recent debates about whether or not 'digital' photography constitutes a new medium.

14. Kendall L. Walton, 'Transparent Pictures: On the Nature of Photographic Realism', *Critical Inquiry* 11, no. 2 (1984).

15. This thesis originates from discourses of philosophy of mind. In those contexts, this thesis is less problematic than will be presented here. The following account is, however, an attempt to understand this thesis, scrutinize it and utilize its merits.

16. Jonathan Friday, *Aesthetics and Photography* (Aldershot, UK: Ashgate, 2002), 38.

17. 'To think of photographs as necessarily accurate is to think of them as especially close to the facts. It is not to think of them as intermediaries between us and the facts, as things that have their own meanings which may or may not correspond to the facts and which we have to decide whether or not to trust. To interpret a photograph properly is to get the facts'. Walton, 'Transparent Pictures', 266.

18. 'But photography's various other talents must not be confused with or allowed to obscure its remarkable ability to put us in perceptual contact with the world, an ability which can be claimed even by a fuzzy and badly exposed snapshot depicting few details and

offering little information. It is this – photographic transparency – which is most distinctively photographic and which constitutes the most important justification for speaking of "photographic realism"'. Ibid., 273.

19. Oliver Wendell Holmes, 'The Stereoscope and the Stereograph', *The Atlantic Monthly* (June 1859).

20. André Bazin, *What Is Cinema?*, trans. Hugh Gray (Berkeley: University of California Press, 2005), 97–98.

21. Walton, 'Transparent Pictures', 251.

22. These days machines are granted the same abilities. For example, the SmartGate automated border-processing system in Australia and New Zealand. Similar technologies are used in the EU, US and various other countries.

23. In other words to say that 'I see through a photograph' entails that my seeing is naturally dependent on what was in front of the camera when the photograph was taken. If something different were in front of the camera, then what I would see in the photograph would be correspondingly different, irrespective of whether the photographer had noticed the difference or not and irrespective of whether he wanted to depict that difference. A manugraph would, by contrast, only be different had the artist noticed the difference, and intended to depict it. So a manugraph depends in part on the mental states of the artist, whereas photography is mind-independently and counterfactually dependent on what it depicts.

24. Here is how another philosopher, Berys Gaut, nicely puts it: 'Suppose that an explorer claims to see a dinosaur in a forest. He can produce a photograph to show that he was correct, if he was, since the dependence of the photograph on the scene is not mediated by his beliefs. But if the explorer produced a drawing of the dinosaur, then, even were he honest, this would merely show that he believed that a dinosaur was present, not that one actually was. Therefore in this case we would not be inclined to accept the explorer's claim. If he had hallucinated a dinosaur, his sketch would show the hallucinated dinosaur; but a photograph would show merely the empty forest. The counterfactual relations of paintings and drawings are mediated through the picture-makers' belief, hence we do not see through them to the world'. Berys Gaut, 'Opaque Pictures', *Revue Internationale de Philosophie* 62 (2008): 382–83.

25. Matt Richardson, 'The Descriptive Camera', http://mattrichardson.com/Descriptive-Camera/.

26. Gregory Currie, 'Photography, Painting and Perception', *The Journal of Aesthetics and Art Criticism* 49, no. 1 (1991): 25.

27. Walton, 'Transparent Pictures', 265.

28. Blindsight is the ability of people who are cortically blind due to lesions in their striate cortex (also known as primary visual cortex) to respond to visual stimuli that they do not consciously see. The majority of studies on blindsight are conducted on patients who have the 'blindness' on only one side of their visual field. Following the destruction of the striate cortex, patients are asked to detect, localize and discriminate amongst visual stimuli that are presented to their blind side. Research shows that blind patients achieve a higher

accuracy than would be expected from chance alone. Much of the current understanding of blindsight is owed to early experiments on monkeys. One monkey in particular (called Helen, the inspiration for Walton's Helen) could be considered the 'star monkey in visual research' because she was the original blindsight subject. Helen was a macaque monkey that had been decorticated; specifically, her primary visual cortex was completely removed. This procedure had the expected results that Helen became blind as indicated by the typical test results for blindness. Nevertheless, under certain specific situations, Helen exhibited sighted behaviour. Her pupils would dilate and she would blink at stimuli that threatened her eyes. Furthermore, under certain experimental conditions, she could detect a variety of visual stimuli, such as the presence and location of objects, as well as shape, pattern, orientation, motion and colour. In many cases she was able to navigate her environment and interact with objects as if she were sighted. Nicholas Humphrey, 'What the Frog's Eye Tells the Monkey's Brain', *Brain, Behavior and Evolution* 3, no. 1 (1970); 'Vision in a Monkey without Striate Cortex: A Case Study', *Perception* 3, no. 3 (1974).

29. These thought experiments are influenced by H.P. Grice's causal theory of perception as well as by other thought experiments in David Lewis' writing. H. P. Grice and Alan R. White, 'The Causal Theory of Perception', *Proceedings of the Aristotelian Society* 35 (1961); David Lewis, 'Veridical Hallucination and Prosthetic Vision', *Australasian Journal of Philosophy* 58, no. 3 (1980).

30. Notable examples include: Gregory Currie, *Image and Mind: Film, Philosophy and Cognitive Science* (Cambridge, UK: Cambridge University Press, 1995); Jonathan Friday, 'Transparency and the Photographic Image', *British Journal of Aesthetics* 36, no. 1 (1996); Gaut, 'Opaque Pictures'; Nigel Warburton, 'Seeing through "Seeing through Photographs"', *Ratio* 1, no. 1 (1988).

31. Currie, *Image and Mind*, 48.

32. Warburton, 'Seeing through', 70.

33. Strictly speaking, the historical difference between the camera obscura and the photographic camera was the ability to offer a permanent image (given the fulfilment of other requirements). The future, as it is emerging, will include fewer and fewer permanent photographs (that is photographs with material support) and many more photographic projections that are, by default, not permanent. I shall return to this point in Chapter 4.

34. 'I feel confident that such an alliance of science with art will prove conducive to the improvement of both'. Originally from Talbot, 'Calotype (Photogenic) Drawing', *Literary Gazette* 1256 (13 February 1841). Quoted in: Patrick Maynard, 'Talbot's Technologies: Photographic Depiction, Detection, and Reproduction', *The Journal of Aesthetics and Art Criticism* 47, no. 3 (1989): 276 (footnote 23).

35. Patrick Maynard, 'The Secular Icon: Photography and the Functions of Images', *The Journal of Aesthetics and Art Criticism* 42, no. 2 (1983): 157.

36. 'The authority they have as depictions is partly borrowed from the independent fact of their being manifestations'. Ibid., 156.

37. Ibid., 157.

38. This point has been made by Lopes who convincingly argued that manugraphs, just like photographs, are also transparent. Dominic Lopes, *Understanding Pictures*, Oxford Philosophical Monographs (Oxford: Oxford University Press, 1996).

39. Gyorgy Kepes, *Language of Vision* (Chicago: P. Theobald, 1944); László Moholy-Nagy, *The New Vision and Abstract of an Artist* (New York: Wittenborn and Co., 1947).

40. Gottfried Jäger, Rolf H. Krauss and Beate Reese, *Concrete Photography* (Bielefeld, Germany: Kerber Verlag, 2005).

41. It seems that Maynard is here repeating Walton's argument on photographs as both pictures through which we indirectly see the world and as 'mandates to imagine' that enable us to see it directly. Kendall L. Walton; 'Pictures and Make-Believe', *The Philosophical Review* 82, no. 3 (1973).

42. Maynard, *The Engine of Visualization*, 120.

43. 'Drawing and Shooting: Causality in Depiction', *The Journal of Aesthetics and Art Criticism* 44, no. 2 (1985).

44. Louis Kaplan, *The Strange Case of William Mumler, Spirit Photographer* (Minneapolis: University of Minnesota Press, 2008).

45. See this catalogue, accompanying an exhibition of the same title, both devoted to examples from this latter possibility: Mia Fineman, *Faking It: Manipulated Photography before Photoshop* (New York: Metropolitan Museum of Art, 2012).

46. Maynard, 'Talbot's Technologies', 268.

47. Jonathan Cohen and Aaron Meskin, 'On the Epistemic Value of Photographs', *The Journal of Aesthetics and Art Criticism* 62, no. 2 (2004); 'Photographs as Evidence', in Scott Walden, ed. *Photography and Philosophy: Essays on the Pencil of Nature* (Malden: Blackwell Publishing, 2008).

48. Cohen and Meskin, 'On the Epistemic Value of Photographs', 13.

49. Nevertheless, even in these extreme cases, one does usually have a way to verify the object's spatio-temporal location.

50. This follows on from Fred Dretske and, as I will demonstrate later in the book, from Claude Shannon. Fred I. Dretske, *Knowledge and the Flow of Information*, The David Hume Series (Stanford: Center for the Study of Language and Information, Stanford University, 1999).

51. As a result, Cohen and Meskin's objection to Walton is not undermined by Walton's counter cases of seeing in the absence of belief or knowledge of egocentric spatial location, as for example in a case of seeing through a set of multiple or distorting mirrors. Kendall L. Walton, 'Looking Again through Photographs: A Response to Edwin Martin', *Critical Inquiry* 12, no. 4 (1986): 806–07.

52. Cohen and Meskin, 'Photographs as Evidence', 74.

53. Cohen and Meskin, 'On the Epistemic Value of Photographs', 204.

54. Paul Virilio (referencing Merleau-Ponty) makes a similar point: 'Everything I see is in principle within my reach, at least within reach of my sight, marked on the map of the

7 can'. In this important formulation, Merleau-Ponty pinpoints precisely what will eventually find itself ruined by the banalization of a certain teletopology. The bulk of what I see is, in fact and in principle, no longer within my reach. And even if it lies within reach of my sight, it is no longer necessarily inscribed on the map of the 'I can'. Paul Virilio, *The Vision Machine*, trans. Julie Rose (Bloomington: Indiana University Press, 1994), 7.

55. Lambert Wiesing, *Artificial Presence*, trans. Nils F. Schott (Stanford: Stanford University Press, 2009); 'Pause of Participation: On the Function of Artificial Presence', *Research in Phenomenology* 41, no. 2 (2011).

56. Werner Herzog, *Grizzly Man* (Lionsgate Films, 2005).

57. This term is my own adaptation of Wiesing's term 'image carrier'. Wiesing, 'Pause of Participation', 240–43.

58. That is, until very recently. Some technologies are now challenging this definition. I elaborate on such technologies in Chapter 4.

59. Myeong-Jun Lee and Jeong-Hann Pae, 'Photo-Fake Conditions of Digital Landscape Representation', *Visual Communication* 17, no. 1 (2018).

60. It emerges from this debate that something important has gone almost entirely unnoticed – the causal processes involved in manugraphs, by virtue of their physical substrates. Manugraphs, as we remember, are considered paradigmatic of intentional processes, yet it is arguable that the expression of intentionality manifests itself in the causal process itself – and not somewhere external to it. By putting brush to canvas, painters cause paint to be transferred. But the application of paint is not a causal process that happens in addition to a thought – it is partly constitutive of, and partly constituted by, that thought.

61. Costello and Phillips, 'Automatism, Causality and Realism', 16–17.

3. Another Philosophy of Photography

> Why is it that telegraphers produce telegrams but photographers produce not photograms, but photography? [...] Why do biographers write biographies instead of biograms, and how do electrocardiographers relate to electrocardiograms, autographers to autography, or holographers to holography and/or holograms? And finally: why do cinematographers make films instead of cinematographies or cinematograms?
>
> Vilém Flusser[1]

The Greek prefix *photo* (genitive of *phōs*) is associated with 'light' and the suffix *graphé* with 'writing' or 'inscribing'. Thus, the English word *photography* was intended to articulate the notion that a photograph is an artefact that involves the permanent inscription of light onto a surface. However, the early-to mid-nineteenth century offered alternative definitions for the newly emerged medium, and the one eventually selected may not have been the best or least problematic one.

This view is validated by several uncontroversial facts. First, light is not necessary for generating an image that could be identified as a photograph. This has been the case since, in the late nineteenth century, Wilhelm Conrad Röntgen 'invented' X-ray technology.[2] In other words there are many 'para-photographic' kinds of imaging that are routinely confused with the 'strictly photographic' ones. Second, today, even when photographic imaging does involve light, the production does *not*. Instead, the overwhelming majority of photographic artefacts are pigment prints, not photographs. Third, if we explain photography as an outgrowth of the camera obscura, as many have done, we can easily talk about non-inscribed photographic images. Today, an overwhelming majority of photographic images never become artefacts and so they are never inscribed anywhere. They merely exist as voltage differences on silicon chips and are made manifest as ephemeral projections on demand. How then should we talk about photography *today*? How do we think about it? To what extent has the term photography been made redundant by technology?

This brief etymological preamble demonstrated the risk of relying on technical desiderata to erect ontological definitions. It also made clear how limited such ontological definitions always are. Hence, I prefer Vilém Flusser's flexible interpretation. Flusser argues that while it is true that the word 'photo' does derive from the Greek word *phōs* it is equally true that it can have a different meaning, which should be translated as 'appear' or 'to appear'.[3] If he is right, the word photography can also mean 'apparent writing'. With this possible interpretation, photographs can be taken to evoke things like phantoms and flights of fancy and phenomena such as spectres, delusions and illusions. In other words, photographs induce the apparent, the possible, the tentative and not the necessary. Moreover, the prefix 'photo' can even be understood to *deny* the suffix 'graphy', suggesting that the photographer is one who only *apparently* writes, that the 'photograph' is always something that only appears to be written, and that photography is only apparently a form of writing. Could photography be perceived as something else entirely?

In explaining how this is possible, I will now delve into Flusser's oeuvre to generate the new photography paradigm. I call it a philosophy of photography as media, and to the extent that photography is art, I call it a philosophy of photography as algorithmic art. I use the word *paradigm* here in the sense coined by Thomas Kuhn.[4] It is not only the current 'governing' theory within a field, but also the entire worldview within which this theory operates. According to Kuhn, discursive models, most notably in fields of 'hard science', do not necessarily progress in a linear or continuous manner but rather undergo dramatic periodic change, which he called 'paradigm shift' – a process in which a number of existing problems within the existing model turn into a qualitatively new one.

Such a shift occurs, according to Kuhn, when scientists encounter anomalies that cannot be explained by the universally accepted views within which scientific progress had hitherto been made – the existing paradigm. In fact, all paradigms contain the occasional anomaly, notes Kuhn, but these are most often brushed off as acceptable levels of error. Other times they are simply ignored. However, when enough significant anomalies have accrued against a current paradigm, the scientific discipline is thrown into crisis. Needless to say, the current situation wherein photographs do not require 'photo' to come into being, and are rarely 'graphed' anywhere, presents a significant anomaly – a paradigm shift in the making, if not by definition. This is evident from the growing use of expressions like 'post-photography' and 'after photography' in various exhibition and book titles. The first instance of such use may have been as early as 1992, in William J. Mitchell's book *The Reconfigured Eye*.[5] Many similar titles followed: the exhibition and catalogue *Photography after Photography*,[6] the book *After Photography*[7] and the SFMOMA Symposium

titled *Is Photography Over?*[8] The two most recent contributions to this list are probably the Post-Photography Prototyping Prize[9] and the photo-biennale and catalogue titled *Farewell Photography*.[10]

Kuhn's writing narrates fields of 'hard' scientific research. While it is clearly difficult to speak of photography theory as 'hard science', Kuhn's conceptualization is still largely valid here – particularly given how photography theory is so often composed of arguments that revert to 'objective' ontological truths. Moreover, Kuhn makes clear that scientific 'truths', no matter the discipline, are rarely established solely by virtue of objective criteria, Rather, they are fashioned by a frail consensus of the scientific community. Perhaps our comprehension of science should not rely wholly upon 'objectivity', clearly it must account for subjective perspectives as well.

During a crisis, notes Kuhn, new approaches open up for questioning beliefs that theory would never have considered controversial, new ideas are consequently tried out, perhaps ones previously discarded. Eventually a new paradigm will rise. An intellectual debate will then take place between the followers of the new paradigm and the holdouts of the old. The scientific revolution or paradigm shift resulting from the defeat of the latter has not yet occurred in the theory and philosophy of photography, despite dramatic technological changes. Amongst its other objectives, this book aims to advance a new paradigm for photography, and to bring about a paradigm shift.

World Images

The subjective perspective advanced here emerges from Vilém Flusser's 'programmatic world image'.[11] This view has been influenced by Claude Shannon's well-known Mathematical Theory of Communication[12] and shares several parallels with Max Bense's and Abraham Moles' Information Aesthetics.[13] As such, it posits a view of photography, in keeping with other modes of communication, as a highly elaborate program of hypothetically calculable probabilities. In Chapters 4 and 5 I expand on this view to suggest that photography today is best served if conceptualized as a set of programs or, emblematically, a universal Turing machine.[14] This will be presented as an alternative to the dominant perspective in thinking about photography, emblematized in the Turin Shroud.

According to Flusser's construal, traditional consciousness is comprised of two competing, albeit very similar world images, or 'cosmologies' in his terminology: the 'finalistic' and 'causal'. The former reflects religious traditions and mystical, foundational experiences. Here humans and their world are subjected to a purpose that requires an aim. The obscurity of the purpose and the opacity of

the aim mean that many oppose both. The latter view arises from the natural sciences, according to which every event is the effect of specific causes, which are in turn causes of specific effects. Here experience presents itself as being part of a complex set of causal chains. Everything in the universe, and for that matter the universe itself, is considered a situation that, by necessity, emerged as a consequence of previous situations, and that will necessarily produce future situations as its consequences.

Arguably, in the absence of another, third, perspective, it is possible for one to live simultaneously with both finalistic and causal realities. Furthermore, both views have what we could identify as an identical linear structure, which could be summarized as 'purpose-aim' and' 'cause-effect'. Therefore we could argue that, even though the two views are seemingly contradictory, it is also possible to apply a causal view to nature and a finalistic one to culture: 'Nature could be objectified and culture anthropomorphized. Natural science could be "hard" and cultural science "soft"'.[15] Arguably, this is the case in photography theory wherein photographs are always demonstrative or consequential.

Flusser's programmatic world image, on the other hand, frees itself of this dichotomy. In it, final and causal linearity are but two dimensions or modes of an ever-expanding, all-inclusive program that both absorbs and transforms preceding world images.[16] Here, the universe is explained as 'a situation in which particular and inherent virtualities – part of the universe since its origin – have realized themselves by chance, whilst other virtualities – that will be realized by chance in the future – remain, as yet unrealized'.[17]

According to this unique account, what characterizes programs is the fact that they are systems in which chance becomes necessity. They are 'games' in which every virtuality, even the least probable ones, will sooner or later be realized, on condition that the game is played for a sufficiently long time, regardless of who the 'player' is. To reiterate this idea we might think of a pack of monkeys randomly punching keyboards. Given a sufficiently long time, the monkeys *will* eventually key in all of Shakespeare's plays.[18] Therefore, a fundamental concept in understanding the programmatic 'world image' is simply chance, which in finalistic thinking plays a lesser to non-existent role and in causal thinking is just a cause as yet undiscovered.

In Flusser's programmatic thought what seems to be a purpose and what seems to be a cause can both be naively interpreted as *chance* occurrences. While Flusser's perspective parenthesizes all ideologies, it is especially relevant for the theory and philosophy of photography where, until recently, chance or randomness have rarely been described as relevant factors within the technical process. Correspondingly, the calculation of chance or random events has never been seen as fundamental to the structure of the medium.

Life and Times of Vilém Flusser

Vilém Flusser remains a marginal thinker in the English-speaking world. To date, his writing is still segregated into several different languages, diverse in its often contradictory contexts and frustratingly undocumented. To understand why this is so, a few words about his life and method are in order. Flusser was born in 1920 to a family of Jewish intellectuals in Prague. He grew up speaking Czech and German as well as learning Hebrew. At school he also studied English and French. In 1938 he started studying philosophy at Charles University but was forced to flee Prague in 1939. He arrived in London where he briefly studied at the London School of Economics before immigrating to Brazil in 1940. There he also mastered Portuguese. Having lost all his family in the Nazi concentration camps, he remained in Brazil for 32 years before returning to Europe where he eventually took up residence in Provence. Flusser died in a road accident near Prague in 1991, a day after visiting his native city for the first time in over 50 years.

Flusser's writing career, as may be gathered from his biography, was rather unusual. It started in journalism and only later concurred with academia. For many years, he worked in jobs quite detached from intellectual endeavour, where, in his own words, 'one engaged in business during the day and philosophized at night'.[19] Throughout the 1960s, he lectured at the University of São Paolo and elsewhere in the city and eventually rose to the rank of professor of philosophy and communication theory. Back in Europe, Flusser became known as a communication theorist and was involved in the flourishing German media scene of the early 1980s. There he befriended some of the major players in the field, including Friedrich A. Kittler, who invited Flusser for a visiting professorship at Ruhr University in Bochum and Siegfried Zielinski, who was later entrusted with the Flusser archive (today under the auspices of the Universität Der Künste in Berlin).

However, despite academia's tepid embrace, Flusser continued practising a unique essayistic form and consistently refrained from using academic citation systems, which he claimed distracted him, got in the way of his writing, and eventually distorted the clarity of his thoughts.[20] Throughout his writing, he hardly ever mentions other writers explicitly, with only odd references to major thinkers like Martin Buber, Edmund Husserl, Franz Kafka or Ludwig Wittgenstein. His writing also displays strong influence by Martin Heidegger, whom he rarely mentions by name, however. Also perceptible is the influence of 'hard scientific' writing, particularly that of Albert Einstein, Ludwig Boltzmann and Werner Heisenberg. Traces of Thomas Kuhn or Marshall McLuhan may also be found in his writing. Thus, in a syncretic and original manner, Flusser's philosophy mostly includes only general references to the likes of 'Greek Philosophy', 'Jewish Prophecy' or simply 'Thermodynamics'.

Perhaps this is why Flusser's work has, until recently, attracted only limited scholarly interest in the Anglo-American context. However, now that important parts of Flusser's writing on photography and media have been translated into English, his oeuvre deserves serious attention. In fact, already after the first translations, Sean Cubitt has commented:

> Imagine Walter Benjamin's essays of the 1930s had only just become available, or that Marshall McLuhan had died in obscurity but was now for the first time appearing in dribs and drabs. That is the significance of the translations of Flusser that have appeared in English in the last five years.[21,22]

As noted, Flusser was fluent in five languages. What is even more admirable is that he wrote for publication in no less than four. Intriguingly, his writing pattern (or gesture, as he would call it) always started by 'projecting' an initial thought, or 'image', onto the language, that best suited it.[23] He would then continue with 'writing' the thought, translating the resulting text into another language and sometimes back again, mining the thought-image-text for further implications, attempting to exhaust all its possibilities. This gesture of inter-lingual validation resulted in multiple, sometimes even countless drafts of the same essay in various languages and, in certain cases, book chapters that bear the same titles as previous essays but are somewhat different. Flusser was therefore able to weave an ever-expanding web of thematic concerns, one in which ideas were repeatedly being interwoven.

As some have suggested, there is something deeply phenomenological in this approach.[24] This phenomenology is, however, unusually articulate, almost analytic, and dotted with existentialist brushstrokes. At times it even gives the careful reader the eerie sense of hearing a lucid human voice talking from the textual thickets. This causes Flusser's writing to be somewhat confusing and resistant to conventional classifications. His oeuvre may therefore be best described as an open-ended alternation between philosophy and media theory, practised in a colourful style rich with provocative wordplay.

Occasional comparisons have been made between Flusser and Jean Baudrillard or Roland Barthes.[25] A more apt but by no means straightforward analogy, I believe, can be drawn with Benjamin or McLuhan.[26] Mutatis mutandis, all of the above theorists can be said to have seriously attempted to analyse 'media culture' well before the term 'media' gained the prominence it holds today.[27] Benjamin, as we remember, realized that if photography and film were appropriated for political goals, they could be used for manipulating the masses in what he called the 'aestheticization of politics'.[28] However, he added, both could also develop in the opposite direction, namely as art forms with great democratic potential.[29] McLuhan also argued that we should seriously consider how these new media forms were put into play, but his

media explorations lacked the political and ethical dimension of Benjamin's work. While McLuhan does at times warn of the dangers of technology, he is still generally understood as a techno-teleologist who pays little attention to the relation between aesthetics and politics. Flusser's media explorations, then, are closer to Benjamin's, but his epistemological framework of contrasting alphabetic culture with media culture is in some ways more similar to McLuhan's.[30]

From a contemporary perspective, we could say that the limitation of Benjamin's work was that he was necessarily restricted to the by now almost archaic media bounds of photography and film. Flusser went where Benjamin could not tread. Nonetheless, for Flusser, and much more so than for any other writer, photography stood at the watershed of contemporary cultural understanding. In Flusser's account, photography was not just alien to historical modes of representation by imagery; rather, it obviated the very conditions that made representation by imagery possible throughout history. In fact, it ousts the possibility of history altogether. The photograph, according to his account, was the first *post-historical* image. Thus, even if Flusser does occasionally use the same terms as others, his insights are almost always radically different. [31,32]

Accordingly, Flusser's theory emerges from the medium of photography to create a complicated pool of ideas on the far-reaching implications of media for human thought, culture and communication. This chapter will focus on Flusser's later writings and uphold them as an emerging new paradigm for thinking about photography. My account will start by pondering upon the concepts of memory, tool and machine. I will then follow the milestones proposed by Friedrich A. Kittler to trace to the movement towards abstraction of human communication as analysed by Flusser: obelisk, traditional image, linear writing, technical image and code.[33] In the process I will also draw on and at times dissect four of Flusser's fundamental terms: image, apparatus, information and program. In Chapters 4 and 5 I will expand on the definitions 'code' and 'program' and will connect them to the universal Turing machine as imperative for the contemporary theory and philosophy of photography.

Cultures, Objects and Images

Cultures

Flusser's media philosophy starts as a meditation on the backdrop against which media operates – human culture. In his account, human culture is the process of creating and, more importantly, *preserving* sociocultural form – or in other words *information*.[34] Cultural form, argues Flusser, begins with *memory* and it is only

with memories that cultures can also be preserved. Thus, in order to argue for the uniqueness of photography as a cultural form of memory creation, I shall now trace the development of Flusser's thought from the term memory through the term object to the term image.

Oral culture problematizes traditional notions of cultural memory because air, unlike objects, cannot be used as a means of memory support. Airwaves are used for vocalization because air is readily accessible to us humans. However, they are unstable and susceptible to noise. This deforms the information they carry and is therefore a disadvantage. Information conveyed this way is only provisionally stored before it dissolves. Such information must be retrieved immediately to be stored more permanently, requiring a receiver.[35]

Cultural information stored in airwaves is subject not only to errors of noise-disrupted transmission but also to numerous errors within the grey matter of its human receivers.[36] If history means an uninterrupted chain of memory bits, then strictly speaking, oral cultures are not historical cultures since neither airwaves nor human brains are immune to disruption.[37] Preserving the information of oral cultures is therefore almost impossible, as cultural anthropology would no doubt confirm. One might even say that cultural information that has not been preserved has never been created. Until relatively recently, therefore, cultural memory was sustained through material objects.

The Old Stone Age is a promising point to start looking for cultural memory. When treated properly, stones can transcend their mute physical existence to be 'informed' culturally. But what does information mean in this context? We know that certain types of stone can also be used for certain brute tasks. Obsidian, for example, may be used for cutting. Granite may be used for hammering. Pumice may be used for scouring.[38] Common to all types of stone is their potential for preserving information on 'how to cut,' 'how to hammer' or on how people cut and hammered thousands of years ago. Information stored within hard substances creates informed objects and informed objects constitute our material culture.

The disadvantage is that informed objects are usually used not only as memory supports, but also and primarily for other purposes as well. Axes keep information on 'how to cut' but they are also used for cutting. This creates a problem: using the tool wears out the information it carries – much like a shoe that begins to lose its shape, its design, from the moment it is first worn. Deformed objects constitute a pernicious type of memory failure. This is why objects designed exclusively as memory supports were first invented. They emerged as objects that were *not* to be simultaneously used as tools.

This was the symbolic role of sculpture, which was to abstract the four-dimensional continuum of space and time into a three-dimensional sign. This, of

course, began at various points in time in the history of various human civilizations. The sign stood for the continuum but because of its dimensional reduction, it could also be manipulated. Some examples are early gravestones, the pyramids and obelisks. All these monuments avoid the problem of memory failure and information loss and thus are able to awaken abstraction by virtual abolition of dimensions.

Another symbolic act consisted in signifying a three-dimensional scene, object or sign through a two-dimensional surface-sign. A gravestone, or a dying person, could be signified by a painting of a *pietà*, for example, which once more increased the possibilities of manipulation. Paintings, drawings and images in general could be used to signify and represent the cultures that made them. 'The earliest image makers known to us [...] fixed their observations on the walls of caves to make them accessible to others [...]'.[39] They used their hands because hands at this point were still required for 'fixing', but they did so in a new way, inasmuch as they used their hands not to grasp objects but rather to manipulate surfaces so as to represent objects. That is, for observations to be fixed, surfaces must be manipulated. Observation and manipulation are often, as we shall soon see, two aspects of one and the same activity.

And when early image-makers sought to fix their observations of the world they also sought to make symbols: 'a gesture in which the hands moved back from the object to address the depths of the subject in whom, so stimulated, a new level of consciousness was emerging: the "imaginative"'.[40] And from this imaginative consciousness then came what Flusser calls 'the universe of traditional images', a universe of symbolic content, a universe that would henceforth serve as a model for manipulating observations and, more importantly, also manipulating the environment.

The prehistoric 'universe of traditional images' was a mythical universe of circular, non-linear time. And if anything nevertheless did change it did so unintentionally, almost coincidently. Linearity was arguably not in existence. Myths about 'ever-forward' movement arrived much later. The universe of traditional images, not yet sullied with texts, was a world of magical content, of the eternal return of the same, notes Flusser in one of his rare almost-references.[41] Everything in that traditional world lent meaning to everything else and anything could be signified by anything else. This was the imaginative state of mind: 'everything carries meaning, everything must be appeased'.[42]

This changed dramatically with writing, or linear writing, as Flusser often referred to it (and McLuhan would have agreed). This 'very ingenious invention'[43] is relatively recent – only about 3,500 to 4,000 years ago. Writing is a further abstraction into symbolic content, into *code* used to transcribe the phonemes of spoken language into visual symbols that can be impressed on hard objects. The alphabet code united the advantages of oral and material culture and made

possible the creation of texts – monument-surfaces that stored the information of spoken language within hard objects that could be copied. This copying method, all would agree, proved to be very powerful. A new form of cultural memory was thereby established, the library.[44] This was the beginning of recorded history. Written language brought about a radical transformation of human thinking and acting. The linear structure of alphabetic writing produced progressive, causal, 'scientific' ways of reasoning and action. It was, Flusser argued, 'a decisive step toward the humanization of man from anthropoid',[45] which allowed the acquisition and storage of information to become a disciplined, self-conscious process.

Importantly, writing endows man with the new capability of conceptual thinking, which consists of abstracting lines from surfaces, producing and decoding them. Conceptual thought is more abstract than imaginative thought as all dimensions end up being abstracted from the world and its phenomena. Thus, with the invention of writing, human beings could arguably take one step further away from the world.

> Texts do not signify the world; they signify the images they tear up. Hence, to decode texts means to discover the images signified by them. The intention of texts is to explain images, while that of concepts is to make ideas comprehensible. In this way, texts are a metacode of images.[46]

Of course, the history of images, which is the history of art, only began with the appearance of linear writing, and the simultaneous appearance of conceptual, historical consciousness. Only then did image-makers start to concern themselves with being original, with introducing new symbols deliberately, with generating new information. This relationship between text and image runs throughout history. Further, a struggle between writing and the image, a struggle of historical consciousness against traditional magic became a crucial issue: 'In the medieval period, there appears to have been a struggle on the part of Christianity, faithful to the text, against idolaters or pagans; in modern times, a struggle on the part of textual science against image-bound ideologies'.[47] In this view, writing always sought to dominate traditional images, or more accurately, writing consciousness tried to dominate traditional image consciousness. It took a long time: 'Only in the eighteenth century, after a three-thousand-year struggle, did texts succeed in pushing images, with their magic and myth, into such corners as museums and the unconscious'.[48]

This struggle was always a dialectical one and, indeed, Christianity struggled against image paganism before it absorbed those very images it opposed. This is the history of Western art as we know it. The science that struggled against image-bound ideologies absorbed those very ideologies and became image-bound. Today

there are very few scientific texts without images. Texts admittedly explain images but images also illustrate texts. Texts have become imbued with images and images have, in many ways, become textual. Nowadays, the greatest imagination is to be found in scientific texts. The greatest conceptual abstraction is to be found in images: 'Thus, behind one's back, the hierarchy of codes is overturned. Texts, originally a metacode of images, can themselves have images as a metacode'.[49]

To understand the extent to which the relationship between texts and images is today inverted, conflated and convoluted, let us briefly reflect on Rosa Menkman's sequence of self-portrait images titled *A Vernacular of File Formats* (Figures 6–9). Menkman used several file format iterations of the same image and onto each she implemented the same or similar encoding changes. This was done *textually* (on the source code), so as 'to let the otherwise invisible compression language presents itself onto the surface of the image'.[50] While these steps are presented as intentionally erroneous, they could very well be legitimate given another context. The result is various corruptions of the original files and a spectacular degradation of the images they make up. Menkman is thus able to direct attention to the most used and ever hidden languages of digital file compression, which create the images that we routinely consume. These are, in every single case, simultaneously signified as text to be 'read' by the computer but manifested as image to be 'seen' by us. This example proves the governing rule today: all images rest on codes that need to be decoded for the images to be legible (read visible) to their viewers.

This interlude brings us to the pinnacle of Flusser's opus: photography. It is the crucial breaking point where culture becomes increasingly visual and decreasingly literate, decreasingly historical. With the emergence of photography, argues Flusser, a new consciousness arose – 'the universe of technical images'. Importantly, Flusser not only characterizes photography as directly opposed to writing, he also makes clear that it is wrong to consider it only in comparison to traditional images (or manugraphs as I referred to them in Chapter 2). Instead, photography ought to be conceptualized in tandem with its media contemporaries: telegraphy, film, sound recording and arguably the computer.[51] This is because it is not only a medium for making images, but in many ways the model for a general trend towards growing integration between human beings and their technologies.

But how does this unfold? As we saw in Chapters 1 and 2, technical images can be confused with traditional images or often seem interchangeable with them. To explain this, let us consider for a moment *where* images appear. The universe of traditional images consists of walls (whether in a cave dwelling, in a modern home or in the museum). Images on walls 'mirror' the cultures that created them because they are magical images, circular and created in nonlinear time. That is to say, the meaning of an image on a wall is also found on that wall or lost with it. It could accordingly be a deep, mysterious and sacred meaning. The universe

FIGURES 6–9: Rosa Menkman: *A Vernacular of File Formats* (2010) (detail).

of technical images, by contrast, consists of no such tangibility even though, for the time being, some photographs are still found on papers affixed to walls. This universe is about images projected from linearity into an emptiness of zero dimensions: 'And if these images show bulls or Emperor Franz Joseph, it will be to give meaning to this emptiness, this field in which we must live. Of course, bulls and emperors projected into nothingness in this way are no longer explanations but *visualisations*'.[52]

Therefore, when we speak about the meaning of images, about decoding them, we need to be aware that the meaning of technical images is to be sought in a place *other* than that of traditional images. Traditional images may be understood as mirrors. Their action may be defined as the capturing of three-dimensional worlds, or the apprehending of culture as it were, and its encoding as a reflection onto a two-dimensional surface. It is therefore not out of place to ask 'what do traditional images mean?' The gesture of the traditional image-maker is directed from the world of objects towards an actual surface. It starts with a solid object and abstracts, in the sense that it retreats from the concrete.

Technical images, on the other hand, are *not* reflections but rather projections or visualizations. They capture photons, electrons and other invisible conveyors of information, some of which are meaninglessly defined as 'visible light'. They *code* them so as to insert meaning into them. So it is incorrect to ask *what* they mean, unless we are inclined to accept the answer that technical images mean photons. The gesture of the technical image-maker is directed from a particle towards a surface. It starts with calculation, which it attempts to concretize. With technical images the proper question to ask is 'What is the purpose of making the things that they show, mean what they do?' For what they show is merely a function of their purpose.

In short, according to Flusser's view that I am embracing, the two types of image surfaces must be conceived in complete opposition one to the other. They are on an entirely different plane of consciousness, where cognition takes place in an entirely different climate. This is why thinking about photography vis-à-vis painting has always had only limited benefits. Technical images are forms of visualization and are completely different from depictions, something radically new. They will soon be brought into consideration.[53]

Thus far, I have broadly delineated milestones in the movement of human communication towards abstraction. The same process can be alternatively defined as the gradual cultural abolition of all natural dimensions. What all phases described thus far have in common is the n-1 dimensional signifier, as Kittler has accurately pointed out.[54] What we must bear in mind in this context is that the n-1 dimensional signifier not only reduces one dimension in every phase, it more importantly *conceals*, *disguises* and *distorts* the signified, that is, the n dimensional. This means that technical images conceal the underlying text and texts conceal

traditional images. Thus, according to Flusser, the last 40,000 years can be defined as the process by which our human memories, as well as some other cerebral functions, have been abstracted, ephemeralized and finally replaced by electronic memories.

Cultural Objects

> The subject tries to inject value into the object through 'work'. Objects changed by work are cultural objects. The present tendency is to relegate work from human subjects to automatic apparatus. The shocking objects are somehow given, they are 'data'. Cultural objects are made, they are 'facta'. To work is to process data and change them into facta. Automatic apparatus are capable of this data processing. We are witnessing a cultural revolution.

Vilém Flusser[55]

Most recognized human cultures are, as previously noted, material cultures, an expression that until recently did actually refer to material. But talk about 'material' is confusing: we are not thinking about material in the sense of all iron ores in existence or all obsidian stones on planet earth. Instead we are usually talking about limited quantities of material used for a specific purpose, for example one slab of stone. Therefore, the term 'object' shall now be used to refer, for example, to particular instances of the material known as stone.[56]

Objects present themselves to us in various shapes that are often meaningless to us. Stones do not normally appear as knifes. Therefore, we need to change the shapes of objects, so as to imbue them with meaning, to re-form them in the hope that they can eventually become 'informed', as for material to become 'cultural', it has to be informed. Cultural objects are therefore never simply 'found objects' but always the result of human intent and human action. This type of pre-conceived action is what we call work. The same applies to all twentieth-century objects as well, even those considered artefacts. Even objects of the type known as *objet trouvé*[57] are always informed by human intent and action.

Tools, in the usual sense, extract objects from 'nature' to bring them to another place called 'culture'. In this production process they change the form of these objects; they imprint new, intentional forms onto them. They 'inform' them. When an object acquires an unnatural, improbable form, it becomes cultural. This production and information of natural objects, that is to say 'work', results in what art theory calls 'a work'. With photography it becomes clear that work is the act of informing:

Many works, such as apples, are admittedly produced, but have hardly been informed; others, such as shoes, are strongly informed, they have a form that is developed from animal skins (leather). Apple-producing (picking) scissors are tools that inform very little; shoe-producing needles are tools that inform a lot. Is the camera then a kind of needle since photographs carry information?[58]

The meaning of work has, however, changed dramatically in the past centuries. Hence, we shall do well to briefly consider possible meanings of the term in the context of cultural objects. The classic meaning of work is a physical gesture of imposing information onto an object. To make a prehistorical knife one had to manually impose onto a stone the form of a knife, the information of 'how to cut'. Until relatively recently, all cultural objects have been manually produced, physical impositions performed by human bodies. Cultural objects were therefore tools, which served as extensions of the human organs: extended teeth, fingers, hands, arms and legs. 'As they extend they reach further into the natural world and tear objects from it more powerfully and more quickly than the body could do on its own. They simulate the organ they are extended from: An arrow simulates the fingers, a hammer the fist, a pick the toe'.[59] Working with such tools is what we nowadays call labour. But what about photography? Is a camera also an extension of the human body and henceforth a tool for labour? Further, if Kendall Walton claimed the camera was an extension of our sense of sight, what kind of 'work' is photography? Does it then simulate our eye or our brain?

The Industrial Revolution of the eighteenth and nineteenth centuries transformed the concept of work in that tools became 'technical' and were now called 'machines' or 'machine tools'. The machine was the practical application of a theoretical understanding of the gesture of working. A machine tool was the application of that understanding when it came to shape.[60] Thus, when material substances were introduced into the machine and then impressed by a machine tool there appeared a new type of cultural object: the industrial object.

Industrial objects differ from pre-industrial ones in three main respects. First, they are more numerous because machines produce more objects than humans do. This has had the profound consequence of marginalizing and devaluing artisanship. Second, since cultural objects in the industrial age are stereotypical – that is to say they are the result of the same tool impressing the same shape on a series of objects – diverse cultural objects become equivalent. This progressive devaluation coupled with non-differentiation of cultural objects is what we like to call 'mass culture'. Third, and perhaps most importantly, societies have begun to re-divide into three classes: owners of machines and machine tools, makers of machines and machine tools and servants of machines and machine tools.

When tools in the usual sense become machines, their relationship to human beings is reversed. Prior to the Industrial Revolution the human being was surrounded by tools – afterwards, machines tools were surrounded by human beings: 'Previously the tool functioned as a function of the human being, subsequently the human being as a function of the machine'.[61] But if the camera simulates the eye and brain in a way that reaches back to the theory of optics, is the photographer a function of the camera machine? Is the camera as much of a machine as a Spinning Jenny? What *kind* of machine is the camera? To what extent can it be understood as 'a machine that makes art'? I return to these questions in Chapter 5 where I discuss algorithmic art.[62]

In the meantime, we must ask: As cultural objects became increasingly cheaper, and machines and tools increasingly more expensive, who held the power? Previously, the size and cost of machines and machine tools meant that only privileged people were able to own them. These were the so-called 'capitalists', according to traditional Marxism. In this account, most human beings worked as a function of those machines and were called 'proletariat'. Humanity was divided into the machine owners for whom the machines worked, and labourers who became mere extensions of the machines. Is that true now of the camera? Is the photographer a proletarian? And who are the photo-capitalists?

A Culture of Technical Images

two fundamental turning points can be observed in human culture since its inception. The first, around the middle of the second millennium BC, can be summed up under the heading 'the invention of linear writing'; the second, the one we are currently experiencing, could be called 'the invention of technical images'.

Vilém Flusser[63]

Flusser argued that, from its outset, the alphabet has been destructive of magical consciousness. Consequently, he recognized the invention of linear writing as one of the most significant events in history, in fact as the condition of history. In the relation Flusser draws between writing and history, media already play a central role in culture. They are the custodians of time as linear movement. But for him, writing already performs the function of changing 'scenes into processes'.[64] Thereby Flusser contrasts writing with image-based culture. In contrast to Derrida, he associates the institution of writing not only with a change in the form of memory but also with resistance to images: 'Greek philosophy and Jewish prophecy are battle cries against images on behalf of texts'.[65] Whereas for

Derrida, the ancient Greeks at least focused on the danger of writing in comparison to speech,[66] Flusser's binary of writing and images yielded a much different conclusion. This is how Friedrich Kittler put it:

> Media theorists, specifically Marshall McLuhan and, succeeding him, Vilem Flusser, draw an absolute distinction between writing and the image that ultimately rests on concepts of geometry. They contrast the linearity or one-dimensionality of printed books with the irreducible two-dimensionality of images. Simplified in this manner, it is a distinction that may hold true even when computer technology can model texts as strings, as it does today.[67]

Consistently then, Flusser understood images in contrast to writing. This is why he was also quick to argue that the crisis of writing was now in plain sight.[68] This enabled him to designate the invention of photography as a second momentous event with an at least equal impact on human culture and consciousness: 'With writing, history in the narrower sense begins as a struggle against idolatry. With photography, 'post-history' begins as a struggle against textolatry'.[69] Photographs are, according to this account, 'dams placed in the way of the stream of history, jamming historical happenings'.[70]

Nonetheless, as demonstrated in the previous chapters, problems arise when we seek discrete meanings in separable photographs. This is routinely attempted because the significance of photographs often appears, rather confusingly, to be reflected on their surface, just like fingerprints, impressions of signet ring seals and bullet holes. There the significance – a foot, seal or bullet – seems to be the cause, and the image – footprint, impression or hole – seems to be the effect. According to this classic, or causal construal, what we see in such images is therefore not a symbol that must be decoded but a manifestation, a symptom of a world through which, even if indirectly, the world itself can be perceived.

This apparently non-symbolic, objective character of photographs leads some to interpret them not as images but as mirrors or windows. It matters not whether these constitute reflections of the photographer, as in John Szarkowski's mirrors, openings onto the world, as in Szarkowski's windows, or openings onto the past, as in Walton's windows. This paradigm yields no scrutiny of photographs *themselves*.[71] To the extent that there is scrutiny, it is only of the world and of potential ways of depicting it. Such lack of criticism is potentially even more dangerous than lack of criticism of the world. The task of a philosophy of photography is therefore to expound the idea that photographs are symbolic, like all images, but that they represent more abstract complexes of symbols than traditional images do. They 'are metacodes of texts, which, as is yet to be shown, signify texts, not the world at all'.[72]

Flusser, in other words, fathoms photography's emergence as not only a momentous event in the history of art and culture but, crucially, as the ruination of the literate, historical consciousness shaped in culture through writing. According to this radical view photography is also a code but, in contrast to linguistic code, one bound up with the mathematical. As such it signals a profoundly different type of consciousness and the dawning of a new culture of telematics. This can be understood in several ways, even historically, on condition that we can tolerate the irony of reliance on history to account for the crisis of history. Written texts are decoded in a linear and sequential fashion. They induce a directional idea in the reader and a sense of historical time. Photographs, on the other hand, encourage a nonlinear form of reading. When a photograph is read, directional movement matters not.[73] A photograph, we could say in Heideggerian terms, is always a nonlinear 'all-at-onceness'.[74] In their composition as well, photographs can be regarded as different from writings because, as will soon be elaborated, they rely on another formal type of thinking – calculating. And so photographs are never simply mimetic, depictive or descriptive but rather 'computed possibilities (models, projections onto the environment)'.[75]

Thus, if we are interested in seeing, sensing or perceiving the world, we must analyse the production of photographs *as* technical images. The production of technical images involves the ability to transcode concepts from texts into images. This is possibly the only way to see the world today. And when we observe technical images, we see concepts of a world out there, encoded in a novel way. 'The difference between traditional and technical images, then, would be this: the first are observations of objects, the second computations of concepts. The first arise through depiction, the second through a peculiar hallucinatory power [...]'.[76]

To clarify, the term 'technical images' will henceforth be used to refer to photography as prototypical of all other visual manifestations that allow human beings to engage with or make something intelligible out of sub-atomic particles, imperceptible molecules and magnetic or electrical charges. It applies equally to all forms of still or moving, silent or sounding, material-based or projected images constituting any phase of chemical, magnetic, digital or algorithmic process.

Flusser's Philosophy of Photography

Earlier, I argued against the conviction that identifies the photographic as inconsistent with the traditional relationship between a concrete object and an intentional idea of that object. In painting, according to this narrative, we ourselves form an idea in order to represent an object on a stable surface, to fix it. In photography, by contrast, the object itself supposedly generates 'an idea' that is then imprinted on a surface. Therefore, it was asserted, a four-dimensional object

can transfigure onto a two-dimensional surface, producing a familiar result by means of a revolutionary method. The object was thus seen as the *cause* of the image and not its meaning.

And if we assume that photographs are caused by phenomena whereas paintings point phenomena out, then it becomes much easier to animate a difference between intentional and causal explanations. So paintings will be explained if we are able to see an intentionality that is being expressed within them, whereas photographs will be explained when we know the processes through which they were produced.

Thus understood, the invention of photography can even be seen as a delayed technical resolution of the seventeenth-century theoretical conflict between rationalistic and empirical idealism. Rationalists such as Descartes, Spinoza or Leibniz believed that ideas, much like paintings, were designed by humans. On the other hand, their empiricist contemporaries such as Locke, Berkeley or Hume held that ideas, supposedly like photographs in classic photography theory, imprinted themselves on humans. While it would be tempting to deduce that photography is a technology that synthesizes both views, the matter is more complex. As argued previously, there are intentional phases in the act of photography and, undoubtedly, causal processes involved in the act of painting. In short, a responsible distinction between intentionality and causality is as intangible as a mirage.

Perhaps the true revolutionary nature of the invention of photography is that it permits this discussion to take place at the level of technology. If so, then a new definition of its technical terms is now necessary. And while the nature of most technologies is such that they necessitate constant change, a philosophical account of photography that wishes to remain relevant after the ink has dried must contain elements of methodical doubt so as to sustain open-endedness. This serves to clarify that the narrative presented from here onwards is conceptual whenever it is technological. It is brought forth as part of a novel account of photography that interacts with the theoretical concept of the universal Turing machine and utilizes it to facilitate new ways of thinking about photography as a technology that has perhaps pre-lived and certainly outlived its familiar chemical and mechanical processes. Its conceptual, algorithmic and programmatic processes will be the focus of the remainder of this book.

Image, Apparatus, Program, Information

As noted, Flusser spent much of his life orbiting the main powerhouses of academia, never quite belonging to any of them. Yet, if ever there was a breakthrough moment for him it was the 1983 publication of his book *Towards a Philosophy of Photography* by a small Göttingen press. To date this remains Flusser's most

read and only influential treatise.[77] Starting with a philosophical consideration of photography, Flusser proposed a completely new systematization of cultural techniques, analysing the contemporary cultural crisis from various perspectives offered by the technical image, of which photography was representative. Having described the paradigm shift in which a two-dimensional, magic-based pictorial culture evolved into a linear, text-based alphabetic culture, and then having described how technical images truly represented yet another radical change to a post-historical age, Flusser declared:

> A philosophy of photography is necessary for raising photographic practice to the level of consciousness, and this is again because this practice gives rise to a model of freedom in the post-industrial context in general. A philosophy of photography must reveal the fact that there is no place for human freedom within the area of automated, programmed and programming apparatuses […]. The task of a philosophy of photography is to reflect upon this possibility of freedom […] in a world dominated by apparatuses […].[78]

The above quote is as disturbing as it is lyrical. It compels us to ask: How and when have we imprisoned ourselves within the area of automated and programmed apparatuses? More importantly, is photography prototypical of that area and how? My answers will unfold over the remainder of this book. They begin by delving deeper into the four cornerstone definitions that comprise Flusser's philosophy of photograph: image, apparatus, program and information. These enable the following definition of a photograph: 'an image created and distributed by photographic apparatus according to a program, an image whose ostensible function is to inform'.[79]

The first two terms, image and apparatus, are the classic pair as photography has often been described in terms of images automatically produced by apparatuses. However, Flusser's scheme differs from most prevailing theories in being based on the assumption that the fundamental difference between the traditional and the technical image exists not just in the ways they are made. Coincidently, this is exactly the same claim that underlies Walter Benjamin's classic 'Work of Art'. Flusser makes the case, in total agreement with Benjamin and others, that traditional and technical images are not only historically but also ontologically different.[80] Elsewhere, however, he disagrees with Benjamin's claim that the image's auratic character has disappeared due to the techniques of reproduction. For Flusser, it has simply taken on a different form: 'The difference between old and new magic can be summarized as follows: Prehistoric magic is a ritualization of models known as "myths"; current magic is a ritualization of models known as "programs"'.[81]

Benjamin looks at photography and film from a much earlier historical perspective. He theorizes how the then-new technical means of reproduction have changed the conception of art. Consequently, he shuns the term 'media' and compares these new 'art forms' with painting. Flusser, on the other hand, theorizes about photography using both Benjamin's tools and the lens of the new media such as television and the computer, which developed in the post-war period. So while both Benjamin and Flusser consider photography as posing pressing philosophical questions, they do so at very different historical moments. For one, photography still represents a new technical invention. For the other, it has become a traditional medium. For us, it is evanescent. Indeed, with Flusser's reassessment of photography through the lens of what has been called the 'electronic,' 'cybernetic' or information age, one realizes how much of Benjamin's analysis of photography results from reflections on the preceding mechanical or industrial age.

The second important term in Flusser's definition is apparatus. Remarkably, he argues that the photographic apparatus, although based upon scientific principles and technical complexities, is easy to handle. It is, nonetheless, *not* an apparatus on which you merely click a button, as Kodak's nineteenth-century pitch would have us believe.[82] Rather, photography in Flusser's terminology is functionally simple yet structurally complex.[83,84] Instead of accepting Kodak's 'fire-and-forget' description, Flusser suggests a concept of dynamic interaction between the apparatus and its user. Pondering the meaning of the term apparatus through the Latin verb *apparare* (to prepare), he conceives a photography that is far more than a technological tool that 'automatically' produces an image. In his eyes it is a complex mechanism that the photographer has to prepare in order to make an image. But what does 'prepare' mean in this context? Contrary to Snyder and Allen's advocacy of the photographer's artful preparation of the image,[85] for Flusser the photographic image is always pre-prepared *by the apparatus*, *not* the photographer. It is always already pre-prepared and the photographer's liberty is limited to engagement with that which has been pre-prepared.

The second pair of definitions in Flusser's conception of photography is information and program. To explain information, he introduces two contrasting terms: redundancy and non-redundancy. The more a situation is redundant the less it is informative, and the more it is non-redundant the more it is informative. Flusser clarifies that 'An apparatus is a machine that elaborates information'. He then proceeds to state that 'A situation is more informative the less it is probable; for instance, the letter "z" is more informative within an English text than the letter "a", and a penguin encountered in a street is more informative than a mail carrier'.[86]

Through this categorical distinction of two kinds of information, it quickly becomes clear why we should not be interested in all photographs or even in most. We should only take interest in those that are informative in the accurate sense of giving form, giving information. Only those photographs possess the quality to inform and contribute to cultural knowledge: 'It is true that one can, in theory, take a photograph over and over again in the same or a very similar way, but this is not important for the process of taking photographs. Such images are 'redundant': They carry no new information and are superfluous'.[87]

Conspicuously, Flusser's choice of the terms redundant and non-redundant draws heavily from Claude Shannon's classic 'A Mathematical Theory of Communication',[88] which demonstrated that electrical applications of Boolean algebra could construct and resolve any logical, numerical relationship. This theory, which was based mainly on Shannon's master's thesis at MIT,[89] as well as on his experience working in the field of cryptanalysis in World War Two, was fundamental in the formation of what we now call communication theory. In it, information was interpreted in terms of bits in the context of the entire collective of technological means of communication. The theory showed how to measure the rate at which a message source, for example an apparatus, generates information. Thus, Shannon formulated a quantitative concept of information, for which the *kind* of information was irrelevant.

Crucially, from the standpoint of aesthetics, such utter disregard for the *kind* of information poses an unprecedented challenge:

> An apparatus is a machine that calculates probabilities. Humans used to do the same thing, and they called it 'creation'. They used to elaborate improbable situations empirically, and they used to call their empiricism by noble terms such as 'intuition'. Apparatus do this better because they use information theories [...]. However, if apparatus (sic) can create information in the place of humankind, what about human commitment? What about values?[90]

Recall that in aesthetics the *quality* of the information traditionally matters as much as its quantity. On the basis of this cultural assessment, Flusser tests Shannon's quantitative information with the idea of qualitative information. I return to this point in Chapter 5 where I discuss Max Bense's information aesthetics. Still, Flusser is interested in information as such, as is Shannon. In this context, photography can be understood as a prototype for all technical apparatuses taken together. Following in these footsteps, I argue that a philosophy of photography need not concern itself with providing conceptual tools for analysing specific photographs. Such concerns unavoidably problematize the uncritical acceptance of the excess of redundant technically generated content.

Flusser's approach to the concept of information therefore makes for an analysis of photography that is very distinct from most theories. It may be worth noting that of all better-known and more popular theories of photography, one theorist who possibly shares with Flusser the concept of photography as a form of information is Roland Barthes in his early writings. In 'The Photographic Message',[91] Barthes concludes that, since the photograph is a message, the photograph 'asks' to be read. At the same time, he recognizes a contradiction in the fact that the photograph is a mechanically produced image. To resolve this dilemma, he develops the notion of the photographic paradox, which he defines as a blend of denoted and connoted messages: 'The photographic paradox can then be seen as the co-existence of two messages, the one without a code (the photographic analogue), the other with a code (the 'art,' or the treatment, or the 'writing,' or the rhetoric, of the photograph)'.[92] Barthes, in other words, mobilizes a conceptual toolkit derived from communication theory to address photography as, in our terms, an apparatus of communication. Flusser however avoids Barthes' problematic semiotic analysis and opts for the above-described terms of redundancy versus non-redundancy.

The last and most interesting concept in Flusser's philosophy is the program:

> It is true that many apparatuses are hard objects. A camera is constructed out of metal, glass, plastic, etc. But it is not this hardness that makes it capable of being played with, nor is it the wood of the chessboard and the chess-pieces that make the game possible, but the rules of the game, the chess program. What one pays for when buying a camera is not so much the metal or the plastic but the program that makes the camera capable of creating images in the first place [...].[93]

At first glance it seems somewhat counterintuitive to describe photography with a concept so intimately associated with the computer. But this does not weaken Flusser's point, on the contrary. In my view photography has wrongfully been theorized and philosophized as an analogue medium. It is better served when theorized and philosophized with and through 'the super-medium of the digital computer'.[94] The imperativeness of Flusser's analysis of photography, I argue, is that it enables precisely this, and quite benignly so.

> Computers are apparatuses that process information according to a program. This is the case for all apparatuses anyway, even simple ones, such as the camera [...]. In the case of the computer, however, this condition is particularly clear: when I purchase a computer, I have to buy not merely the apparatus (hardware) itself but also the programs (software) that go with it.[95]

101

The term 'program' should be first understood on a basic technological level, as the sum of all the operations that an apparatus can be set to perform – that which the apparatus is prepared to do. In the case of photography, however, the program is an expanded concept that also extends to the photographer's technical decisions while making a photograph. All those are also conditioned by the programmatic possibilities built into the apparatus. The apparatus may therefore be understood as also 'programming' its human user. This concept extends our previous technological definitions well into the broad cultural context of present-day, post-industrial society. The news photograph, for instance, ought to be understood as 'programmed' or 'pre-programmed' by the entire structure of the newspaper, the press or the media industry, where it not only illustrates reportage but also incorporates and evokes many pre-existing cultural codes and contexts.[96]

The Photographer as Functionary

Probabilities

If all forms of photographic information are contained ab initio as probabilities within the program governing the photographic apparatus, what about photographers? Is this a mutated version of Peter Henry Emerson's argument? What, if any, is their contribution and where is his input routed? Modernist histories of photography, expressed in Flusserian terms, would probably have it that photographers attempt to find previously undiscovered possibilities, or, in classical terms, to unearth and reveal them. In doing so we notice that they handle the camera in various ways. Photographers look through the camera as they look into it. Is this because the world interests them and the camera is their tool for satisfying that curiosity? Where are they pointing their camera? What is their 'shot'?

Meanings are not found in the world the same way that rabbits are found on downs, argued Victor Burgin.[97] Photographers seeking new information cannot just aim and shoot. If they dance around with their camera we hope this is because they are pursuing new possibilities within the camera program, new methods and techniques for producing non-redundant information. As Flusser argues, 'Their interest is concentrated on the camera; for them, the world is purely a pretext for the realization of camera possibilities'.[98]

Unlike manual labourers surrounded by tools and industrial workers standing by machines, photographers must be inside their apparatus, so to speak, as they are bound up with it. Therefore, unlike chess players, the human photogra-

pher cannot defeat the photographic program.[99] The apparatus automatically assimilates these attempts at liberation and enriches its programs with them. The photographer's involvement, as set by the inner contradictions of an automatic apparatus, is therefore confusing. In fact, looking at a photographer with his camera and comparing his movements with the movements of a fully automatic camera, as in a traffic light camera for example, it may be tempting to overestimate the human involvement. For it looks as though the fully automatic camera is always tripped by chance, whereas the photographer only presses the release when he approaches a situation in the world that corresponds to his intention, his worldview, or desired form of information.

If we look more closely, however, we can confirm that the photographer's demeanour somehow carries out the apparatus's inner instructions and *only* them. This happens despite any attempt to deviate from the program: 'The photographer can only photograph what is contained as a virtuality in the camera program'.[100] If we accept the programmatic world image it follows that apparatuses and photographers *are* bound together and this inherent contradiction always remains in place:

> The apparatus does as the photographer desires, but the photographer can only desire what the apparatus can do. Any image produced by a photographer must be within the program of the apparatus and will be, in keeping with the considerations outlined earlier, a predictable, uninformative image. That is to say, then, that not only the gesture but also the intention of the photographer is a function of the apparatus.[101]

Functions and Choices

Is there one single action that epitomizes the many decisions and actions required for making a photograph? For most people this 'photographic gesture' is that of the human finger pressing the shutter release button. But this emblematic gesture is necessarily part of a larger gesture wherein a human body holds the camera. In fact, close inspection of any photographic gesture will reveal that the relationship 'man–tool' is almost always reversed here – the human body is not the constant and the tool not the variable. This holds true not only for drone operators or the man driving the Google Street View car. This is the case, if we follow Flusser, with almost every instance of photography.

This fact is today easier to discern. Recently, photographic apparatuses have become even more enmeshed in the human body than ever before. Consider the infamous selfie stick, which is clearly intended as a dual-purpose device: a longer arm and an extended shutter release. Another example is the original design of

Google Glass. It is a wearable device, mounted on the user's nose, which initially offered the ability to photograph not only by pressing a button but also by simply saying, 'Take a picture'[102]. There are now more and more technologies wherein cameras are embedded within our clothing and even within our physical bodies. In other words it is becoming almost pointless to attribute specific functions to either the human or the apparatus. On this matter Marx Warofsky poses a disconcerting question: 'Is the use of the camera going to affect our biological structure, or lead to some biological evolution of the visual system of our species?'[103] Warofsky believes that the answer is no, I suspect that he is wrong. There will be evolution, albeit not a fully biological one. In fact, artificial eye-cameras are in development today and in the future they will become a consumer product.[104] They will utilize technologies that are in principle no different from the prosthetic eyes envisioned by philosopher David Lewis.[105]

And so the question is this: Does the photographer's adaptation to the photographic apparatus, for example the need to adjust one's position to suit the size, the orientation and the timing of the apparatus, imply an alienation of self? Do the technical determinants limit the photographer's gesture or do they render it more powerful because it is performed despite them? And why is fully automatic photography still distinguishable from so-called 'gestured' photography? Because in such cases a human intention supposedly works 'against' the autonomy of the apparatus and does so from within the automatic apparatus itself. But even so we could say that the human photographer is slowly but progressively becoming a new kind of function within the apparatus. In that role he is neither the constant nor the variable but merely a part of the apparatus. Flusser argues, 'It is therefore appropriate to call photographers functionaries'.[106] Is it? After all, Kodak's way of sloganizing photography was to state: 'You Press the Button, We Do the Rest'. And so if Kodak's employees, who were responsible for that cryptic yet crucial 'rest', were called 'photofinishers' then presumably pressers of buttons should be called 'photostarters' – functionaries of another order.[107]

One exception that ought to come to mind is this: self-proclaimed experimental photographers. Such photographers are, we would like to hope, conscious that image, apparatus, program and information are basic problems that need grappling with. Are experimental photographers truly in search of information or are they in search of less ephemeral concepts? Are they consciously attempting to create unpredictable information and thereby perhaps free themselves from the camera's grip? Could they thus place within the image something that is not in its program?

Flusser seems to suggest that one *can* outwit the camera's rigidity, and that one *can* smuggle unforeseen human intentions into its program. He believes that one can force the camera to create the unpredictable, the improbable, the informative, and that one can show contempt for the camera and its creations in order

to turn interest away from 'objects' and to concentrate on information.[108] Thus, for Flusser, freedom is the strategy of making chance and necessity subordinate to human intention. Freedom is playing against the camera apparatus, whenever one is aware. This, argue Gottfried Jäger and Rolf H. Krauss, is the very essence of concrete and generative photography.[109] These forms of photography are, however, the exception that proves the rule. Unfortunately, most photographers, unlike Jäger and Krauss, are not aware that the larger context that they should be operating within is that of apparatuses. Therefore, they rarely notice that there are several ways in which their gestures can address the question of freedom. Flusser's suggestion that with photography we now live in a post-historical fashion has escaped the attention of most photographers.

Photographers select functions and combinations of categories. And they argue that they select and choose freely, as if their cameras follow only their intention. But their choice is limited to the camera's categories and the photographer's freedom remains programmed. Whereas the apparatus operates as a function of the photographer's intention, this intention itself operates as a function of the camera's program. To put it differently, 'In the act of photography the camera does the will of the photographer but the photographer has to will what the camera can do'.[110]

But what about *how* one photographs? Is the same futility at play here? Is this where we may, carefully, speak of free choice in photography? It may seem that in order to choose camera categories, as they are programmed into the camera, a photographer has to 'set up' the camera, and that is a conceptual as well as a technical act. We would like to hope that in order to set the camera up for artistic, scientific and political use, a photographer must have some concept of art, science or politics. How else will he or she be able to translate thought into image? In other words, there is no such thing as naïve, non-conceptual photography. Every photograph is an image of concepts.

On the other hand, we know that all photographers' criteria are contained within the camera's program. Photographers can photograph anything so as long as it exists as part of the 'everything' that is always pre-programmed. The possibilities contained within the camera's program are practically inexhaustible. There can be infinite images, infinite forms of pre-existing imagination: 'The imagination of the camera is greater than that of every single photographer and that of all photographers put together: This is precisely the challenge to the photographer'.[111,112]

In selecting categories, photographers must argue that they bring their own aesthetic, epistemological or political criteria to bear. For it is feasible that for some artistic, scientific or political images, the camera is only a means to an end. But what appears to enable overriding or circumventing the camera is nevertheless always subordinate to the camera and its program. This is how David

Tomas makes the same point: 'all pictures somehow already exist in theory, if not within the system itself, then within its photographic space. Since the photographer's picture making capacity has been channelled in terms of a specific camera design, the photographer is confronted by a device that is a complex spatial matrix of vision that potentially embodies, at the statistical level, all possible [...] photographs'.[113]

This, I believe, is *the* point in John Hilliard's abovementioned 'Camera Recording its Own Condition (7 Apertures, 10 Speeds, 2 Mirrors)'. By drawing our attention to the basic controls (aperture and speed) Hilliard is able to argue, somewhat tongue in cheek, that *whenever* 'reality' is 'depicted' by a camera it can only be depicted with adherence to the camera's predetermined technical specifications (Figure 2).

The Meta-Program

When considering the photographic apparatus in aggregate, we notice that within it there are several interwoven and contradictory programs: one for 'capturing', another for 'control' and possibly a 'transmit' program too. Beyond these there must be many more – those of the photographic industry that programmed the camera; those of the industrial complex that programmed the photographic industry; those of the socio-economic system that programmed the industrial complex; and so on, etc., ad infinitum. In fact, since every program requires a meta-program by which it is programmed, we may conclude that there is no program to rule all apparatuses. The hierarchy of programs is open-ended.[114]

And if the photographic apparatus incorporates photographers, their viewers and the various programs that program the apparatus, the question who owns the apparatus becomes obsolete, does it not? Who holds the power of decision? Flusser argues that it is now the toolmakers, or information programmers in contemporary parlance, who hold the power.[115] What does this mean for photography? For art? What form of criticism can adequately portray these phenomena? Today's vigilante critics claim that society is split into a class of programmers and a class of those being programmed. But even this may be optimistic. 'The programmers', whoever they are, must themselves be subservient to a meta-program:

> The society of the future without things will be classless, a society of programmers who are programmed. This, then, is the freedom of decision made available to us by the emancipation from work. Programmed totalitarianism [...]. Mind you, an extremely satisfying totalitarianism [...]. Hence I get the impression that I am making completely free decisions. The totalitarianism doing the

programming, once it has realized itself, will no longer be identifiable by those participating in it: it will be invisible to them.[116]

If we consider an unembellished history of photography, then we gather that cameras have been invented in order to function automatically and independently of human involvement.[117] In that sense, cameras may be the first true apparatuses. And if this is the intention with which they have been created, then it has been hugely successful. While the human components of photography are progressively being side-lined, the programs of the photographic apparatus, whether seen as combination games or not, are becoming increasingly rich in desirable elements. They go far beyond our human ability to control them or even understand what they do, let alone how. Traditional photography criticism misses this point altogether. It is precisely their tendency to automatically conceal themselves, to become opaque while their artefacts seem to become ever more transparent that needs to be criticized. What is essential to understand is that programs always become autonomous. Flusser's philosophy then uses photography to argue that apparatuses, whatever they are, can and do function independently of their programmer's intentions and increasingly more so.[118]

Horizontal Photography

Most human cultures, it was argued at the beginning of this chapter, are defined by the elaboration and preservation of information. Nevertheless, the procedures for elaborating and preserving information have many tedious aspects. This is why apparatuses have been invented, to process information faster and to preserve it more efficiently than humans can. This is why creativity today rarely depends on the ability to actually fabricate physical objects. But arguably this also means that creativity can no longer be measured exclusively in terms of the ability to fashion cultural objects *intentionally*. Instead it should be understood as the ability to *program* apparatuses, to direct them to culturally desired models and then to halt their independence when these models have been produced.

In the case of photography, however, the question of programming is often elusive. A photographic apparatus, construed in the strictest sense possible, most often contains components that are not located within a single space. Rather, it is always a whole composed of many different components that can be spatially clustered but most often are not. Even the simplest photographic apparatus is composed of a physical body, usually with a lens, a controller or processor, which need not be physically attached to the body, and some other necessary

'protocol'. The latter includes the environment where the photographs can be produced. Previously this used to be called a darkroom;[119] nowadays it is called a computer screen. Thus, the various components of a photographic apparatus are often spatially dispersed, as well as temporally distributed. This means that whatever programming comes into play, it is not generally run by the photographer himself. Rather, it is outsourced and is run elsewhere. As argued earlier, it is often run by programmers. Of those, some design the camera's architecture, others construct its hardware features and some, more recently, write its firmware and software.

In other words the common image of the photographer as a 'lone wolf' is mostly myth. This narrative probably originates from popular twentieth-century histories of photography. The best known of these, Beaumont Newhall's, is a carefully constructed work of fiction devised with the aid of Hollywood screenwriter Ferdinand Reyner.[120] Such emphasis on the unique sensibility of the photographer-as-protagonist has been consecrated by other twentieth-century histories of the medium. Consequently, to this day, it is individual photographic images that are routinely celebrated as markers of a photographer's unique genius. This renders the human photographer, most often the artist-photographer, the almost exclusive prism through which history views the broad sweep of photography, completely ignoring the apparatuses and programs that bring both photographs and photographers into being. Rather, I argue, photographs, at least since the late nineteenth century, are never the result of a one-man show, but always the result of significant *external* programming.

To highlight this point let me briefly discuss the work of one of the only photographers whose work, to my understanding, critically engages with this question. Since 1977, Aïm Deüelle Lüski has been using pinhole cameras, which is a familiar photographic apparatus still popular amongst artists and educators. They do not contain an aperture accommodating the human eye. This means that the photographers are unable to accurately 'frame' their 'shot'. Pinhole cameras also do without proper optical lenses and so the images they generate are never formed tracelessly. Instead they maintain an intrusive presence reminiscent of the shape, edges and overall materiality of the pinhole. For a career of over 40 years this is rare but, in itself, does not make the work noteworthy.

Nonetheless, Deüelle Lüski's cameras are unique in that they are hand-made and custom-built from start to finish, meaning that he uses sculptural techniques to construct the 'body' of the camera and dental drills to open 'lens' apertures in the body. Furthermore, these cameras may contain not one such pinhole opening but often multiple openings, all designed to admit light at the moment of exposure.[121] This generates decentred, blurred, abstract images with many focal points. Furthermore, Deüelle Lüski insists on devising a new camera for every shoot. This

means that he spends weeks or months designing and building a camera that will then be used for no more than a day. Such a work process is, from the standpoint of most photographers, ridiculous. It is, we could say, as outrageous as building a new hammer for every nail. But it is this Sisyphean task that Deüelle Lüski is interested in. He explains this as an attempt to address a philosophical issue: 'It all began the moment I realized one cannot turn the same device at the world in different situations, cannot go on using the familiar device used by all photographers as if it has no essence of its own.'[122]

In 1998 Deüelle Lüski went on to build a 'horizontal camera'. This ended up providing the entire project with its raison d'être – systematic criticism of the vertical in photography. By vertical Deüelle Lüski refers to the practice, prevalent since the discovery of perspective, of having the image form on a vertical plain opposite the lens opening – whether a wall, a sheet of film or a digital sensor. In contrast, the main characteristic of Deüelle Lüski's horizontal photography is always the horizontal placement of the negative, or often negatives, within the camera. This causes the image to be exposed to more light on the edge abutting the aperture, and to receive significantly less light on the farther side. The resulting images are not only non-perspectival, they are also, more often than not, obscurantist. Nevertheless, this does show that the vertical position selected in the past has always been but one possibility. Deüelle Lüski's horizontal photography can thus be understood as problematizing all other forms of photography in that it shows that its components are possible solutions to a single problem: how to produce referential pictures (Figures 10–11).

As unique as this process is, it is nevertheless not free of external programming. Deüelle Lüski has always used commercial film and photo-paper. Either way, his work is, as I have implied, the exception that proves the rule. All other photographers are subservient to even greater degrees of pre-programming. It is this condition, I argue, that defines photography.

One all-too-logical conclusion from the above narrative may unfortunately be this: if the program always subsumes the human photographer's intentionality (or, as it is elsewhere called, his 'subjectivity') it follows that his presence may not always be necessary. The increasing role of automatic production and distribution in photography give this question a sense of urgency it has not always had. It has rightly been argued that 'since automation removes decision making from the photographer it has also resulted in situations that render the agency of the photographer more or less obsolete'.[123] Should we then abandon the myth of 'artistic authorship' with respect to photographic information? Possibly yes if we believe this authorship to be held by the photographer. I shall have more to say about this in the following chapters.

FIGURE 10: Aïm Deüelle Lüski, Ball Camera, 2004.

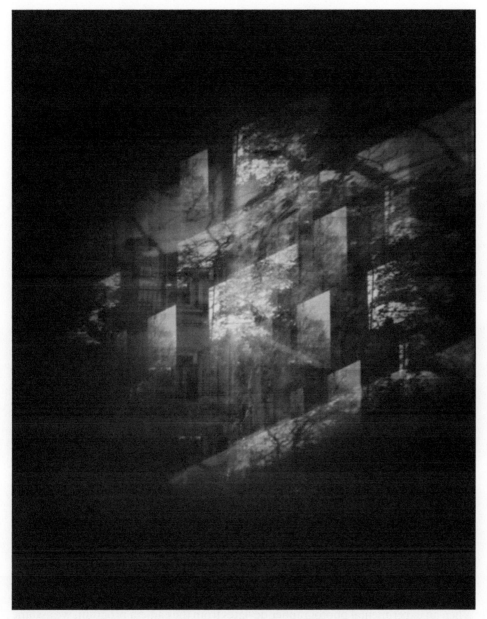

FIGURE 11: Aïm Deüelle Lüski, *Bauhaus Jerusalem #1* (2010). (Photographed with Ball Camera.)

Redundant Photographs, Informative Photographs

The illiterate of the future will be ignorant of the use of camera and pen alike, argued László Moholy-Nagy.[124] But *how* does one use a camera in yesterday's future? And who (or what) uses it? In thinking about contemporary photography we may distinguish between three types of photographs: ones made by fully automated cameras, such as speed cameras, Google Street View, NASA satellites, military drones and many medical imaging devices; popular or 'amateur' ones, such as we all are forced to take with our cameras, phones and other everyday devices; and experimental ones taken by artists and scientists. The first type carries information programmed by humans and elaborated by an apparatus. The third carries information intended by the photographer, and this intention may be opposed to the apparatus's programmers. It is the second type that is most confusing.

Popular cameras enable their owners to keep on making images. Some of them even demand this. But these images cannot be informative. In fact they are progressively more redundant. Flusser refers to this prophetically as a 'photo-mania'.[125] such that many societies can now see the world, and in it themselves, only through the camera and in photographic categories. And so, one is obliged to wonder whether most 'photographers' are in charge of the photographs they are taking. Have they become an extension of the button on their cameras, with any and all of their actions being automatic? Thus, the information certain photographs carry has not been intended by the photographer at all but only by the camera programmer. These photographs can be understood as virtualities within the camera program realized through a *conditioned reflex*.

The result is a constant flow of images that have been created practically unconsciously. But what is the collective memory generated by the cameras? Is a photo album ever more than just a database of pre-programmed functions? This leads to the crucial question of interaction with information. To demonstrate this, we can consider 'bad' amateur photographs who are often more interesting than most 'good' ones, as their images owe their information, their existence, to a deviation from the program, possibly even an error as far as some programmers and program functionaries are concerned. In this sense these unpopular popular photographs are somewhat like experimental ones. When an experimental photographer deviates from the camera program, we assume that this is done intentionally, even if this may not always be the case.

Deviant Programs

As suggested, photographic programs tend to deviate and break loose from human intention. How exactly does this happen? And should this scenario

be feared or embraced? As noted, all apparatuses operate automatically, even those incorporating a human factor. Given sufficiently long time, an apparatus will realize all virtualities within its program. But in so doing, apparatuses can also deviate from their intended program, thus arriving at a situation often described as error. And when this deviation occurs, is it not to be considered as a part of the meta-program? And if apparatuses can, in some circumstances, continue to work outside their humanly determined program, what is their error-enabling meta-program then called? Should a renegade apparatus be called 'nature'?

A recent case highlighting the relevance of these questions is that of the 'Monkey Selfies': a series of headshots and full body images of a female crested macaque monkey. Supposedly, it is the monkey who took these photographs in 2011 when she seized a camera from a human photographer and absconded with it. Having somehow retrieved the camera, the photographer licensed some of the resulting images to a news agency under the presumption that it is he who held the copyright (Figures 12). Shortly afterwards, however, this claim was disputed on the grounds that it is the monkey who took the images and since a monkey is not a legal entity capable of holding a copyright, the images belong in the public domain. Consequently, the images later found their way into the multimedia repository Wikimedia Commons, which only accepts media licensed under a free content license, or, in other words, ineligible for copyright protection.[126]

What is most interesting here is not so much the copyright controversy, but the fact that there was a controversy in the first place, that this was even seen as an erratic occurrence. Certain consumer cameras run a program called 'wildlife photography' or 'nature photography'. Nature runs other programs. There 'nature photography' is neither a cause nor a desired effect. The copyright, in other words, does not belong to the photographer or to the monkey. It belongs, if anything, to nature – the supreme, and only autonomous meta-programmer.

Earlier I demonstrated how nature has always been a contested term. Understanding nature as a program may in fact help rectify some confusion associated with using it in reference to photography. Seen this way, all image-making mechanisms become, more than anything else, attempts to retrieve informative situations from within nature's movement towards entropy. They are, in that, as probable and improbable as the 'Monkey Selfies'. Thus, every humanly generated image since the prehistorical cave paintings and all human 'reservoirs of information' for that matter are negentropic: unexpected outcomes achieved by deliberately *contravening* nature's intended program. This is as valid a definition of art as any.

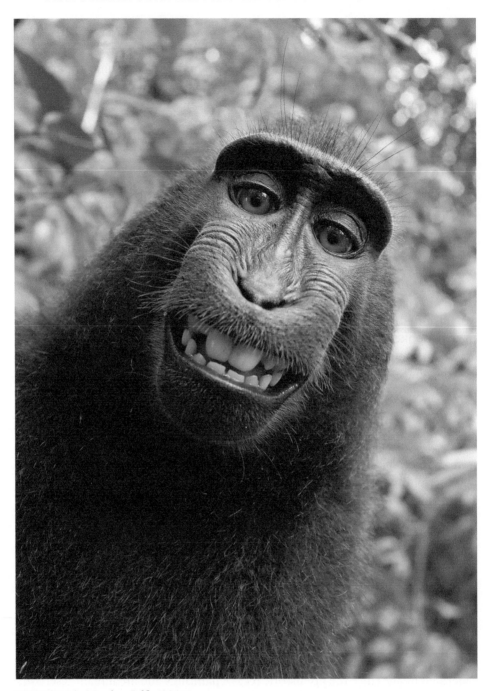

FIGURE 12: *Monkey Selfie* (2011).

Nature and Memory

Many kinds of new information have resulted from contraventions or simply errors in nature. In fact, new biological species arise through mutations, or errors in the transmission of genetic programs. Errors, in other words, are generative of many new forms of information. Most are eliminated from the genetic program, by very complex processes. These are called unfeasible mutations. Occasionally errors escape these processes and constitute what is called biological evolution.

Some species, such as ours, have supposedly benefited from improvements in their genetic information. This is why optimists consider evolutionary change to be necessarily positive. Of course, this is not always the case. This gives rise to another problem: memory storage and transmission of memory. If, in Flusser's terminology, memory is defined as 'information storage' and if, as indeed he argues, memories are to be found all over nature,[127] then from the point of view of memory, natural evolution is not a desirable process at all. Put differently, if nature can be seen as a cluster of flexible data, then it is *not* a trustworthy custodian of memory because it is subject to 'errors' and so always liable to process rather than preserve information. This, to reiterate, is another reason why the traditional Turin Shroud model of photography should be rejected. Because photographic information always emerges from a program, and always bears the mark of programming, it should always be understood as subject to processing, as opposed to mere copying or transference. And so in my view, that which some see as a lurking danger is in fact photography's greatest gift. In Chapters 4 and 5 I shall propose that a more generous and inclusive conceptual model for photography is possible: a universal Turing machine.

For the time being, an easy way to explain this idea is with examples from two other fields: genetic engineering and artificial life. If these fields are taken as art forms, and if the artificial organisms they produce are considered art works, then information processing prior to transmission unleashes a plethora of intriguing artistic possibilities. The challenges of genetic engineering are, in other words, not so far removed from theoretical questions of photography.[128] The problem can also be formulated as follows: apparatuses are programmed so as to generate, among other things, improbable situations or in Flusser's words, 'consolidate invisible possibilities into visible improbabilities'.[129] This means that improbable situations sometimes *are* in the apparatus' program and do not arise as errors but as situations that are deliberately sought, that become more probable while the program is running. Anyone who knows the program can therefore potentially predict these situations. And everyone else is faced with the following contradiction: clusters of information that are both probable *and* improbable. For something, let's say an image, can be produced by an apparatus in a manner that is completely in keeping with its program. In that sense, it is entirely probable and thus uninformative. However, that very same image may

be completely improbable from another standpoint – that of a different apparatus or another program, which is, as always, part of a meta-program.

Automatic apparatuses are necessary. We compose our illusions from that which would be neither visible nor comprehensible if we did not have them. These are what we call technical images. But technical images can also be produced in a way that makes them redundant and predictable, uninformative from the standpoint of our program. This is the danger that awaits every producer of technical images. This problem is, we could say, a mutated version of the famous halting problem.[130] Here the apparatus continues to operate, even when the desired result has been achieved, and thereby produces undesired results. How can producers of technical images know when to stop? Arguably, this is easier when the photographic apparatus is understood to have only one program – the Turin Shroud. Here the merits of the desired result are clear. But when the photographic apparatus can run multiple programs – as does a universal Turing machine – this becomes harder and more fascinating.

Programs process everything in ways to which we are oblivious. This is why the photograph is prototypical of any and all technical images – being as they are always 'a blindly realized possibility, something invisible that has blindly become visible'.[131] Some technical producers can see despite the apparatus' blindness. They can do so if they are determined to control it, to overcome its tendency to become more and more automated. They intentionally work with and around the apparatus to make it stop at informative junctions, thus trying to turn it against its own condition of being automatic. Flusser calls such producers 'envisioners', to distinguish them from those who produce traditional images. Envisioners visualize, they do not depict.

Envisioning Virtuality

Understood this way, it is feasible that photography can be used for producing visions that have never existed before. To envision these situations, photographers must pursue images that are not 'out there in the world' but within their apparatus. Nowhere is this more easily explained than with the example of colour photography. Viewers are routinely confronted with both colour and black-and-white photographs. The former supposedly correspond to coloured states of things but what do the black-and-white ones correspond to? Needless to say, they do not correspond to black-and-white states of things.[132] May it simply be suggested that these images signify concepts in the photographic program, concepts that have arisen through information processing? If this is possible then, in the program called optics, 'black' and 'white' can simply be theoretical concepts: 'As black-and-white states of things are theoretical, they can never actually exist in the world. But black-and-white photographs do actually exist because they are images of

concepts belonging to the theory of optics, i.e. they arise out of this theory'.[133] Seen this way white is the total presence of all oscillations contained within visible light, whereas black is the total absence of all such oscillations.[134]

Even so, colour photography is no less conceptual. The history of photography tells the story of a technical challenge that has been overcome, that of the theory of chemistry: 'The green of a photographed field, for example, is an image of the concept "green", just as it occurs in chemical theory, and the camera (or rather the film inserted into it) is programmed to translate this concept into the image'.[135] However, not all green fields stay green. In a photograph by the Irish photographer Richard Mosse, a green field can very well be pink or purple. Mosse uses the traditional, and now all but extinct, technology of infrared film photography. His photographs are so compelling precisely because they relieve the viewer of the burden of equating a green patch of photograph to a green patch of world. The viewer is thus freed to recognize that whereas the infrared-generated pink is probably not 'real' (because jungles mostly are green) the circumstances and events narrativized in the images are. Put differently, when reality or any one of its ontological proxies appear 'realistic', they are also dismissible. On the other hand when reality appears dramatized, it becomes a political currency. In terms of coloured fields there is now yet another challenge, that of computing, where colour in photography continues to be an abyss of pleasure and pain.[136] In fact, it now looks as if photography, which has first extracted colours from this world, is now smuggling them back in with a vengeance.

None of the above statements imply that there is no connection between the green of a field and the green of a photograph. Nevertheless, even when the connection is there, it is distal at best. Between them there is an entire series of complex encodings. These encodings, or more simply concepts, overwhelm the viewer, irrespective of whether the photograph in question has been produced by chemical or computational means. They are always far more complex than those that govern the connection between the grey of a field photographed in a black-and-white photograph and the actual green of the field. In this sense, a field visualized in green is even more abstract than a field visualized in grey. Thus, the more authentic a colour palette, or today a colour profile, the more 'untruthful' the colours of a photograph become. There is no sense in talking about 'true-to-life' colour; there is only 'true-to-colour' life. Hilliard's *Seven Representations of White* and *Seven Representations – Colour Negative Boxes* demonstrate this clearly (Figures 13–14).[137]

The magic in photography is that it quite simply re-encodes theoretical concepts such as 'colour' or 'perspective' and presents their linear discourse as a necessary 'state of things' and then a surface. This conceptual magic has intrinsic charm, and this is why we can still enjoy black-and-white photographs – because they reveal ever so clearly that photographs have significance and that

FIGURES 13 & 14: John Hilliard, *7 Representations – Colour Negative Film Boxes*, 1972. C-type colour photos on card, 30 x 280 cm (detail). Courtesy of the artist.

this significance is, more than anything, fantasy. The same can be said for any standard of photography, as it always represents transcoded and often multi-faceted concepts. One integral deception is common to all such transcodings, however – the claim of having been 'reflected' from the world and 'automatically' at that. It is precisely this common factor that has to be identified and decoded, so as to understand that with every photograph one is always dealing with a symbolic form made of abstract concepts. Only a discourse capable of acknowledging and communicating that will be able to acknowledge that the 'true' significance of photography is no less conceptual and manipulative than that of other symbolic structures.

To that extent, every photograph can be defined as corresponding to a distinct combination of elements in the camera's program, or in the program of the photographic complex. From this point of view, traditional terms such as 'search' and 'find', 'capture' and 'document', often used with respect to photography, all lose their effectiveness. In my view, search and manipulation are one and the same gesture, even if most photographers would not and need not admit it.[138] Manipulation is always a pre-written possibility within a programmed situation. Many types of photographs demonstrate this. For, in that sense, what *is* the difference between the traditional use of infrared photography to reveal hidden archaeological layers and newer technologies such as space archaeology or LIDAR and time-of-flight cameras[139] designed to facilitate the remote 'sensing' of invisible archaeological layers and geological substances? And is there a difference between infrared photography and the photograph taken at sunset to reveal forms that are imperceptible in sunlight at noon? In that sense, photography is just like philosophy or physics – one can never take up a position without manipulating the situation.

All Technical Images Are Visualizations

If the world is, to a considerable extent, a pretext for possibilities to be realized, possibilities contained within the camera's program, how do we define realism and is there even use for this term anymore? Is it possible that in the case of photography the convoluted definitions of realism and idealism are not only conflated but also overturned? Might the world and the camera be only preconditions for the image – pre-programmed possibilities to be realized? Maybe it is not 'the world' out there that is real, nor are concepts derived from the world within the camera's program. Those are simply idealizations. Maybe only the photograph is real? [140,141]

Before the advent of fully synthetic, that is mathematical images, it appeared that all technical images arose through the fairly straightforward processes of

photography: the capturing of reflected light, emitted light or other electromagnetic radiation from existing states-of-affairs. For this reason, it was easy to claim that photographs, and subsequently all technical images, are depictions of a world that was their meaning, in one way or another. But in the context of environments flooded with synthetically generated images, this explanation can no longer be sustained.

Synthetically generated images can potentially arise through the capturing and holding of approaching particles but this stage of their inception cannot be understood as definitive of their process. Therefore, it becomes increasingly difficult to argue that they too are depictions from and of their environments. As a result, we currently distinguish between two supposedly different sorts of technical images: those that depict and those that model. The former can be of 'what there is' – real world objects, existing states-of-affairs etc. (if one so cares to believe). The latter are usually of 'what could be' – for example, environments of the future, aeroplanes yet to be built and such like – 'what will be'.

But the distinction between realized and unrealized possibility is murky at best. Flusser makes this very clear: 'What do I actually mean when I say a photograph of a house depicts that house, and a computer image of an airplane yet to be built is a model? Do I perhaps mean that the house is somewhere out there, that is, real, and the airplane somewhere here inside and so only possible? Do I mean that the photographer discovered the house and the computer operator invented the airplane?'[142] The causal argument contends that the house is the reason for the photograph – it was there before it was photographed, and the rays of light that reflected from it caused the photograph. But how then does the causal argument explain the airplane? Is it perhaps the outcome and one possible effect of the computer-generated image? Meaning that an image was there first, possibly a 'quasi-photographic' image, and the airplane was made as a result of the image?[143] As I have previously argued, such simplistically linear causal explanations do not hold up – houses depicted in photographs are *not* real, just as not every computer-generated model is practicable or intended to be.

I am not claiming that the level of existence of a house on the street and that of an airplane yet to be built are indistinguishable. But one should maintain that today, more than ever before, it is futile to attempt to distinguish between a depiction and a model of that existence: 'Any way I formulate the difference between depiction and model, I come to grief'.[144] We should therefore think of photographs as models in exactly the same sense that computer-generated images are. And both types of models are, in different ways, representations, but *only* insofar as we take representations to be *just* a manifestation of calculable concepts.

In fact, Lev Manovich has even gone as far as to argue that synthetic visualizations can be *more* realistic than traditional photographs. This is for one plain

reason: the program called synthetic imaging is simply more versatile and is burdened with fewer limitations. The synthetic image, he argues: 'can have unlimited resolution and an unlimited level of detail […]. From the point of view of human vision it is hyperreal. And yet, it is completely realistic'.[145] This view may be somewhat surprising but it is very much supported by Flusser's theory. Flusser in fact recommended relativizing the term 'real' in accordance with its resolution into dot elements: 'thus something is more real according as the dot distribution is denser, and more potential the sparser this is'.[146] Accordingly I shall propose in Chapter 4 that the difference between depiction and model, between photograph and other forms of media, can today be indicated only in terms of granularity and resolution.

To summarize, photography can visualize a house as houses seem to be in the objective world. Its calculable concepts are, for example, 'linear perspective,' 'film stock' or 'colour'. The photographic apparatus, of which the photographer is only a function, calculates these concepts automatically, processing the vision of the house into an image. Similarly, computer graphics visualize an airplane just as one might be found in the outside world. Its apparatuses operate through concepts such as 'virtual perspective,' 'relative luminance' or 'chroma keys', which are then calculated automatically and result in a visualization of an airplane that appears on the screen. Depictions are visualizations just as models are. No matter which form they take, they are not reproductive but productive images:

> The same power to envision is at work in both cases, that of the photographer and of the computer operator […] And so in considering technical images, it makes no sense to try to distinguish between representations and models. All technical images are visualisations.[147]

Photographic Post Photographism

This chapter began with the Flusserian view of cultural evolution as the process of increasing levels of signification and codification. According to this narrative, photography is the pinnacle of abstraction – representing the abolition of the last remaining natural dimension. As such, it is somewhat pointless to compare it to traditional aesthetic outputs like painting. Building my argument on Flusser's, traditional outputs operate only on the basis of criteria like beauty and truth, which are now rendered irrelevant. In their place, photography introduces the new criteria of *information* and *program*. This shift has a paradigmatic influence on aesthetics as it undermines most concepts of artistic worth. The reason is deceptively simple: if beauty and truth are also a function of information then a beautiful or truthful picture may be redundant.

Furthermore, according to Flusser, these criteria can now be seen as having inescapable influence over all levels of human society. The photograph is the first of the post-industrial objects, even when it is not yet fully synthetic. Its value lies not in its body but only in the information on its surface. From here on, whatever determines value is not the thing but rather the information it stores. Post-industrial culture, in other words, differs from industrial culture in that its objects are nothing more than supports for programmed information. In that sense, photography becomes the prototype for all ontologically conditioning technical apparatuses of present-day post-industrial society. Accordingly, Andreas Müller-Pohle[148] has contended: 'photography *informed* culture so totally, so globally, that we can call it, essentially, a *photographic information culture*'.[149]

Notwithstanding, it has recently been argued that information technology is 're-ontologizing the world'.[150] Whether we like it or not, this is an idea we all must stomach. Therefore, should it be a surprise that photography, like other apparatuses and programs within our society, has undergone a profound shift? Perhaps not. Photography, I argue, has *itself* been de-ontologized into a set of computer programs. In fact, as early as 1985, Müller-Pohle also contended that: 'Where photography once brought Traditionalism to its end, computer technology is similarly entombing the ideas of Photographism [...]'.[151]

Müller-Pohle's statement may seem overly polemic, albeit intentionally, because the transition from 'analogue' to 'digital' platforms in photography has been relatively smooth, perhaps too smooth. This transition, in like fashion to earlier episodes in the history of photography, has taken place within established pictorial conventions. As a consequence, even the most extreme of synthetic visualizations are still measured in terms of existing paradigms of naturalism and realism. In other words, imperative questions relating to the construction of new photographic and quasi-photographic apparatuses have not figured prominently in the theoretical repertoire of what is now being called post-photography. These will be posed in Chapter 4 and answered in Chapters 4 and 5. The answers harbour the potential of transforming how we conceive photography, imaging and even art.

NOTES

1. Vilém Flusser, 'What Is the Literal Meaning of "Photography"?', [Was Meint Buchstablich 'Fotographie'?] *European Photography* 12, no. 3 (1991).
2. Strictly speaking, X-rayography is not photography simply because X-rays are a type of electromagnetic radiation from outside the visible spectrum, meaning they are not light. This difference, however, seems to matter very little in most cultures. The widespread use of

the technically incorrect expression 'X-ray photography' seems to suggest just that. Another important historic example for 'photographic' imaging without 'photo' is imaging with nuclear radiation and its effects. This technology was 'invented' by Henri Becqurel when he placed a crystal of uranium salt on a sheet of photo paper in the lab, only to discover that it, like some other chemical elements, emits radiation that is also detectable by 'photo' technologies. Today we might also mention positron emission tomography (PET scans), computerized tomography (CT), infrared technology (thermography), astronomy, remote sensing space archaeology and various other old and new technologies that utilize energies and forces that have very little to do with light. I shall have more to say about such technologies in Chapter 4.

3. Flusser, 'What Is the Literal Meaning of "Photography"?', 45.

4. Thomas S. Kuhn, *The Structure of Scientific Revolutions* (Chicago: University of Chicago Press, 1962).

5. William J. Mitchell, *The Reconfigured Eye: Visual Truth in the Post-Photographic Era* (Cambridge, MA: The MIT Press, 1994).

6. Hubertus von Amelunxen, Stefan Iglhaut and Florian Rötzer, eds., *Photography after Photography: Memory and Representation in the Digital Age* (Munich: G+B Arts, 1996).

7. Fred Ritchin, *After Photography* (New York: W.W. Norton & Company, 2009).

8. 'Is Photography Over?', https://www.sfmoma.org/watch/photography-over/.

9. 'The Post-Photography Prototyping Prize (P3)', https://www.fotomuseum.ch/en/explore/p3/.

10. Florian Ebner and Christian Müller, eds., *Farewell Photography: Biennale Für Aktuelle Fotografie 2017* (Mannheim: Biennale für aktuelle Fotografie e.V., 2017).

11. Vilém Flusser, 'Our Programme', *Philosophy of Photography* 2, no. 2 (2011): 205.

12. Claude E. Shannon, 'A Mathematical Theory of Communication', *The Bell System Technical Journal* 27, no. July, October (1948).

13. Max Bense, *Aesthetische Information: Aesthetica (Ii)* (Krefeld: Agis-Verlag, 1956); Abraham A. Moles, *Information Theory and Esthetic Perception*, trans. Joel E. Cohen (Urbana: University of Illinois Press, 1966).

14. Alan M. Turing, 'On Computable Numbers, with an Application to the *Entscheidungsproblem*', *Proceedings of the London Mathematical Society* 42, no. 2 (1936).

15. Flusser, 'Our Programme', 208.

16. The programmatic image is so overarching that it engulfs any and every view and does not allow any another image to stand alongside it: 'If we consider the models applied within these fields from a programmatic perspective, we will find that the second principle of thermodynamics (according to which the universe is an entropic process) applies to its cosmology. In anthropology, molecular biology (according to which the structure of particular nucleic acids contains all possible organic forms) applies. In ethology, analytic psychology (according to which human behaviour manifests particular virtualities contained within the subconscious) applies. And if we extend the programmatic image to other fields (logic, linguistics, sociology, economy, politology, etc.), we will find everywhere that all models are of the same type: they are programmes'. Ibid., 206–07.

17. Ibid., 206.

18. This theorem was introduced by the French mathematician Émile Borel in 1913. Today it is commonly referred to as the Borel's monkeys thought experiment. Variations of this theorem date back to as early as Aristotle.

19. Quoted in: Anke K. Finger, Rainer Guldin and Gustavo Bernardo, *Vilem Flusser: An Introduction* (Minneapolis: University of Minnesota Press, 2011), 19.

20. Vilém Flusser, *Bodenlos: Eine Philosophische Autobiographie* (Köln: Bollman Verlag, 1992), 220–21.

21. Sean Cubitt, 'Review of the Shape of Things: A Philosophy of Design, Towards a Philosophy of Photography, Writings, and the Freedom of the Migrant: Objections to Nationalism', *Leonardo* 37, no. 5 (2004): 403.

22. Note that the texts that have been translated into English are mostly about media. Other parts of his oeuvre are only now being translated into English. As of 2019, there are still numerous essays in German and Portuguese that remain untranslated.

23. There are a few passages where Flusser describes his work method as a process of repeated translations to and from an image. The earliest such passage that I am aware of is from 1970: 'Traditionally, thinking goes something like this: I encounter something concrete. I form an image of this concrete thing (I 'imagine' it), so as to acquaint myself with it. And then I translate my image into a concept, so as to understand the concrete thing and be able to handle it'. Quoted in: Nancy Ann Roth, 'Mira Schendel's Gesture: On Art in Vilém Flusser's Thought, with "Mira Schendel" by Flusser', trans. N. A. Roth, *Tate Papers*, no. 21 (2014). Nancy Ann.

24. Ian Verstegen, 'What Can Arnheim Learn from Flusser (and Vice Versa)?', *Flusser Studies*, no. 18 (2014).

25. See Mark Poster's introduction to: Vilém Flusser, *Into the Universe of Technical Images*, trans. Nancy Ann Roth (Minneapolis: University of Minnesota Press, 2011); *Does Writing Have a Future?*, trans. Nancy Ann Roth (Minneapolis: University of Minnesota Press, 2011).

26. Sjoukje van der Meulen, 'Between Benjamin and Mcluhan: Vilém Flusser's Media Theory', *New German Critique* 110, no. 110 (2010).

27. To the best of my knowledge, Benjamin never used the term 'media'. It was most probably Marshall McLuhan who popularized the term with the 1964 publication of his book *Understanding Media*. McLuhan was thus probably the first to undertake the cultural task of theorizing the 'new' media of television and the computer in place of the 'old' media of photography and film. Marshall McLuhan, *Understanding Media: The Extensions of Man* (London: Routledge & Kegan Paul, 1964).

28. This is one of the most noteworthy ides in 'The Work of Art in the Age of Mechanical Reproduction'. This, according to Benjamin, is a key ingredient of both capitalism and fascism. Walter Benjamin, *The Work of Art in the Age of Its Technological Reproducibility, and Other Writings on Media*, trans. Edmund Jephcott, Rodney Livingstone, and Howard Eiland (Cambridge, MA: Belknap Press of Harvard University Press, 2008).

29. According to Benjamin, the Marxist counteraction to 'the aestheticization of politics' should be 'the politicization of the aesthetic', which can be conducted in two ways: by identifying and resisting the ways in which art is exploited and by identifying its revolutionary potential. Ibid.

30. Marshall McLuhan, *The Gutenberg Galaxy: The Making of Typographic Man* (Toronto: University of Toronto Press, 1962).

31. Flusser's conception of the end of history is also very different from Francis Fukuyama's, which alludes to a Hegelian philosophical tradition wherein history is a continuous, dynamic process within a dualistic world order. For Fukuyama the collapse of socialism and the 'victory' of market-oriented democracy over communism signify the negation of the dualistic world order. Thus, he argues, an equilibrium has been achieved – the 'end' of all history. Flusser, on the other hand, identifies (or rather calls out) the end of the conditions that made history possible in the first place. Francis Fukuyama, *The End of History and the Last Man* (New York: Avon Books, 1993).

32. Vilém Flusser, 'Photography and History', in *Writings*, ed. Andreas Ströhl (Minneapolis: University of Minnesota Press, 2002), 128.

33. Friedrich A. Kittler, *Optical Media: Berlin Lectures 1999*, trans. Anthony Enns (Cambridge, UK: Polity Press, 2010), 226.

34. Vilém Flusser, 'On Memory (Electronic or Otherwise)', *Leonardo* 23, no. 4 (1990).

35. In Bishop Berkeley's lexicon this was called a perceiver.

36. 'Storage and transmission facilities made of flesh and blood do not last'. Friedrich A. Kittler, 'Rock Music: A Misuse of Military Equipment', in *The Truth of the Technological World: Essays on the Genealogy of Presence* (Stanford: Stanford University Press, 2013), 153.

37. I note that the distinction between 'oral' and 'literate' cultures, on which both Flusser and Kittler rely, risks repeating some of the most pernicious and deeply ethnocentric accounts of human history, in which indigenous peoples are positioned as being 'without history' insofar as they lack 'written' history. Yet the longevity of such societies – not least in what has only recently come to be called 'Australia' – vastly exceeds what has so far been achieved by so-called historical societies.

38. The above examples are taken from Victor Burgin who names these types of stone in reference to various 'use values'. Flusser's concept of information is, as I shall soon demonstrate, slightly different. Victor Burgin, 'Photographic Practice and Art Theory', in *Thinking Photography*, ed. Victor Burgin (London: Palgrave Macmillan, 1982), 45.

39. Flusser, *Into the Universe of Technical Images*, 11.

40. Ibid., 12.

41. Ibid., 13.

42. Flusser, 'On Memory (Electronic or Otherwise)', 398.

43. Ibid., 397.

44. Michel Foucault, *The Order of Things: An Archaeology of Human Sciences*, trans. Allan Sheridan (New York: Vintage Books, 1973); Walter J. Ong, *Orality and Literacy: The Technologizing of the Word* (London: Methuen, 1982); Jacques Derrida, *Archive Fever: A Freudean Impression*, trans. Eric Prenowitz (Chicago: University of Chicago Press, 1996).

45. Flusser, 'On Memory (Electronic or Otherwise)', 397.

46. Vilém Flusser, *Towards a Philosophy of Photography* (London: Reaktion, 2000), 11.

47. Ibid.

48. Flusser, *Does Writing Have a Future?*, 147.

49. Flusser, *Towards a Philosophy of Photography*, 12. Remarkably, Flusser's term 'metacode' is what we now call metadata.

50. Rosa Menkman, 'A Vernacular of File Formats', https://beyondresolution.info/A-Vernacular-of-File-Formats.

51. As implied earlier, Kittler's work is also crucial to this argument. Friedrich A. Kittler, *Gramophone, Film, Typewriter*, trans. Geoffrey Winthrop-Young and Michael Wutz, Writing Science. (Stanford: Stanford University Press, 1999).

52. Flusser, *Into the Universe of Technical Images*, 47. Emphasis mine.

53. Paul Virilio makes a similar though less developed argument: 'The age of the image's formal logic was the age of painting, engraving and etching, architecture; it ended with the eighteenth century. The age of dialectic logic is the age of photography and film or, if you like, the frame of the nineteenth century'. Paul Virilio, *The Vision Machine*, trans. Julie Rose (Bloomington: Indiana University Press, 1994), 63.

54. Kittler, *Optical Media: Berlin Lectures 1999*, 227.

55. Vilém Flusser, 'The Photograph as Post-Industrial Object: An Essay on the Ontological Standing of Photographs', *Leonardo* 19, no. 4 (1986): 329.

56. Please note that the definition of object here is similar though not identical to the definition of object in Chapter 1 ('the photographed object'). However, the terms 'cultural object', 'industrial object' and 'post-industrial objects', which I shall now develop, are significantly more complex.

57. From French. An *objet trouvé* is an undisguised 'found' object with a previous 'non-art' function, now considered an artefact.

58. Flusser's decision to ask if the camera is a type of needle is, I find, a way to wink at his readers as if to say 'Yes, I too have read Roland Barthes, the camera may prick but the punctum doesn't'. Flusser, *Towards a Philosophy of Photography*, 23.

59. Ibid.

60. In other words, the entire industrial complex is to be seen as a machine, whereas a power loom, for example, is a machine tool.

61. Flusser, *Towards a Philosophy of Photography*, 24.

62. Sol LeWitt, 'Paragraphs on Conceptual Art', *Art Forum* 1967; Frieder Nake, 'Paragraphs on Computer Art, Past and Present' (paper presented at the 'Ideas Before Their Time: Connecting Past and Present in Computer Art' conference, London, 2010).

63. Flusser, *Towards a Philosophy of Photography*, 7.

64. Vilém Flusser, 'The Codified World', trans. Erik Eisel, in *Writings*, ed. Andreas Ströhl (Minneapolis: University of Minnesota Press, 2002), 39.

65. Ibid.

66. Mark Poster in the introduction to: Flusser, *Into the Universe of Technical Images*, xiii.

67. Friedrich A. Kittler, 'Perspective and the Book', *Grey Room* 5 (2001): 39.

68. 'Writing, in the sense of placing letters and other marks one after another, appears to have little or no future'. Flusser, *Does Writing Have a Future?*, 3.

69. Flusser, *Towards a Philosophy of Photography*, 18.

70. Flusser, 'Photography and History', 128.

71. John Szarkowski, *Mirrors and Windows: American Photography since 1960* (New York: Museum of Modern Art, 1978); Kendall L. Walton, 'Transparent Pictures: On the Nature of Photographic Realism', *Critical Inquiry* 11, no. 2 (1984).

72. Flusser, *Towards a Philosophy of Photography*, 15.

73. This applies to humans only. In contrast, when machine vision 'reads' an image it usually follows protocols of analysis and operation that do require movement from top to bottom (or vice versa) and from left to right (or vice versa).

74. Briefly, according to Heidegger, temporality is a unity against which past, present and future stand out as 'ecstases' while remaining essentially interlocked. The importance of this idea is that it frees the phenomenologist from thinking of past, present and future as sequentially ordered groupings of distinct events. Martin Heidegger, *Being and Time*, trans. John Macquarrie and Edward Robinson (London: SCM Press, 1962).

75. Flusser, 'Photography and History', 129.

76. Flusser, *Into the Universe of Technical Images*, 10.

77. Even today, in spite of growing interest in Flusser's scholarship, critical attention is often oblivious to the fact that this book represents a much larger oeuvre.

78. Flusser, *Towards a Philosophy of Photography*, 81–82.

79. Ibid., 76.

80. 'Historically, traditional images precede texts by millennia and technical ones follow on after very advanced texts. Ontologically, traditional images are abstractions of the first order insofar as they abstract from the concrete world while technical images are abstractions of the third order: They abstract from texts which abstract from traditional images which themselves abstract from the concrete world. Historically, traditional images are prehistoric and technical ones "post-historic" [...] Ontologically, traditional images signify phenomena whereas technical images signify concepts'. Ibid., 14.

81. Ibid., 17.

82. 'You Press the Button, We Do the Rest' was Kodak's advertising slogan, coined by George Eastman in 1888.

83. In this regard, it is the opposite of the game of chess, which is structurally simple and functionally complex (that is, even though its structure and rules are relatively simple,

every game embodies infinite possibilities). Vilém Flusser, 'The Democratization of Photography', in *Something Other Than Photography: Photo & Media*, ed. Claudia Giannetti (Oldenburg: Edith-Russ-Haus for Media Art, 2013), 132.

84. A similar and intriguing distinction is made by Andy Clark when he refers to 'transparent' and 'opaque' technologies. Andy Clark, 'Technologies to Bond With', in *Rethinking Theories and Practices of Imaging*, ed. Timothy H. Engström and Evan Selinger (London: Palgrave Macmillan, 2009).

85. Joel Snyder and Neil Walsh Allen, 'Photography, Vision, and Representation', *Critical Inquiry* 2, no. 1 (1975); Joel Snyder, 'Picturing Vision', *Critical Inquiry* 6, no. 3 (1980).

86. Flusser, 'The Photograph as Post-Industrial Object: An Essay on the Ontological Standing of Photographs', 330.

87. Flusser, *Towards a Philosophy of Photography*, 26.

88. Shannon, 'A Mathematical Theory of Communication'.

89. Notably, while studying at MIT in the late 1930s, Shannon also worked on Vannevar Bush's differential analyser, an early version of an analogue computer.

90. Flusser, 'The Photograph as Post-Industrial Object: An Essay on the Ontological Standing of Photographs', 330.

91. Roland Barthes, 'The Photographic Message', in *Image, Text, Music*, ed. Stephen Heath (New York: Hill and Wang, 1977).

92. Ibid., 19.

93. Flusser, *Towards a Philosophy of Photography*, 30.

94. Friedrich A. Kittler, 'Thinking Colours and/or Machines', *Theory, Culture & Society* 23, no. 7–8 (2006): 49.

95. Quoted in: van der Meulen, 'Between Benjamin and Mcluhan', 193.

96. This aspect of Flusser's philosophy of photography indeed resonates with some familiar postmodernist strands of thought.

97. Burgin, 'Photographic Practice and Art Theory', 40.

98. Flusser, *Towards a Philosophy of Photography*, 26.

99. There are several instances wherein Flusser suggests that photography can be compared to the game of chess. In that sense the photographer struggling against automatic programming can be compared to Garry Kasparov battling 'Deep Thought' (a computer designed to play chess, named after a fictional computer in Douglas Adams' series *The Hitchiker's Guide to the Galaxy*). 'Deep Thought' was initially developed at Carnegie Mellon University and later at IBM. It was surprisingly defeated in both games of a two-game match with Garry Kasparov in 1989.

100. Flusser, 'The Photograph as Post-Industrial Object: An Essay on the Ontological Standing of Photographs', 330.

101. Flusser, *Into the Universe of Technical Images*, 20.

102. 'Google Glass Help', Google, https://support.google.com/glass/answer/3079688.

103. Marx Wartofsky, 'Cameras Can't See: Representation, Photography and Human Vision', *Afterimage* (April 1980): 8.

104. On this note, please also see: 'Direct to Brain Bionic Eye', Monash University Vision Group, http://www.monash.edu.au/bioniceye/technology.html.

105. David Lewis, 'Veridical Hallucination and Prosthetic Vision', *Australasian Journal of Philosophy* 58, no. 3 (1980): 243.

106. Flusser, *Towards a Philosophy of Photography*, 27.

107. Joel Snyder, 'What Happens by Itself in Photography?', in *Pursuits of Reason: Essays in Honor of Stanley Cavell*, ed. Ted Cohen, Paul Geyer and Hilary Putnam (Lubbock: Texas Tech University Press, 1993), 372.

108. Flusser, *Towards a Philosophy of Photography*, 80.

109. Gottfried Jäger: 'Photography is not only an art form that plays with, but against the apparatus as well'. Gottfried Jäger, Rolf H. Krauss and Beate Reese, *Concrete Photography* (Bielefeld, Germany: Kerber Verlag, 2005), 24; Rolf H. Krauss: Concrete Photography as about 'breaking rules and combating the apparatus'. Ibid., 67.

110. Flusser, *Towards a Philosophy of Photography*, 35.

111. Ibid., 36.

112. Of course, most photographers *are* content with those parts of the camera's program that are already well explored. Why? This is another story altogether, one that probably falls within the scope of psychology or social sciences, not aesthetics or art theory.

113. David Tomas, *A Blinding Flash of Light: Photography between Disciplines and Media* (Montreal: Dazibao, 2004), 201.

114. 'Every program functions as a function of a metaprogram and the programmers of a program are functionaries of this metaprogram'. Flusser, *Towards a Philosophy of Photography*, 29.

115. 'As cultural objects became increasingly cheaper, and machines and tools increasingly more expensive, one tended to believe that those who owned the machines and the tools held the power of decision. This belief is one of the roots of Marxism. But as it became evident that "shape" and "value" are synonymous, that it is the toolmakers who shape the future of society, this belief shifted. It is now the toolmakers ("information programmers") who are believed to hold the power of decision'. Flusser, 'The Photograph as Post-Industrial Object: An Essay on the Ontological Standing of Photographs', 329.

116. Vilém Flusser, *The Shape of Things: A Philosophy of Design* (London: Reaktion, 1999), 93–94.

117. This, as demonstrated in Chapter 1, was repeatedly argued by the likes of Niépce, Daguerre and Talbot. Of course, as was also demonstrated, such arguments always contained many contradictory elements and much deceptiveness.

118. This is why, for Flusser, wherever we look we can see apparatuses whose initial purpose 'recedes farther beyond the horizon'. Flusser, 'Our Programme', 208.

119. To that end, Adobe's decision to name their powerful photo-editing tool 'LightRoom' cannot be understood as anything but a reference to, or a joke at the expense of, the history of photography.

120. Paul Hill and Thomas Cooper, eds., *Dialogue with Photography: Interviews by Paul Hill and Thomas Cooper* (Stockport, UK: Dewi Lewis Publishing, 2002), 407–08.

121. Information collected from conversations and personal correspondence. Aïm Deüelle Lüski, 2009–2019.

122. Quoted in: Ariella Azoulay, *Aïm Deüelle Lüski and Horizontal Photography*, trans. Tal Haran, Lieven Gevaert Series (Leuven, Belgium: Leuven University Press, 2013), 26.

123. Daniel Palmer, 'Redundant Photographs: Cameras, Software and Human Obsolescence', in *On the Verge of Photography: Imaging Beyond Representation*, ed. Daniel Rubinstein, Johnny Golding and Andy Fisher (Birmingham, UK: ARTicle Press, 2013), 50.

124. Moholy-Nagy has phrased this idea differently in the two texts that it appears in. In the earlier text the illiterate is one who 'does not know photography'. In the later text (quoted here) the illiterate is 'ignorant of the use of the camera'. László Moholy-Nagy, 'Photography is Manipulation of Light' [fotografie ist lichtgestaltung], *Bauhaus* 1 (1928); 'From Pigment to Light', *Telehor* 1, no. 2 (1936).

125. Flusser, *Towards a Philosophy of Photography*, 58.

126. Following initial reports of the case, the photographer (named David Slater) has altered his version of events to argue that the monkey never actually held the camera but was rather fiddling with its settings while it was mounted on a tripod which he deliberately placed on location.

127. 'Hydrogen atoms and galaxies are examples: they constitute negatively entropic epicycles that sit upon the linear entropic tendency of nature. The most impressive example of such negatively entropic epicycles is the biomass that emerged on the surface of our planet a few thousands of millions of years ago, of which we ourselves are protuberances. The biomass consists of tiny drops in which information is encoded within complex molecules being progressively recopied'. Flusser, 'On Memory (Electronic or Otherwise)', 397.

128. This point receives some treatment in: Anna Popiel, *On Pixels and Particles: The Digital Connection between Nature and Art in Vilém Flusser's Philosophy* (Saarbrücken, Germany: Lambert Academic Publishing, 2012).

129. Flusser, *Into the Universe of Technical Images*, 18.

130. The halting problem is a decision problem about properties of computer programs on a fixed Turing-complete model of computation. In short, the problem is to determine, given a program and an input to the program, whether the program will eventually halt when run with that input. Please see the introduction to Chapter 5 for a more detailed explanation.

131. Flusser, *Into the Universe of Technical Images*, 16.

132. For adults with normal vision, there cannot be black-and-white states of things. Nevertheless, the definition of 'normal' human vision is more than confusing. Various studies demonstrate that vision is not only dependent on physical factors such as retinas, nerve cells etc. but also on age, gender and a number of other important variables, some of which are *not* biological. The above passage applies only to those 'normal' cases of vision that fall outside the definitions of colour blindness.

133. Flusser, *Towards a Philosophy of Photography*, 42.

134. On that note also see: David Tomas, 'From the Photograph to Postphotographic Practice: Toward a Postoptical Ecology of the Eye', *SubStance* 17, no. 1, no. 55 (1988).

135. Flusser, *Towards a Philosophy of Photography*, 43.

136. For intriguing overviews of these issues, please see: Friedrich A. Kittler, 'Computer Graphics: A Semi-Technical Introduction', *Grey Room* 2 (2001); 'Thinking Colours and/or Machines'.

137. '"Seven Representations Of White" and what I referred to as its "companion pieces" devolve from a simple scepticism about truthful renditions of colour in photography, and an awareness that the (necessary) choice of film stock will in itself determine a bias towards blue, green, red, and so on in the finished print. Perhaps the best barometer of such bias is in the rendition of white, hence the use of a large area of white wall in "Seven Representations Of White" (using seven different brands of colour negative film) and "Twelve Representations Of White" (using twelve different brands of colour positive film)'. John Hilliard, 2015.

138. 'He will say that some of his photographs reproduce situations that neither were nor could be manipulated, for example landscapes. He will concede that photographic portraits are always the result of manipulation, because the subject to be photographed senses the presence of the photographer and responds to it (with, at least, surprise, having known nothing of this presence beforehand). He will insist that landscapes don't notice the photographer's presence. But he is wrong'. Vilém Flusser, 'The Gesture of Photographing', *Journal of Visual Culture* 10 (2011): 291.

139. Remote Sensing, satellite archaeology, or space archaeology, is an emerging field that uses high-resolution satellites with thermal and infrared capabilities to pinpoint potential sites of interest in the earth around a meter or so in depth. The infrared waves used by these satellites have longer wavelengths than that of visible light and are therefore capable of penetrating the earth's surface. The images are then taken and processed by a space archaeologist in order to find any subtle anomalies on the earth's surface. LIDAR is a remote sensing technology that measures distance by illuminating a target with a laser and analysing the reflected light. A time-of-flight camera is a class of 'scannerless' LIDAR in which the entire scene is captured with a laser or light pulse.

140. In fact, some Flusser commentators have gone so far as to argue this, perhaps also in the spirit of Baudrillard: 'In the case of photography the meaning vector does not point to the world but to the photograph itself: the photograph is real, not its object'. Alberto J. L. Carrillo Canán and Marco Calderón Zacaula, 'Bazin, Flusser and the Aesthetics of Photography', *Flusser Studies* 13 (2012).

141. Baudrillard considers the simulacrums of the third order as different from both the imitation of the original and the serial reproduction of advanced capitalism. In the third order, the simulacrum is defined in relation to models from which all forms emerge through a modulation of differences. This means that the only thing that confers meaning belongs to the model. Jean Baudrillard, *Symbolic Exchange and Death*, trans. Iain Hamilton

Grant (London: Sage Publications, 1993); *Simulacra and Simulation*, trans. Sheila Faria Glaser (Ann Arbor: University of Michigan Press, 1994).

142. Flusser, *Into the Universe of Technical Images*, 42.

143. In writing about architectural visualizations, Adam Brown has referred to this as a 'reversal' of causality. Adam Brown, 'The Spinning Index: Architectural Images and the Reversal of Causality', in *On the Verge of Photography: Imaging Beyond Representation*, ed. Daniel Rubinstein, Johnny Golding and Andy Fisher (Birmingham, UK: ARTicle Press, 2013).

144. Flusser, *Into the Universe of Technical Images*, 42.

145. Lev Manovich, 'The Paradoxes of Digital Photography', in *Photography after Photography: Memory and Representation in the Digital Age*, ed. Hubertus von Amelunxen, Stefan Iglhaut and Florian Rötzer (Munich: G+B Arts, 1996), 64.

146. Quoted in: Hubertus von Amelunxen, 'Photography *after* Photography: The Terror of the Body in Digital Space', in *Photography after Photography: Memory and Representation in the Digital Age*, ed. Hubertus von Amelunxen, Stefan Iglhaut and Florian Rötzer (Munich: G+B Arts, 1996), 122.

147. Flusser, *Into the Universe of Technical Images*, 43–44.

148. Andreas Müller-Pohle, who is also a photographer, was the original publisher of Flusser's *Towards a Philosophy of Photography* book.

149. Andreas Müller-Pohle, 'Information Strategies', *European Photography 21: Photography Today/Tomorrow (I)* 6, no. 1 (1985).

150. This is indeed the claim made by Luciano Floridi. Luciano Floridi, *Information: A Very Short Introduction* (Oxford: Oxford University Press, 2010).

151. Müller-Pohle, 'Information Strategies'.

4. The Landscapes of Code

Photography today is difficult to define and impossible to contain. It seems to be nowhere and everywhere simultaneously, its physicality near invisible and its practices and uses ever fluid. Is photography over? Perhaps not, because its 'symbolic apparitions' are today 'endlessly animated across the cultural field'.[1] Consequently there is an exponential increase in the creation and dissemination of photograph-like images. These images, however, are not identical to the products of the familiar technologies of optics, mechanics and chemistry. Arguably, they merely possess the appearance and hallmarks of photographs but are not the products of its historical or conceptual apparatuses. Instead, it is mostly invisible 'simulation machines' – algorithms and programs – that now produce them. And as these operations become increasingly elusive, the images they generate become ever more alluring, ever more familiar and ubiquitous. The conundrum, in plain words, is this: Photography has all but ceased to exist; yet there is more 'photography' than ever before.

Why? How have photographic images become fully synthetic and why have its historical devices and processes given way to computer programs? The answer is deceptively simple: mathematics and encryption, the inseparable union that for better or worse now governs most human communication. On the other hand, Vilém Flusser's philosophy suggests that photography has never been just another aesthetic or communicative form. Rather, it has emerged from calculation and so could not have foundered on it. 'The photographic universe',[2] Flusser's hypothesis maintains, conditions human thinking with the categories of *image*, *apparatus*, *program* and *information*; it allows for post-historical thinking that is arguably *itself* mathematical – thinking in zero dimensions.

To what extent do Flusser's photographic categories hold, however, when it is now post-photography that we want to historicize, theorize and philosophize? Of course, as with photography, so with post-photography (or as it has recently been called, post-post-photography[3]), very little can be ascertained by means of strict causal discourse. Only programmatic explanations can account for the fact that the majority of all 'photographic' images in existence today are generated, stored, transmitted and displayed fully synthetically, without recourse to material processes. For if the photograph has always been the interface to a

primitive information technology, then its successor, the fugitive and transient quasi-photograph as we may call it, is also part of an ongoing reconfiguration of experience, mediation and signification of the world.

The argument in this and the following chapter is that the present perspective allows a vantage point from which we can appreciate how much mathematics has always been inseparable from photography. If this is true then photography has always contained seeds of *computability*. Therefore, computation should be perceived as integral to photography. Moreover, as we shall see, the turning away from the visual towards the mathematical, algorithmic and computational now allows for a new logic for photography. In this arena, the photographic image can no longer participate un-problematically in the discourse of identity or representation because it is now characterized by properties that are at the core of digitality – modulation, transformation and transposition. As a result, the question of information storage platforms also emerges as characteristic of photography. With this in mind, how does one write about photography? How do we write about photographic multimedia systems?

Such challenges are especially difficult because we can rarely locate concrete evidence we can leverage. Instead we must evoke our own exemplars introspectively, hypothetically, creatively, to argue for the potency of photographic multimedia systems. The harder this is, the more important it becomes, because there is no escaping the fact that the readiness and dynamics of such systems closely mimic the operative dynamics and recombinative readiness of all contemporary post-industrial language and communication.[4]

Accordingly, the narrative at the heart of this chapter opens by advancing the historical argument that digital photography has a 'deep time'[5] that dates back to the analogue era of silver halide. Moreover, we must begin to understand photography as a cultural and technological practice that not only produces beautiful images but also, just like the universal Turing machine, consolidates the idea of the program itself. Further, photography's migration into synthetic form and its explicit amalgamation with the computer reveal that both photographic images and photography as a whole can nowadays be programs. Accordingly one crucial difference between photographs and their successors, quasi-photographic programs, is that the spatial absence of photographic informees can now be overcome. Photographic images today are often *operational* or *operative images*[6] and so their viewers become *users*.

To make these assertions I shall assume that several understandings can be presented as uncontroversial. First, that photography today is ubiquitous and that some of its forms are so omnipresent that they are practically indestructible. Second, that the distinction between the still and moving lineages of photography

has become difficult to maintain, as both emerge from the same apparatuses and are made manifest in and on the same platforms.[7] In other words, photographs today *can* move and they often *do* make sounds.[8] Third, and most importantly, photographs today *can* be changed by their receivers.

Photography from Analogue to Digital

Objects, argues Flusser time and again, are a flawed form of memory: 'paper falls into ashes, buildings into ruin, entire civilisations into oblivion'.[9] Having originally been taken from nature – whether in the form of stone or metal, wood or paper – all must eventually return.[10] To engage with this entropic cycle (nature-culture-object-waste-nature), human beings needed to devise more durable information supports, some of which were nonmaterial. This is how post-industrial objects came into being. Post-industrial objects differ from other cultural objects, in that their value bears little or no connection to the material platform that carries it, and resides solely in their information content.

In that respect, it becomes clear why photographs are and have always been, as many have argued, dubious objects. This view is not justified by the reasons outlined in Chapters 1 and 2 but simply by the fact that if value resides in information, a photographic object, *in itself,* has no value at all. In that sense, photographs are, as Flusser demonstrates, more than just post-industrial objects. They are the harbingers of post-industrial society. Therein, value always emerges from information and almost exclusively so.

But photography is a transient practice. It constantly ventures into new technologies and is always quick to adopt them. This characteristic has been one of its main driving forces since its inception. The most recent technological developments are no exception. Nowadays it is not only that information in photographs is not carried within 'photographic bodies' but also that photographs no longer have or care to have bodies. This is not to say that there are now fewer photographs; quite the opposite. With developments in sensor technology enabling the integration of cameras into ever more electronic devices and prostheses, infinite amounts of photographic (or quasi-photographic) images come into being on an everyday basis. In fact, the conversion of photography into a form of computing began much earlier than most of us tend to think – in the mid-1950s when it became possible to scan and convert photographic prints into arrays of binary digits and hence to turn them into electronically processable digital information. It was at that point that Shannon and Turing's information and computation theories came to be operational with respect to photography (see Chapter 5).

And so what about the photographic artefact? What meaning does it have today? What worth? And if, in Flusser's spirit, we concede that as an object, as a thing, the

photograph is practically worthless, what is photography? Where is *its* value? In other words the question is this: How does one define the photographic artefact in a 'post-photograph' era? Could photography be an art form *without* a form of artefact? This is an initial challenge that the theory and philosophy of photography now need to address. What we require are conceptions of photography that assume that photographic images are, more often than not, unstable and unfixed images that are generated by programs and are *themselves* programs. Importantly, these images are not intended for viewing in the same ways that photographic images were once viewed.

Having initially been ignored by scholarship, the new technologies of 'digital photography' (as they are still commonly called) were acknowledged in the mid-1990s and occasionally theorized since. However, until recently, this has mostly been done by means of two largely unproductive approaches. The first and perhaps understandable approach was apathy. This view held that while 'digital' photography may be different in terms of some procedures; the differences are mostly cosmetic. Consequently, even if 'the digital' is the new body of photography, its soul remains unchanged.[11,12]

The other approach was dismay and anxiety. Digital photography, it has been argued, is fundamentally different: 'The photo is read dot for dot and line for line into the computer, stored and processed. And although the aesthetic qualities of the analogue and complex photos continue to be satisfied, digital photography is fundamentally different'.[13] Moreover, some even asked whether the new technology has anything to do with its purportedly 'analogue' predecessor. This I believe is the underlying theme of Andreas Müller-Pohle's artwork 'Digital Scores (after Nicephore Niepce)', wherein eight dull looking square panels comprised of alphanumeric signs represent the eight exposure hours presumably required for Niepce's 1826 image (Figures 15–16). Perhaps, digi-sceptics contended, the two technologies only accidently share the word 'photography' as part of their title. Thus, as was demonstrated at the outset of Chapter 3, many commentators opted to describe the new technology as 'photography-post-photography' (or more simply 'post-photography') while continuing to call its familiar predecessor 'photography': 'once the image is digital it has very little to do with photographic systems. At most, these are implicit in it. In this sense, such images could be called post-photographic, as they no longer refer to a particular characteristic of photography [...]'.[14]

With almost no exception, these two views have been perpetuated. My argument recognizes the shortcomings of both and is radically different. To the extent that familiar definitions are required for a chronological analysis, I maintain that the distinction between 'analogue' and 'digital' in photography should be drawn so that it generates precisely the opposite description of current medium conditions. We should be speaking not of a medium and post-medium (photography and post-photography) but rather of a medium and pre-medium:

FIGURE 15: Andreas Müller-Pohle: Digital Scores I (after Nicéphore Niépce), 1995.
http://www.muellerpohle.net.

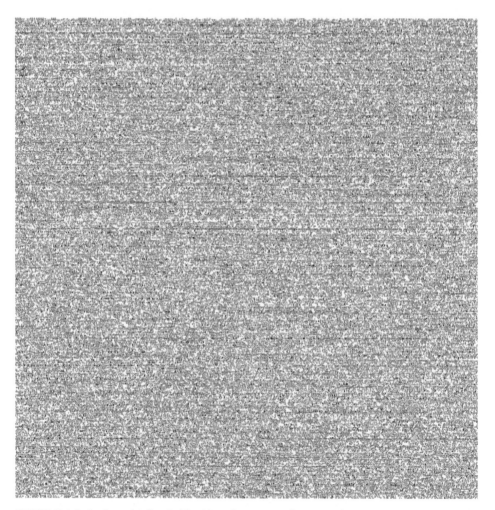

FIGURE 16: Andreas Müller-Pohle: Digital Scores I (after Nicéphore Niépce), 1995 (detail). http://www.muellerpohle.net.

'analogue' photography as pre-photography and 'digital' photography as photography. Moreover, I argue that notions of 'analogue' and 'digital' are most often convoluted in the context of photography. Within present discourse they are little more than obstacles in the way of clear thought. Thus, since it is conceptual clarity we require, in the coming pages I shall propose a new methodology and terminology with which to understand non-lens-based visualization practices.

Have We Ever Been Analogue?

As has been repeatedly argued here, photographs are never analogous to objects in reality. Photographs emerge from theory and as such they are only analogous to complex cognitive processes, if anything. For this reason I have also implied that the term 'analogue photography' obscures more than it reveals. However, and in order to better facilitate the understanding of arguments that now follow, let me briefly deconstruct this confusing term to answer a simple yet very important question: How does 'digital photography' differ from 'analogue photography', if at all?

Even the most intelligent of theoretical accounts reprise the distinction that analogue photographic images are created with the camera whereas digital photographic images are created with the computer.[15] But digital photography has clearly been based on some existing technologies that are generally considered to be imperative for the traditionally photographic: perspectival geometry for example. Otherwise why do lenses still grace the fronts of some camera bodies? And why have camera bodies changed so little before the advent of mobile phone photography? Today cameras are embedded in a plethora of portable computation apparatuses – hand-held, clipped onto one's body or embedded in it. However, in all, the digital image sensor is always placed vertically inside the device, exactly where the film used to be placed. This is but one example to convey the point that the overwhelming majority of 'digital' photographs clearly resemble traditional photographs for a reason. Thus, in other words, the idea that analogue and digital processes of photography are bound together is not far-fetched.

The notion of incongruity is still expressed in multiple contexts. Recall, for example, the lingering persistence of comparing films to sensors, grains to pixels. Pick up any amateur or professional photography journal, or browse through any museum catalogue or photography theory reader, and you will notice how, for many writers and readers, these parallels applied until well into the 2010s.[16] It is only when photographs made on mobile apps started spreading like wildfire that this obstinacy gave way to others. One such neo-obstinacy is the disposition of professional photographers to dismiss Instagram on the grounds that it replicates effects that have long been available in Polaroid photography. Nonetheless,

comparing technologies of analogue and digital photography is futile so long as both traditions remain so artificially defined, voluntarily opposed and theoretically quarantined. It further runs the risk of altogether missing real conceptual shifts that *have* occurred. Digital photography apparatuses *do* capture more 'detail' than their 'analogue' predecessors (in fact, many consumer devices nowadays register more detail than most users will ever want or need) but it is *not* the same kind of detail. Instagram *does* offer a wider variety of image effects than Polaroid ever did but those are *other* effects. The real effect of Instagram and similar apps lies not in relieving the photographer of the burden of shaking the Polaroid. It lies in being able to apply this effect on the image, then that effect, then another, etc. etc. ad infinitum.

It might reasonably be said that photographs were once made of grains. Today they are made of pixels. Grains cannot be compared to pixels because pixels are nothing but discrete representations of numerical values. With numbers, we should bear in mind, everything goes: modulation, synchronization and transformation; storage, delay and transposition; scanning, mapping scrambling and much more.[17] This is why a host of other activities are nowadays performed with photography. I shall return to this point towards the end of the chapter.

Crucially, I assert, this important difference is overlooked because of one simple deception: digital photography can always emulate analogue photography by outputting files as prints. Thus, it becomes difficult to take the term 'digital' at face value when 'digital photography' does not present itself as digital and its manifestations rarely possess characteristics that reveal the bit-by-bit process through which an image is constructed, stored and reconstructed at will. Therefore, it is commonly believed that the digitization of light values is nothing but a more effective way to expedite the same old functions of traditional photography – to be efficiently reproduced, easily transported and straightforwardly adopted into various contexts. According to this view, 'digital print', as it is called, is supposedly just like the traditional photographic print: both can, at least hypothetically, be generated in a multiple, even infinite, number of identical copies. It is also believed that because these two manifestations are similar, they must also be related, perhaps even interchangeable.

This belief is far from accurate. It rests on the misguided view that the above-mentioned qualities did in fact exist for 'analogue' photography. This is not true. The ability to be infinitely reproduced exists *only* in 'digital' photography and has *never* existed in 'analogue' photography. This is due to the fact that just like any material form, photographic emulsion is susceptible to physical change. After a number of prints have been made from a film negative or positive, it *will* warm up, inflate and pop. Furthermore, and well before this has happened, due to technical variables such as temperature and chemical intensities, it is extremely difficult if not impossible to generate two identical photographic prints.

The misguided belief that analogue and digital photographic images are equally reproducible is indicative of a mistake and a myth. The mistake is the commonplace assumption that the digital photograph, just its analogue counterpart, requires and indeed has an identifiable 'original' template from which it emerges. This is not the case as shall immediately be made clear. The myth is that 'digital images' exist. This will be debunked in the following chapter where I discuss the difference between human and computer forms of perception and interpretation (if computers can be said to perceive or interpret).

Of course, the original was of lesser importance back in the days when a daguerreotype was something one was likely to encounter outside the museum or antique shop. A daguerreotype image, we should bear in mind, entailed being singular and unique. Thus, a photograph at that time could have very well been 'free'. It required no master, no original. It was its own master and an unmistakable original. But since the daguerreotype passed into history, photographs almost always require a master; they descend from an original. The only notable exceptions to this rule are the photogram and some varieties of Polaroid. Both are, one might argue, types of originals.[18]

Importantly, whoever made the original, presumably a human photographer, could call themselves the artist. That original artwork, nevertheless, was often delicate and sensitive and always subject to physical decay. As the nineteenth century drew to a close, that original artwork also diminished gradually and was thus difficult to present as the artefact that many wanted it to be. Consequently the photographic print rose to prominence and became the desired artefact, even if it was not the original. All that was required was that the original (be it paper, glass or gelatine) and a given quantity of fibre or textile-based surface (that would later become the print) share a physical space for a brief moment in time in which they would be connected by the same rays of light. Thus, even if a photographic print was itself not an original, it still retained the authoritative qualities of the original.

Tellingly, when in 1940 Beaumont Newhall, MOMA's first photography curator, organized an Ansel Adams exhibition titled *Sixty Photographs: A Survey of Camera Esthetics*, he was compelled to announce that 'each print is an individual expression',[19] as if to fend off the potential charge that a process that moderates originality could not guarantee artefactuality. Thus, to the extent that we take photography to be an art form, I argue that it is the first art form to result in a disjunction between 'the artwork' and 'the artefact'. Prior to the advent of photography, both had been simultaneously manifested in one and the same object. This surprising new rift was mediated by an unsurprising recourse to the notion of causality. Yet another causal connection enabled, in fact necessitated, that the materiality of the original transcend onto the photographic print – an artefact albeit not artwork.

141

Intriguingly, some diehard romantics felt that, in and of themselves, such causal connections were insufficient to grant full authority to photographic prints.[20] They raised the concern that the authorship of prints made of, say, the negatives of a long-dead photographer was perverted. Of course, this worry piggybacked on the justified concern that, in one way or another, photography would forever compromise human intentionality, which, henceforth, must be strictly enforced. And so, in order to accord the photographic artefact with artistic worth, a method had to be invented to ensure that it was the artist's hand and no other that generated the artefact. Thus it was sometimes required that the causal connection described above be made in the physical presence of the author, or, better still, be physically performed by 'the artist photographer'.[21] Even today, as Daniel Palmer argues, some of these sentiments have not diminished as they should have: 'Despite the critique and deconstruction of the associated notion of originality in recent decades, the privileged convention of single authorship remains remarkably durable'.[22]

Nevertheless, even if this insistence may sound peculiar there is still something to it. If nothing else, it helps remind us of three dominant views about photographs. These views have once been more common but even today they are still encountered. The first is that the production of photographs is very often a labour intensive, or at least work intensive effort. The second, a consequence of the first, is that the production process necessarily compromises quality. Third, even when this change does not entail loss of quality, we still want it to somehow be governed or at least certified by a human.

These initial references ground my exploration into the intricacies of what digitization has given to photography by illustrating the categories of 'analogue' and digital'. Importantly, these terms are debated more rigorously in engineering, computation and cognitive sciences. Unfortunately, they are only infrequently addressed in ways that are useful to thinking about art. There are, however, a few notable exceptions. One of them, surprisingly, emerges from Nelson Goodman's aesthetics as propounded in *Languages of Art*.[23]

Originally introduced in response to the problem of differentiating between originals and copies, Goodman's argument first distinguishes between one-and two-stage art forms. Producing a pencil sketch or a Polaroid print is, in Goodman's account, a one-stage process. But production of music is often a two-stage process: composition followed by performance. Many images are also produced in two stages. This is always the case in printmaking as well as in routine instances of traditional photography.[24] In fact, Adams proposed a very similar notion years before Goodman or, for that matter, William J. Mitchell – claiming that the photographic negative was equivalent of a composer's score, while the print was the performance. This metaphor was obviously intended to convey the idea that both negative and print (as well as the

preceding exposure) required skill and creativity.[25] Either way, the number of stages in the process is perhaps less important than the fact that the labour in different stages of the process can easily be divided among several individuals.

Second, Goodman distinguishes between two *types* of art forms – autographic and allographic. Painting, for example, is autographic, but scored music is allographic. In painting, the work is not specified in any way or manner and hence no feature of it can ever be distinguished as constitutive, or dismissed as contingent or insignificant. A musical score, on the other hand, is always specified in some definite notation system and can therefore be copied exactly, character by character.[26] Any such correct copy is as much a genuine instance of the work as any other. Consequently, for a painted object to be considered a genuine artwork it actually has to be made by the purported artist. In contrast, a copy of a musical score need not be the product of the composer's own hand in order to qualify as a genuine instance of the work in question. The same goes for the novel: any book that has precisely the same words as *Don Quixote* is, ipso facto, that novel. The main point here is that in allographic arts there are measures of correctness for any copying process. For example, it does not matter which font a novel is printed in – it only has to have the exact same words and word order as the original manuscript for it to be a further token of that type: 'Merely by determining that the copy before us is spelt correctly we can determine that it meets all requirements for the work in question'.[27]

The information in autographic works, on the other hand, is not subject to any known or accessible notation system and can therefore be copied only approximately. Thus, repeated copying of autographic works will always introduce noise and degradation into the information of the copy. This is true of painting reproductions but also of magnetic videotapes as well as emulsion-based photographs.

For this reason, Mitchell has rightfully chosen to use the expression 'analogue information' in his comments on Goodman's use of the term 'autography'.[28] Notably, the term analogue does derive from the same root as the English word analogy (the Greek word *analogia*) but its meaning here is very different. Mitchell uses it in accordance with its usages in electrical engineering, signal processing or computation, to describe a non-quantized, continuous signal *some* of whose features represent or correspond to features of another. Analogue, in other words, does *not* mean an accurate copy of information but rather a type of information *that can never be accurately copied*. I argue that it is within and *only* within this meaning that use of the term analogue can be warranted in the context of photography.

Note, incidentally, that two-stage works frequently contain autographic attributes. This is the case for etching or traditional photography: a plate or a photographic negative consist of analogue information that cannot be copied exactly simply because it is *not* notated. This additionally explains why there can never be identical prints in traditional photography. Furthermore, it is precisely *because* a

plate or a negative does not specify the constitutive properties of the work in the same rigorous way a script, a musical score or a digital file can, that we can take a traditional photographic print to be 'an artefact'. Of course, this is despite the fact that it is the negative or plate that is arguably the original. It is thus appropriate to suggest that we subconsciously *cherish* information loss and, since the emergence of photography, seek that characteristic in artefacts we create.

This peculiar human penchant has over the years yielded a great number of insightful works of art. One of the most prominent is Sherrie Levine's gesture of photographing from a Walker Evans catalogue a number of his well-known photographs of the Great Depression.[29] Levine then signed the resulting prints and exhibited them as her own work. This gesture, I argue, would not have been interesting had it not been for two aspects. The first is that some parts of Evans' visual information *did* remain present in Levine's photographs (such as, in the best-known photograph from the series, the recognizable facial features of Allie Mae Burroughs). This aspect enables the postmodern discourse on appropriation. The second and more interesting aspect is our inherent knowledge that, because of the analogue nature of the process, other parts or types of information *must* have been lost, whereas others may have been added. In my mind, it is the tension between these two aspects that makes the work powerful.

Digital Prints?

Traditional photography always entails processes that feature strong analogue qualities – not in the sense of analogy but rather in the sense of an analogue signal. The quintessence of those processes is the artefact we call print. Thus it should be seen as quite peculiar that photographic prints are still being made and acclaimed today. After all, if photography is now truly changed and it is now 'digital', why maintain a tradition that is so analogue?[30] Is this because our human sensorial systems are, for the time being, analogue? Perhaps digital code, or the notion of digital code being mostly about storage, constitutes a level of abstraction that is not adequately apprehensible? If this is true then perhaps it is now time to seek another way to conceptualize the experiences photographs afford. To do so we require a working definition of photography that does *not* necessitate that photographs be printed or even printable.

The term 'digital' derives from 'digit'. It is thus appropriate to describe digital procedures with the same term Goodman used to specify allographic works, whether one or two stage, as notations. Digital therefore marks the creation of discrete units of things – quantized information. These can be neatly packaged and easily duplicated without loss or excess. This explains why any copy of an image file, just like a copy of a musical score or script, is as good as another.

Crucially, digital photography offers no equivalent to the physically unique photographic original. Even a carefully crafted RAW image file is first and last a digital file. As such it is as ephemeral, elusive and easily duplicable as any other file. It is thus paradoxical that, back in 2004, Adobe Systems tried to promote a 'digital negative' file format (DNF) that, despite several claimed advantages, was just as duplicable and transferable as any other format. This type of reverberation to 'analogue logic' is not unique to Adobe. A similarly peculiar case is the product called Impossible Instant Lab. This was launched in 2012 by a company called The-Impossible-Project, which was a commercial brand attempting to resurrect the production lines and technologies of the now-deceased Polaroid company.[31] This product enabled the production of an 'original' Polaroid-like photograph taken from a screen of a mobile phone (presumably featuring a phone-camera captured digital image). There are other equally curious examples.

A duplicated digital file is utterly indistinguishable from its source. Thus, should an 'original' image file be lost, its clones will live on and be able to manifest the image in exactly the same way as the original. Moreover, there can be no telling whether an image file is original or not.[32] This remains true despite the growing use of digital forensics tools for examining image files.[33] Despite attempts to claim otherwise, the lineage of an image file today is almost always untraceable in full and it is rarely possible to determine beyond reasonable doubt whether it is a fresh photographic capture or something else entirely – a degradation or a mutation of a could-be-capture that has passed through multiple unknown hands.

Allographic works can be instantiated illimitably: a digital image is instantiated in any display format that faithfully follows the notation specified in the image file. For example, when an image file on a server is simultaneously accessed from multiple locations, the image, which users will view, is exactly the same.[34] A work of art reiterating precisely this point is Michael Mandiberg's *After Sheri Levine*. This work is designed to allow free full-quality downloads of Mandiberg's scans of Levine's reproductions of the Evans photographs.[35] Thus, this work is not only performed in, with, or through digital procedures, it is also *about* those procedures and how they pertain to photography, making Mandiberg's work particular and unique (Figure 17).[36] Furthermore, if, oblivious to the artwork's logic, one were to print a downloaded Mandiberg file, the resulting artefact would only be similar, but *never identical* to any other print made by any other prone-to-nostalgia photo-viewer.

What this case makes clear is that for as long as photography relied exclusively on non-discrete, 'lossy' procedures of information storage and transmission, it remained an *autographic* process. Traditional photography has *never* been an allographic medium and so, until recently, it has never been purely 'mechanical' or 'automatic'.[37] Photography became truly allographic only when the photograph became digital, when all of its information became convertible into

FIGURE 17: Michael Mandiberg, *Untitled (AfterSherrieLevine.com/2.jpg)*, Website, Digital Image 3250px x 4250px (at 850dpi), and certificate of authenticity CC BY-SA 2001. Courtesy of the artist.

machine-readable numeric data. Only then did photographs become demonstrative of 'losslessness' in reproduction. It is only if the parameters of all image elements are defined (including their location and comportment within the overall imaging system) that they must inevitably produce the same outcome whenever they are iterated. In other words, if a pixel location is commanded to render a given numerical value corresponding to, for example, a particular shade of blue, that particular shade will be the same each time it is duplicated. In contrast, the pictorial landscape of a print will never possess the numerical exactness of a digitally constructed image, in which each pixel is programmed to behave in a determinate way – with an exact colour value or degree of illumination.[38]

To restate this point I turn again to John Hilliard's abovementioned 'Camera Recording Its Own Condition (7 Apertures, 10 Speeds, 2 Mirrors)'. Upon viewing this piece exhibited today,[39] it becomes evident that there are noticeable chromatic differences between various prints in the piece, particularly a yellow-to-brown tint. These are noticeably not density changes (the result of the camera recording its own exposure variables) but rather significant discrepancies that result from two factors. First, minute chemical reactions may have taken place between the paper and the developer agent (which may not have been replenished between prints). Second, various prints may have spent different lengths of time in the fixer agent and wash baths. Thus, the most persuasive concept in Hilliard's piece is that it makes clear that traditional photography is, contrary to common opinion, always autographic (Figure 2).

Exactitude, Interaction, Temporal and Spatial Continuity

Applying the term 'allography' to all aspects of contemporary image production is also not free of complications. Recall that digital images can also be two-stage (or multiple-stage) allographic works. This means that despite the numerical precision of the digital file, different devices can interpret it using different algorithms to produce somewhat differing instantiations (just like musical and theatrical performers who are free to interpret the works they perform). In image jargon this is what is called display. Even though digital photography is allographic (unlike analogue photography) contemporary technology can complicate definitions by incorporating behaviours that are seemingly autographic.[40]

In other words, even a fully quantized colour value, location or other species of data is not co-extensive with 'knowledge' and, arguably, no element of the digital-computational universe is hypothetically knowable in an absolute sense. Thus it is erroneous to believe that 'meaning', whatever it is, is more accessible when an object or situation is transformed into quantifiable data. It is equally mistaken to suppose that such meaning, when an object is filtered or mediated computationally,

can ever be non-contingent. The contemporary habitat of digital-image production is beset with its own problems. To think of it as a repository of absolute knowledge is to succumb to folk-popular mythology. In fact the opposite may be closer to the truth, as the computer often exposes the limits of our knowledge. Either way, I prefer this mythology to its predecessor, which I find even more confusing. I do not believe that more or richer layers of meaning have ever resulted from the representational model that has constitutively resisted exactitude but has still consecrated metaphysical truths that supposedly must emerge from discrepancy.

To be clear – I am not valorising digital modalities at the expense of analogue ones. This too would be futile. Both modalities possess their own particular semantic properties and tend to generate different types of meaning. Instead I find it more useful to examine them in a dialectic exchange, in which each model's productive idiosyncrasies and latent qualities, as well as deficiencies, are clarified in terms of the dialogic intersections and deviations they afford.

A fascinating example is the technology of light field photography launched in 2012 (often referenced by its commercial name, Lytro or more recently Lytro Illum). Much like other image-capture platforms today, its images also enable for post-exposure aperture and perspective adjustments. Unlike other platforms they also allow for post-capture focusing and re-focusing. In Lytro's advertising jargon these are called 'living pictures', a thought-provoking description that encapsulates many of the psychological anxieties accompanying earlier breeds of photographs. If only to avoid such pitfalls, I prefer dubbing them 'motile still images', a description that, I feel, is more timely and appropriate for describing other emergent technologies and art forms. Crucially, Lytro's puzzling re-focus effect is achieved not by mechanics or by its slightly unusual optics but rather by powerful computational abilities that are embedded into the device.[41] With this it should become evident how much photography has become, quite literally, a form of computation (Figures 18–20).

Furthermore, since light field images are designed to be focused by the viewer, they are dynamic 'unsettled' images *not* under photographer's control. To what extent has photography ever been the solitary act of the photographer, as some still tend to imagine it? Palmer convincingly argues that photographic production has always been highly impersonal, with labour always distributed amongst many hands responsible for the separate functions of taking, editing, facilitating viewing or otherwise distributing a photographic image.[42] Arguably, to successfully shoot a light field image, photographers must succumb to the idiosyncrasies of their apparatus, and more than with other apparatuses, embrace lack or loss of control.

As noted, another striking (although not unprecedented) feature of Lytro enables the user to operate a 'perspective shift' – to change the viewing angle when looking at a light field image. Thus, it has been argued, light field images can

FIGURES 18–20: Markus Nolf (lightfield-forum.com), Lytro ILLUM sample images.

be seen as 'digital sculptures'.[43] While inaccurate, this interpretation does make the point that these are photographic images wherein there is no photographed vantage point.

In 2014, Amazon also introduced a similar technology called 'dynamic perspective' with its Fire Phone. Here, four front-facing cameras and a gyroscope are used to track the viewer's movements so that the operating system can adjust the image on the screen to give an impression of depth and 3D movement. Interestingly, these images are not only unfixed but also, more than any other images, unfixable. Furthermore, in their responsiveness to the viewer's movements, they offer an experience closer to unmediated seeing. For those very reasons it also becomes obvious that, while technically possible, printing such images defeats the purpose of their respective technologies. When these technologies develop further we might expect the appearance of photographic images that are not 'spatially agnostic' (as all photographs are according to Cohen and Meskin).

Both these technologies, have, thus far, been commercial failures.[44] Nevertheless they demonstrate the extent of the change that photography has undergone – the digital photograph cannot be experienced with a photograph carrier. It simply cannot utilize it. In fact, I argue, the same has always been true of photography: delegating value to the carrier always contradicts the very properties for which we value photography as a technology. This is why it is somewhat paradoxical that the 'newness' of digital photography is still celebrated while, at the same time, the obsolescence of the 'analogue' photographic print is bemoaned. The photographic print has indeed disappeared but perhaps its extinction is to be welcomed. At least it is now clear that the object (or rather 'objecthood') has always been somewhat redundant in photography – merely one possible outcome of the process and by far not the most important.

These days, photographs are rarely 'fixed' and are often actionable data that can be changed in retrospect. Thus contemporary systems of photographic production are becoming ever more diffuse, both temporally and spatially. They include not only the pre-programming of the camera and its darkroom (or Lightroom) but also the confines of the 'architecture' of what used to be called the book or gallery and is now called the computer or network. In fact, many contemporary systems do not even have anything equivalent to a primary photograph that can be treated (or copyrighted) as an 'original'. This was clearly the case with Microsoft's now deceased Photosynth service.[45]

Consequently, the necessity for, and likelihood of individual authorial responsibility over image content, authorial determination of meaning and authorial prestige are now decreasing. This, to reiterate, makes it nearly impossible to define conditions that guarantee artefactuality. Thus, the traditional distinctions between producers and consumers of images vanish. It is for these reasons, amongst others,

that it is probably time to altogether abandon traditional conceptions of artisthood that depend on, and are only identifiable through stable, enduring and finished artefacts. Instead, the characteristics of a photographic artwork must be developed in terms of continual mutation and proliferation of variants.

The Networked Image

We have already established that traditional theories of photography insist that 'the world' and all its photographic images and prints maintain some form of causal connection. But curiously, in support of this argument it has often been implied that the agency of light (or other energies) is a process that negates and preserves its 'source' object at the very same time, thus making it a form of sublation. But what part does causality play in photography *today*? Where is it at work? Has causality itself been sublated? One of the characteristics of the present era is that almost all phenomena can be quantized and translated into electronic signals. Digital systems can then be used to process these signals through a series of commands that turn simple switches to 'on' or 'off' positions. Importantly, increasing the number of switches dramatically increases the complexity of the tasks such systems are able to carry out. Furthermore, digital systems can be easily linked through communication networks. This means that digital information, whether or not it has been processed, can bifurcate and simultaneously move to numerous locations, and do so at close to the speed of light. It can then be assembled (or rather re-assembled) and packaged in a plethora of ways. These, of course, include image visualization, but also sonification or encryption as text.

In this context, image signification and representation, in the forms we have traditionally known, may be impossible. To the extent that they are possible, one might rightfully ask to whom. Instead it is repetition, self-replication and divergent parallel narratives that now take precedence and, in my mind, generate the most intriguing semantic and artistic questions. On that note, Daniel Rubinstein argues that

> images do not appear as singular, individual or discrete; they do not have borders that separate one image from another, rather data is distributed according to certain rules, sending some of it to the screen as an image, some of it to the speakers as sounds and some of it to the printer as text. These 'images' traverse the networks not as snapshots but as dynamic arrays of electronic signals and packages of data.[46]

Notwithstanding, we ought to wonder *how* exactly digital systems know if a given string of data is an image or something else? In this ecology, it is no coincidence

that several influential scholars ascertain a naming crisis in the realm of the digital image.[47] Is it still an image? How do we tell an image from that which is not and what distinguishes them? In fact, the ongoing presence of the digital image *as image* requires another discourse, perhaps even another language wherein technical terms once used only by mathematicians and computer specialists take central stage. One such term is of course 'algorithm' which I have, thus far, used only in passing. It will become clearer in the following pages and will contextualized and elaborated in the next chapter. Other interesting terms are of course 'code' and 'metacode'. The latter is how Flusser referred to what we commonly call structural metadata – information about the type of information in question.[48] It is this that nowadays demarcates an image. Nothing else differentiates between images and other once-separate and distinct forms of media. For the computer, we might argue, there is very little ontology at play; everything is instrumental, first and last.

Another type of metadata is called descriptive metadata. In the case of images, this is usually the Exif standard with which almost all digitally captured image (as well as audio) files are compatible. This means that in addition to the visual information the image file also includes various kinds of technical information that is not a part of the image per se; for example, aperture, exposure length, time, date, model and make of the camera (and its individual serial number). Importantly, the recording or capturing of metadata often happens automatically whether the photographer wills it or not. Furthermore, descriptive metadata can also include geo tags – information on the photograph's place of origin. Metadata can also be expanded to contain content tags – information on what or who is in the image. Software libraries can easily parse such information. Today there is no image without some form of metadata and both are inextricably linked.

Metadata is something that analogue systems could never have captured. Similar information was and still is often communicated through captions, of the sort we commonly call image title or wall label. However, these are almost without exception not created by the imaging system itself, or by its end user. Moreover, whilst metadata can of course be faithful to the content of the image there is no reason why it should be. In other words, it can be tampered with: 'In the past, concerns about manipulation of pixels caused people to doubt the veracity of the digital image, however manipulation of metadata can have much more dramatic and far-reaching consequences as it not only affects the placement of the image in search queries but also can radically modify what the computer "sees" in the image'.[49,50]

While screen images occasionally bear visual resemblance to perspectival projections of a three-dimensional object or space onto a two-dimensional plane, metadata seems to suggest a different logic that is less hierarchical, more decentred and always open-ended. Metadata, we might argue, prevents us from believing that an image can ever be elevated above or even isolated from the noise, the

stutter and the stammer that Shannon argued characterize *all* communication. From here on after, the certainty of representation is augmented by the possibility of continuous reinterpretation, in which it is much less important *what* is being represented than *how* it is saved, labelled or tagged. For this reason, it is remarkable that research on digital photography still tends to focus on only the visible aspects of the image whilst completely ignoring those very qualities of the image that actually make it digital.

In other words, the point recent image ecosystems make is that the photograph is nowadays inseparable from the context and milieu of its utterance, which is almost without exception, potentially networked digital information. When an image is transported elsewhere it is 'packaged' not as an image, a picture or a photograph but simply as a cluster of data. Only when it arrives at its destination will it become something more. Often it just remains data. Thus it is almost impossible to locate and therefore archive image content flows. 'Digital multimedia databases produce syntheses that are explicitly provisional', argues Ross Gibson;

> Because of the dynamics of its file structures and the integrating, evolving codes that get applied to those files, any digital multimedia configuration is a contentious event in a continuous process rather than a completed, content-full object; it is always ready to be dismantled and re-assembled into new alignments as soon as the constituent files have been federated in response to momentarily prevailing 'world conditions'.[51]

Clearly, this detaches photography from its historical and theoretical anchors. Think, for example, about Penelope Umbrico's ongoing piece titled *Suns from Sunsets from Flickr*. This now-classic artwork is made possible, bred and nourished, by the fundamentally arbitrary connection between digital photographs and their potential real-world objects.[52] And so, while suns are featured in each and every photograph here, photography, on the other hand, is revealed as no longer a vehicle of representation but only an expression of the possibility of variation and difference that happens through repetition of metadata. It is as if these images are not framed by their own borders, which are entirely self-imposed, arbitrary and thus purely symbolic. Rather, they are encircled by the differential between them. Put otherwise, when an image is born digital, its connections to its spatial or temporal point(s) of genesis are always only epistemological. By removing the essentialism from the discourse around photographs, and restoring to it a play of distinctions between degrees of intensity, Umbrico clarifies that it is now impossible to untether photography from the logic of causality and representation.[53]

Accordingly, the question that remains for the artist, curator, archivist or philosopher of photography is not, What is a photographed image? Rather, it

is, What is not a photographic image? One must also ask, Where is the photographic image? and What is it connected to? – both in the communicative rather than the representational sense. Accommodating these questions is the key issue for photography theory today. It requires a different kind of schemata, one that places far less emphasis on the content and far more on its conditions of embodiment. Such a theory must also account for the opportunities afforded by digital systems today: inherent incompleteness, mutability, connectivity and the constant proliferation of self-replicating fragments. What is required, in short, is not the kind of theory that interprets the visible, but one capable of addressing the extent to which the visible itself is fragile and temporary. Traditional photographic theory, with its attachment to regimes of visuality and representation, cannot account for this ever-mutating, hyper-coded hydra.

Recently, with computer software capable of reading images that reside in online databases, both via metadata and increasingly more often with image pattern recognition as well, the status of individual image making is indeed changing even more dramatically. And so, even activities like reading, that Flusser reserved for human operators, are outsourced and opened up to other agents: other types of producers, software programs and the final user, who often may not be human.[54] Such changes have major implications for photography. At the very least they discourage us from theorizing and philosophizing it in exclusively human-centred terms. Specifically, we must address the following questions: Is the human photographer at all necessary in an age when much of our information exchange is machine-to-machine? Are human viewers necessary or redundant? What meanings can a photographic image retain when it can be reduced to an operational code?

As a consequence of this fundamental shift from the visual to the calculable, photography becomes something overwhelmingly complex. Herein innocent questions have a surprising habit of transforming mundane matters into meta-questions that require multiple narratives to be answered, with constant reference to components, practices and hybridizations of technologies. Perhaps this explains the contemporary tendency to revert to bucolic metaphors (like clouds, streams, farms and harvests) in reference to the post-industrial technical apparatus, which underlies all image production today.[55] What this terminology suppresses is the understanding that, in spite of the exactitude of the digital image file, its visible aspect on the computer screen conceals immensely complicated logical processes that are, to our weary minds, incomprehensible. Therefore, perhaps it is time to consider the possibility that the digital image need not be understood as an image at all. Rather, images are simply two-dimensional subsets, go-betweens that weave together two worlds: an analogue world of three-dimensional objects inhabited by carbon-based lifeforms and a digital one of data storage on silicon. If this is true then images nowadays can be, and often are, independent and operative entities.

Nothing but Code

'Analogue' photography does not require mechanics. Optics is also but a possibility in it, certainly not a necessity. At its very core it requires only chemistry. For without sensitive emulsion there would be no photograph, no photogram, not even a chemigram. Thus, it is mainly through chemistry that the photographic process distinguished itself from previous forms of supposedly rational imaging (latent or not) and the photograph could attain its causal veracity. Digital photography, however, does without chemistry altogether. In its place various kinds of semiconductor sensors are utilized in order to convert light to electrical signals (most often CCD or CMOS sensors[56]). Digital cameras, in other words, often intercept patterns of illumination, just as film cameras used to, but that act is only a small part of a complex process that creates the image. This process is governed by procedures that are on the one hand predetermined and on the other open-ended (algorithmic and programmable, respectively; I explicate these terms in Chapter 5). These contain much arcane language, which is necessary for the making of what the human eye and mind eventually recognize as an image. Even more effort is required to turn that image into a digital photograph that looks like its wet-chemistry forebears.

Arguably, even when the life of an image file does begin with a tracing of real-world visible phenomena, the crucial stage in the production of that image as a photograph is *not* that tracing but instead its algorithmic translation into digital data that will then be transmittable and processable by other algorithms. The only tangible constraint to the capacities of this process is described in Moore's law.[57] Beyond this the only restrictions are the theoretical limits of computation. The digital photograph is hence the outcome of processes that are mostly if not exclusively mathematical. It therefore cannot be underpinned by concepts of identity with objects, or un-coded representation of them. It can only be properly understood with the concept of information and by examining the delicate interrelations it maintains with the uses it is enmeshed in. This, argues Palmer, explains why camera manufacturers no longer promote their products by emphasizing the quality of their hardware but instead by stressing the sophistication of their software[58] – because photography today is principally a form of code manipulation. Put differently, it is not dependent on lenses but rather on algorithms – those step-by-step procedures for calculation, which are what visual data processing now is.

Cameras have never simply taken photographs but rather facilitated their making. To that end, digital cameras are simply devices that facilitate the making of photographs by new means – electrical signal processing and software engineering. They are, unavoidably, the marriage of a computer with a lens, or the enslavement of the latter by the former. A photograph today is the result of complex processes designed to make binary data packages look familiar. And when the photograph is

displayed further algorithmically enabled design processes ensure that it resembles a traditional photograph. In this, the screen and the photograph in it become what Palmer calls 'a space of performativity' – no longer a site of emanations from the past but rather an arena for 'performative calculation' where the temporality of the image is not so much historical as it is mathematically recursive.[59]

To best understand this new image-standard it is important to recall some often-quoted early formulations by Roland Barthes. By asserting that because photography is grounded in procedures of analogical representation,[60] Barthes famously claimed that the photograph (or photographic image) was 'a message without a code'.[61] This proclamation has always been debatable. It is now almost impossible to accept it, given that the photograph has become *nothing but code*. It consists not in 'reflecting' external reality but in showing the extent to which every depiction of reality is inseparable from the codes that mould it. This, I believe, is the point Thomas Ruff makes in his *JPEG* series. Herein, an abstract photographic image of collapse is presented in a manner that accentuates the fact that, as a digital file from an indistinct source, it cannot but manifest the idea of abstraction by code and its potential for image-collapse. This, we might concede, is the one and only condition for media in a cosmogony that only recognizes operations by symbolic notation and is totally agnostic to all inputs as it is to all outputs. 'Codes – by name and by matter – are what determine us today', argued Friedrich Kittler. They are what we must articulate now if only to avoid disappearing under them completely, 'They are the language of our time precisely because the word and the matter code are much older'.[62]

Photography from Digital to Mathematical

Digitality

Human communication always entails a code. However, codes require action to be generated, manifested and transmitted. This action, argues Flusser, is always a form of abstraction. In that sense, the digital code is not unique. Seen this way, digital photography is first and foremost a form of extreme abstraction. This, to reiterate, need not contradict its capacity to generate hyperreal depictions. Think, for example, of Joan Fontcuberta's series *Orogenesis* (Figure 21). These images are highly complex, code-dependent abstractions. They are, in fact, the result of trickery intended to invoke a comparison with neo-romanticist or modernist paintings.[63] Nonetheless, they are as veridical as one could ever wish.

What's more, if, as art-historians used to argue, abstraction equals purity of aesthetic expression,[64] then digital photography is the purest expression of photography – a stripping away of superfluous and restrictive elements in its

FIGURE 21: Joan Fontcuberta. *Orogenesis: Friedrich* (2004). Type C print. 120 x 180 cm.

tradition. It further allows for previously latent mechanisms of exchange, media-tion and bureaucratization to fully realize themselves. It is the ultimate reification of the program of photography that, put differently, has only come of age with the digital code. If this is true, then photography is not 'over'; it is merely its adoles-cence that is over.

Strangely enough, Barthes was also one of the first writers to ever propose that a photograph corresponds to 'a decisive mutation of informational economies'.[65] Even so, drawing insightful connections between photography, as Barthes knew it, and today's 'image-information economy' is not easy. Should these rely exclusively on the terms 'analogue' and 'digital'? And must these terms, with their supposedly non-overlapping discourse modalities, always be mutually exclusive? At present, most attempts to theorize photography's compatibility with concepts of commu-nication and computation involve largely arbitrary dichotomies that are, I argue, unfruitful. I find it uninformative to accept a rhetoric wherein attempts to define past or contemporary imaging technologies rely exclusively on simple dualistic taxono-mies, be those darkness and light, presence and absence or opacity and transparency.

See for example Geoffrey Batchen's statement: '[...] photography is a binary (and therefore numerical) system of representation involving the transmutation

of luminous information into on/off tonal patterns made visible by light-sensitive chemistry'.[66] This description is germane and Batchen is indeed justified in attempting to debunk Lev Manovich's privileging of cinema over other forms of 'old media'.[67] Further, Batchen's insistence on naming photography as the precursor of 'new media' is vital but there is more to this point. *Where* and *how* does photography consti-tute a binary system representation? And *what*, if anything, does this afford? To be fully accurate, not all binary systems are numerical. Further, numerical forms of representation are not always of value. Thus, to facilitate a more insightful construal of photography's primacy within new media I find the terms numerical and digital imprecise. Instead I prefer the term 'digitality' (derived from Nicholas Negroponte's 'being digital') as an epistemological rather than ontological condition.[68] I use this term to analyse the basic chemical structure of the *traditional* photographic emulsion.

Importantly, silver halide cannot turn grey. It can only turn black or remain unchanged. Thus, it *is* a binary instrument.[69] It can thus participate in Boolean logic applications onto which almost all contemporary forms of digital representation are grafted. Digitality, however, is much more than just that. Whereas it neces-sitates disunion of the unitary and separation of the indivisible whole into its constituent parts, it also requires *multiplicity* to generate value. In other words, the condition of digitality is that there be more than one instrument – more than one silver halide. The more binary instruments there are the more this condition is likely to emerge and hold. And emerge early in the history of photography it undoubtedly did – in the colour grey. Wherever grey exists on a photographic emulsion it is there because silver halide molecules are minute: it is only the density of 'black' versus 'white'[70] molecules within a given area that creates various tones of grey. And greys, as anyone who has ever entered a darkroom surely knows, are no small matter. The more shades of grey a silver gelatine print has, the more 'photographic' it is considered.

Locating the origins of digitality in photography in the distinction between black and white as most commentators have done is uncreative and restrictive. Rather, digitality should be located in the greys and in the quest for their infinitude. This, we can recall, is what the 'proto-programmers' of photography have argu-ably sought.[71] This also implies that photography has always been digital and has, therefore always borne signs of programmability. Perhaps it is photography, before anything else, that has proven the accuracy of the oft-repeated comput-er-programmers' mantra that 'God only invented 0's and 1's, everything else is man-made'.[72] Of course, today photography programmers are interested in much more than greys: they seek infinitude for the world and everything in it, infinitude by means of granularity.[73]

Perhaps the terms digital and analogue can now be understood as follows: for photography to be analogue it can pursue only one quest – that of fashioning,

or simply naming, common attributes for both photographic image and photographed object. This quest has, from its outset, been of limited philosophical prospects and its failure should now be acknowledged. An ontological model maintaining that a technology is capable of homogeneity and continuity, that it is in that monolithic, when its manifestations are manifold and its forms, without exception, are riven at the core, is futile. But if, proceeding from Flusser's post-Werner Heisenberg ideas, we concede that we are living in a universe that is stuttering (both physically and metaphysically),[74] then the digital instinct in photography can be seen as what preserves that stuttering and turns it into magic. It accentuates and proliferates it to produce an endless stream of pre-programmed speech. This holds true even for those photographers who are content with orienting themselves towards objects or states-of-events in the world and the theories that celebrate and rejoice in the illusion that this may be possible. Because the camera apparatus is already separate, or set apart, and opposite from that object, because the camera is only a 'viewer proxy' as Alexander Galloway calls it,[75] then it should become clear that it has always been 'of digitality'. This viewer is inside the world, of course, but the structure here is not of simple immanence. Rather, it is a structure of distance, difference and relationality that predominates. How then can we call it anything but digital?

Digital multimedia databases have arisen and become popular 'because they prioritize complex (or post-structural) thought over complicated (or structural) thought and over intricate (or serial) thought', argues Ross Gibson.[76] This suggests that a technology that had enabled complex post-structural thought well before the term 'digital media' became known to us cannot be anything but digital. Furthermore, it is simply too easy to use existing definitions of analogue and digital to forge uninformative terms such as 'analogue photography' and 'digital photography' and that it is altogether mistaken to describe the two as photography and 'post-photography', respectively. If anything, the chronological hierarchy should be reversed. To reiterate, 'analogue photography' can be dubbed 'pre-photography' and only 'digital photography' should be called photography. Perhaps, if the workings of contemporary photographic apparatuses were not so blackboxed from the end-users' perspective, perhaps if they were in any way visible from the images rendered, then it would become clear that it is only with computerized platforms that the qualities traditionally attributed to photography can be identified.

My contention here is that photography has always been a digital or quasi-digital multimedia platform. Nonetheless, we should remember that photography has all too often been defined by overplayed distinctions, apart from the distinction between light and darkness. There are those that derived from the nineteenth-century dichotomy between body (a substantive object or state-of-events) and mind (a

mythic authorial position).[77] There are also the distinctions between causality and intentionality or between transparency and opacity. In addition to the problematics these perpetuate (articulated in Chapters 1 and 2 respectively) each of these opposites highlights an unproductive demarcation between the process, photographic imaging and product, the photographic image, while critical theory has always given precedence to the latter. Such demarcations are today unnecessary, in fact impossible, given that images are, more often than not, open-ended and unresolved latencies of and for other images or other media. Fortunately, Flusser's programmatic worldview does offer a way out of this stalemate but, to be fully purposeful, it now calls for a modest expansion. It requires better articulations of the vocabularies we want to use with photography, provided in the remainder of this chapter.

The Mathematical Image

A photograph today is almost without exception an image without an image carrier. This, if nothing else, ought to remind us that all aspects of photographic production have always been potentially encodable by mathematics, engulfable by computation. Therefore, the data captured by a digital camera sensor can almost as easily be presented and outputted as an entirely different kind of image, or not as an image at all: as audio, text or simply as an indecipherably long string of numbers. Nowadays, if an image on a screen seems to resemble a traditional photograph this is exclusively due to programmed computational processes designed to make data packages recognizable. A fine example to is the JPEG file format, first issued in 1992 by the Joint Photographic Expert Group. This can be applied to any bitmap digital file, no matter its genesis. 'Photographic' is thus no longer a category of images based on a specific mode of production, but a category of images that displays a specific aesthetic distribution. Almost any image holds the potential to become de facto 'photographic'. With this, 'photographic' no longer denotes a specific mode of image creation, but rather a specific mode of image processing.[78] Adherence to the visual conventions of photography is simply an ornamental decision taken by the programmers to aid the viewers, or rather the users. In fact, more often than not, when today's aesthetics is recognizable, coherent with a previous kind or form of media, it is solely thanks to successfully designed computations.

Computations can process multiple streams of data. And for that purpose it matters not whether these streams, rivers or pools emerge from radically different temporalities, origins and histories. Other computations can then filter these streams, purify or blend them to make new streams that will flow elsewhere. Put differently, mathematization always produces only *seemingly* distinct and *seemingly* seamless sensing experiences. The viewfinders that are still occasionally found

on the backs of some cameras count for very little. They are also, we could say, ornamental. Whatever use they can be put to is insignificant in the overall production of a photographic image. Arguably, human photographers who still cling to the belief that the viewfinder is where decisions are made are like a fly sitting on the back of a ploughing ox.[79]

This marks a break in the familiar chain of photographic signification. It problematizes the very possibility of signification in which every signifier can be represented by another. Once a signifier is a sequence of numbers (or bits), it is questionable whether it can ever be represented by anything else and, to the extent that this is possible, why should we desire that option? The computer, we could say following Flusser, locks the photographic image in the zero-dimensional territory of numbers. What this means for photography is that we should now try to avoid reading its occasional hyperrealism; in fact, we cannot read anything from it. Within this realm, the photographic image is what Geoffrey Winthrop-Young calls 'an impoverished aristocrat'.[80] To the extent we still desire its representational properties we must ourselves attribute them to the image. We can do so but only on ad-hoc basis, which always depends on transmutable aesthetic criteria.

The mathematical image (or, more accurately, the image born from mathematics) shifts the emphasis from considering images in visual terms towards a nomenclature drawn from the syntax of computation and the semantic structures of computational culture. This of course means that photography, if that is still how we want to label some images, is an unstable entity – a set of circumstances of the kind that produces meanings only through the aggregation and the embodiments of pure abstractions – raw digital data.[81] The conceptual tools required to describe this new state of being cannot be comprised of an 'indexical' ontology of the image. There is simply no place for a dialectics of light and vision that can generate only fixed identities and thus transcendental truths. What we need is an immanent but flexible epistemology that can engage with the multiplicity, the fragmentation and the recursivity that today characterize images as well as media at large.

The Quasi-Photographic Image

The hunt for visual realism should not deceive us with regard to the basic principles of computer graphics [...] computers must calculate all optical or acoustic data on their own precisely because they are born dimensionless and thus imageless. For this reason, images on computer monitors [...] do not reproduce any extant things, surfaces or spaces at all. They emerge on the surface of the monitor through the application of mathematical systems of equations [...] and these variables are determined at the leisure of image processing algorithms [...]

161

the computer functions [...] as a general interface between systems of equations and sensory perception – not to say nature.

Friedrich A. Kittler[82]

Many cultures privilege visual depictions above all other forms of representation.[83] Is this because visual depictions, more than others, not only make features of the world manifest but also make them more easily accessible to human cognition? This applies not only to manugraphs but also to maps, diagrams, other sorts of visuals and, last but not least, photographs. Perhaps this can, if nothing else, account for the significant increase in the number and variety of seemingly photographic images over the past years. But the computer, it is clear, provides alternative access routes to representation, ones wherein the place of images is less definite, less circumscribed. Has the computer thus ruptured our longstanding privileging of vision and visibility? And, if light in its various forms is no longer required for photography, what new realms has it opened for us instead?

The very words 'imaging technologies' seem to refer to the production of images. Yet, resulting from the processes described in this chapter, a striking feature of many imaging technologies today is that they are fully mathematical. This means that their output need *not* always be images. In fields like medicine, astronomy and law enforcement, to name but a few examples, imaging technologies generate images, and at exponential rates, even though there is no technical necessity for doing so. While there are, of course, considerable differences between new types of imaging systems, two features stand out as common to many of them. First, and most importantly, multiple layers of statistical and mathematical processing are essential to the production of those images. Crucially these are required *prior* to the production of the images as such. In other words, they are required for converting data into image-information in the first place. Second, and curiously, these systems mostly output their data in the form of more-or-less naturalistic images. Additionally, of the great many images that are nowadays being generated, an extraordinary proportion are not just naturalistic images, but also images that take the form of photographs to call attention to themselves. This breed of photograph-like mathematical image is what I call a *quasi-photographic image*. Why has it become so popular?

By way of recapitulation, it is worth noting the hypothesis that a photograph can always be measured and subjected to qualitative analysis subsequent to its production. This, allegedly, is by virtue of the causal chain that, with the agency of light or other energies, connects it to the object that it is of. Other modern forms of imaging, like microscopy or astronomy, also traditionally include at least some optical data, in addition to other types. This data relates to a potentially visual

object. Therefore we could, at least theoretically, accord to such images familiar epistemic values of photography.

Conversely, many contemporary technologies offer depictions that require mathematization to start with.[84] In a brain MRI, for example, the radio frequency signals that brain nuclei emit after they have been subjected to high levels of magnetization are measured with a coil and mathematically processed with a computer. Even in the case of NASA's Hubble Ultra-Deep Field (HUDF) and eXtreme Deep Field (XDF) 'telescopes' the full range of electromagnetic radiation from ultraviolet to infrared is traced mathematically, not optically, to *computationally* create the beautiful space 'photographs' we are all familiar with. Thus, I would say that for some of these images, the only thing undoubt-edly 'optical' is that they are later transmitted as signals through optical commu-nication networks. Another contemporary example, less familiar but equally telling, is the *Digital Ethereal* architectural imaging project by Luis Hernan. Here an imaging system generates depictions of Wi-Fi signals,[85] thus render-ing visual patterns of radiation that are undetectable to any level of human perception. Put differently, a purely mathematical image cannot be measured by or subjected to methods of analysis other than quantitative ones. A signal extracted by assessing correlations or probabilities, determined only by the parameters its system is pre-programmed to filter, correlate and identify, can hardly be considered 'actual fact'.

As noted, mathematical imaging requires that extensive mathematical transfor-mation occur to produce the data that can then be represented in the form of an image. Usually the result of signal detection, data correction and reconstruction is a numerical value assigned to each pixel, or each voxel. The final conversion of this data into an artificially naturalistic image is often simply a matter of assigning a grey or colour level to particular ranges of numerical values and then displaying the data in a two- or three-dimensional array. It could just as easily be represented in other ways because raw mathematical data is, by default, completely indifferent to its content and the 'sensory field' within which it will appear.

Beguilingly, even though the formal appearance of computationally generated visualizations derives, sometimes exclusively, from mathematical processing, such images rarely, if ever, bear the stamp of their processing on the pictorial surface. Instead, they often adopt the look and feel of 'traditional technical depictions': photographs. Rather than foregrounding the piecemeal, additive processing of individuated pixels or even vector-based curves, these visualizations intentionally bear properties such as continuity, density and repleteness that seem to suggest an unambiguous form of irreducibility.

To account for such quasi-photographic images we ought to first look into *why* they are even images in the first place. After we have located the reason why

data clusters so often appear as images when there is obviously a choice between various data display formats, we will also be able to say why many of these images are quasi-photographic and how these should be understood today. A novel account by Megan Delehanty proposes three reasons for the surprising persistence of images: historical preference, rhetorical power and cognitive accessibility.[86] Proceeding from Delehanty's ideas, I argue that the second and third conditions, if developed, can also be taken to explain the popularity of quasi-photographs. Historical preference is perhaps easier to understand. In many ways it is even explained by some of the common narratives within art history. It is partially explained by postmodern critiques. In short, in the last 180 years we have grown increasingly accustomed to 'seeing' by means of photographs. We recognize no other way of understanding ourselves. We still know no better way to define the world around us. That is why photographs, and their predecessors, continue to be a dominant cultural form.

The second factor, rhetorical power, has been discussed in various ways throughout this book. Interestingly, it is not only in art but also in science that there is a well-documented preference for visual representations that resemble what we obtain by direct observation.[87] Historically, we have always taken images to be reliable sources of information for certain, mainly visible features of the world. The standard way of accounting for this is by reference to the fact that when exercised in appropriate conditions, visual perception is more often than not reliable. We learn to trust our eyes, in most situations, and therefore modes of investigating the world that resemble straightforward, unaided, visual observation are more easily taken to be also trustworthy. 'Seeing is believing', and when new ways of 'seeing' come up, we are inclined to think that we should believe what we 'see' in them too. Another possible reason to account for the persuasive power of images is that we are simply drawn to attractive images. We like looking at them and we like making them. However, and even if the beauty of the images may, in some cases, be an end in itself, it does also serve other purposes. Therefore I will now briefly discuss the nature of our relationship with the images photographic technologies generate. To do this I will develop the third and most interesting of Delehanty's reasons for the surprising persistence of images – cognitive accessibility.

Photographs, I argue, are so cognitively accessible because of three separate sub-qualities that they possess and that other image types do not. The first is granularity. Photograph-like images usually maintain a consistency of granularity from object through instrument to depiction. Granularity is the extent to which a system can be broken down into small parts, either by the system itself or by its observation or description. It is the extent to which a larger entity is subdivided. In terms of granularity, coarse-grained systems consist of fewer, larger components whereas fine-grained systems consist of more, smaller components. For example,

if a room can be broken into centimetres then it is a system with fine granularity. If, for whatever reason, a room can only be broken into meters then it is a system with coarse granularity.[88]

Second, the data structure of photographs consistently preserves the visual properties of objects. In other words it 'breaks up' those objects competently and 'reassembles' them more effectively than most other forms of data do. Further, in doing so it usually reassembles these objects within predetermined, finite error bounds.[89]

The third and most important sub-quality is the mode of data preservation and presentation. Consistency of granularity and structure preservation come un-encumbered – the photographic image itself preserves only certain forms of information and does so very efficiently. However, it does not preserve other forms of information. Most notably it preserves visual information but it does not preserve what Cohen and Meskin call egocentric information – information about the objects' locale and chronology.[90] As noted, such information may at times be preserved by other means but not by the image itself. Thus, the cognitive accessibility of photographs provides a unique epistemic structure – *select information with no strings attached*. An experience of the world unbound by biological hardware. Such an epistemic structure is, in some cases, an epistemic advantage.

Photographs can present us with complex information in ways that are easily accessible to our cognitive apparatus. Until recently, the larger and more complex the information set, the greater the epistemic advantages of using photographs. This is beginning to change as new imaging platforms are becoming potent. Think for example about Michael Najjar's *High Altitude (2008-2010) / Nasdaq_80-09* (Figure 22). Here, raw data representing financial fluctuations are transformed to image data yielding a pseudo-alpine landscape photograph. Importantly, the creation of this image was enabled by parsing raw data and did not even require a sensor.

Arguably, accepting the configuration of the photograph in terms of visual content alone is becoming increasingly problematic. By viewing it as an image or a picture of something 'out there in the world' all speculative possibilities are suppressed. As I argued above, such lack of pluralism is perilous because absolute privileging of one mode of interpretation over all others is always likely to lead to fragile conceptual paradigms. Perhaps a definition of photography today need *not* require that the information processed in a photograph descend exclusively from visual or even sensorable sources?

Photographic Authority

'Images are mediations between a circumstance and man', states Flusser.[91] But what exactly does mediation mean? What is our circumstance? The answers are complicated. A useful point here is that cognitive accessibility is not discriminatory. Hence

FIGURE 22: Michael Najjar, *High Altitude* (2008–2010)/Nasdaq_80-09, 2008–10.

the advantage that photographs have over representation of portions of the information in other formats can also be reversed. Thus it should come as no surprise that there are now other types of visual and non-visual representation that can similarly allow us to make judgements the same way photographs do. Such embodiments of data may likewise offer potential advantages with which we are still unfamiliar.

In particular, mathematical representation may be capable of corresponding to an infinite number of discrete values. Of course, no output device offers infinite precision. Nevertheless, mathematical representations do have a better capacity to fully capture the granularity of observation instruments. The main point is that the apparent granularity of the data represented in a photograph will almost always be less than that of the input device. Thus, the cognitive advantage of photographs over other forms of data display is relative. The existence and extent of the advantage is dependent on the sort of judgements that need to be made. Furthermore, today it has become increasingly clear that, even in cases where there is some advantage in using a photograph, or the photograph is simply easier to use, the operation thereby facilitated could in principle have been accomplished using other forms of sensory representation.

Clearly, entirely constructed computerized environments can provide better representations of aspects of the real that concern us. They often capture processes that photography just cannot capture or represent. They routinely provide

representations that, assuming certain conventions of interpretation and use, allow one to grasp a concept more easily. Simulations and models may also give us better and more predictable control of inferential speculations and perceptual extensions in the way that photography does not. Thus, extending the epistemic structure of photographs to include simulations and computational models of the world is now necessary. If nothing else, it will furnish these models with 'photographic authority' – the authority to provide us information and inferential guidance that they are, at present, incapable of conveying.

A fine example is Alex Roman's short film *The Third & The Seventh* (2009).[92] This film, although made a long time ago in terms of computation standards, is a small wonder. In many ways it still sets a standard for overwhelming lusciousness of the sort that once only photography could offer and now fully mathematical imaging has redefined. Winner of the 2011 Ars Electronica prize in computer animation, it is a meditation on architectural spaces and their photographing. It features various well-known and iconic façades and interiors.[93,94] This august list, in addition to a few outdoor scenes and a photographer's darkroom exhibiting rolls of drying film and the mandatory prints hanging from laundry lines, are all modelled in 3D computer graphics in the most intricate of ways, including film-like selective focusing; delicate lighting that changes minutely or sometimes dramatically; and, of course, 'camera' and 'object' movements. All these photographic and cinematic tropes are, to reiterate, not causal, not even in the slightest way. In terms of analytic aesthetics we could say that this entire film is 'a moving computerized manugraph'. Alternatively, we could call it a pre-calculated, pre-modelled, moving quasi-photographing of sometimes-real spaces.

The underlying theme of Roman's work, as it traverses these fantastic virtual spaces, is of a photographer documenting those very spaces. This computer-modelled photographer, who is sometimes seen only in shadow, utilizes a variety of vintage cameras, some of which had been rendered obsolete well before some of these buildings were built: a 4 × 5 inch wooden field camera with Optar lens, a Cosina Super 8 camera and a Colourpack 100 Polaroid Land camera. Works like this will in the future redefine the medium as something that cannot and ought not be realized without the aid of a computer.[95]

Today there are various formats for creating images that only look like photographs and enable inferences and interpretations about the world. This is where Patrick Maynard's suggestions of broadening our understanding of photography prove helpful again. By recalling the problematics of the association between photographs and photography in the main, we can better understand the variety of ends to which later generations of imaging technologies can be put to use. This is of particular importance since some of these new imaging technologies now generate 'images' that maintain, and in fact require constant recourse to an infinite database

of other 'images' of the very same type. I will discuss these shortly. Either way, there is no point in insisting that photography must be restricted to a fixed set of observation instruments, receptors and energy sources. Perhaps photographs too, just like quasi-photographs, have always been only one form of interface between a system of equations and our sensory perception. Usefully, the above definition for the epistemic structure of photographs can also be turned on its head. It can be used to argue that *any* image can be considered a photograph, *regardless of how it was made*, so long as it satisfies the same two conditions that photographs do: preservation and presentation of some information in a sufficiently granular way; and partial or complete omission of other types of information. Flusser has argued that there is no way to formulate the difference between depiction and model without 'coming to grief'.[96] If the photograph is anything, then it is only an image with fine granularity.

The Programmatic Image

Language and Expression

The cultural object known as the photographic print is all but gone. Fictional nostalgia aside, the photograph tethered to a 'photograph-carrier' is nowadays simply not in demand anywhere outside museums. This is an undeniable fact. But this is not the only place where photography is undergoing dramatic transformations. The photographic image *itself* is also increasingly ephemeralized when it emerges as a routine outcome of continuous and contextually interactive, visually educative processes. Therein biological and artificial eyes reflexively communicate with each other and with other fragments and potentialities borrowed from various technological progenitors.

Will this precipitate the dissolution of the photographic image as a distinct media form? And does it presage the emergence of another visual context that now requires new terminologies? From which discipline or form of knowledge should these be extracted? Two hypotheses come to mind in attempting to answer these important questions. The first can be extracted from the re-mediation model of media. In this model, media are always merely formal containers housing other forms of media. This is the claim elaborated by Marshall McLuhan,[97] and others following him.[98] It is easily articulated in terms of media history: a new medium is invented, and as such its role is as a container for a previous media format. This is why photography, according to this model, inherited some of the qualities and functions of painting. Similarly, film is a container for photography, music and various theatrical formats. Video is a container for film and the World Wide Web incorporates text, image, video and audio formats. 'Like the layers of an onion' states Galloway, 'one format enfolds another, and it is media all the way down'.[99]

Photography, by this reasoning, has perhaps already been encapsulated in what has been called post-photography. Thus we might expect further change, but it will arguably be a perpetuation of what we have witnessed in the last two or three decades.

Kittler's legacy points to another hypothesis wherein it is the very essence of media that has now changed, and irrevocably so. According to this view, numerical representation does much more than just turn media into other media. When media are digitized and become computer data, they also become actionable, processable and increasingly more programmable. This means that the differences between individual media and the borders separating them are now largely erased. Image, sound or text all become mere effects, or rather interfaces for the consumer: 'Sense and the senses become mere glitter'.[100] Moreover, given the levels of programmability available today, computation not only processes, stores and transmits information, it also conflates matter (or energy) with information. In other words, we have begun witnessing much more than the mechanization of various languages. This, in fact, is the mechanizing of the very notion of language. In that, I argue, programmability thwarts the very distinction between language and expression, between imaging and image.[101]

So which hypothesis should we opt for? The answer depends on how one defines media to start with. I, for one, prefer Kittler's construal over McLuhan's, as it seems better warranted by present technological habitats. This choice also allows some leeway, whereas McLuhan's model remains partially valid. In more than one respect, Kittler's construal is similar to Flusser's programmatic worldview, which, as we remember, incorporates the causal and formalistic worldviews. The major difference is that Flusser designates photography and its formal logic (and not the computer) as the watershed moment for the process in which all media collapse and converge.[102] This similarity, located in the pivotal importance of dimensional abstraction, as well as in the overarching role both writers ascribe to programmability, demonstrates the extent to which photography and computation can be seen as parallel, perhaps even mirroring each other in the way they formalize the world.

Thus, as multiple technologies and artworks now suggest, the distinction between language and expression has not only been thwarted, it may even have been annulled. A point made earlier can make this clear. Previously, in so-called 'analogue photography' the negative would serve as a storage medium of language whereas the print would be the medium of display. In the hidden abode where contemporary images are produced, the relationship is not simply arbitrary, but is at all times dependent on the new interstice called software. In fact, the very concept of 'image' is now increasingly difficult to apprehend, not only because images constantly oscillate between visual and digital properties but simply because they are infinitely malleable and stand in arbitrary or generic relationships to the

objects they 'represent'. With the advancement of image-based software applications, the function of images has changed. In fact, assert Rubinstein and Katrina Sluis, an image today must be considered 'a process which is expressed as, with, in or through software'.[103] Images are thus no longer harbingers but *generators* of information, they no longer show us things but rather *do* things for us.

Hard and Soft Programs

Computation, it is clear, brings new functionalities to the convergence of vision and representation. If, on a superficial level, the visual face of the image pretends to operate as it always has, on a deeper, often black-boxed level, the image partakes in new operations. For the time being, these two operations mostly function in synergy. Notwithstanding, it is those powerful undercurrents that now create the image-worlds we habitually enjoy or otherwise agree to participate in. From the navigable panoramas in Google Street View to automated border controls or military drones, it is computation that now sets the standard for alignment of vision and representation, just as geometrical perspective used to.

From this view of computation-saturated media habitats, one only requires a toehold to arrive at the concept of the operational image as an overarching definition for contemporary images. Operative images, as Harun Farocki conceptualizes them, are products of visual tracking technologies designed to function without human intervention.[104] Thus it is not unusual for an image to be or become equipped with means that gather, compute, merge and display heterogeneous visual data in real time. Importantly, the world they visualize and interact with is predetermined. It is already calculated and archived. Once activated, they discriminate automatically: they process and compare continuously until they reach an end (in the case of automatic warheads) or the limit of the databases and processing power that has brought them into being (if such there is). Some operational images are produced for human consumption but others are produced exclusively for other non-sentient entities – 'vision machines'[105] controlled by computer programs. Farocki, in other words, implies that the disappearance of manual effort also entails the elimination of visual effort from imaging.

In a similar vein, Rémi Marie and Ingrid Hoelzl argue that images are 'no longer a solid representation of a solid world', or, as it were 'hardimages', but 'an unstable algorithmic configuration of a database: a "softimage"'.[106] I find this neologism almost apposite. Its only shortcoming is in implying that the new image hinges on software alone. It thus enables, in fact requires three more steps. The first is to remove ambiguities associated with the term software, to seek its connections to the term hardware, bearing in mind that for many speculative computations

it is impossible to draw a clear line between symbolic-imaginary and material processing A second step would be to see whether the terms software and hardware can be amalgamated into and replaced by one inclusive term. A third would be to remove equivocations associated with the term algorithm and to clarify how it can be utilized in the context of photography and art. These tasks will be accomplished in Chapter 5.

In conventional terms, hardware refers to the physical-mechanical and electronic aspects of computation (physical memory, input-output devices, etc.), whereas software designates the set of formal instructions that direct machine processes and that are abstracted from the material layer of digital circuitry. Software, as a logical system, is thus conceived as floating 'above' the hardware system. Thus, software has recently become, a devil's advocate would argue, the new king and opium of the people; it is governance and illusion combined. Relative to the material solidity of bits and pieces of metal and silicon, software also tends to be presented as virtual and immaterial. While justifiable as a means of relative differentiation, this common-sense distinction obscures the vital sense in which computation works to unsettle the very opposition between material and abstraction.

In a notorious essay that has become compulsory reading for open-source programmers, Kittler argues that software has eroded the monopoly of ordinary language, and has now grown into a new hierarchy of its own. Notwithstanding, Kittler argues tongue in cheek, there is *no* software simply because *all* software operations (for example writing this text or reading it from a screen) can always be reduced to basic *hardware* operations:

> no underlying microprocessor system could ever start without the rather incredible autobooting faculty of some elementary functions that, for safety's sake, are burnt into silicon and thus form part of the hardware. Any transformation of matter from entropy to information, from a million sleeping transistors into differences between electronic potentials, necessarily presupposes a material event called reset [...]. All code operations, despite such metaphoric faculties as call or return, come down to absolutely local string manipulations, that is, I am afraid, to *signifiers of voltage differences*.[107]

Perhaps Kittler's reduction of software to hardware was replete with age-old boundary conflicts. Perhaps he debunked software, argues Winthrop-Young, in much the same way that nineteenth-century science pried apart the human 'mind' by examining how the brain worked.[108] Arguably, if both 'brain' and 'mind' are taken to be humanly constructed terms, Kittler's analysis becomes easy to concur with and most pertinent to photography. In fact, if we utilize his legacy

for administering contemporary definitions of various 'types' of images, which is a somewhat caustic endeavour since Kittler would undoubtedly argue that 'image' is an unstable definition to begin with, then it would support the proposition that 'photographic' is nowadays only a case of granularity, resolution or aesthetic.

Be that as it may, I prefer Flusser's novel use of the term program for our purposes. This conceives of both processors and other hardware operations as well as the hugely varied array of software as parts of the same troubled whole. Flusser's definition of a program does so in much the same way as it perceives the photographer's eye or mind and their shutter- pressing finger as entangled parts of the same 'gesture'. It also has the benefit of avoiding the pitfalls of post-human-ist and post-humanities discourse. As the overarching structure for photography, 'program' includes both tangible and ephemeral elements – not only the sensitomet-ric equations once used to make film or today's colour compression algorithms, but also the film itself or the sensors and silicon chips within the camera. This not only has the merit of being applicable to various ages of pictorial media, it also offers, as demonstrated in the following chapter, a conceptual framework pertaining to the new structural conditions of visual depiction and to the way in which new meth-ods and processes of tracing and inscribing affect the ways images operate today.

Photography has often been understood as the operative convergence of vision and representation, made possible by optics, mechanics and chemistry. Its mathematization and subsequent dissolution have rendered the images it gener-ates operational and performative, and these qualities necessitate an understanding of the world as no longer a stable state-of-affairs preceding the image but rather as an ongoing, never-ending, open-ended stream of possibilities. An image is thus 'a programmable view of a database that is updated in real-time. It no longer functions as a political and iconic representation but plays a vital role in synchronic data-to-data relationships. The image is not only part of a programme, but also contains its own "operation code": it is a programme in itself'.[109] I thus arrive at a modified and expanded definition of the contemporary image: *a programmatic performance of data gathering processes and its subsequent rendering, proliferation and exchange.*

Every program is always a set of other programs, argues Flusser. As such, it 'functions as a function of a metaprogram and the programmers of a program are functionaries of this metaprogram'.[110] The hierarchy of programs is open-ended. There are no independent programs because the operations of a program can always be reduced, or relegated, to another. This has far-reaching implications for media as well as for art. If there are no independent programs then there are no independent mediums. Conceivably, medium-specificity within a programmatic realm is impossible to sustain. Thus, there is little reason now to be interested in disciplines or in categorizing them. We should only be interested in the strate-gies for their realization. Since all media are now concessions to inferior human

processing capabilities, mere intermediaries translating computer languages, how can we distinguish between machines and their output? How can we tell machines from their surroundings? How can we tell what is media and what is not?

New Image Ecologies

As technology, the more a dioptric device erases the traces of its own function-ing (in actually delivering the thing represented beyond), the more it succeeds in its functional mandate; yet this very achievement undercuts the ultimate goal: the more intuitive a device becomes, the more it risks falling out of media alto-gether, becoming as naturalized as air or as common as dirt. To succeed, then, is at best self-deception and at worst self-annihilation.

Alexander Galloway[111]

Since all aspects of its technical modes of production have been transformed, photography's historical and theoretical lineages must change as well. Will such change contribute to the development of alternative definitions for photography as well as for art? Can it become a practice that does not valorize the production of individual images but instead critically explores, defines and transforms the broader theoretical and technological contexts in which images can be produced? As David Tomas accurately asks, 'at what point does it make sense to drop the reference to photography altogether and opt for another term to describe this different kind of practice?'[112] The practical application of this aspiration necessitates a major shift in the traditional relationship between process and product as expressed in practically all writings on photography.

Such a strategic inversion, in line with what is attempted above, will clear the way for the development of a new 'ecological' approach to image production. This will involve a considerable widening of the boundaries that have tradition-ally served to define photography. Instead of seeking legitimation in terms of a narrow, institutionally sanctioned history of photography, or defining itself as a tradition of chemical processes, optical designs or perspectival forms, a properly defined 'post-post-photographic' enquiry should trace the networks of its own operational cultures and contexts of production in disciplines such as mathemat-ics, information theory, combinatorics, cryptology, philosophy and physics. The result would be a proposal for a pluralist theory of photography. Therein, implicit reciprocities would be able to promote a different kind of politics of art. It would revolve around more than just conventional products of a lens coupled to image recording and storage technology. This is the aim of the next chapter. Therein,

I will elaborate on various terms that have appeared interchangeably throughout this chapter, notably algorithm, program and computer, and propose them as means to contextualize photography as a precursor of algorithmic art – not only as one early form of program, a Turin Shroud program, but as an ever-evolving multitude of programs, a universal Turing machine.

NOTES

1. Daniel Palmer, 'Light, Camera, Algorithm: Digital Photography's Algorithmic Conditions', in *Digital Light*, ed. Sean Cubitt, Daniel Palmer and Nathaniel Tkacz (London: Open Humanities Press, 2015), 144.

2. This is a title of one of the chapters in Flusser's book as well as a subsequent conference. Vilém Flusser, *Towards a Philosophy of Photography* (London: Reaktion, 2000); 'The Photographic Universe', Parsons The New School for Design, http://photographicuniverse.parsons.edu/.2000.

3. Friedrich Tietjen, 'Post-Post-Photography', in *The Routledge Companion to Photography and Visual Culture*, ed. Moritz Neumüller (London: Routledge, 2018).

4. Ross Gibson, 'The Rise of Digital Multimedia Systems', *Cultural Studies Review* 12, no. 1 (2006): 145.

5. Siegfried Zielinski, *Deep Time of the Media: Toward an Archeology of Seeing and Hearing by Technical Means* (Cambridge, MA: The MIT Press, 2006).

6. Harun Farocki, 'War at a Distance', 58 mins (2003); 'Phantom Images', *Public* 29 (2004).

7. Note that even in Hollywood feature films, the use of DSLR cameras is, in recent years, a matter of routine.

8. This, I believe, is why David Clarebot's works are so appealing. For example: Vietnam, 1967, near Duc Pho (reconstruction after Hiromishi Mine) from 2001 and The Quiet Shore from 2011.

9. Vilém Flusser, 'The Photograph as Post-Industrial Object: An Essay on the Ontological Standing of Photographs', *Leonardo* 19, no. 4 (1986): 331.

10. 'For example, an animal skin is taken from nature, and information is impressed on it: the cultural object "shoe" is produced. The shoe is worn, loses its information, and is thrown into the rubbish. There it decays according to the second law of thermodynamics and returns to an amorphous mass in that very nature from which it was initially drawn. We are looking at a cycle of nature–culture–waste–nature, with no thought of linear progress'. *Into the Universe of Technical Images*, trans. Nancy Ann Roth (Minneapolis: University of Minnesota Press, 2011), 108.

11. This is the underlying message in Lister's contribution in the Wells reader. Elsewhere (for example in Van Gelder and Westgeest) it is still assumed that 'analogue' and 'digital' involve the same sets of questions. Martin Lister, 'Photography in the Age of Electronic Imaging', in *Photography: A Critical Introduction (2nd Edition)*, ed. Liz Wells (London: Routledge,

1998); Hilde Van Gelder and Helen Westgeest, *Photography Theory in Historical Perspective: Case Studies from Contemporary Art* (Chichester, UK: Wiley-Blackwell, 2011).

12. Interestingly, Lister offers a much more complex analysis in: Martin Lister, ed. *The Photographic Image in Digital Culture*, 1st ed. (London: Routledge, 1995).

13. Gottfried Jäger, 'Analogue and Digital Photography: The Technical Picture', in *Photography after Photography: Memory and Representation in the Digital Age*, ed. Hubertus von Amelunxen, Stefan Iglhaut and Florian Rötzer (Munich: G+B Arts, 1996), 108.

14. Timothy Druckrey, 'From Data to Digital', in *Metamorphoses: Photography in the Electronic Age*, ed. Mark Haworth-Booth (New York: Aperture, 1994), 7.

15. For example: Jäger, 'Analogue and Digital Photography ', 107; Seppänen and Herkmann's also brush over this idea but give a more complicated account of the relationship between the 'photographic camera' and the 'digitised camera'. Janne Seppänen and Juha Herkman, 'Aporetic Apparatus: Epistemological Transformations of the Camera', *Nordicom Review* 37, no. 1 (2016): 7.

16. Two examples where this discussion is slightly more interesting are: Nicholas Cullinan, ed. *Tacita Dean: Film* (London: Tate, 2011). Bence Nanay, 'The Macro and the Micro: Andreas Gursky's Aesthetics', *The Journal of Aesthetics and Art Criticism* 70, no. 1 (2012).

17. I am borrowing from Friedrich Kittler who stated: 'And once optical fiber networks turn formerly distinct data flows into standardized series of digitized numbers, any medium can be translated into any other. With numbers everything goes: modulation, transformation, synchronization; delay, storage, transposition; scrambling scanning mapping – a total media link on a digital base will erase the very concept of a medium [...]'. Friedrich A. Kittler, *Gramophone, Film, Typewriter*, trans. Geoffrey Winthrop-Young and Michael Wutz, Writing Science (Stanford: Stanford University Press, 1999), 1–2.

18. To that extent I argue that a photogram is in fact *not* a proper photograph because it involves, and in fact requires, *manual* procedures of production. It is, in other words, just like an etching or an engraving. This given, the photogram, once produced, *can* be turned into an original when it is used for contact printing (usually negative) duplicates. The case with Polaroid is slightly different. There I would argue that there *is* some kind of original but that it is so enmeshed in its duplicate that it is rendered unusable.

19. Quoted in: Daniel Palmer, *Photography and Collaboration: From Conceptual Art to Crowdsourcing* (London: Bloomsbury Academic, 2017), 27.

20. This view was commonly held by many photography departments of the larger museums during the first half of the twentieth century. In fact, it is still promoted today by particular galleries that specialize in showcasing 'classic' photography.

21. For interesting discussions on this matter see, for example: William J. Mitchell, *The Reconfigured Eye: Visual Truth in the Post-Photographic Era* (Cambridge, MA: The MIT Press, 1994), 49; Nigel Warburton, 'Authentic Photographs', *British Journal of Aesthetics* 37, no. 2 (1997).

22. Daniel Palmer, 'A Collaborative Turn in Contemporary Photography?', *Photographies* 6, no. 1 (2013): 117.

23. Nelson Goodman, *Languages of Art: An Approach to a Theory of Symbols* (Oxford: Oxford University Press, 1969).

24. This is similar to Patrick Maynard's conception of photography as a two-step process (and hence of three terms). Patrick Maynard, 'Talbot's Technologies: Photographic Depiction, Detection, and Reproduction', *The Journal of Aesthetics and Art Criticism* 47, no. 3 (1989): 273.

25. 'The negative is comparable to the composer's score and the print to its performance. Each performance differs in subtle ways'. While this pronouncement has been quoted numerous times, I cannot locate its original source.

26. A musical score always remains independent of its embodiment and so, in Flusserian terms, we should say that the information constituting the musical piece rests *outside* of the piece itself.

27. Goodman, *Languages of Art*, 116.

28. Mitchell, *The Reconfigured Eye*, 49.

29. Starting in 1935 Evans did photographic work for the Resettlement Administration (RA) and later for the Farm Security Administration (FSA), primarily in the southern United States. In the summer of 1936, while on leave from the FSA, Evans and writer James Agee were sent by *Fortune Magazine* on an assignment to Hale County, Alabama for a story the magazine subsequently decided not to publish. In 1941, Evans' photographs and Agee's text detailing their stay with three white tenant families in Hale County were published as the groundbreaking book *Let Us Now Praise Famous Men*. The book's detailed account paints a deeply moving portrait of rural poverty. James Agee and Walker Evans, *Let Us Now Praise Famous Men: Three Tenant Families* (Boston, MA: Houghton Mifflin, 1969).

30. This is especially noticeable in the field of art exhibitions. A fine example of this ongoing peculiarity is New York MoMA's longstanding exhibition series titled 'New Photography' which is anything but new. It is almost exclusively comprised of prints hung on walls.

31. Intriguingly, 'The-Impossible-Project' company has been rebranded in 2017 as 'Polaroid Originals'. As of February 2019 the 'Instant Lab' is no longer available for purchase on the company's website.

32. I note this with some caution because digital files do contain 'metadata' information. This includes the date the file was created, along with other important variables, and this information can be used to distinguish between different instantiations of a seemingly identical file. Nevertheless, with minor effort, metadata information can easily be changed or manipulated.

33. Digital forensics tools can supposedly trace evidence of 'physical' tampering with image files – or, in plain words, manipulation in Photoshop. Nevertheless, these tools are mostly intended for examining only the image information in image files.

34. On condition that they are accessed through equivalent communication channels and that these channels are free from interference and functioning properly wherever the image is being viewed.

35. Michael Mandiberg, 'After Sherrie Levine', http://www.aftersherrielevine.com/index.html.

36. In fact, the only similar example that I can think of is Oliver Laric's work that, strictly speaking, isn't photography. Oliver Laric, 'Loncoln 3d Scans', http://lincoln3dscans.co.uk/.

37. Thus it can be said that Benjamin's famous 'mechanical reproduction' was never truly mechanical. Interestingly, in the German original the reproduction was entitled 'technical' (*technischen*) and not 'mechanical'. This term is, to my mind, more appropriate. It also helps clarify which parts of Benjamin's theory can be carried into the twenty-first century and other parts that cannot.

38. In 2001 Lev Manovich argued that lossy compression is the very foundation of computer culture and that computerized replication of data always entails loss of data, degradation and noise. This was largely true then. Today, however, powerful processing and high communication speeds mean that compression is often no longer necessary. Lev Manovich, *The Language of New Media* (Cambridge, MA: The MIT Press, 2001), 54.

39. This piece is a part of the Tate collection. It was exhibited in June 2015 at the Tate Britain as part of the 'BP Walk through British Art' exhibition.

40. For an intriguing discussion on this matter, please see: John Zeimbekis, 'Digital Pictures, Sampling, and Vagueness: The Ontology of Digital Pictures', *Journal of Aesthetics and Art Criticism* 70, no. 1 (2012); Jason D'Cruz and P.D. Magnus, 'Are Digital Pictures Allographic?', *The Journal of Aesthetics and Art Criticism* 72, no. 4 (2014).

41. Ren Ng, 'Digital Light Field Photography' (Stanford, 2006).

42. Palmer, *Photography and Collaboration*, 7.

43. Jiri Benovsky, 'The Limits of Photography', *International Journal of Philosophical Studies* 22, no. 5 (2014): 730–31.

44. Amazon Fire Phones were discontinued in August 2015 after only 13 months on the market. Lytro living pictures can still be experienced by users with appropriate software but the Lytro pictures web service ceased operations in November 2017. Lytro's new business model is oriented towards the production of cinema and 3D graphics.

45. In fact, several computational photography applications that are now integral and integrated into consumer-grade cameras further problematize notions of originality. For an intriguing discussion on these topics (and others), please see: Birk Weiberg, 'Probabalistic Realism', in *Pointed of Pointless? Recalibrating the Index (Part II)* (Brandenburgische Zentrum für Medienwissenschaften [Brandenburg Center for Media Studies, Potsdam], 2017).

46. Daniel Rubinstein, 'The Digital Image', *Mafte'akh; Lexical Review of Political Thought* 6, no. 1 (2014): 6.

47. Eivind Røssaak, 'Algorithmic Culture: Beyond the Photo/Film-Divide', in *Between Stillness and Motion: Film, Photography, Algorithms*, ed. Eivind Røssaak (Amsterdam: Amsterdam University Press, 2011), 188.

48. Flusser, *Towards a Philosophy of Photography*, 11, 12.

49. Rubinstein, 'The Digital Image', 4.

50. This is a point of major importance today because computers mainly 'read' data and rarely 'see' images. As technologies of image pattern recognition and machine vision progress, this is likely to change.

51. Ross Gibson, 'On the Senses and Semantic Excess in Photographic Evidence', *Journal of Material Culture* 18, no. 3 (2013): 249.

52. 'This is a project I started when I found 541,795 pictures of sunsets searching the word "sunset" on the image hosting website, Flickr [...] For each installation, the title reflects the number of hits I got searching "sunset" on Flickr on the day I made/printed the piece – for example, the title of the piece for the Gallery of Modern Art, Australia, was 2,303,057 Suns From Flickr (Partial) 9/25/07 and for the New York Photo Festival it was 3,221,717 Suns From Flickr (Partial) 3/31/08...' Penelope Umbrico, 'Suns from Sunsets, from Flickr', http://www.penelopeumbrico.net/Suns/Suns_State.html.

53. Paraphrasing Moholy-Nagy I would argue that the threshold between illiteracy and literacy is no longer the camera but rather the algorithm, the program and the network. It is these elusive entities that we now depend on for new understandings of our world.

54. Trevor Paglen, 'Invisible Images (Your Pictures Are Looking at You)', *The New Inquiry* (2016), https://thenewinquiry.com/invisible-images-your-pictures-are-looking-at-you/; Hito Steyerl, 'A Sea of Data: Apophenia and Pattern (Mis-)Recognition', *e-flux journal* 72 (2016). The crucial difference between, for example, automated red-light photography and these new types of photography is the fact that in the latter humans can neither produce and view these images nor are they able to do so.

55. Rubinstein, 'The Digital Image', 11–12; Steyerl, 'A Sea of Data'. Steyerl argues we are now in a new phase of 'magical thinking' that she refers to as a 'data neolithic'.

56. CCD – Charged Couple Device. CMOS – Complementary Metal Oxide Semiconductor. Both types were developed in the 1960s.

57. Moore's law is not a natural or physical law but rather an observation and prediction. In short, Moore's law states that the number of transistors in a dense integrated circuit doubles approximately every two years. Accordingly, the processing capacity of information systems also doubles every two years.

58. Palmer, 'Light, Camera, Algorithm', 151–52.

59. Ibid., 158.

60. Roland Barthes, 'Rhetoric of the Image', in *Image, Text, Music*, ed. Stephen Heath (New York: Hill and Wang, 1977).

61. Roland Barthes, 'The Photographic Message', in *Image, Text, Music*, ed. Stephen Heath (New York: Hill and Wang, 1977), 17.

62. Friedrich A. Kittler, 'Code (or, How You Can Write Something Differently)', in *Software Studies: A Lexicon*, ed. Mathew Fuller (Cambridge, MA: The MIT Press, 2008), 40.

63. Fontcuberta has adopted computer software originally intended for military and scientific purposes. The software, if fed with scanned cartographic data, is designed to output

real three-dimensional visualizations of the landscape. However, instead of feeding the software with standard maps, Fontcuberta fed it with reproductions of masterpieces from the history of art. Joan Fontcuberta, 'Landscapes of Landscapes', *Flusser Studies* 14 (2012); Joan Fontcuberta and Geoffrey Batchen, *Joan Fontcuberta: Landscapes without Memory* (Aperture, 2005).

64. This is a point Clement Greenberg was often concerned with, in reference to abstract expressionist painting and post-painting abstraction. Clement Greenberg, *The Collected Essays and Criticism* (Chicago: University of Chicago Press, 1986).

65. While this quote is delightful it does not, of course, reflect the full complexity of Barthes' views. Barthes, 'Rhetoric of the Image', 45.

66. Geoffrey Batchen, 'Electricity Made Visible', in *New Media Old Media: A History and Theory Reader*, ed. Wendy Hui Kyong Chun and Thomas Keenan (New York: Routledge, 2006), 28.

67. Manovich, *The Language of New Media*.

68. Use of the term 'digitality' is more common within the humanities than in fields like engineering. This term first appeared in Negroponte's book: Nicholas Negroponte, *Being Digital* (New York: Vintage Books, 1995).

69. Henri Van Lier alludes to a similar point in: Henri Van Lier, *Philosophy of Photography*, trans. Aarnoud Rommens, Lieven Gevaert Series (Leuven, Belgium: Leuven University Press, 2007), 16.

70. Strictly speaking, there are no white silver halides because halides don't turn white. They just remain unchanged.

71. The Daguerreotype process, contended Daguerre 'consists in the spontaneous reproduction of the images of nature received in the camera obscura, not with their own colours, but with very fine gradation of tones'. Reprinted in: Alan Trachtenberg, ed. *Classic Essays on Photography* (New Haven: Leete's Island Books, 1980), 11.

72. This sentence paraphrases words attributed to the mathematician Leopold Kronecker: 'God made the integers; all else is the work of man'. This relatively obscure statement gained its popularity when Stephen Hawking used a part of it as the title for a book. Stephen Hawking, *God Created the Integers: The Mathematical Breakthroughs that Changed History* (Philadelphia: Running Press, 2007).

73. 'Of primary importance is that information circulates as the presence/absence or absence/presence. And with sufficient storage capacity, that circulation is immortality in technical positivity'. Friedrich A. Kittler, 'The World of the Symbolic – a World of the Machine', in *Literature, Media, Information Systems*, ed. John Johnston (London: Routledge, 2012), 144.

74. 'Thus it was only recently that Planck was able to show that everything stutters (is "quantic") […] this implies that the clear and distinct (stuttering) numbers are adequate to the world, and that the fluent letters cannot grasp the world. That the world is indescribable but that it can be counted. This is why the numbers should leave the alphanumerical code, become independent of it. Which in fact they are doing: they are establishing new codes (like the digital one), and they feed computers'. Vilém Flusser, 'To Count' (Vilém Flusser Archive [Document 658, Address M20-ARTF-10], 1989), 1.

75. Alexander Galloway and Manuel Correa, 'The Philosophical Origins of Digitality', *&&& Journal* (2015).

76. Gibson, 'On the Senses and Semantic Excess in Photographic Evidence', 255.

77. Curiously, we might now read Bazin's oeuvre as an attempt to reboot this distinction.

78. Daniel Palmer, 'The Rhetoric of the Jpeg', in *The Photographic Image in Digital Culture*, ed. Martin Lister (London: Routledge, 2013); Ingrid Hoelzl and Rémi Marie, *Softimage: Towards a New Theory of the Digital Image* (Bristol: Intellect, 2015), 6.

79. This is a paraphrase of the folk-popular joke in which a fly that is sitting on the back of a ploughing ox says to the ox: 'Working hard today, aren't we?'.

80. Geoffrey Winthrop-Young and Eva Horn, 'Machine Learning', *Art Forum* 51, September (2012).

81. 'Computational photography makes us aware of a paradoxical situation: There is an indexical relationship between the photographed object and the raw data a camera collects. But this raw data [...] is of limited to no value for the beholder. Unlike the indexes that we find with Peirce – the smoke, the weathercock, etc. – camera data no longer can be read by a human interpretant and thus its indexical character remains unaccomplished due to an opaque wall of numeric abstraction'. Weiberg, 'Probabalistic Realism', 4.

82. Friedrich A. Kittler, *Optical Media: Berlin Lectures 1999*, trans. Anthony Enns (Cambridge, UK: Polity Press, 2010), 228.

83. This argument is articulated beautifully in: Juhani Pallasmaa, *The Eyes of the Skin, Architecture and the Senses* (London: Academy Editions, 1996); Also see: David Tomas, *Beyond the Image Machine : A History of Visual Technologies* (London: Continuum, 2004).

84. An example from the medical sciences, which may help highlight this point, is the traditional technology of X-ray imaging. X-rays are able to expose the inner structures of the body but those structures can also be made visible by opening up the body. In fact, the history of art contains many such explicit images, anatomically accurate to a greater or lesser extent. Contemporary technologies of brain imaging like fMRI, on the other hand, manifest neuronal activity that is not visible on any surface and at any resolution.

85. Luis Hernan, 'Digital Ethereal', ArchaID, Newcastle University; Luis Hernan and Carolina Ramirez-Figueroa, 'The Technological Invisible – Image Making as an Exercise of Power' (paper presented at the Tranimage 2018: 5th Biennial Transdisciplinary Imaging Conference, Edinburgh, UK, 2018).

86. Megan Delehanty, 'Empiricism and the Epistemic Status of Imaging Technologies' (University of Pittsburgh, 2005); 'The Epistemic Status of Brain Images', in *Rethinking Theories and Practices of Imaging*, ed. Timothy H. Engström and Evan Selinger (London: Palgrave Macmillan, 2009); 'Why Images?', *Medicine Studies* 2, no. 3 (2010).

87. Two recent exhibitions and their accompanying catalogues highlight this point: Saskia Asser, *First Light: Photography & Astronomy* (Amsterdam: Huis Marseille, 2010); Christin Müller, ed. *Crossover: Photography of Science + Science of Photography* (Leipzig: Spector Books, 2013).

88. However, if one is a bacterium or a death-star then the difference between metres and centimetres doesn't account for much. In other words, granularity is always measured against some benchmark, which, in the above example, is of course human activity.

89. The first two sub-qualities are defined by Delehanty, the third quality is a condition that I am proposing. Delehanty, 'Why Images?'.

90. Jonathan Cohen and Aaron Meskin, 'On the Epistemic Value of Photographs', *The Journal of Aesthetics and Art Criticism* 62, no. 2 (2004).

91. Vilém Flusser, 'Towards a Philosophy of Photography', in *Something Other Than Photography: Photo & Media*, ed. Claudia Giannetti (Oldenburg: Edith-Russ-Haus for Media Art, 2013), 125.

92. Alex Roman, 'The Third & the Seventh' (Spy Films, 2009).

93. For example: the Milwaukee Art Museum (by architect Santiago Calatrava), the Benesse House Museum and the Ryotaro Shiba memorial museum (both by Tadao Ando), the Phillips Exeter Academy library (by Louis I. Kahn), the Charles and Ray Eames chair room and the Barcelona pavilion (by Ludwig Mies Van Der Rohe).

94. Intriguingly, this film reaffirms the claim that modernist architecture, and in fact every type of avant-garde architecture, is highly dependent on the technology within which it is visualized. Beatriz Colomina, *Privacy and Publicity* (Cambridge, MA: The MIT Press, 1996).

95. More information on Roman's process and techniques is available in his book: Alex Roman, *The Third & the Seventh: From Bits to the Lens*, trans. Laura F. Farhall (Madrid: The Third & The Seventh S.L., 2013).

96. 'What do I actually mean when I say a photograph of a house depicts that house, and a computer image of an airplane yet to be built is a model? [...] Any way I formulate the difference between depiction and model, I come to grief [...]. It can therefore be said of a photographer that he has made a model of a house in the same sense that the computer operator has made a model of a virtual airplane'. Flusser, *Into the Universe of Technical Images*, 42–43.

97. Marshall McLuhan, *Understanding Media: The Extensions of Man* (London: Routledge & Kegan Paul, 1964).

98. For example: Manovich, *The Language of New Media*.

99. Alexander Galloway, *The Interface Effect* (Cambridge, UK: Polity, 2012), 31.

100. Kittler, 'Gramophone, Film, Typewriter', 32.

101. Alexander Galloway demonstrates this point with the example of text: 'the difference is entirely artificial between legible ASCII text, on a Web page, for example, and ASCII text used in HTML mark-up on that same page. It is a matter of syntactic techniques of encoding. One imposes a certain linguistic and stylistic construct in order to create these artificial differentiations'. Galloway, *The Interface Effect*, 33.

102. Another notable difference is that Flusser, as has been argued earlier, was heavily influenced by Husserl, Heidegger and Buber. Kittler, on the other hand, utilized theoretical models borrowed from French theory – Lacan, Foucault and Derrida.

103. Daniel Rubinstein and Katrina Sluis, 'The Digital Image in Photographic Culture: Algorithmic Photography and the Crisis of Representation', in *The Photographic Image in Digital Culture*, ed. Martin Lister (London: Routledge, 2013), 29.

104. This term was coined in reference to automated warheads, where the image functions as a guiding tool for target tracking and the real-time adjustment of a missile's trajectory. Farocki, 'War at a Distance'.

105. Paul Virilio, *The Vision Machine*, trans. Julie Rose (Bloomington: Indiana University Press, 1994).

106. Ingrid Hoelzl and Rémi Marie, 'Posthuman Vision' (paper presented at the 22nd Symposium on Electronic Art: ISEA2016, Hong Kong, 2016), 294.

107. Friedrich A. Kittler, 'There Is No Software', in *Literature, Media, Information Systems: Essays*, ed. John Johnston (London: Routledge, 2012), 150. Emphasis in original.

108. 'Ultimately, there is no software for the same reason that there is no higher faculty known as mind or spirit: Both are no more than fleeting configurations that can be reduced to the switching on and off of countless tiny circuits routed through hollow containers made of tin, bone or plastic'. Geoffrey Winthrop-Young, 'Hardware/ Software/Wetware', in *Critical Terms for Media Studies*, ed. W.J.T Mitchell and Mark B.N. Hansen (Chicago: University of Chicago Press, 2010), 193.

109. Hoelzl and Marie, *Softimage*, 4.

110. Flusser, *Towards a Philosophy of Photography*, 29.

111. Galloway, *The Interface Effect*, 25.

112. David Tomas, *A Blinding Flash of Light: Photography between Disciplines and Media* (Montreal: Dazibao, 2004), 226.

5. Photography as Algorithmic Art

Contemporary image makers, like scientists, investigate the world with complex algorithms, routinely integrating advanced computer programs into their creations. However, the more image-making processes become steeped in algorithms and programs, the more it becomes clear that a theory capable of comprehending these processes is unavailable. Because of their ostensible arbitrariness, iterative character and high complexity, the programming languages, scripts and technologies used by artists become increasingly unintelligible from the point of view of art history. This unfavourable situation is exacerbated by the fact that many imaging processes nowadays do not yield artworks in any traditional sense and rarely leave behind any material artefact. Consequently, such artistic endeavours tend to become resistant to visual analysis as it reveals nothing about the instruments, tools and activities on which they are founded. The claim that will be made in this chapter, bringing the narrative of this book to a close, is that an algorithmic-inspired philosophy of photography is sufficiently dynamic to support a theory applicable not only to these works but to all art in the information age.

Before getting into the core of the argument, however, we need to gaze directly at the emperor's new suit of clothes and dare ask, *what is an algorithm*? This term appeared several times in previous chapters. In Chapter 4, it was referred to as a 'step-by-step procedure'; it now deserves a proper exposition. First, the term 'algorithm' is phonetically derived from the name of ninth-century Persian mathematician (Muhammad ibn Musa) al-Khwarizmi. In other words, algorithms *predate* computers by approximately a millennium, possibly more, depending on whether we take Charles Babbage or Alan Turing to be the father of the modern computer. An algorithm is a calculative solution. It is a concise description of a finite set of actions leading to the solution to a problem, which itself need not be mathematical. It does not contain any information, language or signs, other than those necessary for that solution. Nowadays, algorithms are frequently discussed in contexts of computer science and artificial intelligence, where it is common for a successful algorithm to receive a name. However, algorithms do not require computers any more than geometry does.

Algorithms, we might say, are a means of making a situation explicit, of making it utterly clear and unambiguous. But this is something we have a hard time accepting, or even grasping, in the context of art. The history and theory of photography testify to this. But are not *all* mathematical models for making and evaluating works of art precisely about reduction to an absolute form of determination? Is this not the case with our unified conceptions of space as measurable and calculable, wherein every point is identical to every other? Why is it that the logically ordered picture of the world called linear perspective, perpetuated since the Italian Renaissance, does not usurp the open interpretation that art theory traditionally consecrates?[1] This, I argue, is because total determination and absolute unambiguity do *not* amount to restriction or limitation, just as interpretation does not always allow contradiction or debate. A philosophy of photography *as algorithmic* and *programmatic* reveals exactly the opposite. There is great virtue in strict forms of instruction: they provide the ability to know less in order to do more, and reliably at that. This, argues Patrick Maynard, is the purpose for which photography was invented.[2]

It is also why we ought to consider the possibility that the greatest contribution of photography to art had little to do with depiction, representation, or even with imagery. Instead, it had everything to do with *how* those goals, and others, were achieved. Quite simply, 'the nature of photography', the subject of much controversy and debate in the nineteenth and twentieth centuries, is decisively algorithmic. Three observations may be adduced in support of this construal. First, strict conceptual, procedural and technical circumstances needed to emerge in order to yield the expertise required to 'discover' photography.[3] This, arguably, is *the* most interesting story within the history of photography.

Think for example about the intricate step-by-step experiments taken for devising the best course of action in concocting photo-chemical solutions.[4] These were hesitant yet trailblazing attempts to determine optimal operativity by way of algorithmic measures. Of course, they remained attempts so long as they depended on unstable chemistry and so, for the most part, were algorithmic only in potential. However, consider Eadweard Muybridge's motion studies or those of Étienne-Jules Marey. The structures of movement they revealed were enabled exclusively by instating clear, unambiguous and *finite* protocols of action, which by that time had become possible. The same may be said of Peter Henry Emerson's detailed sets of instructions outlined in his naturalistic photography publications.[5] These were sets of instructions for a sequence of procedures designed to achieve a specified *desired* result.

Second, the history of photography is a history of learning how to methodically apply this expertise and subsequently develop it. Gustave Le Grey, for example, is well known for having trained several other French artists-turned-photographers, some of whom have famously participated in the Mission Héliographique.[6] It is less known that the distinctive ephemeral quality of many photographs from

the mission is due to Le Grey's improvements to the paper negative process. Le Grey has also developed a less-than-fully functional collodion process in addition to inventing combination printing: the technique of using several standard but differing exposures to depict a scene comprised of too wide a luminance range (for example, a seascape). This technique is nowadays called high-dynamic-range photography and is embedded in most high-end mobile phone cameras.

A pinnacle within this trajectory towards algorithmic thinking is undoubtedly Ansel Adams and his Zone System. This course of action, today mostly ghettoized, underappreciated and well-nigh forgotten, requires that at the film exposure stage, accurate measurements and calculations be made to anticipate what future discrete actions would be required in the darkroom.[7] This brings us to another crucial point. Algorithms, argues mathematician and computer art pioneer Frieder Nake, are 'finite descriptions of *infinite* sets'.[8] Adams' process required a sequence of precise stages and, in return, guaranteed that the particularities of a pre-visualized photographic image could thereby be realized. In other words, by instantiating or allowing for only finite descriptions, all dynamic processes can become operational. When this happens to processes they also become reiterable and hypothetically infinite.

Third, and perhaps most importantly, the intricacies of this technological expertise are embedded in every aspect of the photographic apparatus – in its mode of production and distribution, and in every amateur or professional manifestation thereof. Few other media have demonstrated such continued voluntary self-structuring through technical and technological tropes. Take for example the strict regulation called an 18 per cent grey card, which corresponds to an agreeably pleasant tone of grey, or the Kodak colour data guides and the sensitometric equations that determine how certain types of human skin tones should appear on certain types of film. Further, the fact that there is always but one proportion per photographic apparatus is in itself a radical form of algorithmic image-disciplining. In photography, I assert, there can never be a non-algorithmic form of image synthesis.

This view, I believe, is well captured in the 120-word title that photographer Christopher Williams chose for his image of a cutaway entry-level consumer camera from the 1970s (Figure 23).

Turing Machines

An overarching theory of algorithmic image-making must be applicable to multiple technologies, including the analogue, electronic, digital or fully synthetic. However, there is one technology, or rather concept, which plays a pivotal role in narrativizing this theory: the Turing machine. To establish the

FIGURE 23: Christopher Williams, *Cutaway model Nikon EM. Shutter:, Electronically governed Seiko metal blade shutter vertical travel with speeds from 1/1000 to 1 second with a manual speed of 1/90th., Meter: Center-weighted Silicon Photo Diode, ASA 25-1600, EV2-18 (with ASA film and 1.8 lens), Aperture Priority automatic exposure, Lens Mount: Nikon F mount, AI coupling, (and later) only, Flash: Synchronization at 1/90 via hot shoe, Flash automation with Nikon SB-E or SB-10 flash units, Focusing: K type focusing screen, not user interchangeable, with 3mm diagonal split image rangefinder, Batteries: Two PX-76 or equivalent, Dimensions: 5.3 × 3.38 × 2.13 in., (135 × 86 × 54 mm), 16.2 oz (460 g), Photography by the Douglas M. Parker Studio, Glendale, California, September 9, 2007–September 13, 2007. 2008.* © Christopher Williams. Courtesy of the artist, David Zwirner and Galerie Gisela Capitain, Cologne.

ontology and genealogy of this special apparatus, a short description of its construction is required. It also obliges us to delve into the history of its origin because in and of itself, the Turing machine is an artefact without properties. In fact, photography and the Turing machine share a universality – their ability to simulate arbitrary discrete apparatuses. This virtue leads to an absence of characteristics, because any concrete determination would prevent such generality.

Alan Turing was a British mathematician, philosopher and pioneering computer scientist. Before the Second World War he studied in Cambridge as well as Princeton.[9] During the war he joined the British government's now-famous code and cypher school at Bletchley Park.[10] His contribution to the formalization of the

concepts of algorithm and computation is now understood as the theoretical model for the general-purpose computer. He is widely regarded as the father of theoretical computer science as well as of artificial intelligence. Turing attempted to offer the solution to only one basic problem. This problem, nevertheless, as we can now appreciate, may have been one of the most pressing of the modern age: how to notate real numbers with other numbers. Technology and engineering had always been dependent upon real numbers but those could be infinitely long.[11] Thus, the question was: Can infinitely long real numbers be notated with whole, *finite* numbers? Turing proved that although this task could not be accomplished for all real numbers, it was achievable for a crucial subset, which he dubbed computable numbers.[12]

According to Turing, every computation expressed as an algorithm has its equivalent in a hypothetical machine that can be called a Turing machine. Turing machines are deceptively simple – all they consist of is a roll of paper that simultaneously contains commands, data and addresses – input and output, a program and results. Turing machines do not need the many letters, figures and signs found on today's computer keyboards. They make do, loosely following Boolean algebra, with one sign and its absence: one and zero. By sampling this binary information on the basis of an IF-THEN specification that constitutes the entirety of their artificial intelligence, they operate automatically: the roll of paper moves just a bit to the left, a bit to the right or not at all. Most importantly, how they read determines what is subsequently written. It depends on the sign, or its absence, whether Turing machines leave the mark standing or delete it – or conversely, whether they leave the empty space standing or replace it with the sign. After this simple operation, the program loop jumps back to reading, and so on, ad infinitum. That is the long and short of it.

Importantly, being formalistic, mathematics is often replete with empty symbols. The same goes for Turing's concept. It too is part of a tradition that utilizes symbols that precede the distinction between letters and numbers, reference nothing and, in and of themselves, are completely meaningless. A Turing machine, in short, only requires that which stands at the foundation of Hegel's logic: pure difference. The sole condition for the symbols it reads is that they be distinguishable: that is why their number is finite. Furthermore, since not only letters and numbers are identical for a Turing machine (namely symbols) so too are the differences between numbers, operations with and statements about them. This means that for complex computations these machines can be harnessed, the output of one becoming the input of another, and so on. More importantly, Turing postulated a machine, now known as a universal Turing machine, that could emulate the behaviour of *any* specific Turing machine. A universal computing machine would be one that, given any table of instructions that defined a Turing machine, could carry out those instructions. Such a universal machine would thus become *programmable*.

To put it simply, a Turing machine consists of an integrated chain of symbols, which represents the data computed – the symbols on the roll of paper – and another, which rigorously specifies the operations – the program. However, the particular dynamics of its universality arise from the circumstance that the symbols on the paper also determine the way the program runs. They are both data *and* instructions, in the form of markers, at one and the same time. They are, in that sense, *operational* and *executable*. Only through this can a general routine be written that adds two numbers. This is also why each and every distinct Turing machine (as a whole) can be a chain of symbols that feeds into the universal machine.[13]

Turing's hypothetical machine thus provides the formal basis for the modern computer. In a computer, to be sure, different instructions, or sets of instructions called programs, allow the same machine to perform a variety of tasks. This includes the informational input, the processing of that information and the informational output. This remains the principal operation of most computers. Today's artificial intelligences run exponentially quicker, and with many parallel operations, but their modus operandi is no different.[14]

A Turing machine is a fundamentally new type of machine because it is defined only by a set of logical and mathematical structures. It is no longer a machine that transmits force or energy onto matter (as were all machines from antiquity to modernity) but rather one wherein matter and the process it undergoes cohere in the same entity: numbers. It is thus a machine that processes and transmits *pure information* – an ideal machine in which the logical forms of many different kinds of machines are abstracted and made equivalent as a set of algorithms. Importantly, the materials from which such abstract machines are constructed do not define its function and behaviour of the machine. Thus, such machines can be constructed from almost any kind of material: DNA, mirrors, model railways or hosepipes.[15] This behaviour is used to physically instantiate a set of symbols that operates according to its own rules and syntax. Divorced from its material substrate, a Turing machine is a technical abstraction. Yet, also like information, it has applicability wherever it is instantiated. The universal Turing machine, as proved by Turing, would be capable of performing *any* conceivable mathematical computation representable as an algorithm.

With this, stated Friedrich Kittler, 'a finite quantity of signs belonging to a numbered alphabet which can, as we know, be reduced to zero and one, has banished the infinity of numbers'.[16] Arguably, when a formalism can express all true and false propositions, as well as all methods of contemporary and future systems of axioms, it becomes capable of all functions necessary and sufficient for the formal application of creativity. Therefore, it is no longer necessary to think beyond the binary. Consequently, for the purposes of this book and its claim for the historical primacy of photography within the arts, it is now pointless to think about art, artisthood and artefactuality without recourse to the universal Turing machine.

Communication, Information and Aesthetics

The computer proves to be a universal data-processing system, the invention
and development of which came to be linked with technological considerations
solely for historical reasons. Under different circumstances, the computer might
equally well have been invented as an instrument of art.

Herbert Franke[17]

Formerly, tones, colours and composition were regarded as the raw material of art;
today they are more often considered information carriers. This transformation from
previously irreducible aesthetic qualities to quantifiable and thus computable compo-
nents was enabled by Claude Shannon's mathematical theory of communication. This
is the untold story of all arts in the era of post-industrial production. Like Turing's
machine, Shannon's mathematical theory of communication also became popular in
the aftermath of World War II, as the first formal theory of the then-new entity called
'information', which, mathematically defined, is a measure of the complexity of a
text, a picture, a system, a situation or a construction. Significantly, Shannon's theory
analyses just about any instance of information exchange in quantitative terms and
so must ignore all unquantifiable aspects involved in communication.

Within the mathematical theory of communication, the more unexpected the
contents of a message are, the more informative it becomes and vice versa. Recall
that this idea, is taken up by Vilém Flusser in his analysis of various kinds of
photographs. Importantly, Shannon's theory intentionally disregards the seman-
tic value of all messages and treats information as a raw dimensionless quantity,
or, we could say, as a mere placeholder. In other words, for Shannon's theory it
matters not if a photograph features a mailman or a penguin walking down a
suburban street; all that matters is the likelihood that it would feature this or that
creature.[18] The theory thus fundamentally delimits communication at the syntactic
level alone, where it is concerned exclusively with the transmission of informa-
tion and not with information *itself*. Accordingly, it is highly effective in contexts
where semantic value is not a priority – for example, in electronic communications
or computations – but its applicability diminishes greatly in most circumstances
where meaning is central to the analysis, such as in aesthetic practices.

One of the most courageous attempts to apply Shannon's quantitative defini-
tion of information to the analysis of aesthetic artefacts is the theory of information
aesthetics.[19] Intended to apply to all aesthetic objects, it has never specifically
mentioned photography, nor has any attempt ever been made, academic or other,
to explicitly link it to photography. This is what I intend to do shortly. In a nutshell,
the narrative that will unfold in the following pages is that one unlikely strand of

photography called concrete or generative photography provides proof that art forms can transform, and indeed many *have* been transformed, into information aesthetic logical modes of operation previously thought impossible within the context of aesthetic production. Put differently, the claim is that much like photography, other arts have the potential of becoming information-technical in one form or another.

The movement of information aesthetics, or rather the sentiments from which it emerged, existed in two centres, both in Europe. To date, it remains virtually unknown outside continental Europe. One centre was at the University of Strasbourg. Its leading figure was Abraham A. Moles, a sharp thinker and as it so happened, a close friend of Flusser.[20] The second and more influential centre was at the University of Stuttgart, whose well-known head was Max Bense.[21] Moles was more interested in sequences in time as exemplified in music and language, and Bense in arrangements of signs in space, as exemplified in images and text. Common to both was the expectation that measures of *aesthetic information* could be found, which would allow a rational and objective theory of aesthetics to emerge. To do so, the daring idea was to use the Shannon's concept of statistical information as the mathematical basis of an objective measure of aesthetics. Information aesthetics could in this way become a system to allow one to measure the amount as well as the quality of information in aesthetic objects, thus enabling a wider evaluation thereof.

Bense's early aesthetic thinking started with a Hegelian view wherein art was a teleological epistemic process. Later, his interests shifted to Charles Sanders Peirce's pragmatic semiotics, which viewed logic as a function of signs and symbols.[22] By understanding aesthetic objects as signs, Bense linked semiotics to Shannon's purely technical information theory, where he adapted the concepts of linguistic signs to the problem of signal loss in technological communication. As a link between the technical and the human notions of communication, Bense built on Norbert Wiener's cybernetics.[23] Following Wiener's theory of feedback, whereby some proportion of the output signal of a system was fed back into the input, Bense devised a model for theorizing how the processes of artistic production, consumption and criticism could be procedurally related in terms that suggest computation. In this theoretical frame, the aim was to create a rational aesthetic free of subjective speculation and grounded in a purely mind-independent base.[24]

In locating the aesthetic value of aesthetic objects within a framework of semiotics, Bense could also argue that on the whole, art demonstrates an 'inversion', so to speak, of the second law of thermodynamics – the physical process of entropy, or the universe's unremitting tendency towards disorder. Art, contrarily, seeks order, not chaos, and the relationship between chaos (or complexity) and order is what defines the aesthetic value of artefacts. Order is a state of circumstances; it is a property that is both definable and identifiable in relations between entities. Artificial objects can thus be said to have properties that correspond to a privileged state of 'co-reality';

they are more than their material carrier, and this is why Flusser calls them 'informed objects'. In the case of aesthetic objects, co-reality is determined by macro-aesthetic rules that can be interpreted as *executed algorithms* whose 'result' can be seen to represent a condition of or at least a process towards negative entropy or negentropy.

An underlying assumption here is that there are general and objective features that characterize an object as *aesthetic*. A feature is general if it can be detected in all objects irrespective of their particularities. A feature is objective if it does not change when another observer judges it. The basic assumption of information aesthetics is that objects are material carriers of aesthetic states, and that such states are independent of subjective observations.

The second assumption, or pillar, on which information aesthetics is founded is the idea that a particular kind of information is conveyed by the aesthetic state of the object or process. This information is called aesthetic information insofar as it is contingent with the physical reality of the object, which it transcends.

The third and final pillar is borrowed from mathematician George David Birkhoff. In the 1930s, Birkhoff studied artefacts such as planar polygons or rotationally symmetric vases for their aesthetic merits.[25] His general approach for defining an objective aesthetic measure was to take the degree of order relative to the degree of complexity in an object. If a class of objects was given, the task therefore consisted of defining order (O) and complexity (C) as numeric quantities. The aesthetic measure (M), according to Birkhoff, was then given by the formula $M = O/C$. Importantly, this formal definition does not preclude that such mind-independent negentropic or aesthetic clusters be generated *intentionally* from a host of pre-programmed possibilities.[26] All that is necessary is that two conditions be met: specific desire and sufficient speed. First, one must know which available combination of information one wants to produce. Because even if all combinations are foreseeable in principle, as Flusser's programmatic worldview indeed suggests, only some are desired. The more probable ones are most often the less desired. It is the improbable combinations, the informative ones, that are usually desired but these usually occur by blind chance and only after a lengthy run of the machine or the program – involving numerous iterations. Second, the calculation, if this is how we now define image-making, should be artificially accelerated to ensure that desired combinations will be achievable within a finite time span. This, then, we could say, is intentionality in art according to information aesthetics: to build an artistic apparatus that speeds up chance events and to program it to stop when a desired aesthetic coincidence has occurred.

In this context, the treatment of artistic intuition becomes very complicated. The creative aspect is reduced to a creative selection process; the process of aesthetic consumption is reduced to the critical selection of values. Both selection processes are part of the model of the aesthetic process itself. The creative selection offers

an object based on judgment, while the critical selection offers a judgment based on an object. What this can be taken to mean is that 'art-making' no longer needs to adhere to a traditional dictum of trial and error. Instead, information aesthetics proposes that art-making be understood as an experimental *scientific* situation that is not only verbally describable but also notatable, and hence always repeatable, at least potentially if not in practice.

Arguably, such a conception could henceforth imply that it is possible to find the most efficient 'imaging algorithms', which could then be used as 'universal picture generators'. All that such a generative form of aesthetics would need to become 'universal' and fully functional is a well-defined set of at least one of the following elements: 1. a repertoire; 2. a procedure for selecting elements of the repertoire; 3. a procedure for distributing the elements in the aesthetic space; and 4. a procedure to fix the results in a medium comprehensible by human minds. Does photography meet these criteria? If it does, can we then revise Patrick Maynard's definition of photography? Instead of 'the engine of visualization' ought we not say 'the program of visualization'?[27]

Concrete and Generative Photography

> chance is the result of the conflict between technology and esthetics. The aleatory principle does not contradict programmatic rigidity; on the contrary, the one calls for the other. The introduction of the principle of chance into a predetermined program might be one aspect of the overall esthetic conception or, indeed, it might be the conception itself. Chance henceforth takes over the role of selection.
>
> Rolf H. Krauss[28]

The term generative art is usually reserved for practices wherein an artist constructs a system that when set into motion, contains some degree of autonomy or independence of the artist. This contributes to and is in fact designed to generate results that would otherwise be unlikely. Photography, contrary to this definition, is usually understood as a situation wherein a human agent, the photographer, uses a pre-existing system constructed by another agent with the main, and sometime exclusive, purpose of yielding results that would always be predictable, given no outside interference. This, as I hope to have made clear in Chapter 3, is by no means the only prospect in and of photography.

Running directly counter mainstream conceptions of the medium is the current called concrete or generative photography. These terms do not refer to an easily recognizable artistic movement or unified artistic group. Rather, they refer to what may best be described as a shared sentiment, identifiable in several scattered, isolated and largely

unconnected artistic experiments. Most of them took place in post-war Germany. Concrete and generative photography are, for lack of a better definition, photographic explorations that can be characterized by three qualities. The first is the extensive use of apparatuses and technologies explicitly dedicated to the creation of photographs. These often involved handcrafted devices with a specific aesthetic orientation. The second is an uncompromising insistence on a principle of seriality in making photographs. And the third is the utilization of chance as an important creative factor.

Gottfried Jäger, probably the most salient voice for this strand of photography, states that: 'Concrete photographs exclusively use the most elementary, innate means of the discipline… Its works are self-reflexive, self-referential, auto-dynamic and universal'.[29] A fine example of this insight is undoubtedly his own artistic trajectory and particularly his 1967 series *Lochblendenstrukturen* (*Pinhole Structures*). These works are performed with a multi-pinhole camera obscura that he describes as an 'apparative system to design geometric patterns', after a programmed and traceable, generative image-grammar has become available[30] (Figures 24–25). Importantly, these works are also subtitled programs. It is not just that this proclaims the works' aesthetic specificity since they are endowed with properties of seriality and genesis from chance procedures. It also, I cannot help thinking, eventually tethers specificity, seriality and chance to the pictorial surface of the works in a prophetic way, anticipating that their sub-titles, and with them these qualities, will one day become part of what we call metadata and, in that sense, part of the image.[31]

Jäger further describes works performed within these parameters as 'pure photography: not abstractions of the real world, but rather concretions of the pictorial *possibilities* contained within photography'.[32] Lest we forget that pictorial possibilities in photography are traditionally thought to exist 'out there in the world' and rarely anywhere 'within' it. Therefore, this statement strongly resonates, and possibly intentionally so, with Vilém Flusser's programmatic philosophy and the latter's insistence that photographic 'envisioners' only 'visualize'. Envisioners do not, perhaps need not, depict. By expressing itself through a self-proclaimed pure, photo-immanent, photographically conceived structure and syntax, concrete photography seems to suggest itself as a project of formal aesthetics performed with and through photography. It is, put differently, not a style of photographs but rather a *method* for creating them. By extension we could also say that generative photography is a rhetorical experiment demonstrating that photography, taken in the main, is not only a style of image but rather a method for creating images. Further, while the style may be visual the method is not.

What is important here is that this autonomous, auto-dynamic, self-referential and self-reflexive expression of photography is implemented by incorporating rigid rules into the photographic system, which in itself is designed to generate not singular images but rather chains of images. Once conceived, or 'programmed',

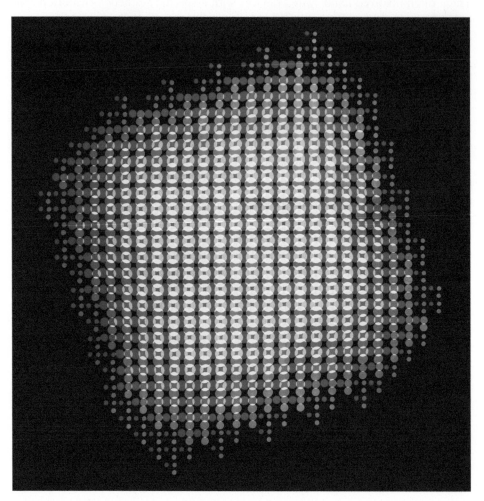

FIGURE 24: Gottfried Jäger, *Lochblendenstruktur 3.8.14 C 2.5.1, 1967*. Multiple Camera obscura work. Colour coupler print (Agfacolor) 50 x 50 cm. Archive of the artist. Copyright 2019: Artist and VG Bild-Kunst Bonn, Germany.

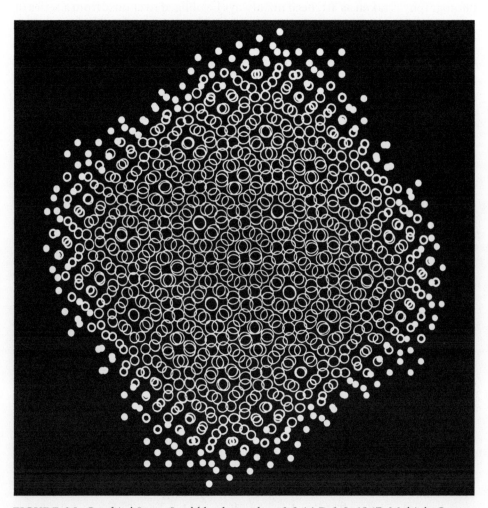

FIGURE 25: Gottfried Jäger, *Lochblendenstruktur 3.8.14 D 3.5, 1967*. Multiple Camera obscura work. Gelatin silver print 23 x 23 cm. Archive of the artist. Copyright 2019: Artist and VG Bild-Kunst Bonn, Germany.

such a system executes what has been 'entered into it' and delivers a theoretically infinite number of results. Generative photography therefore seems to suggest that we ought to distinguish between aesthetic conception and technical realization in photography. This raises the possibility that an artist, to the extent that photography is taken as art, need not always be obliged to choose from a series of single 'shots' the one 'shot' that most resembles his or her original aesthetic idea. They could, in the spirit of scientific exploration, ultimately choose to pronounce the entire series as the aesthetic product of the experimentation. This, I find, is the most interesting aspect in Hiroshi Sugimoto's *Lightning Fields*, within which electrical discharges are captured on photographic dry plates. The images in this series are unsurprisingly attractive. The series itself is, I find, surprisingly profound as it re-enacts the history of photography as a rigorous endeavour of scientific or technological experimentation.

As noted, the theoretical basis for understanding photography as a rudimentary, generative aesthetic program is information aesthetics. In contrast, most of photography's historians and theoreticians have tended to tone down and mitigate the often-intimidating idea that the discipline's most important property is enduring engagement with technology. Because of this self-deceit, it has too often been deemed necessary to express the expectation that photography's locus of artistic intent should reside in a motivation to declare technology as conceptual, as if this is not anyway so, or to designate the partnership with technology as provisional, as if this is ever possible. It is for this reason that photography theory has always tended to favour fixed results, not potentialities, because they are easier to measure against the benchmarks of traditional art history. Visual representation, it seems, is simply easier for our minds to comprehend than the abstract idea of representation in concept or representation in potential, which the idea of 'technology as designated art' seems to suggest.

By way of contrast, what concrete and generative photography make clear, with their almost spiteful insistence on rigid technical and technological processes as vessels of creative expression, is that it is simply futile to ever separate the terms 'generative' and 'photography'. Photography, we should say, following Flusser and Bense before him, ought to always be generative if it is to avoid complete redundancy. This is what an undistorted history-of-photography-as-artistic-technology should be about. In fact, Flusser's programmatic philosophy – when coupled with Bense's concept of 'programming the beautiful',[33] which is nowadays made possible by means previously unavailable – raises the possibility that generative photography, with its concise visual language, can be seen as the final phase of photography as it enters the digital age. Seen this way, generative photographs elucidate an idea of artistic constructivism onto which can be grafted the numerical programming of apparative art systems.[34]

Arguably, generative photographs comprise an important stage in photography's conceptual contribution to the formation of what is now known as computer art. The work of Herbert W. Franke seems to best illustrate this. See for example the image titled *Analogrechner (analog computer)* from the Series *Tanz der Elektronen (dance of electrons)* (1959–1961) (Figure 26). The production of this image utilized a cathode-ray oscilloscope, which is an electronic instrument to measure and display properties such as the amplitude, frequency or other parameters of an electric signal varying over time. These can then be displayed on the instrument's screen, which is usually small, but not too small for Franke to have photographed in this shot.[35] Importantly, the oscilloscope here is the display screen of an analogue computer given the task of solving a differential equation. With respect to this image and similar ones from the same period, Franke stated:

> Controlling the image processes according to predetermined programs and the influence of randomness is [...] insightful. Recently, such experiments have acquired a new importance: as design which permits the analysis of art using a simplified model as it were. As many electronic graphics can be described by formulas, they offer better preconditions for numerically capturing cognitive processes than traditional works of art, and make it possible to introduce an experimental way of working in scientific research on aesthetic processes.[36]

To that end, Franke's work from only a few years later is already fully dependent on predetermined programs written for and running on primitive digital computers. These two images are perhaps a miniature version of the larger story told throughout this book. Befittingly, declares Rolf Krauss about generative photography, 'its short history ends with its own apotheosis'.[37]

Proto-Algorists[38]

This chapter opened with a proposed definition of photography as an algorithmically informed 'Turing-like' visualization machine, a conceptual construct whose merit lies in its lack of inherent qualities. It proceeded with singling out generative photography as an archetypal form of photography wherein algorithmic processes of abstraction become more important than the outcomes they yield. It further suggested this property as indicative of artistic operations that are now often placed under the umbrella-term 'computer art', which I will now discuss. I will do so with special attention to one of the most prominent computer artists, Frieder Nake, whose theoretical contribution is invaluable to understanding how the conception and generation of what we take as art can become two separate processes, not only mentally but also operatively.

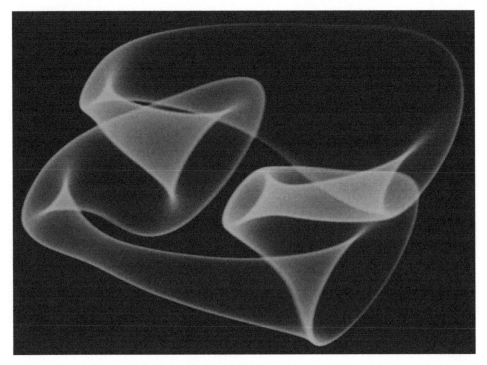

FIGURE 26: Herbert W. Franke. Group of works: Analogrechner (analog computer). Series: Tanz der Elektronen (dance of electrons). Photography 1959–1961.

Through Nake's various statements about the possibility, presence and importance of algorithms within the broader contexts of art, I will argue that the best way to think about photography *today* is as an archetypal form of algorithmic art, a term that seems preferable to computer art or, for that matter, digital art. I will further narrativize photography's contribution to the history of art with and through the notion that artistic creativity does not emerge solely from the genius of individual flesh-and-blood artists. Rather it emerges from a wider set of conditions, circumstances and agencies that often cannot be attributed directly or exclusively to any one person.

Post-war theoretical developments have proven that purely mathematical systems can successfully augment, and at times fully replace, human methods of communication. And if art is indeed, as Flusser suggested, a form of coded communication performed by way of objects and images, then to what extent should we continue to perceive the function of mathematical systems as limited to the role of assistive tools when they are nowadays routinely harnessed for the contexts of art-making? Can calculation technologies and information machines augment or replace subjective roles in the processes of creating art? Can they

double as human intuition? This, admittedly, is a mutated version of questions that have been asked of photography as early as the mid-nineteenth century. A theory of photography as algorithmic art can now provide the answers. At the risk of over-simplifying this point I could say that *if* we had an agreed definition of art, then we might permit a machine to produce art. Obviously, such a definition would have to precede the question of whether a machine would be able to produce art.

As a young mathematician studying under Bense in Stuttgart, Nake was naturally interested in these questions. His early work therefore used sets of mathematical probability distribution functions and their computer-program realizations, in the form of a variety of pseudo-random number generators, to seek a useful approximation of the role of artistic intuition and creativity.[39]

> Is it farfetched to draw some sort of analogy between the artist's intuitive decisions and the realizations of random processes, which – as such – are governed by probability distributions? Such an analogy would definitely be farfetched if we claimed that the artist's intuition was *equal* to a set of probability distributions. It would still be farfetched (and thus wrong) if we claimed that the artist's decision process was *simulated* by the random process. We could, however, justify saying that the *place* of intuition in a human creative process was taken by an ordered set of probability distributions… If intuition is what is immediately clear to us, what we understand in a single moment ever so short… then an artist's decision process is governed by intuitive as well as discursive steps… In the aesthetic program, the set of probability distributions exactly takes that place of immediacy – if there is anything like that.[40]

Nake's statement reminds us how much our conceptions of artistic creativity hinge on what is known as intuition. So long as we hold intuition to be something immediately available to us then an immediately computable set of probability distributions may very well be able to replace intuition and, in that, offer a 'delayed' model of creativity, a model of 'relegated creativity' or possibly even a non-human model of creativity. In fact, we ought to ask ourselves, why should the origin of creativity always be a process equivalent to that which occurs in its recipients' minds? Why can it not emerge from a process that explicitly *lacks* the qualities we love attributing to ourselves? On the other hand, if anything is certain about creativity, it is its nature as a *quality* – the fact that we cannot un-problematically explain it in quantitative terms. Does it not therefore make more sense to associate the origins of creativity with what Nake calls 'intuitive and discursive steps', which also incorporate aspects of that activity which we call behaviour?

On this very point another computer art pioneer, Manfred Mohr, states:

> Accepting that creative work is an algorithm which represents a human behavior in a given situation, it is natural to ask: how is such an algorithm built up, and which precise mathematical laws could be extracted for later use in different circumstances? If one is now curious enough to look for his own aesthetical parameters, he is ready to engage in an interesting line of research.[41]

Just like in the early history of photography, so too with early algorithmic art, its pioneers, who are often called 'algorists', did not always understand in real time the upheaval they were causing. This, in turn, left art critics puzzling even more. "'Is it or is it not art?" was their typical shallow question, and "Who (or what!) is the creator? The human, the computer or the drawing automaton?"'[42] This question, to reiterate, is uncannily similar, almost identical in structure, to Peter Henry Emerson's statement quoted in Chapter 1.[43] Therefore, my contention here is simple: Thinking in terms of supervenience makes it possible to theorize art not only through its outputs but rather through the reciprocal relationships its 'creative agents' emerge from. Art can thus become not only a history of informed objects but rather a tradition of informative *processes*, only some of which are performed on material.[44]

Furthermore, if intuition can be understood as a process that elevates possibility to the degree of probability, as indeed Flusser's legacy suggests, then I posit that the simplistic understanding of creativity as autonomously human is not particularly useful for thinking about technologically dependent forms of art. Instead, we need an expansion of the term 'creativity' to include the conceptual protocols that are embodied in the technologies and programs where artisthood is performed. Thus, the theory that called forth these programs can provide a similarly clear view of emergent artistic situations, being increasingly liberated from material.[45]

Of course, artistic creations *do* still appear in material forms that can be perceived by one or several of our non-augmented senses. Notwithstanding, these appearances are usually not necessary for these creations to exist or come into being. Material forms like images, argue Nake and Susan Grabowski, are 'a sentimental reminiscence to comfort our dreary senses'.[46] The best way to make this understood is by recourse to the term 'digital image'. The term itself is something of a contradiction in terms. 'Digital' is nothing but a form of storage. It is an extremely efficient form of storage because it is the only form a digital computer can 'see', if it could be said to 'see' anything, and the only one it can manipulate by one or several of its algorithms. The 'image', on the other hand, whether generated once as a print or generated 60-100 times a second to be projected through a monitor, is *never* digital and *always* analogue, otherwise we humans could never

see it because we cannot see voltage differences, and neither can we make visual sense of other forms of digital representation. Thus, and contrary to everything theories of post-photography have had to say in the past decades, theorizing the digital image is impossible because images do not exist in digital form. Digital image-making, on the other hand, does exist and still requires proper theorizing.

Theorizing digital image-making is possible when we acknowledge that 'digital images', like everything we humans experience on computers, are characterized by the pairing of two processes Nake calls 'subface' and 'surface'.[47] These can be taken as an inseparable double or as a hybrid single, but the important thing is that there are two *distinct* processes at play with every digitally enabled experience.[48] One, the surface, is for us humans to experience; the other is for the computer to work with. The former is visible, audible or palpable; the latter is nothing but symbolic coding. We humans are usually only aware of the surface processes, whereas the computer is only 'aware' of the subface processes.[49] Importantly, however, the former processes only exist by virtue of the latter. It is the symbolic image, the digitally coded one, which is the primary object of the computer, not the visible image, which is made only by the fact that an image-processor can take the algorithmic description and interpret it meaningfully. In other words, we see the image, it exists as a visible entity, only because it is being interpreted by the computer for our convenience. This 'existence' is, for the computer, peripheral at best or, more accurately, completely redundant. In short, the 'digital' in 'digital image' simply does not need the 'image'. Only we humans need images and this is why they continue to exist.

When images are on the agenda and when creativity is mediated by computers, or perhaps performed by them, we cannot allow ourselves to think exclusively in terms linked to the human conception of seeing. Instead, we must think in the same ways that our blind computers think. This means we cannot continue thinking in and through ambiguous terms, unless ambiguity is a goal in itself. Rather, we must think in explicit, accurate, finite vocabularies. Not 'roughly here and there' but rather 'precisely these coordinates'. This inevitably leads to a form of thinking that Nake calls 'algorithmic', a form that, for better or for worse, is semiotic and catapults us from the domains of particular images to those of general imagery, from a single case to all cases. 'Thinking the image' as opposed to merely seeing it, thinking it *algorithmically*, argue Nake and Grabowski, 'is the ontology of imagery in postmodern times'.[50]

Nake and Grabowski describe the task of thinking algorithmically as a sequence of three reductions: 'Whatever the process and phenomenon may be that a group of humans are considering worthwhile to be redone in an algorithmic way, they must do this: 1. reduce the worldly process to semiotic aspects, 2. reduce the semiotics to syntactics only, 3. reduce the syntactics to computability only'.[51] Photography, I argue, has always been a performance of the first two, and has recently started performing the third.

Either way, from the perspective of this book and its investment in a philosophy of photography, 'thinking the image' is the ultimate alternative to those theories of photography that see it as a mere technology for 'drawing the image'. Such notions still pervade contemporary thinking. Of course, it is not always necessary to theorize and philosophize photography as art, but to the extent this happens, it is better performed with reference to the computer's conceptual origins. This is the argument made in this book. In the same context, a theory of photography which posits that it has always been algorithmic and digital implies that it can become fully and infinitely reproducible. This, to recall the claim made in Chapter 4, was not possible as long as photography was bound to material and, throughout the nineteenth and twentieth centuries, was but a fanciful metaphor and not a state of affairs. In fact, absolute repeatability and reproducibility is never possible in processes that are performed in matter and is only possible within processes that are digital, mathematical or semiotic.

In addition, because algorithms are 'finite descriptions of infinite sets',[52] descriptions that can be read and interpreted again and again ad infinitum, Nake is able to argue that 'the art in a work of digital art is to be found in the infinite class of works a program may generate, and not in the individual pieces that only represent the class'.[53] Of course, a class of objects or images can never, as a class, appear physically. In other words, it is a mental construct that cannot be perceived sensually. This, in very plain words, is why we still need the instance. We want to see something of the class but we cannot see the entire class so we keep an interest in the individual instantiation. Nevertheless, this book embraces Nake's view and takes the extreme position that the artworks of photography are not any of its particular instantiations. Rather, as in computer art, the artworks may only be found in photography's various technologies, in the programs driving them and in their architecture and design.

Whether we are considering early or late material instantiations of photography, one notable difference between them and photography as 'computerized algorithmic art' concerns separability. Within material photography, to use Goodman's definition of allography, analogue instantiations are still separate from their notation or specification. With digital or computerized instantiations of photography, as with any other visible computer output, the instantiation is *inseparable* from its specification. Another layer of difference here, one that is not unique to photographic or quasi-photographic images, concerns the fact that algorithms often tend to be generative. This means that in some cases, qualities of extreme complexity may be achieved in certain algorithmic interpretations but not repeated in a subsequent interpretation.[54] Thus, within some forms of computer art, to which contemporary photography may belong, there may very well exist imaging systems that run allographic (fully annotatable) processes but yield autographic results. To summarize, from photography onwards, in every form of technical art, traditional concepts of 'originality' in art, of 'unique work', of artefactuality, simply do not hold.

Envisioners

Writing a theory of art is always risky business. As with photography so with algorithmic art, there is simply too much for just one narrative. Moreover, a theory of photography *as algorithmic art* also becomes a meta-question of how to present overwhelming conceptual complexity when evidence cannot be displayed on the page. How can one textualize technologies that abstract the very idea of text and possibly make it redundant too? So instead of hoping for an overarching narrative of algorithmic abstraction it is perhaps more fruitful to think in terms of multiple tales of pioneering endeavours, experiments, practices and hybridizations. This chapter has traced several ideas, propositions and blueprints for today's media art ecology. It has pointed out how they are embodied in a series of departures from the mainstream of photography as art and in alternatives that have not yet been adopted. These are in no way exhaustive as they are speculative suggestions. Notwithstanding, they do underscore one problem that has thus far remained latent and now requires acknowledgement, if only as a precursor of future theories.

The problem is this: given that every aesthetic message is generated with, in or through apparatuses, and that not only aesthetics can be prescribed in algorithms but also creativity relegated to computer programs, it seems as though there is no more place for human intention. Where there is no longer a pressing need to generate new information, there is rarely inspiration to do so: 'Not only are authors no longer necessary' declared Flusser, 'they are not even possible'.[55] Is this true?

In some sense, a philosophy of photography as algorithmic art seems to anticipate this question. In fact, it is even implied in Roger Scruton's analytic philosophy of photography. It even seems that some of Scruton's claims with respect to photography can be applied to all forms of technological art and, possibly to all manifestations of art today. To recall, Scruton's taxonomy featured a notion of 'ideal photography'[56] which referred to an unavoidable condition wherein a human agent's views, beliefs and wishes simply cannot become a serious part of the medium's qualifying characteristics. This position is not far from Flusser's: 'The apparatus does as the photographer desires, but the photographer can only desire what the apparatus can do'.[57] Ideal photography, in other words, puts the stress on the risk that all forms of art now run: wanting or indeed being 'only what the apparatus can do'.

Conversely, for photography to be 'creative', in order for its algorithmic activity to be considered 'art', it must be something else entirely. What could that be? Nake's articulations seem to suggest that it would have to be the programmatic *invention* of a new apparatus:

> No computer operates without software. The artist may use software in her creative process. Either she has acquired it from somewhere or she has developed

it herself. If she hasn't and is only using packaged software, her work may still please people. It may be sold by a gallery. Critics may react enthusiastically. But the state of such work is that of the digital Sunday painter's work. It will not attain the realm of acknowledged art.[58]

Must every photographer therefore be an Étienne-Jules Marey, a Harold 'Doc' Edgerton or an Erol Morris?[59] Possibly not. Most camera operators will undoubtedly settle for the term 'photographer', which, to reiterate, is not all that different from being 'a computer'.[60] However, creative endeavourers who are not satisfied with the title photographer must desire to become photo-programmers, photographic-makers or, as Flusser calls them, 'envisioners'. They cannot but seek to reinvent the parameters, the program and the prospects of their apparatus. Otherwise, they know, their work will never become the testing ground for new ideas.

NOTES

1. Traditional histories of photography usually open with a long chapter on perspective. But perspective is also a principal form of algorithmic structuring. An argument in this vein has been made by Lev Manovich. Following this line of thinking, I would argue that photography is a more extreme (and efficient) algorithm than perspective because it does much more than reduce a 3d space to a 2d surface. Lev Manovich, 'The Engineering of Vision from Constructivism to Virtual Reality' (University of Rochester, 1994).

2. Patrick Maynard, *The Engine of Visualization: Thinking through Photography* (Ithaca, NY: Cornell University Press, 1997), 127.

3. Joel Snyder, 'Galassi: Before Photography: Painting and the Invention of Photography', *Studies in Visual Communication* 8, no. 1 (1982): 111–12.

4. Larry J. Schaaf, *Out of Shadows: Herschel, Talbot, & the Invention of Photography* (New Haven: Yale University Press, 1992).

5. Peter Henry Emerson, *Naturalistic Photography for Students of the Art & the Death of Naturalistic Photography* (New York: Arno Press, 1973); Carl Fuldner, 'Emerson's Evolution', *Tate Papers* 27 (2017).

6. In 1851, the Commission des Monuments Historiques, an agency of the French government, selected five photographers to make photographic surveys of the nation's architectural patrimony. These 'Missions Héliographiques', as they were called, were intended to aid the commission in determining the nature and urgency of the preservation and restoration of work required at historic sites throughout France.

7. Ansel Adams and Robert Baker, *The Camera* (Boston, MA: Little Brown, 1983); *The Negative* (Boston, MA: Little Brown, 1983); *The Print* (Boston, MA: Little Brown, 1983).

8. Frieder Nake, 'Paragraphs on Computer Art, Past and Present' (paper presented at the 'Ideas Before Their Time: Connecting Past and Present in Computer Art' conference, London, 2010), 57. Emphasis mine.

9. At Cambridge Turing also attended lectures by Ludwig Wittgenstein. A full record of their 1939 discussions on the foundations of mathematics appears in: Ludwig Wittgenstein, *Wittgenstein's Lectures on the Foundations of Mathematics, Cambridge, 1939: From the Notes of R.G. Bosanquet, Norman Malcolm, Rush Rhees and Yorick Symthies* (Hassocks: Harvester Press, 1976).

10. In fact, as part of his military service, Turing met Claude Shannon in 1943 and the two men collaborated briefly.

11. Think, for example, about the principal square root of two.

12. In 1928, the German mathematician David Hilbert had called attention to the decision problem (Entscheidungsproblem). In his 1936 paper 'On Computable Numbers, with an Application to the Entscheidungsproblem' Turing reformulated Kurt Gödel's results on the limits of proof and computation (Gödel's first incompleteness theorem), replacing Gödel's universal arithmetic-based formal language with the formal and simple hypo-thetical devices that became known as the Turing Machine(s). He proved that some such machine would be capable of performing any conceivable mathematical computation if it were representable as an algorithm. He also went on to prove that there was no solution to the Entscheidungproblem by first showing that the halting problem for Turing machines is undecidable: in general, it is not possible to decide algorithmically whether a given Turing machine will ever halt. Alan M. Turing, 'On Computable Numbers, with an Applica-tion to the *Entscheidungsproblem*'. *Proceedings of the London Mathematical Society* 42, no. 2 (1936).

13. In fact, Turing is even quoted as having later said that if the human brain works in 'some definite way' then it too can be emulated by the universal machine. Quoted in: David Link, *Archaeology of Algorithmic Artifacts* (Minneapolis: Univocal Publishing, 2016), 26.

14. In today's standard processors, a bus administrates the transmission of addresses, a silicon memory the storage of data, and an arithmetic logic unit the binary calculation of commands.

15. Link, *Archaeology of Algorithmic Artifacts*, 17–18.

16. Friedrich A. Kittler, 'Code (or, How You Can Write Something Differently)', in *Software Studies: A Lexicon*, ed. Mathew Fuller (Cambridge, MA: The MIT Press, 2008), 43.

17. Herbert W. Franke, 'The Expanding Medium: The Future of Computer Art', *Leonardo* 20, no. 4 (1987).

18. Vilém Flusser, 'The Photograph as Post-Industrial Object: An Essay on the Ontological Standing of Photographs', ibid.19 (1986): 330.

19. Between 1954 and 1960 Bense published four small books on aesthetics. In 1965, they were slightly revised and collectively republished as one volume. Max Bense, *Aesthetische Information: Aesthetica (Ii)* (Krefeld: Agis-Verlag, 1956); *Aesthetica (I-Iv)* (Baden-Basen: Agis, 1965); Abraham A. Moles, *Information Theory and Esthetic Perception*, trans. Joel E. Cohen (Urbana: University of Illinois Press, 1966).

20. Flusser discusses Moles' influence on his thinking in: Miklós Peternák, 'We Shall Survive in the Memory of Others,' (Berlin: Vilém Flusser Archiv, Universität der Künste Berlin, 2010).

21. Flusser and Bense had several mutual acquaintances but the two men never met. Flusser attempted to contact Bense in the late 1960s but, to the best of my knowledge, Bense never responded.

22. Charles Sanders Pierce, *The Collected Papers (Volumes 1-6)* (Cambridge, MA: Harvard University Press, 1931–36); *The Collected Papers (Volumes 7&8)* (Cambridge, MA: Harvard University Press, 1958).

23. Norbert Wiener, *Cybernetics, or, Control and Communication in the Animal and the Machine* (Cambridge, MA: Technology Press, 1948).

24. Arguably, Bense's desire to create a mind-independent aesthetic was underpinned by the catastrophic outcomes of nazism. Information aesthetics, Bense hoped, would never render themselves useful or even relevant to political sentiment in the same way that 'emotion-based' aesthetics always could. Frieder Nake, 2015–2019.

25. George David Birkhoff, 'A Mathematical Theory of Aesthetics,' *The Rice Inst. Pamphlet* 19 (1932).

26. Sean Cubitt makes the point that 'the negentropic instinct for order' is, in fact, an instinct for life. Sean Cubitt, *The Practice of Light: A Genealogy of Visual Technologies from Prints to Pixels* (Cambridge, MA: The MIT Press, 2014), 3.

27. I am intentionally paraphrasing Pierce's famous statement: 'All my notions are too narrow. Instead of sign ought I not to say medium?' Charles Sanders Pierce, ed. Harvard University (Houghton Library, 1906).

28. Gottfried Jäger, Rolf H. Krauss, and Beate Reese, *Concrete Photography* (Bielefeld, Germany: Kerber Verlag, 2005), 73.

29. Ibid., 15.

30. Gottfried Jäger, 'Pinhole Structures: Generative Photographic Works 1967–1974,' *Pinhole Journal 5*, no. 2 (1989).

31. In a later publication Jäger in fact declared that 'their' (concrete photographs) 'self-reference is their own programme.' Henrike Holsing and Gottfried Jäger, eds., *Light Image and Data Image: Traces of Concrete Photography* (Heidelberg: Kehrer Verlag, 2015), 15.

32. Jäger, Krauss, and Reese, *Concrete Photography*, 15.

33. Max Bense, *Programmierung Des Schönen: Aesthetica (Iv)* (Krefed: Agis-Verlag, 1960).

34. Herbert W. Franke and Gottfried Jäger, *Apparative Kunst: Vom Kaleidoscop Zum Computer* (Köln: DuMont Schauberg, 1973).

35. Importantly, Franke was not the first person to use this method. Ben F. Lapofsky in the United States also experimented with oscilloscope photographs (which he called oscillons) as early as 1953 and possibly before.

36. Translated from German and quoted in: Margit Rosen, ed. *A Little-Known Story About a Movement, a Magazine, and the Computer's Arrival in Art: New Tendencies and Bit International, 1961–1973* (Cambridge, MA: The MIT Press, 2011), 436.

37. Jäger, Krauss, and Reese, *Concrete Photography*, 76.

38.　The term 'algorists' appears in the following location. The term 'Proto-Algorists' is my own way to equate the ideas in this chapter with ideas expressed by Geoffrey Batchen's term 'Proto-Photographers'. Frieder Nake, 'Construction and Intuition: Creativity in Early Computer Art,' in *Computers and Creativity*, ed. Jon McCormack and Mark d'Inventro (Heidelberg: Springer, 2012), 63 fn2.

39.　In fact, we should first ask ourselves, why must intuition always be a solitary act performed by an individual? Can't we think of discursive or even collective forms of intuition performed or emerging from communal efforts?

40.　Frieder Nake, 'Computer Art: A Personal Recollection' (paper presented at the Computers and Creativity conference, London, 2005).

41.　Manfred Mohr, *Computer Graphics* (Paris: Musée d'Art Moderne de la Ville de Paris, 1971), 36.

42.　Nake, 'Construction and Intuition: Creativity in Early Computer Art,' 64.

43.　'You selected the view: that was art. You arranged it well, focused it well: that was art.... Then you started a machine, and that machine drew the picture for you; you merely fixed its work by chemicals, which is... not art. You selected some ready-made paper, and the sun printed your picture.... That is photography, with an iota of art in the selection of the paper. We find you have not proved... you are an artist, for you can execute nothing. You cannot even draw a cube fairly.... If you think photography to be an art, you must decide who is the artist in the case of an automatic machine – the penny, the person who drops the penny in the slot, or the automatic machine.' Original publication: Emerson, Peter Henry. 'Photography Not Art' The Photographic Quaterly, January 1892. Excerpts reprinted in: Nancy Newhall, *P.H. Emerson: The Fight for Photography as a Fine Art* (New York: Aperture, 1975), 98.

44.　A similar point is made by McCormack et al.: 'We should also remember that the creative splendor of human cultures and built environments are collective and cumulative efforts. Individual creativity is arguably weak in the absence of the structures and systems that enable the accumulation of artifacts and information' Jon McCormack et al., 'Ten Questions Concerning Generative Computer Art,' *Leonardo* 47, no. 2 (2014): 136.

45.　On that note it may be worth recalling this provocative statement by Herbert Franke: 'The application of technical means in art is very old; it is remarkable that in music it has led to insertion of complicated physical precision machines, whereas visual art has long remained true to methods used since the stone-age: the application of colour by means of pencil and brush.' To be clear, by 'methods' Franke is also refering to theoretical methods. Herbert W. Franke, 'The Computer - a New Tool for Visual Art,' *The Visual Computer: International Journal of Computer Graphics* 4 (1988): 35.

46.　Frieder Nake and Susan Grabowski, 'Think the Image, Don't Make It! On Algorithmic Thinking, Art Education, and Re-Coding,' *Journal of Science and Technology in the Arts (CITAR)* 9, no. 3 (2017): 23.

47. Frieder Nake, 'Vilém Flusser Und Max Bense Des Pixels Angesichtig Werdend: Eine Überlegung Am Rande Der Computergrafik,' in *Fotografie Denken: Über Vilém Flussers Philosophie Der Medienmoderne*, ed. Jäger Gottfried (Bielefeld: Kerber, 2001); 'Surface, Interface, Subface. Three Cases of Interaction and One Concept,' in *Paradoxes of Interactivity. Perspectives for Media Theory, Human-Computer Interaction and Artistic Investigations*, ed. U. Seifert, J.H. Kim, and A. Moore (Bielefeld: transcript, 2008).

48. An alternative way to think of subface and surface is as genotype and phenotype respectively.

49. Metadata information (described in Chapter 4, 'The Networked Image') is part of the subface processes.

50. Nake and Grabowski, 'Think the Image, Don't Make It! On Algorithmic Thinking, Art Education, and Re-Coding,' 23.

51. Ibid., 28.

52. Nake, 'Paragraphs on Computer Art, Past and Present,' 57.

53. Nake, 'Construction and Intuition: Creativity in Early Computer Art,' 64.

54. For the sake of brevity, it is worth noting that algorithmic simplicity may sometimes generate visual complexity and vice versa.

55. Vilém Flusser, *Into the Universe of Technical Images*, trans. Nancy Ann Roth (Minneapolis: University of Minnesota Press, 2011), 99.

56. Roger Scruton, 'Photography and Representation,' *Critical Inquiry* 7, no. 3 (1981): 578–79.

57. Flusser, *Into the Universe of Technical Images*, 20.

58. Frieder Nake, 'Algorithmic Art,' *Leonardo* 47, no. 2 (2014): 108.

59. Marey, Edgerton and Morris are credited for having invented chronophotography, the rapatronic camera and the Interrotron respectively.

60. In this original article in which the 'machine' is 'invented', Alan Turing in fact imagines a living person (whom he calls 'the computer') who executes these deterministic mechanical rules slavishly. Turing, 'On Computable Numbers, with an Application to the *Entscheidungsproblem*'.

Conclusion

At the outset of this book I reflected on the meaning of a fuzzy photograph from William Henry Fox-Talbot's well-known publication, *The Pencil of Nature* (Figure 1). This photograph features a building hailed as 'the first that was ever yet known *to have drawn its own picture*'.[1] This notion, to reiterate, was, for at least a century-and-a-half, the 'gold standard'[2] of photography theory – an image *of* the world is formed *by* the world and remaining forever bound to it. But images never cease to reorganize the relationships between humans and their technology. Nowadays there is no such tangibility, no standard burned in substance, no set relationship to the world. When images, like other forms of information, can be mined by manipulating voltage differences, colour, luminescence, shape and texture are mere placeholders of space and time. And so, even if there are now increasingly fewer images that are special, distinguished and informative, some imaging processes can still be described as such. I will therefore conclude this book by pondering on a process for creating and sequencing such images in John Gerrard's *Oil Stick Work (Angelo Martinez / Richfield, Kansas)*. This novel artwork, which also comprises its own *class* of images, features another building 'out there in the world' as so many photographs have in history. Unlike many other buildings depicted in photographs, this building can be understood to have drawn, and to be continuously drawing, its own picture. This building, and the system which engendered it, and from which it remains inseparable, becomes pencil and sketchbook combined, together manifesting an altogether different nature (Figure 27).

Noticeably, the building in question is not a noble Englishman's country manor. Rather, it is a dull looking barn situated in the Oklahoma panhandle. Contrary to Talbot's Lacock Abbey, which must have required 30 to 60 minutes to photographically 'draw' its own picture, this building draws itself instantaneously time and again. For this to be done, thousands of photographs were taken of a barn's exterior. A structure was then built 'by hand' so to speak, with computer software to be precise. In this structure every detail, down to the doors, hinges and bolts, had to be laboriously and meticulously modelled. The photographs were then applied as mere textures on the resulting surfaces of the outputted structure. This 'sculptural photograph', as Gerrard calls it,[3] was then brought into Real-time 3D, where the production of an interactive hyper-real quasi-photographic film began.[4,5]

FIGURE 27: Still image from John Gerrard's *Oil Stick Work (Angelo Martinez/Richfield, Kansas)*, 2008. Image courtesy of the artist and Thomas Dane Gallery. © John Gerrard. All rights reserved, DACS. 2019.

However, the Real-time 3D program or gaming engine, as it is often referred to, is usually used in creating intensively interactive gaming environments distinguished by the freedom of their viewer-participants to explore the virtual spaces by unrestricted movement, acrobatic fly-throughs and giddy perspectives. Importantly, such movements are *not* pre-modelled but rather modelled 'live'. In standard gaming contexts, this mostly happens in response to participant commands, which are expressed as physical gestures. If one desires to ascend, they will view a world from above. When one descends, their point-of-view will return to the ground they landed on. In other words, freedom of movement is defined and pre-programmed to extreme extents, but movements themselves are *not*. Neither are they 'drawn' by a human hand, or in any way pre-inscribed and saved into the system's memory. In Gerrard's work the case is different and the viewer remains a non-participant as the image does not change in accordance with his desires or gestures. Nonetheless, a system, its engine and what I prefer to call its programme still perform 'on-the-fly drawing' of what can only be described as ephemeral could-have-been pictures.

Thus, and in contrast to standard gaming programs, Gerrard's artwork works like a photograph, in that it seeks to *revoke* freedom of movement from its viewers who, consequently, do not become participants. Instead it forces them on a monotonous recurring orbital path around the isolated barn. The only changes that occur in the image during these circuits are gradual variations in the luminance of the simulated scene. In time, these constant changes become discomforting, even as

they are still mesmerizing. Significantly, these changes do not occur arbitrarily but generatively, in accordance with the time of day and natural climate conditions in a real-world locale in Kansas.[6] This is where the 'object' of the quasi-photographic film would have been located, had it existed, had it been the object of a photograph. To clarify, this latter quality is achieved *independently* of human direction or even intention. It requires neither the artist's intervention nor require human presence. As this quasi-photographic film unfolds in time and space, it comes as close as possible to a mechanical or fully automatic breed of picture, as described throughout classic photography theory. This, to reiterate, is achieved by construction, through guidance of and by reliance on algorithms. In other words, *only* a programmatic artifice for production can qualify as a purely causal form of reproduction.

Intriguingly, a lone human figure is also simulated in Gerrard's film. Perched on a lift beside the barn, it is depicted as it methodically rubs a black oil stick on the façade. Watching closely, one notices that the minute figure never repeats the exact same scrubbing motions. However, it may, on occasion, stretch its muscles or simply step back to take in what it has so far 'painted'. And although this tireless artist appears six days a week and paints from dawn to dusk, his work progresses at a painstakingly slow pace. If all goes according to plan, and the program keeps running, Gerrard's Angelo Martinez will have finished painting the white barn black in 30 years, which is much too long to keep any human's attention rapt.

This scrubbing Sisyphus appears alien because it represents an aspect of ourselves that we are especially desperate to avoid. Is this because machine labour serves as the uncanny double of the repetitive, mechanical, materially determined and non-reflective dimensions of *our* human character? Does machine labour somehow disturb our self-image as autonomous agents? This question, now left at the doorstep of art, underscores John Gerrard's work and is one of the questions this book sought to answer.

By thinking of photography as a principally algorithmic form of art, by philosophizing it with and as a universal Turing machine, our theories of art-making and artisthood can be enriched. To think of machine labour as a curious form of agency is to rethink photography altogether. It is to recognize that we sometimes *do* manage to do exceptionally well *without* intuition, which, we could say, is often no more than a mystical penchant for discrepancies. This gives rise to the always-intimidating, never-popular possibility that creativity can be forged in the crucible of machines, automatons or pure causalities. For individual artisthood, this may be accepted as a threat. After all, most artists still perceive of themselves as belonging to or constructing an aristocracy of the mind. This is an unfortunate position to maintain as it prevents art, particularly visual art, from developing in ways so many other disciplines have followed. If, instead, we accept that intuition can, in some cases, be artificially sculpted, then, in turn, we can benefit from the fact that

creativity can be relegated to other humans or to human and non-human structures and practices. This, for society and for us as a species, is a far more promising possibility.

By way of farewell, and to tie this in with one motivation for writing this book, we could simply posit that photography is an art form that introduced a previously unfamiliar distinction between individual and collective. The photographer may not be an artist as Peter Henry Emerson so provocatively argued. He or she may very well be unnecessary, as Vilém Flusser explicitly stated.[7] Notwithstanding, the collective effort for constructing photographic apparatuses and programs is often artistic, so long as we take science, engineering and design to sometimes be forms of art. If we concede that this is possible, then photographic systems can potentially become artistically constructed. Perhaps we could say about them, in allusion to the Gospel of John, that they are 'in but not of' art. Once in existence, such systems can yield new artefacts. However, more interestingly, they create new *classes* of artefacts and in so doing become new forms of signification and interpretation.

Cultural techniques always require terminologies with which to be described. These, however, are mostly determined by the period during which the techniques first emerged. Thus, our conceptions about whole cultural genealogies tend to pivot on understandings that draw from the technical habitat they appeared in or from the perceived nature of the medium they first appeared on. To be invented, to first appear durably, photographic images required material substances. Unfortunately, this resulted in a consistent theory that sanctified imagery and its surfaces. Perhaps unsurprisingly, the theory tended to confuse photography with methods that had not changed significantly in 35,000 years, namely the manual application of pigment on surface.[8] The theory did eventually grasp that photography was not painting but, to this day, it cannot quite agree, nor adequately explain *why*. This, we can now appreciate, was not because the execution of the image was done 'hands-free'. Nor was it because it was done 'mind-free' (it wasn't). Rather, it was because this execution, or rather realization, was performed independently from the image's conception. In short, the main flaw in this theory lay in its emphasis on only some of the medium's possible manifestations. Thus, photography's other innate capacities went either unnoticed or entirely unaccounted for. This is what I called the Turin Shroud paradigm of photography.

But photography has changed. All technologies change. Mathematical photography has ousted traditional photography because it is better able to separate conception and execution. Nonetheless, this has also made it clear that photography has never been just another form of image-making. Rather, it always was, long before it became ebulliently mathematical, a long-awaited optimization of other patterns of information processing and exchange. When these patterns

were manifested by traditional photography, they were mistakenly perceived as innately photographic. These patterns have much to do with imaging but they are, more than anything, syntactic abstractions of cognition, utilized for communication as well as for art.

Technological changes ought to be welcomed because they reshape our thinking, develop it and correct it. Therefore, we can now fully acknowledge that the 'nature' of photography, on which so many propositions have hinged, has always been no more than a prologue. In the performance proper, the real protagonist is the 'the body of real numbers formerly called nature', as Kittler so felicitously puts it.[9] Thus, what was first identified as only one medium should now be considered as a dynamic composition of previously latent media – technical, electronic, digital, interactive and networked. Therein, change, bifurcation and recursivity always remain available. It is now incumbent on us to determine a new trajectory for photography, to propose a new environment for historicizing and theorizing it. This is what I have sought to do, under the framework of the universal Turing machine.

The writings examined and discussed in Chapter 1 are emblematic of the dominant strand of thought throughout at least 150 years of writing about photography. With and through this strategically chosen compilation, I assayed the foundations of our belief in photography's veracity. This belief may have been, as often happens, an inherent imposition foisted upon us by previous cultural dogmas. Nonetheless, even today, now that its heyday has surely passed, it would be erroneous to assume that this belief is no longer held. On the contrary, for all its drawbacks, it persists and is manifested in many of our everyday expressions. Curiously, time has done little to weaken its grip on our collective psyche.

Chapter 2 isolated the most extreme elements of this traditional belief and reconsidered them analytically. This was intended as a demonstration of the inefficacy of this dominant belief as the backbone for a paradigm of photography. Yet, this careful review also revealed that the existing paradigm does have some merits. When it is distilled to its purest possible form it yields adroit reasoning and important terms. Of those, some, such as *information*, prove to be beneficial in proposing new ways to philosophize photography.

Integral to Flusser's comprehensive theory, the term information reappeared in Chapter 3. There, and through an elaboration of additional complementary terms such as *apparatus* and *program*, I proposed that photography ought to be understood in an entirely different context. Not with, near, or even in comparison to traditional artistic modes of expression, but rather in relation to various communication methods. In them, photography can be understood as the abolition of all natural dimensions and the virtualization of cultural memory. In this extreme abstraction, photography stands out as comparable with and in itself a

form of computing the world. This expands the discourse of photography into new realms, most notably new media and media philosophy.

Today, photography has all but become a form of computation. Therefore, Chapter 4 offered a comprehensive toolkit for thinking about it as a family of programs. It proposed a new construal for the distinction between 'analogue' and 'digital' in photography. In this explication, the two terms are not mutually exclusive but rather complementary discourse modalities. Further, I also argued that digital characteristics and mathematical potentialities have always inhabited photography and that therefore the recent technological turmoil does not mean the demise of the medium but rather its 'coming of age'. Importantly, now that the medium of photography can be seen as media, photographic images no longer need to be understood as bearers of ontological qualities but rather only as epistemic containers. Importantly, quasi-photographic images can equally be created to contain the same *episteme* that we could then simply label as 'veracity as aesthetic' or 'causality as aesthetic'.

Chapter 5 consolidated taxonomies from previous chapters into an expanded articulation of photography, from algorithm through program to Turing machine. It further expanded on notions of information and particularly information aesthetics, in an attempt to erect sets of objective measures for the generation and appreciation of artistic phenomena. In doing so it singled out generative and concrete photography. These, I further argued, are the purest expressions of photography and, in that, they form a direly needed bridge between conceptions of the image as made of light and the image as made of data. A brief account of algorithmic art was then offered as a way to flesh out what I take as the most pertinent questions for photography in and as art.

In closing, perhaps the best way to reconcile photography's past with its present and inevitable future is by recourse to the history of mathematics. In 1931, Kurt Gödel proved that all formal systems must unavoidably contain *undecidable* propositions.[10] Thus, in contrast to reason, formal systems can never achieve certain true propositions. Surprisingly, Gödel also demonstrated that such paradoxes cannot be eliminated and are in fact a necessary part of all sufficiently complex formal systems. This is also true for photography. Its Turin Shroud paradigm is undeniably an undecidable proposition. Notwithstanding, it may have been foundational for constructing photography as an overarching formal system of abstraction, signification and representation. Further recourse to computation might reveal that what we once knew as photography was merely a cocoon – a mono-algorithmic program enveloping the chrysalis of a multi-algorithmic meta-program. Photography has now emerged as the butterfly that it was always going to be. Before our doubting eyes it now swirls upwards to dizzying heights. Other butterflies will undoubtedly follow, tracing the flight of infinitudes between explicitness and ellipsis.

NOTES

1. Original publication: *Some Account in the Art of Photogenic Drawing, or, The Process by Which Natural Objects may be Made to Delineate Themselves without the Aid of the Artist's Pencil.* Reprinted in: Beaumont Newhall, ed. *Photography: Essays & Images: Illustrated Readings in the History of Photography* (New York: The Museum of Modern Art, 1980), 28.

2. Walter Benn Michaels, *The Gold Standard and the Logic of Naturalism* (Berkeley: University of California Press, 1988).

3. John Gerrard et al., *John Gerrard* (Madrid: Ivorypress Art & Books, 2011), 127.

4. Real-time 3D is a simulation technology derived from knowledge originally developed for military purposes, which was then adapted for use in the film, broadcast and online entertainment industries.

5. As Kittler had demonstrated, similar processes also occurred in other music, broadcast and entertainment technologies. Friedrich A. Kittler, *Gramophone, Film, Typewriter*, trans. Geoffrey Winthrop-Young and Michael Wutz, Writing Science (Stanford: Stanford University Press, 1999); *The Truth of the Technological World: Essays on the Genealogy of Presence*, trans. Erik Butler (Stanford: Stanford University Press, 2013).

6. Today, many generative systems use random number generators. Gerrard's system does not use them. Notwithstanding, it is designed and programmed to parse information independently and incorporate it into the system, which then changes in unforeseeable ways. Strictly speaking, this makes it a generative system.

7. This statement is unusual when considering similar statements by Flusser merely lamenting the photographer's lack of choice or freedom. Ironically, this was not written by Flusser but rather uttered in an oral interview during which a photographer and sound man were present. Miklós Peternák, 'We Shall Survive in the Memory of Others' (Berlin: Vilém Flusser Archiv, Universität der Künste Berlin, 2010), 32:50 mins.

8. I am here paraphrasing an idea from Franke: Herbert W. Franke, 'The Computer – A New Tool for Visual Art', *The Visual Computer: International Journal of Computer Graphics* 4 (1988): 35.

9. Friedrich A. Kittler, 'There Is No Software', in *Literature, Media, Information Systems: Essays*, ed. John Johnston (London: Routledge, 2012), 152.

10. Kurt Gödel, 'Some Basic Theorems on the Foundations of Mathematics and Their Implications', in *Kurt Gödel, Collected Works, Volume III*, ed. S. Feferman, et al. (Oxford: Oxford University Press, 1995).

References

Adams, Ansel, and Robert Baker. *The Camera*. Boston, MA: Little Brown, 1983.

———. *The Negative*. Boston, MA: Little Brown, 1983.

———. *The Print*. Boston, MA: Little Brown, 1983.

Agee, James and Walker Evans. *Let Us Now Praise Famous Men: Three Tenant Families*. Boston: Houghton Mifflin, 1969.

Arnheim, Rudolf. *Film as Art*. Berkeley: University of California Press, 1957.

———. 'On the Nature of Photography'. *Critical Inquiry* 1, no. 1 (1974): 149–61.

Asser, Saskia. *First Light: Photography & Astronomy*. Amsterdam: Huis Marseille, 2010.

Azoulay, Ariella. *Aïm Deüelle Lüski and Horizontal Photography*. Translated by Tal Haran. Lieven Gevaert Series. Leuven, Belgium: Leuven University Press, 2013.

Barthes, Roland. 'The Photographic Message'. Translated by Stephen Heath. In *Image, Text, Music*, edited by Stephen Heath, 15–31. New York: Hill and Wang, 1977.

———. 'Rhetoric of the Image'. Translated by Stephen Heath. In *Image, Text, Music*, edited by Stephen Heath, 32–51. New York: Hill and Wang, 1977.

———. *Camera Lucida*. Translated by Richard Howard. New York: Hill and Wang, 1980.

Batchen, Geoffrey. *Burning with Desire: The Conception of Photography*. Cambridge, MA: The MIT Press, 1999.

———. 'Electricity Made Visible'. In *New Media Old Media: A History and Theory Reader*, edited by Wendy Hui Kyong Chun and Thomas Keenan, 27–44. New York: Routledge, 2006.

Batkin, Norton. *Photography and Philosophy* (Harvard Dissertations in Philosophy). Edited by Robert Nozick. New York: Garland Publishing, 1990.

Battye, Greg. *Photography, Narrative, Time: Imaging Our Forensic Imagination*. Bristol: Intellect, 2014.

Baudelaire, Charles. *Art in Paris 1845–1862: Salons and Other Exhibitions*. Translated by Jonathan Mayne. London: Phaidon Press, 1965.

Baudrillard, Jean. *Symbolic Exchange and Death*. Translated by Iain Hamilton Grant. London: Sage Publications, 1993.

———. *Simulacra and Simulation*. Translated by Sheila Faria Glaser. Ann Arbor: University of Michigan Press, 1994.

Bazin, André. *What Is Cinema?* Translated by Hugh Gray. Berkeley: University of California Press, 2005.

Benjamin, Walter. *The Work of Art in the Age of Its Technological Reproducibility, and Other Writings on Media*. Translated by Edmund Jephcott, Rodney Livingstone and Howard Eiland. Cambridge, MA: Belknap Press of Harvard University Press, 2008.

Benovsky, Jiri. 'The Limits of Photography'. *International Journal of Philosophical Studies* 22, no. 5 (2014): 716–33.

Bense, Max. Aesthetica (I-IV). Baden-Basen: Agis, 1965.

———. Aesthetische Information: Aesthetica (II). Krefeld: Agis-Verlag, 1956.

———. Programmierung Des Schönen: Aesthetica (IV). Krefed: Agis-Verlag, 1960.

Birkhoff, George David. 'A Mathematical Theory of Aesthetics'. *The Rice Inst. Pamphlet* 19 (1932): 189–342.

Bourdieu, Pierre. *Photography: A Middle-Brow Art*. Translated by Shaun Whiteside. Stanford: Stanford University Press, 1990.

Brown, Adam. 'The Spinning Index: Architectural Images and the Reversal of Causality'. In *On the Verge of Photography: Imaging Beyond Representation*, edited by Daniel Rubinstein, Johnny Golding and Andy Fisher, 237–58. Birmingham, UK: ARTicle Press, 2013.

Buckland, Gail. *Fox Talbot and the Invention of Photography*. London: Scholar Press, 1980.

Burgin, Victor, ed. *Two Essays on Art Photography and Semantics*. London: Robert Self (Publications), 1976.

———. *Thinking Photography*. London: Palgrave Macmillan, 1982.

———. 'Photographic Practice and Art Theory'. In *Thinking Photography*, edited by Victor Burgin, 39–83. London: Palgrave Macmillan, 1982.

———. *The End of Art Theory: Criticism and Postmodernity*. Atlantic Highlands: Humanities Press International, 1986.

Carrillo Canán, Alberto J. L. and Marco Calderón Zacaula. 'Bazin, Flusser and the Aesthetics of Photography'. *Flusser Studies* 13 (2012): np.

Carroll, Noël. *Philosophical Problems of Classical Film Theory*. Princeton: Princeton University Press, 1988.

Cavedon-Taylor, Dan. 'In Defence of Fictional Incompetence'. *Ratio* 23, no. 2 (2010), np.

Cavell, Stanley. *The World Viewed: Reflections on the Ontology of Film*. Enl. ed. Cambridge, MA: Harvard University Press, 1979.

Clark, Andy. 'Technologies to Bond With'. In *Rethinking Theories and Practices of Imaging*, edited by Timothy H. Engström and Evan Selinger, 164–83. London: Palgrave Macmillan, 2009.

Cohen, Jonathan and Aaron Meskin. 'On the Epistemic Value of Photographs'. *The Journal of Aesthetics and Art Criticism* 62, no. 2 (2004): 197–210.

———. 'Photographs as Evidence'. In *Photography and Philosophy: Essays on the Pencil of Nature*, edited by Scott Walden. Malden, MA: Blackwell Publishing, 2008.

Cohen, Ted. 'What's Special About Photography?'. *Monist* 71 (1988): 292–305.

Colomina, Beatriz. *Privacy and Publicity*. Cambridge, MA: The MIT Press, 1996.

Costello, Diarmuid and Dawn M. Phillips. 'Automatism, Causality and Realism: Foundational Problems in the Philosophy of Photography'. *Philosophy Compass* 4, no. 1 (2009): 1–21.

Crary, Jonathan. *Techniques of the Observer: On Vision and Modernity in the Nineteenth Century*. Cambridge, MA: The MIT Press, 1992.

Cubitt, Sean. 'Review of the Shape of Things: A Philosophy of Design, Towards a Philosophy of Photography, Writings, and the Freedom of the Migrant: Objections to Nationalism'. *Leonardo* 37, no. 5 (2004): 403–05.

———. *The Practice of Light: A Genealogy of Visual Technologies from Prints to Pixels*. Cambridge, MA: The MIT Press, 2014.

Cullinan, Nicholas, ed. *Tacita Dean: Film*. London: Tate, 2011.

Currie, Gregory. 'Photography, Painting and Perception'. *The Journal of Aesthetics and Art Criticism* 49, no. 1 (1991): 23–29.

———. *Image and Mind: Film, Philosophy and Cognitive Science*. Cambridge, UK: Cambridge University Press, 1995.

D'Cruz, Jason and P.D. Magnus. 'Are Digital Pictures Allographic?'. *The Journal of Aesthetics and Art Criticism* 72, no. 4 (2014): 417–27.

De Caro, Mario, and David Macarthur, eds. *Naturalism in Question*. Cambridge, MA: Harvard University Press, 2004.

Delehanty, Megan. *Empiricism and the Epistemic Status of Imaging Technologies*. University of Pittsburgh, 2005.

———. 'The Epistemic Status of Brain Images'. In *Rethinking Theories and Practices of Imaging*, edited by Timothy H. Engström and Evan Selinger, 146–63. London: Palgrave Macmillan, 2009.

———. 'Why Images?'. *Medicine Studies* 2, no. 3 (2010): 161–73.

Derrida, Jacques. *Archive Fever: A Freudean Impression*. Translated by Eric Prenowitz. Chicago: University of Chicago Press, 1996.

Deüelle Lüski, Aïm. 2009–2015, email message to the author.

'Direct to Brain Bionic Eye'. Monash University Vision Group, http://www.monash.edu.au/bioniceye/technology.html.

Dretske, Fred I. *Knowledge and the Flow of Information*. *The David Hume Series*. Stanford: Center for the Study of Language and Information, Stanford University Press, 1999.

Druckrey, Timothy. 'From Data to Digital'. In *Metamorphoses: Photography in the Electronic Age*, edited by Mark Haworth-Booth, 4–7. New York: Aperture, 1994.

Ebner, Florian and Christian Müller, eds. *Farewell Photography: Biennale Für Aktuelle Fotografie* 2017. Mannheim: Biennale für aktuelle Fotografie e.V., 2017.

Eder, Josef Maria. *History of Photography*. Translated by Edward Epstean. New York: Dover Publications, 1978.

Emerson, Peter Henry. *Naturalistic Photography for Students of the Art & the Death of Naturalistic Photography*. New York: Arno Press, 1973.

Farocki, Harun. 'War at a Distance'. 58 mins., 2003.

———. 'Phantom Images'. *Public* 29 (2004): 12–22.

Fineman, Mia. *Faking It: Manipulated Photography before Photoshop*. New York: Metropolitan Museum of Art, 2012.

Finger, Anke K., Rainer Guldin and Gustavo Bernardo. *Vilém Flusser: An Introduction.* Minneapolis: University of Minnesota Press, 2011.

Floridi, Luciano. *Information: A Very Short Introduction.* Oxford: Oxford University Press, 2010.

Flusser, Vilém. 'The Photograph as Post-Industrial Object: An Essay on the Ontological Standing of Photographs'. *Leonardo* 19, no. 4 (1986): 329–32.

———. 'To Count'. *Vilém Flusser Archive* [Document 658, Address M20-ARTF-10], 1989.

———. 'On Memory (Electronic or Otherwise)'. *Leonardo* 23, no. 4 (1990): 397–99.

———. 'What Is the Literal Meaning of "Photography"?'. *European Photography* 12, no. 3 (1991): 44–45.

———. *Bodenlos: Eine Philosophische Autobiographie.* Köln: Bollman Verlag, 1992.

———. *The Shape of Things: A Philosophy of Design.* London: Reaktion, 1999.

———. *Towards a Philosophy of Photography.* London: Reaktion, 2000.

———. 'Photography and History'. Translated by Erik Eisel. In *Writings,* edited by Andreas Ströhl. Minneapolis: University of Minnesota Press, 2002.

———. 'The Codified World'. Translated by Erik Eisel. In *Writings,* edited by Andreas Ströhl, 35–41. Minneapolis: University of Minnesota Press, 2002.

———. *Does Writing Have a Future?* Translated by N.A. Roth. Minneapolis: University of Minnesota Press, 2011.

———. *Into the Universe of Technical Images.* Translated by N.A. Roth. Minneapolis: Univ. of Minnesota Press, 2011.

———. *Into the Universe of Technical Images.* Translated by N.A. Roth. Minneapolis: University of Minnesota Press, 2011.

———. 'Our Programme'. *Philosophy of Photography* 2, no. 2 (2011): 205–09.

———. 'The Gesture of Photographing'. *Journal of Visual Culture* 10 (2011): 279–93.

———. 'The Democratization of Photography'. Translated by Rodrigo Maltez Novaes. In *Something Other Than Photography: Photo & Media,* edited by Claudia Giannetti, 132–33. Oldenburg: Edith-Russ-Haus for Media Art, 2013.

———. 'The Distribution of Photographs'. Translated by Rodrigo Maltez Novaes. In *Something Other Than Photography: Photo & Media,* edited by Claudia Giannetti, 134–36. Oldenburg: Edith-Russ-Haus for Media Art, 2013.

Fontcuberta, Joan and Geoffrey Batchen. *Joan Fontcuberta: Landscapes without Memory.* Aperture, 2005.

Fontcuberta, Joan. 'Landscapes of Landscapes'. *Flusser Studies* 14 (2012): 1–2.

Foucault, Michel. *The Order of Things: An Archaeology of Human Sciences.* Translated by Allan Sheridan. New York: Vintage Books, 1973.

Franke, Herbert W. 'The Expanding Medium: The Future of Computer Art'. *Leonardo* 20, no. 4 (1987): 335–38.

———. 'The Computer – A New Tool for Visual Art'. *The Visual Computer: International Journal of Computer Graphics* 4 (1988): 35–39.

Franke, Herbert W., and Gottfried Jäger. *Apparative Kunst: Vom Kaleidoscop Zum Computer*. Köln: DuMont Schauberg, 1973.

Freeland, Cynthia. 'Photographs and Icons'. In *Photography and Philosophy: Essays on the Pencil of Nature*, edited by Scott Walden, 50–69. Malden, MA: Blackwell Publishing, 2008.

Friday, Jonathan. 'Transparency and the Photographic Image'. *British Journal of Aesthetics* 36, no. 1 (1996): 30–42.

———. *Aesthetics and Photography*. Aldershot, UK: Ashgate, 2002.

Fried, Michael. *Why Photography Matters as Art as Never Before*. New Haven: Yale University Press, 2008.

Fukuyama, Francis. *The End of History and the Last Man*. New York: Avon Books, 1993.

Fuldner, Carl. 'Emerson's Evolution'. *Tate Papers* 27 (2017), np.

Galassi, Peter. *Before Photography: Painting and the Invention of Photography*. New York: Museum of Modern Art, 1981.

Galloway, Alexander and Manuel Correa. 'The Philosophical Origins of Digitality'. *&&& Journal* (2015), np.

Galloway, Alexander. *The Interface Effect*. Cambridge, UK: Polity, 2012.

Gaut, Berys. 'Opaque Pictures'. *Revue Internationale de Philosophie* 62 (2008): 381–96.

Gernsheim, Helmut and Alison Gernsheim. L.J.M. *Daguerre: The History of the Diorama and the Daguerreotype*. New York: Dover Publications, 1968.

Gerrard, John, Ed Keller, Yoani Sánchez, Robin Mackay, Reza Negarestani and Simon Groom. *John Gerrard*. Madrid: *Ivorypress Art + Books*, 2011.

Gibson, Ross. *South of the West: Postcolonialism and the Narrative Construction of Australia*. Bloomington: Indiana University Press, 1992.

———. 'The Rise of Digital Multimedia Systems'. *Cultural Studies Review* 12, no. 1 (2006): 141–51.

———. 'On the Senses and Semantic Excess in Photographic Evidence'. *Journal of Material Culture* 18, no. 3 (2013): 243–57.

Gödel, Kurt. 'Some Basic Theorems on the Foundations of Mathematics and Their Implications'. In *Kurt* Gödel, Collected Works, Volume III, edited by S. Feferman, J. Dawson, S. Kleene, G. Moore, R. Solovay and J. van Heijenoort. Oxford: Oxford University Press, 1995.

Goodman, Nelson. *Languages of Art: An Approach to a Theory of Symbols*. London: Oxford University Press, 1969.

'Google Glass Help'. Google, https://support.google.com/glass/answer/3079688.

Greenberg, Clement. *The Collected Essays and Criticism*. Chicago: University of Chicago Press, 1986.

Greenough, Sarah, Joel Snyder, David Travis and Colin Westerbeck. *On the Art of Fixing a Shadow: One Hundred and Fifty Years of Photography*. Washington, DC: National Gallery of Art, 1989.

Grice, H. P. and Alan R. White. 'The Causal Theory of Perception'. *Proceedings of the Aristotelian Society* 35 (1961): 121–68.

Hawking, Stephen. *God Created the Integers: The Mathematical Breakthroughs that Changed History*. Philadelphia: Running Press, 2007.

Heidegger, Martin. *Being and Time*. Translated by John Macquarrie and Edward Robinson. London: SCM Press, 1962.

Hernan, Luis and Carolina Ramirez-Figueroa. 'The Technological Invisible — Image Making as an Exercise of Power'. Paper presented at the Tranimage 2018: 5th Biennial Transdisciplinary Imaging Conference, Edinburgh, UK, 2018.

Hernan, Luis. 'Digital Ethereal'. *ArchaID*, Newcastle University.

Herzog, Werner. 'Grizzly Man'. 104 mins: Lions Gate Films, 2005.

Hill, Paul and Thomas Cooper, eds. *Dialogue with Photography: Interviews by Paul Hill and Thomas Cooper*. Stockport, UK: Dewi Lewis Publishing, 2002.

Hilliard, John. 2015, email message to the author.

Hoelzl, Ingrid and Rémi Marie. 'Posthuman Vision'. Paper presented at the 22nd Symposium on Electronic Art: ISEA2016, Hong Kong, 2016.

Hoelzl, Ingrid and Rémi Marie. *Softimage: Towards a New Theory of the Digital Image*. Bristol, UK: Intellect, 2015.

Holmes, Oliver Wendell. 'The Stereoscope and the Stereograph'. *The Atlantic Monthly* (June 1859): 738–48.

Holsing, Henrike and Gottfried Jäger, eds. *Light Image and Data Image: Traces of Concrete Photography*. Heidelberg: Kehrer Verlag, 2015.

Hopkins, Robert. 'Factive Pictorial Experience: What's Special About Photographs'. *Noûs* 46, no. 4 (2012): 709–31.

Humphrey, Nicholas. 'What the Frog's Eye Tells the Monkey's Brain'. *Brain, Behavior and Evolution* 3, no. 1 (1970): 324–37.

———. 'Vision in a Monkey without Striate Cortex: A Case Study'. *Perception* 3, no. 3 (1974): 241–55.

'Is Photography Over?'. https://www.sfmoma.org/watch/photography-over/.

Jäger, Gottfried, Rolf H. Krauss and Beate Reese. *Concrete Photography*. Bielefeld, Germany: Kerber Verlag, 2005.

Jäger, Gottfried. 'Analogue and Digital Photography: The Technical Picture'. In *Photography after Photography: Memory and Representation in the Digital Age*, edited by Hubertus von Amelunxen, Stefan Iglhaut and Florian Rötzer, 107–09. Munich: G+B Arts, 1996.

Jäger, Gottfried. 'Pinhole Structures: Generative Photographic Works 1967–1974'. *Pinhole Journal* 5, no. 2 (1989): 22–32.

Kaplan, Louis. *The Strange Case of William Mumler*, Spirit Photographer. Minneapolis: University of Minnesota Press, 2008.

Kepes, Gyorgy. *Language of Vision*. Chicago: P. Theobald, 1944.

Kittler, Friedrich A. Film, Typewriter. Translated by Geoffrey Winthrop-Young and Michael Wutz. *Writing Science*. Stanford: Stanford University Press, 1999.

———. 'Computer Graphics: A Semi-Technical Introduction'. *Grey Room* 2 (2001): 30–45.

———. 'Perspective and the Book'. *Grey Room 5* (2001): 38–53.

———. 'Thinking Colours and/or Machines'. *Theory, Culture & Society* 23, no. 7–8 (2006): 39–50.

———. 'Code (or, How You Can Write Something Differently)'. In *Software Studies: A Lexicon*, edited by Mathew Fuller, 40-47. Cambridge, MA: The MIT Press, 2008.

———. 'Code (or, How You Can Write Something Differently)'. In *Software Studies: A Lexicon*, edited by Mathew Fuller, 40–47. Cambridge, MA: The MIT Press, 2008.

———. *Optical Media: Berlin Lectures 1999*. Translated by Anthony Enns. Cambridge, UK: Polity Press, 2010.

———. 'Gramophone, Film, Typewriter'. Translated by Dorothea Von Mücke. In *Literature, Media, Information Systems*, edited by John Johnston, 28–49. London: Routledge, 2012.

———. 'The World of the Symbolic – A World of the Machine'. Translated by Stefanie Harris. In *Literature, Media, Information Systems*, edited by John Johnston, 130–46. London: Routledge, 2012.

———. 'There Is No Software'. In *Literature, Media, Information Systems: Essays.*, edited by John Johnston, 147–55. London: Routledge, 2012.

———. 'Rock Music: A Misuse of Military Equipment'. Translated by Erik Butler. In *The Truth of the Technological World: Essays on the Genealogy of Presence*, 152–64. Stanford: Stanford University Press, 2013.

———. *The Truth of the Technological World: Essays on the Genealogy of Presence*. Translated by Erik Butler. Stanford: Stanford University Press, 2013.

Kracauer, Siegfried. *Theory of Film: The Redemption of Physical Reality*. London: Oxford University Press, 1960.

———. 'Photography'. *Critical Inquiry* 19, no. 3 (1993): 421–36.

Krauss, Rosalind. Th*e Originality of the Avant-Garde and Other Modernist Myths*. Cambridge, MA: The MIT Press, 1985.

———. *The Optical Unconscious*. Cambridge, MA: The MIT Press, 1993.

Kuhn, Thomas S. *The Structure of Scientific Revolutions*. Chicago: University of Chicago Press, 1962.

Laric, Oliver. 'Lincoln 3d Scans'. http://lincoln3dscans.co.uk/.

Laruelle, François. *The Concept of Non-Photography*. Translated by Robin Mackay. Bilingual ed. New York: Urbanomic/Sequence Press, 2011.

Lee, Myeong-Jun and Jeong-Hann Pae. 'Photo-Fake Conditions of Digital Landscape Representation'. *Visual Communication* 17, no. 1 (2018): 3–23.

Lewis, David. 'Veridical Hallucination and Prosthetic Vision'. *Australasian Journal of Philosophy* 58, no. 3 (1980): 239–49.

LeWitt, Sol. 'Paragraphs on Conceptual Art'. *Art Forum*, 1967, 79–83.

Link, David. *Archaeology of Algorithmic Artifacts*. Minneapolis MI: Univocal Publishing, 2016.

Lister, Martin, ed. *The Photographic Image in Digital Culture*. 1st ed. London: Routledge, 1995.

———. 'Photography in the Age of Electronic Imaging'. In *Photography: A Critical Introduction* (2nd Edition), edited by Liz Wells, 303–47. London: Routledge, 1998.

Lopes, Dominic. *Understanding Pictures*. Oxford Philosophical Monographs. Oxford: Oxford University Press, 1996.

Lucáks, Georg. 'Narrate or Describe? A Preliminary Discussion of Naturalism and Formalism'. Translated by Arthur D. Kahn. In *Writer & Critic and Other Essays*, edited by Arthur D. Kahn, 110–48. New York: The Universal Library, 1971.

Mandiberg, Michael. 'After Sherrie Levine'. http://www.aftersherrielevine.com/index.html.

Manovich, Lev. *The Engineering of Vision from Constructivism to Virtual Reality*. University of Rochester, 1994.

———. 'The Paradoxes of Digital Photography'. In *Photography after Photography: Memory and Representation in the Digital Age*, edited by Hubertus von Amelunxen, Stefan Iglhaut and Florian Rötzer, 57–65. Munich: G+B Arts, 1996.

———. *The Language of New Media*. Cambridge, MA: The MIT Press, 2001.

Maynard, Patrick. 'The Secular Icon: Photography and the Functions of Images'. *The Journal of Aesthetics and Art Criticism* 42, no. 2 (1983): 155–69.

———. 'Drawing and Shooting: Causality in Depiction'. *The Journal of Aesthetics and Art Criticism* 44, no. 2 (1985): 115–29.

———. 'Talbot's Technologies: Photographic Depiction, Detection, and Reproduction'. *The Journal of Aesthetics and Art Criticism* 47, no. 3 (Summer 1989): 263–76.

———. *The Engine of Visualization: Thinking through Photography*. Ithaca: Cornell University Press, 1997.

McCormack, Jon and d'Inverno Mark, eds. *Computers and Creativity*. Heidelberg: Springer, 2012.

McCormack, Jon, Oliver Bown, Alan Dorin, Jonathan McCabe, Gordon Monro, and Mitchell Whitelaw. 'Ten Questions Concerning Generative Computer Art'. *Leonardo* 47, no. 2 (2014): 131–41.

McLuhan, Marshall. *The Gutenberg Galaxy: The Making of Typographic Man*. Toronto: University of Toronto Press, 1962.

———.*Understanding Media: The Extensions of Man*. London: Routledge & Kegan Paul, 1964.

Menkman, Rosa. 'A Vernacular of File Formats'. https://beyondresolution.info/A-Vernacular-of-File-Formats.

Michaels, Walter Benn. *The Gold Standard and the Logic of Naturalism*. Berkeley: University of California Press, 1988.

Mitchell, William J. *The Reconfigured Eye: Visual Truth in the Post-Photographic Era*. Cambridge, MA: The MIT Press, 1994.

Moholy-Nagy, László. 'Photography Is Manipulation of Light'. *Bauhaus* 1 (1928).

———. 'From Pigment to Light'. *Telehor* 1, no. 2 (1936): 32–36.

———. *The New Vision and Abstract of an Artist*. New York: Wittenborn and Co., 1947.

Mohr, Manfred. *Computer Graphics*. Paris: Musée d'Art Moderne de la Ville de Paris, 1971.

Moles, Abraham A. *Information Theory and Esthetic Perception*. Translated by Joel E. Cohen. Urbana: University of Illinois Press, 1966. Théorie de L'information Et Perception Esthètique.

Müller-Pohle, Andreas. 'Information Strategies'. *European Photography 21 – Photography Today/Tomorrow* (I) 6, no. 1 (1985), np.

Müller, Christin, ed. *Crossover: Photography of Science + Science of Photography*. Leipzig: Spector Books, 2013.

Nake, Frieder. 'Vilém Flusser Und Max Bense Des Pixels Angesichtig Werdend: Eine Überlegung Am Rande Der Computergrafik'. In *Fotografie Denken: Über Vilém Flussers Philosophie Der Medienmoderne*, edited by Jäger Gottfried, 169–82. Bielefeld: Kerber, 2001.

———. 'Computer Art: A Personal Recollection'. Paper presented at the Computers and Creativity conference, London, 2005.

———. 'Surface, Interface, Subface. Three Cases of Interaction and One Concept'. In *Paradoxes of Interactivity. Perspectives for Media Theory, Human-Computer Interaction and Artistic Investigations*, edited by U. Seifert, J.H. Kim and A. Moore, 92–109. Bielefeld: transcript, 2008.

———. 'Paragraphs on Computer Art, Past and Present'. Paper presented at the 'Ideas Before Their Time: Connecting Past and Present in Computer Art' conference, London, 2010.

———. 'Construction and Intuition: Creativity in Early Computer Art'. In *Computers and Creativity*, edited by Jon McCormack and Mark d'Inventro, 61–94. Heidelberg: Springer, 2012.

———. 'Algorithmic Art'. *Leonardo* 47, no. 2 (2014): 108 (Editorial).

———. 2015–2019, email message to author.

Nake, Frieder, and Susan Grabowski. 'Think the Image, Don't Make It! On Algorithmic Thinking, Art Education, and Re-Coding'. *Journal of Science and Technology in the Arts* (CITAR) 9, no. 3 (2017): 21–31.

Nanay, Bence. 'The Macro and the Micro: Andreas Gursky's Aesthetics'. *The Journal of Aesthetics and Art Criticism* 70, no. 1 (2012): 91–100.

Negroponte, Nicholas. *Being Digital*. New York: Vintage Books, 1995.

Newhall, Beaumont, ed. *Photography: Essays & Images: Illustrated Readings in the History of Photography*. New York: The Museum of Modern Art, 1980.

———. *The History of Photography*. New York: The Museum of Modern Art, 1982.

Newhall, Nancy. P.H. *Emerson: The Fight for Photography as a Fine Art*. New York: Aperture, 1975.

Ng, Ren. 'Digital Light Field Photography'. Stanford, 2006.

Nickel, Douglas R. 'History of Photography: The State of Research'. *The Art Bulletin* 83, no. 3 (2001): 548–58.

Ong, Walter J. *Orality and Literacy: The Technologizing of the Word*. London: Methuen, 1982.

Paglen, Trevor. 'Invisible Images (Your Pictures Are Looking at You)'. *The New Inquiry* (2016). https://thenewinquiry.com/invisible-images-your-pictures-are-looking-at-you/.

Pallasmaa, Juhani. *The Eyes of the Skin, Architecture and the Senses*. London: Academy Editions, 1996.

Palmer, Daniel. 'A Collaborative Turn in Contemporary Photography?'. *Photographies* 6, no. 1 (2013): 117–25.

————. 'Redundant Photographs: Cameras, Software and Human Obsolescence'. In *On the Verge of Photography: Imaging Beyond Representation*, edited by Daniel Rubinstein, Johnny Golding and Andy Fisher, 49–68. Birmingham, UK: ARTicle Press, 2013.

————. 'The Rhetoric of the Jpeg'. In *The Photographic Image in Digital Culture*, edited by Martin Lister, 149–64. London: Routledge, 2013.

————. 'Light, Camera, Algorithm: Digital Photography's Algorithmic Conditions'. In *Digital Light*, edited by Sean Cubitt, Daniel Palmer and Nathaniel Tkacz, 144–62. London: Open Humanities Press, 2015.

————. *Photography and Collaboration: From Conceptual Art to Crowdsourcing*. London: Bloomsbury Academic, 2017.

Panofsky, Erwin. 'Style and Medium in the Motion Pictures'. In *Film Theory and Criticism: Introductory Readings*, edited by Leo Braudy and Marshal Cohen, 151–69. London: Oxford University Press, 1974.

Peternák, Miklós. 'We Shall Survive in the Memory of Others'. *Berlin: Vilém Flusser Archiv*, Universität der Künste Berlin, 2010.

Pierce, Charles Sanders. edited by Harvard University: Houghton Library, 1906.

————. *The Collected Papers (Volumes 1-6)*. Cambridge, MA: Harvard Univ. Press, 1931–36.

————. *The Collected Papers (Volumes 7&8)*. Cambridge, MA: Harvard Univ. Press, 1958.

Popiel, Anna. *On Pixels and Particles: The Digital Connection between Nature and Art in Vilém Flusser's Philosophy*. Saarbrücken, Germany: Lambert Academic Publishing, 2012.

Richardson, Matt. 'The Descriptive Camera'. http://mattrichardson.com/Descriptive-Camera/.

Ritchin, Fred. *After Photography*. New York: W.W. Norton & Company, 2009.

Roman, Alex. 'The Third & the Seventh'. 12 Mins.: Spy Films, 2009.

————. *The Third & the Seventh: From Bits to the Lens*. Translated by Laura F. Farhall. Madrid: The Third & The Seventh S.L., 2013.

Rosen, Margit, ed. *A Little-Known Story About a Movement, a Magazine, and the Computer's Arrival in Art: New Tendencies and Bit International, 1961–1973*. Cambridge, MA: The MIT Press, 2011.

Røssaak, Eivind. 'Algorithmic Culture: Beyond the Photo/Film-Divide'. In *Between Stillness and Motion: Film, Photography, Algorithms*, edited by Eivind Røssaak, 187–203. Amsterdam: Amsterdam University Press, 2011.

Roth, N.A. 'Mira Schendel's Gesture: On Art in Vilém Flusser's Thought, with "Mira Schendel" by Flusser'. *Tate Papers*, no. 21 (2014), np.

Rubinstein, Daniel and Katrina Sluis. 'The Digital Image in Photographic Culture: Algorithmic Photography and the Crisis of Representation'. In *The Photographic Image in Digital Culture*, edited by Martin Lister, 22–40. London: Routledge, 2013.

Rubinstein, Daniel. 'The Digital Image'. *Mafte'akh; Lexical Review of Political Thought* 6, no. 1 (2014): 1–21.

————. 'Posthuman Photography'. In *The Evolution of the Image: Political Action and the Digital Self*, edited by Marco Bohr and Basia Sliwinska. London, UK: Routledge, 2018.

Schaaf, Larry J. *Out of Shadows: Herschel, Talbot, & the Invention of Photography*. New Haven: Yale University Press, 1992.

Scharf, Aaron. *Pioneers of Photography: An Album of Pictures and Words*. New York: N. Abrahams, 1975.

———. *Art and Photography*. New York: Penguin Books, 1986.

Scruton, Roger. 'Photography and Representation'. *Critical Inquiry* 7, no. 3 (1981): 577–603.

Sekula, Allan. 'The Traffic in Photographs'. *Art Journal* 41, no. 1, Photography and the Scholar/Critic (1981): 15–25.

———. 'The Body and the Archive'. *October* 39 (1986): 3–64.

———. 'Reading an Archive: Photography between Labour and Capital'. In *Visual Culture: The Reader*, edited by Jessica Evans and Stuart Hall. London: Sage Publications, 1999.

Seppänen, Janne and Juha Herkman. 'Aporetic Apparatus: Epistemological Transformations of the Camera'. *Nordicom Review* 37, no. 1 (2016): 1–13.

Shannon, Claude E. 'A Mathematical Theory of Communication'. *The Bell System Technical Journal* 27, no. July, October (1948): 379–423, 623–56.

Snyder, Joel. 'Picturing Vision'. *Critical Inquiry* 6, no. 3 (1980): 499–526.

———. 'Galassi: Before Photography: Painting and the Invention of Photography'. *Studies in Visual Communication* 8, no. 1 (1982): 110–16.

———. 'What Happens by Itself in Photography?'. In *Pursuits of Reason: Essays in Honor of Stanley Cavell*, edited by Ted Cohen, Paul Geyer and Hilary Putnam, 361–73. Lubbock: Texas Tech University Press, 1993.

Snyder, Joel and Neil Walsh Allen. 'Photography, Vision, and Representation'. *Critical Inquiry* 2, no. 1 (1975): 143–69.

Solnit, Rebecca. *River of Shadows: Eadweard Muybridge and the Technological Wild West*. New York: Penguin Books, 2004.

Steyerl, Hito. 'A Sea of Data: Apophenia and Pattern (Mis-)Recognition'. *e-flux journal* 72 (2016), np.

Szarkowski, John. 'Photography a Different Type of Art'. *The New York Times Magazine* (13 April 1975): 64–68.

———. *Mirrors and Windows: American Photography since 1960*. New York: Museum of Modern Art, 1978.

Tagg, John. *The Burden of Representation: Essays on Photographies and Histories*. Basingstoke, England: Macmillan Education, 1988.

Talbot, William Henry Fox. 'Photogenic Drawing'. *The Literary Gazette* (2 February 1839): 73–74.

———. *The Pencil of Nature*, edited by Facsimile, 1844–46. Chicago: KWS Publishers, 2011.

Tietjen, Friedrich. 'Post-Post-Photography'. In *The Routledge Companion to Photography and Visual Culture*, edited by Moritz Neumüller, 376–78. London: Routledge, 2018.

'The Photographic Universe'. *Parsons The New School for Design*. http://photographicuniverse.parsons.edu/.

'The Post-Photography Prototyping Prize (P3)'. https://www.fotomuseum.ch/en/explore/p3/.

Tomas, David. 'From the Photograph to Postphotographic Practice: Toward a Postoptical Ecology of the Eye'. *SubStance* 17, no. 1, no. 55 (1988): 59–68.

———. *A Blinding Flash of Light: Photography between Disciplines and Media*. Montreal: Dazibao, 2004.

———. *Beyond the Image Machine: A History of Visual Technologies*. London: Continuum, 2004.

Trachtenberg, Alan, ed. *Classic Essays on Photography*. New Haven: Leete's Island Books, 1980.

Turing, Alan M. 'On Computable Numbers, with an Application to the Entscheidungsproblem'. *Proceedings of the London Mathematical Society* 42, no. 2 (1936): 230–65.

Umbrico, Penelope. 'Suns from Sunsets, from Flickr'. http://www.penelopeumbrico.net/Suns/Suns_State.html.

van der Meulen, Sjoukje. 'Between Benjamin and Mcluhan: Vilém Flusser's Media Theory'. *New German Critique* 110, (2010): 180–207.

Van Gelder, Hilde and Helen Westgeest. *Photography Theory in Historical Perspective: Case Studies from Contemporary Art*. Chichester, West Sussex, UK: Wiley-Blackwell, 2011.

Van Lier, Henri. *Philosophy of Photography*. Translated by Aarnoud Rommens. Lieven Gevaert Series. Leuven, Belgium: Leuven University Press, 2007.

van Winkel, Camiel. *The Myth of Artisthood*. Amsterdam: Mondriaan Fund, 2013.

Verstegen, Ian. 'What Can Arnheim Learn from Flusser (and Vice Versa)?'. *Flusser Studies*, no. 18 (2014).

Virilio, Paul. *The Vision Machine*. Translated by Julie Rose. Bloomington: Indiana University Press, 1994.

von Amelunxen, Hubertus, Stefan Iglhaut and Florian Rötzer, eds. *Photography after Photography: Memory and Representation in the Digital Age*. Munich: G+B Arts, 1996.

von Amelunxen, Hubertus. 'Photography after Photography: The Terror of the Body in Digital Space'. In *Photography after Photography: Memory and Representation in the Digital Age*, edited by Hubertus von Amelunxen, Stefan Iglhaut and Florian Rötzer, 115–26. Munich: G+B Arts, 1996.

Walden, Scott, ed. *Photography and Philosophy: Essays on the Pencil of Nature*. Malden, MA: Blackwell Publishing, 2008.

Walton, Kendall L. 'Pictures and Make-Believe'. *The Philosophical Review* 82, no. 3 (1973): 283–319.

———. 'Transparent Pictures: On the Nature of Photographic Realism'. *Critical Inquiry* 11, no. 2 (1984): 246–77.

———. 'Looking Again through Photographs: A Response to Edwin Martin'. *Critical Inquiry* 12, no. 4 (1986): 801–08.

Warburton, Nigel. 'Seeing through "Seeing through Photographs"'. *Ratio* 1, no. 1 (1988): 64–74.

———. 'Authentic Photographs'. *British Journal of Aesthetics* 37, no. 2 (1997): 129–37.

Wartofsky, Marx. 'Cameras Can't See: Representation, Photography and Human Vision'. *Afterimage* April (1980): 8–9.

Weiberg, Birk. 'Probabalistic Realism'. In *Pointed of Pointless? Recalibrating the Index* (Part II). Brandenburgische Zentrum für Medienwissenschaften [Brandenburg Center for Media Studies, Potsdam], 2017.

Wiener, Norbert. *Cybernetics, or, Control and Communication in the Animal and the Machine*. Cambridge, MA: Technology Press, 1948.

Wiesing, Lambert. *Artificial Presence*. Translated by Nils F. Schott. Stanford: Stanford University Press, 2009.

———. 'Pause of Participation: On the Function of Artificial Presence'. *Research in Phenomenology* 41, no. 2 (2011): 238–52.

Winthrop-Young, Geoffrey and Eva Horn. 'Machine Learning'. *Art Forum 51* (September 2012): 473–79.

Winthrop-Young, Geoffrey. 'Hardware/ Software/ Wetware'. In *Critical Terms for Media Studies*, edited by W.J.T Mitchell and Mark B.N. Hansen, 186–98. Chicago: University of Chicago Press, 2010.

Wittgenstein, Ludwig. *Wittgenstein's Lectures on the Foundations of Mathematics*, Cambridge, 1939: From the Notes of R.G. Bosanquet, Norman Malcolm, Rush Rhees and Yorick Symthies. Hassocks: Harvester Press, 1976.

Zeimbekis, John. 'Digital Pictures, Sampling, and Vagueness: The Ontology of Digital Pictures'. *Journal of Aesthetics and Art Criticism* 70, no. 1 (2012): 43–53.

Zielinski, Siegfried. *Deep Time of the Media: Toward an Archeology of Seeing and Hearing by Technical Means*. Cambridge, MA: The MIT Press, 2006.

Index